THE IMMERSIVE ENC

THE IMMERSIVE ENCLOSURE

VIRTUAL REALITY IN JAPAN

PAUL ROQUET

Columbia University Press
New York

Columbia University Press
Publishers Since 1893
New York Chichester, West Sussex
cup.columbia.edu

Library of Congress Cataloging-in-Publication Data
Names: Roquet, Paul, 1980– author.
Title: The immersive enclosure : virtual reality in Japan / Paul Roquet.
Description: New York : Columbia University Press, [2021] |
Includes bibliographical references and index.
Identifiers: LCCN 2021045737 | ISBN 9780231205344 (hardback) |
ISBN 9780231205351 (trade paperback) | ISBN 9780231555968 (ebook)
Subjects: LCSH: Virtual reality—Social aspects—Japan. |
Virtual reality—Industrial applications—Japan. |
Virtual reality—Economic aspects—Japan. |
Virtual reality—Japan—Psychological aspects.
Classification: LCC HM851 .R6647 2021 | DDC 006.80952—dc23/eng/20211207
LC record available at https://lccn.loc.gov/2021045737

Cover design: Elliott S. Cairns

CONTENTS

CONTENTS

THE IMMERSIVE ENCLOSURE

THE IMMERSIVE ENCLOSURE

INTRODUCTION

The Ambient Power Play

While immersed in virtual reality (VR), sometimes the world goes dark. Perhaps a new program has begun to load, or the program you were using just crashed. Your eyes start to adjust, and you begin to see a multitude of dim points of light in the distance, spread out like stars across a moonless sky. You gaze into the distance and wonder where this galaxy has come from.

After a few seconds, you realize what lies before you. The screen is blank. VR has trained you to look off into the virtual distance. But what floats before your eyes is just the interior back wall of the headset, a few centimeters away. The moment you recognize the speckled darkness as part of the interface, the night sky before you violently contracts.[1]

You cannot see a VR headset while you wear it. As soon as you put the display against your face, the stereoscopic imagery forces your visual perspective through to the other side of the screen. Because you cannot move your head independently of the headset, it is impossible to put some perspectival distance between you and the medium. This interface comes far closer to the head than a cinema screen at the end of an auditorium, a television positioned opposite a couch, or even a smartphone at arm's length. The proximity of the head-mounted display makes it impossible to see the screen *as* a screen.[2]

The same goes for VR headphones positioned over the ears. The binaural audio pulls your auditory focus away from the interface itself and

into a larger virtual space that surrounds you on all sides. In most contemporary commercial VR interfaces, plastic controllers keep your hands full as well. Vision, hearing, and touch are all routed away from the local environment and focused instead on the sensory inputs coming from the device.

Never entirely, of course: sometimes you can look out through the gap around the nose bridge and catch a glimpse of a wall, person, or piece of furniture—often just before you crash into them. But for the VR interface to function at all, it must first reroute most of the audio, visual, and (often) tactile cues humans use to locate themselves in the world. The device overwhelms humans' primary means of spatial localization.

Immersion is often just another word for *enclosure*. Once you strip away the claims to immediacy and presence that are made for VR, what's left is a device that blocks perceptual access to the proximate world. Most industry and critical discourse about VR focuses on the worlds made vivid within the headset. But what if the key to VR's cultural significance was not the seemingly three-dimensional spaces that eventually load, but this initial move to voluntarily sever sensory connections with the local environment?

To understand the cultural politics of VR means to grasp the politics of perceptual enclosure. What draws people to stand alone in a room with a brick-sized monitor strapped to their face? Why stare into the glass and plastic in search of deeper meaning? What calls people to hand over almost all their spatial cues about their physical place in the world to a computer? To find an answer to these questions demands a step back from the fixation on bringing users "through the screen" into a virtual space. The focus shifts instead to historicizing the emergent split between "real" and "virtual," and to understanding why people would want to leave their awareness of this world behind in the first place.

Approaching the VR headset as a perceptual enclosure rather than an immersive gateway clarifies the interface's critical position in media history, both during the initial turn to interactive fantasy worlds in the 1980s and 1990s, and more recently as part of the contemporary era of "walled garden" networked internet platforms. In both periods, the headset manifested the most extreme instance of a broader transformation in the everyday media environment. The first was the move toward what I call (after Nango Yoshikazu) the "one-person space." The second, more

recently, is the campaign to shift embodied social interaction onto a more fully computational—and thus more fully controllable—virtual platform.

PERCEPTUAL ENCLOSURE

The concept of *enclosure* has long been debated by historians and political theorists. I invoke that lineage quite deliberately here. Enclosure discourse initially coalesced around analyses of the English enclosure movement of the eighteenth and nineteenth centuries, where individual owners claimed parcels of land once available for common use. Karl Marx famously took an interest in the social and economic ramifications of this transition as an example of "primitive accumulation" by agricultural capital.[3]

Media theorists working from this tradition have sought to update Marx's focus on the rearrangement of labor relations through land privatization. They point to how new media technologies now play a key role in the exploitation of once-public space. What Mark Andrejevic calls "digital enclosure," for example, marks the use of ubiquitous computing technologies in "an attempt to compel or entice entrance into a monitored space that helps rearrange relations of consumption and production."[4] If earlier modes of enclosure sought to limit movement through physical barriers and legal contracts, digital enclosure instead allows for surveillance and behavioral manipulation without obvious interference in a person's freedom of movement. Rather than draw a firm boundary line between domains, digital enclosure sinks into the background and follows individuals wherever they go. This more indirect and environmental intervention allows supervisory control to extend far beyond the workplace and into an ever-wider range of everyday spaces.

The VR headset is one of a range of interfaces extending the reach of the digital enclosure into the space directly adjacent to the body. Others include augmented reality (AR) glasses, other so-called wearables like the Apple Watch, and a wide range of internet-connected appliances and smart digital assistants taking up residence in every room of the house. Much recent critical VR discourse rightfully focuses on the headset's potential for new levels of invasive tracking and surveillance. This includes the potential use and abuse of biometric data from eye, head, and hand

movements, as well as an ever-larger number of onboard sensors focused both inward at a user's body and outward at the surrounding space.[5]

Yet the cultural politics of perceptual enclosure go far beyond these concerns with the capture of biometric and environmental data. This was already clear from Mark Weiser's early attempt to distinguish his notion of "ubiquitous computing" from the then-ascendent concept of "virtual reality" in 1991. Ubiquitous computing's attempt to blend computational interfaces seamlessly into the existing landscape was set out in direct opposition to the VR headset's rejection of the environmental surround. Whereas ubiquitous computing, Weiser envisioned, works on "invisibly enhancing the world that already exists," VR "focuses an enormous apparatus on simulating the world."[6] Or to rephrase this in perceptual terms: whereas ubiquitous computing aims to remain in the attentional background, the VR interface works to computationally commandeer the entirety of a person's perceptual horizons, both background *and* foreground.

As it moves into the space right around the body, VR remakes how people perceive and locate themselves within the broader worlds they inhabit. Unlike the largely impersonal sensor networks of ubiquitous computing, VR is entirely organized around a first-person perceptual logic.[7] VR positions a user at the very center of the apparatus and builds out a simulated world relative to their perspective and orientation. If legal enclosure now focuses on concepts like intellectual property and copyright, and digital enclosure seeks to control space through data surveillance, what I call *perceptual enclosure* accrues spatial power through an intervention at the very moment humans encounter their surrounding environment. VR appears to offer a world focused entirely on an individual's perception, while in the process enclosing their every perspective on the world.

THE AMBIENT POWER PLAY

Histories of VR traditionally lump the head-mounted interface together with larger architectures aimed at sensory immersion, like Robert Barker's eighteenth-century panoramas or, more recently, big-screen cinemas.[8] Like VR, panoramas and large-format screens can reach deep into a human's sense of spatial awareness, sometimes enough to make a person

dizzy.[9] And all media take up some portion of a person's perceptual field. But there is a qualitative difference in how the VR interface latches onto the head and hands as it simultaneously strips away the local environment. This difference is in the way VR leverages both bilateral sense perception and movement tracking to locate a person more completely within a virtual space.

The term *ambient* is often applied to media that slip into the atmospheric background. As I argued in *Ambient Media*, however, the word can be understood more precisely to refer to media that directly seek to interface with the bilateral organization of the human senses.[10] The literary critic Leo Spitzer's classic essay on the history of the word notes how the Latin prefix *ambi-* emphasizes the use of "both sides (right and left)" by a subject that encounters or acts on an environment, such as the "both hands" of the ambidextrous.[11] Drawing out this distinction further, the Italian studies and comparative literature scholar Karen Pinkus notes that while much scholarship on ambience positions it as something that "surrounds," the word's etymology reveals how ambience is in fact "perceived, written about, and comprehended by a subject whose senses function in *right/left pairs* (eyes, ears, hands). Given that the human subject is or can be ambisensorial, binaural, binocular, it is possible that *ambi-*, when involved with the subject rather than with what surrounds him or her, cedes some of its general fuzziness to a more strictly binary directionality."[12] Rather than focus on a shared spatial background (or atmosphere), an ambience becomes immersive only once it passes through "both sides" of the human body and is composited by human perception into a full three-dimensional space.

In this sense, VR is a deeply ambient interface. The headset relies not just on bilateral sense perception but also the near-continual pivoting of the eyes, head, and torso. VR triangulates the perceptual gap between the two sides of the body to position the user at the center of their own individualized three-dimensional space. While binaural audio, stereoscopic visuals, and physical movement tracking each have a longer history, VR emerges when all three are combined to mediate spatial awareness more fully. VR usurps both focused and peripheral audiovisual perception in every direction and updates these stereo fields every time VR users shift their perspective. This means upwards of sixty to ninety times per second with current-generation headsets.

Think of this as a kind of ambient power play. Rather than fade into the atmospheric background like ubiquitous computing, VR disappears into the space immediately around the head. VR's much touted immediacy works by hiding the mediation just above a person's nose, or, more precisely, the interface hides in the gap between the left and right sides of the perceptual body. A person is then given no choice but to rely on the headset's own stereo images and sounds to piece the perceptual world back together again.[13]

In practice, the immediacy of VR is belied by how awkward and even painful the headset experience can be when it doesn't match with your body or with the immediate space. While more comfortable than in decades past, current-generation headsets can be hard to forget. They slide down your forehead, interfere with your hairstyle, and slip out of focus. While in VR you might trip on cables, bump into unseen furniture, or find yourself low on power. When you remove the headset, you might find yourself with eye strain and neck pain or with motion sickness from a mismatch between actual and simulated movement.[14] It is almost as if these physical signals are offering a warning: be careful when the virtual world and the physical world start to fall out of sync.[15]

JAPAN'S EMBRACE OF PERCEPTUAL ENCLOSURE

American VR discourse has leaned heavily on a rhetoric of immediacy as an immersive ideal. Despite engineers' self-deprecating jokes about "face-sucking goggles," popular VR discourse in the United States has long been eager to draw attention away from the machinations of the device itself.[16] Assertions of VR as a "medium-less medium" dominated the English-language discourse in the 1990s, situating the headset as nothing less than "a medium whose purpose is to disappear."[17] The goal was to distract from VR's role as a media interface by equating it instead with the immediacy of everyday perception. This was exactly Jaron Lanier's strategy when he popularized the phrase "virtual reality" in the late 1980s, claiming "it's not even a medium. It's a new reality."[18]

Prominent American VR proponents today rely on the same rhetorical strategies to situate VR as a functional substitute for real-world situations.

Stanford VR researcher Jeremy Bailenson's 2018 book uses almost identical language: "VR technology is designed to make itself disappear. When VR is done right, all the cumbersome equipment—the goggles, the controller, the cables—vanishes."[19] The market for VR as a training, design, and experimental psychology device with "ecological validity" relies heavily on these frequent assertions of virtual-real equivalency. This extends into the development and marketing of consumer-facing VR games and software. Facebook's "Oculus Best Practices Guide," for example, suggests that developers "not remind users that their virtual world is constructed."[20] The rhetoric of immediacy draws attention away from the fact of enclosure.

But this is not the only approach. Japanese VR developers often adopt a different strategy: the embrace of perceptual enclosure as key to what the headset offers. In Japan, the headset's ability to block out the world becomes a primary feature rather than something to be disavowed. VR promises not just entry into another world but a way to perceptually bracket out the current one—and a user's place within it.

In both the United States and Japan, VR has been shaped by the cultural imagination around the technology as much as by the interface itself. For example, Facebook's "Go Virtually Everywhere" campaign in the United States for their Oculus Go headset contained a clear echo of Microsoft's famous mid-1990s "Where Do You Want to Go Today?" campaign for the Windows 95 operating system. Invoking a Platonic divide between matter and spirit, both promised the ability to transcend physical limitations and render the whole world virtually for a user. Media scholar Ken Hillis argues that this aspect of VR is tied to a specifically American fantasy: "the notion of a sense of individual renewal coupled to encountering a spatial frontier."[21]

In contrast, Japanese advertisements for early internet-enabled phones from companies like NTT Docomo and KDDI focused on how the devices could help a person arrange meetings on the fly and get more done while out and about in the city. Early 1990s Japanese VR demonstrations like Matsushita's popular order-made kitchen studio similarly focused less on individual freedom and more on selling enhanced control over the local environment. Today, titles like *Comolu* (Dentsū, 2018) maintain this focus on VR as a way to perceptually rework the local space. VR is understood as a way to carve out a more personalized and controllable realm from within the existing world.

Comolu is a homonym for the Japanese verb *komoru*, meaning "to withdraw." Presented as a reflective, three-dimensional mood-board for those who want to brainstorm in virtual space, the *Comolu* campaign featured the tagline *Atama ni komotte, kangaeyō* ("Let's withdraw inside our heads and think").[22] The hooded robes from designer label HATRA released in tandem with the application further situate VR use as part of a monastic, retreat-from-the-world scenario (figure 0.1).

Game director Kashiwakura Haruki of Tokyo-based VR developer MyDearest similarly approaches VR as an isolated environment for media consumption, where all distractions can be eliminated in favor of enhanced focus on a virtual narrative:

> I want to read in VR. Because I'm the type of guy where when I read, information from the edge of my visual perception and sounds from my surroundings are too much of an interruption. I want to shift both into VR, where I can relax and focus only on the book's content.[23]

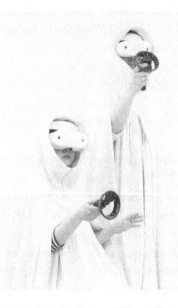

FIGURE 0.1 The Comolu Wear outfit designed by Nagami Keisuke of HATRA for the *Comulu* VR software. Photograph used with permission. See http://comolu.info/.

From this perspective, the most important attribute of the headset is its ability to offer a diminished reality, a tool that brackets out all but the task at hand.[24]

THE TURN TO OTHER WORLDS

This approach to VR enclosure extends to how VR has been taken up by Japanese consumers, often to the surprise of the devices' American manufacturers. While the relatively limited motion tracking of Facebook's Oculus Go headset was derided in the American press as "a step backward," in Japan the portability and small scale of the device was readily understood as part of a long tradition of personal media technologies offering to carve out a private imaginative space in rather tight quarters.[25] The Japanese approach to VR has focused less on the realistic simulation of actual environments and more on what the head-mounted interface helps a person to bracket out perceptually: the immediate spatial, social, and historical contexts in which they might otherwise be stuck.

Japan's more direct embrace of head-mounted perceptual enclosure points toward a different way of understanding the VR interface. While the technology that came to be recognized as virtual reality was initially developed in the United States, Japan is where VR was first repackaged as a consumer technology. And from the early days of the Walkman up through the more recent stand-alone headsets, Japan is where the social and cultural ramifications of the one-person virtual space have been explored most deeply. In *The Immersive Enclosure: Virtual Reality in Japan*, I build from these Japanese perspectives to present a new approach to the VR interface, focusing on the ambient power play and the headset's contentious demands for perceptual enclosure.

In the process, I use this approach to launch a broader examination into the cultural politics of the new media environments emerging in Japan across this period. The high-growth decades of the 1950s and 1960s promised Japanese citizens—especially men—unprecedented levels of control over their local environment in exchange for hard work and personal sacrifice to the company and the nation. This period saw a shift away from shared public entertainments and toward material goods and

technologies focused on domestic life: the family home (ideally with a room for each child), a family car, a television set, and a hi-fi stereo.[26]

While the student political activism of the 1960s had initially pushed against this retreat into the private sphere of consumption, these collective movements largely collapsed inward by the early 1970s. The 1973 oil shock demonstrated how the previous high-growth trajectory of the Japanese economy was no longer so assured. Evidence of industrialization's toxic effects on Japan's physical landscape became more pronounced, and the "natural" environment could no longer be considered an endlessly exploitable resource.[27] The middle-class promise of spatial control and self-determination via the domestic sphere also started to fray with the emergence of new lifestyles and identities less beholden to the traditional family structure. For individuals faced with a decline in economic, environmental, and social power, media technologies emerged as one area where personal control over space could still be achieved: if not in the real world, then in virtual domains.[28]

By the latter part of the 1970s, the focus began to shift from broader movements for social and political transformation to the more private space of personal media. The family-oriented interfaces that had dominated the high-growth years started to be bent to more individual ends.[29] Media devices like the Walkman moved closer to the body, isolating the individual in privatized perceptual bubbles and promising people more direct control over their own virtually mediated horizons. Individuals set out in search of new sensory experiences and projects of self-experimentation on the personal rather than the collective level.[30]

Concurrently, the era heralded what Japanese cultural critics have described as a mass turn away from concern with existing Japanese social conditions and political legacies in favor of immersion in the alternative "virtual histories" presented in genre fiction, manga, and anime.[31] By the end of the 1980s, a new era of interactive role-playing games placed the individual resolutely at the heart of these alternate pasts. Media users could now move into and take control over vast imaginary worlds provided by a computer. In many cases, what the new interfaces offered was less a new ideology or identity and more a new perceptual and experiential space within which a desired self could be generated and sustained. While rarely considered in tandem, the turn to virtual spaces (in the new media technologies) and to virtual histories (in the new media narratives)

were fully intertwined. Each were part of a turn away from the given social situation in favor of more fully mediated, first-person worlds.

When virtual reality crossed the Pacific to reach Japan in the early 1990s, it was quickly understood as part of this broader shift to personally mediated fantasy environments. VR promised Japanese consumers even more immersive first-person perceptual horizons. Often steeped in a rhetoric of colonial conquest, the emergent consumer VR imaginary tapped directly into the desire for personal spatial control. Launched off the momentum of video games and other interactive media, the new VR users were imagined as no less than master and commander of their own virtual domain.

Meanwhile, behind the scenes, the Japanese government and consumer electronics industries saw in VR an opportunity to regain ground lost to the United States in the shift to computer-based consumer electronics. Entrepreneurial Japanese engineers and bureaucrats were eager to compete with the United States over the next high-tech market and quickly staked out a central role in the first VR boom of the early 1990s, spurring the VR hype to ever-greater heights. By 1991, Japan was already home to more VR systems than anywhere else in the world—albeit at a time when the global total was still only about 400.[32] While consumer VR was still in its infancy, the ideas behind the technology exercised a strong pull over the popular imagination, catalyzing a growing desire for mediated virtual alternatives to everyday Japanese life. By the mid-1990s, the major Japanese video game console and home electronics manufacturers would each launch ambitious, if mostly ill-fated, attempts at a consumer VR product.

The collapse of Japan's asset price bubble and the slide into a major recession in the 1990s soon slammed the brakes on this early VR market, but the subsequent economic uncertainty only intensified the desire for alternate virtual worlds. While VR development retreated into university and corporate research laboratories during the long "VR winter" that followed, Japanese storytellers in a wide range of media continued to produce a steady stream of VR-themed narratives. These in turn helped shape VR's image when it reemerged as a consumer device in the mid-2010s. The precise reasons for this reemergence are beyond the scope of this book, but a major factor was access to small, inexpensive, high-resolution screens for use in VR displays, made available thanks to the explosion of the smartphone market in the intervening years.[33] There are now tens of

millions of VR headsets in circulation as opposed to hundreds, and Japan has quickly reemerged as one of the biggest consumer VR markets.

After the mid-2010s revival, Japanese video game and software developers swiftly dove back into the medium, while the Japanese tech hobbyist community immediately began to take apart the headset and imagine new uses for it.[34] With 2016 widely touted in Japan as the "first year of the VR era" (*VR gannen*), the headset emerged as a new consumer-facing platform for fictional narratives, games, social events, education, pornography, real estate, therapy, tourism, and more. Location-based VR arcades sprouted up in media consumption hubs like Shinjuku's Kabukichō neighborhood and Ikebukuro's Sunshine City, while stand-alone headsets sparked a growing Japanese market for at-home VR.[35] The fantasy worlds of anime, manga, video games, and light novels now served not just as a place to imagine a VR future but also as source material for actual VR titles.

There are now essentially two overlapping VR scenes in Japan. One consists of labs at elite universities and research centers that have quietly continued their hardware interface research since the 1990s, largely detached from broader cultural trends. The other consists of commercial and hobbyist VR software developers who draw heavily on Japan's existing popular media to build out alternate worlds within the new VR platforms.

MEDIA MIX AS MEDIA ENCLOSURE

Japanese VR thus emerged directly out of transformations in the Japanese media environment, intensifying the late 1970s turn to fictional worlds. Today Japanese consumer VR is fully integrated with the broader Japanese media industries that first took shape in the last decades of the twentieth century, focused on a mix of anime, manga, light novels, video games, idol singers, and other popular texts that offer alternative fantasy worlds set apart from everyday social concerns. There is a strong recognition within the domestic VR scene that if Japan is to maintain a position in an increasingly global VR industry, it will be by leveraging the audiences and aesthetics of these already popular media. The country is now home to one of the most distinctive markets for VR entertainment software. In

2020 Facebook decided to start a separate Oculus VR store just for Japan, in acknowledgment of the country's highly active VR developer and hobbyist community and its distinct consumer tastes.[36]

As Japanese VR entrepreneur and developer Shin Kiyoshi describes it, "while the VR business in Europe and America aims at 'building a space around humans that is essentially the same as the real world,' in Japan attention often goes instead to 'building imaginary worlds full of lively characters.' "[37] Mizutani Kyōhei of Tokyo-based VR platform STYLY similarly observes how "Western countries view VR as a real-life simulator whereas Japanese people use VR to become something different from their real-life selves," drawing on the anime, manga, and game industries' focus on an "escape to an imaginary world."[38] The focus here is on a departure from rather than a replication of actual places. In this context, the perceptual enclosure of the headset becomes a key means to bracket out existing social contexts and escape more fully to another realm.

The VR enclosure reveals a new side of the broader Japanese media mix focused on anime-styled fictional environments. Pioneered by the publisher Kadokawa in the 1990s, this marketing strategy gave consumers many different access points to a fictional universe through light novels, manga, anime, video games, toys, and magazines. No single piece of media would give the whole story, and audiences would move deeper into the fantasy world as they collected the different component parts and interacted to create new additions of their own.[39]

Most analyses of this anime-centered media mix point to the local affective bonds between fans and fictional characters as the glue that holds the whole system together.[40] More recent "media ecology" approaches diagram the broader circulation of media objects across technological infrastructures and distribution networks.[41] VR suggests instead a more basic strategy is at work between these two scales: the use of media to perceptually block out existing social and physical spaces and thus center the consumer in a more controllable virtual realm instead. While these other approaches tend to flatten media circulation into abstract two-dimensional diagrams, I focus here on the interface between perceiving bodies and media technologies as they encounter each other in everyday three-dimensional space. Media scholar Marc Steinberg notes the "environmental diffusion" of character merchandise as part of the media mix strategy; I understand this quite literally as a quest to remake the

local perceptual environment by pasting over the given landscape with the alternate horizons of a more desirable virtual world.[42] The media mix promises consumers the ability to circulate continuously within the same immersive media universe without the need to face back out toward a nonvirtual reality. At the same time, corporations can reap the profits not just from the occasional media diversion but from an entire perceptual supply chain.

The VR headset takes this strategy of personalized environmental immersion up a notch, offering not just life-sized, three-dimensional renditions of imaginary characters but entire 360-degree worlds to become perceptually situated within. While early studies of the Walkman and related personal media environments in Japan often emphasized their tendency toward atomism and isolation,[43] the more explicitly interactive and networked spaces of contemporary VR suggest the turn to media enclosure is not driven by antisocial or anticommunicative desires, but rather by the promise of alternate social worlds that allow end users more direct control over their appearance and their ambient surroundings.

While the emotions and ideologies that course through the VR imagination remain important in the analysis that follows, the VR enclosure points toward a more fundamental question: How do media determine what becomes perceptible as part of a given "world," and what—often quite deliberately—gets bracketed out?[44] This history of mediated perceptual enclosure suggests it is not enough to consider how gender, race, disability, and other dimensions of social subjectivity function at the level of representation or affect. Nor is it satisfactory to simply ignore the end user to focus on deeper infrastructures at work behind the scenes. The VR enclosure instead points to how media technologies work to render certain parts of social life imperceptible in the first place. A VR user can acoustically and visually bracket off their surrounding domestic space, the people they live with, and even their own body while simultaneously opening up menus to choose (for example) their virtual appearance, virtual environment, and who else may or may not approach them within that virtual space. VR promises escape from situatedness in the given environment, even as it grants new powers of perceptual manipulation to those privileged enough to control the virtual realm.

This in turn lays the groundwork for the emerging "walled garden" immersive platforms of the current century, most notably Facebook's

quest to build the next big social media platform inside VR via their own Oculus hardware.[45] The ambient power play here operates simultaneously at the level of VR user and VR developer. Consumer VR grants users enhanced control over the world as it appears to their senses. Simultaneously, the headset hands access to a person's spatial awareness to the companies controlling the VR platforms. As I explore in this book, the tension between these two modes of control is key for understanding the perceptual politics of the head-mounted interface. At both levels, the VR enclosure favors those with both the technological skills and media literacies to navigate and shape these computational spaces.

SITUATING THE INTERFACE

While recognized as a major site of VR history and development, Japan has long been sidelined in VR discourse. The country haunts the margins of most English-language VR studies, never entirely absent but never fully present either. Japan reliably makes a brief cameo appearance in English-language trade books about 1990s VR, but only as a poorly understood, peculiar sidebar to what becomes a mainly Euro-American narrative.[46] Language barriers and a general unfamiliarity with the country among American and European VR researchers remains an obstacle, despite the best efforts of VR researchers and journalists (largely but not exclusively from Japan) traveling extensively back and forth between continents. Through my focus on how VR intersects historically with broader transformations in Japan's media environment, I aim to challenge the presentation of VR in both industry and academic contexts as either uniquely American (as in Hillis's work), or, more commonly, as a placeless and contextless "universal" technology.[47] This latter kind of universalism, implicit in much English-language technology discourse, simply assumes a North American or European context can stand in as the default setting for the rest of the world.

This approach to VR as inherently placeless is common even in studies closely focused on questions of perception. Media theorist Mark B. N. Hansen's phenomenological approach to VR set out in *Bodies in Code*, for example, productively foregrounds the possibilities that VR offers to

experiment with perception, but almost entirely brackets off the social and historical contexts surrounding VR use.[48] Attempts to understand "the virtual" at a purely philosophical level end up obscuring how and why the virtual/reality binary became attractive in the first place. By locating how VR emerges out of a particular cultural and historical context, I aim to challenge all such attempts to situate VR in a vacuum. I also hope to inspire other researchers to address the local specificity of how VR takes shape in other parts of the world.[49]

My research methods here aim to capture "both sides" of VR as a media phenomenon, considering both fictional and nonfictional contexts. I find it methodologically productive to cross-reference materials documenting actual VR technologies (including journalism, advertising, industry publications, and research papers) with fictional portrayals of how people relate to VR in practice. The former helps me situate VR's tumultuous emergence as a consumer-facing technology historically, while the latter offers a much more nuanced way to trace the shifting and often conflicted emotions swirling around VR as an idea. I draw on both approaches to track how Japanese attitudes toward VR and media enclosure have transformed over time.

While my focus here is on the VR hardware interface rather than any specific VR software, my analysis is grounded in a broad exploration of VR titles from Japan and elsewhere, as well as their associated development platforms like Unity and Unreal Engine. Along the way I attended many VR-related events in Japan and the United States, starting from the early days of the mid-2010s VR revival. I spoke with commercial and indie VR developers, academic VR researchers, and everyday VR users while closely tracking day-to-day developments in the Japanese VR scene both in person and online. While not always explicitly marked on the page, these broader contexts inform my textual and archival analyses throughout the book.

The chapters are loosely chronological, moving from the initial emergence of the one-person media space up through recent developments in the consumer VR scene. Overall, the first three chapters focus more on the research and technology context, while the latter two turn toward VR as a form of popular culture. Through these combined perspectives, *The Immersive Enclosure* sets out a historical and theoretical framework for understanding the cultural politics of immersive perceptual control.

Chapter 1, "Acoustics of the One-Person Space," tracks the emergence of head-mounted ambient mediation back into the realm of spatial audio. I focus on the history of headphone listening and the initially rocky cultural reception of this more private perceptual space. I am particularly interested here in what had to happen to the broader built environment for people to start to *want* to isolate themselves within a one-person perceptual enclosure. I emphasize the central role of sound in the history of immersive media, using Japanese audio-engineering debates over the "sound in the head problem" to draw out a sonic prehistory for the later head-mounted space of VR.

Chapter 2, "Translating the Virtual into Japanese," tracks the emergence of VR as a technology and as a concept in the United States and Japan as part of the popular VR boom of the early 1990s. I explore how the valence of Lanier's term *virtual reality* transforms as it is taken up and translated into Japanese. This Japanese understanding of the term shifts VR away from both the American military history and the West Coast techno-utopian context, and toward a reimagining of the technology as a more personal medium for accessing fictional worlds.

Chapter 3, "VR Telework and the Privatization of Presence," focuses on Japanese projects using VR to drive telepresence robots for rehabilitation—first as a way to take care of the country's aging population and more recently as a way to bring the elderly, persons with disabilities, and foreign overseas workers back into the workforce to do VR-enabled physical labor. I position these approaches to VR labor alongside Facebook's larger project to build VR into an embodied social infrastructure capable of replacing the need for physical transit and in-person communication. The chapter shows how these promises of greater worker mobility, in practice, tend to fix these already precarious workers ever more firmly in place.

Shifting to a popular culture context, chapter 4, "Immersive Anxieties in the VR *Isekai*," turns to fictional Japanese VR narratives to analyze desires and fears surrounding the possibility of complete enclosure in headset-based fantasy worlds. I focus on the spectacular popularity of *isekai* ("other world") VR fantasy narratives where characters become trapped in a headset and must conquer the virtual world in order to get out alive. While *isekai* stories are often written off as a form of low-brow escapism, I draw on Japanese media theory to examine how the convergence of VR

and the *isekai* fantasy allows for a colonialist reimagining of the other world as a virtual alternative to existing Japanese social contexts.

The final chapter, "VR as a Technology of Masculinity," examines VR as a highly gendered space emerging from what has historically been a male-dominated field. Building off early feminist VR criticism as well as more recent Japanese debates over the gendering of virtual characters, I show how VR in Japan often serves as a technology of masculinity promising control over both virtual environments and virtual teenage girls. I examine how the gendering of VR is never simply about what appears within the virtual world, but also about who assumes the first-person perspective, who controls the perceptual space, and how all this intersects with the broader social environments surrounding VR use.

With this book I hope to push media studies to focus more on the perceptual politics of immersive media platforms. As the Japanese context helpfully makes clear, VR offers a powerful ambient means to manipulate humans' everyday social and spatial situatedness. If the rapidly expanding VR industry is to lead somewhere other than the further consolidation of algorithmic control over everyday interactions, a crucial first step is to understand the simultaneously social and spatial power dynamics that have shaped the VR enclosure thus far.

1

ACOUSTICS OF THE ONE-PERSON SPACE

While head-mounted visual media like the stereoscope are most frequently mentioned as predecessors of the virtual reality (VR) head-mounted display, head-mounted audio technologies like headphones offer a more direct precursor. As the digital media scholars Steven Jones and Frances Dyson noted during the first VR boom, popular virtual reality discourse often emphasizes the visual, but much of the 360-degree immersion promised by VR was first achieved in sound.[1]

These sonic precedents for virtual immersion were not lost on some of the central players in VR history. Novelist William Gibson's notion of "cyberspace" was inspired in part by his experiences with the Sony Walkman.[2] Inventor Jaron Lanier came to VR after a career in music and introduced his company VPL Research's pioneering "Eye-phone" head-mounted displays as "the visual equivalent of audio headphones."[3] In more recent years John Carmack, until recently the most prominent engineer of the contemporary VR scene as chief technology officer at Oculus, continues to describe the VR head-mounted display as "headphones for your eyes."[4] Long before the era of consumer VR, audio engineers aimed to produce the "illusion of reality" and the experience of "really being there."[5] But the path to the cultural acceptance of headphone use would be a rocky one. This chapter traces the tumultuous history of spatial audio

and headphone listening to demonstrate how head-mounted virtual space first achieved cultural acceptance in the acoustic realm.

The history of headphone listening and spatial audio reveals a shift in cultural attitudes toward media interfaces that fix the head in place and block out the broader environment. It was only with the turn toward personal listening enclosures that the head-mounted interface began to achieve more mainstream traction as a consumer product. The gradual cultural acceptance of head-mounted audio set the stage for the VR headsets to come.

As with immersive visuals, the history of immersive audio can be understood as a series of attempts to replace a user's immediate perceptual environment with more malleable media alternatives. By the early twentieth century "good sound" came to be associated with dry or spaceless sound that could be tailored more precisely to the listening situation. Much like mid-twentieth-century cinemas would seek to create an "optical vacuum" where no other visuals would distract from the screen, modern listening aimed to deliver sound stripped of its local spatiality that could thus be deliverable to audiences in forms more flexible, mobile, and self-contained.[6]

This development in turn led music producers to deploy the now-malleable spatial signature of a sound recording (such as its reverb and echo) as an expressive material.[7] A single pop song began to mix many different acoustic spaces. For example, a vocal track may sound like it is recorded up close, while the guitar accompaniment is drenched in reverb and thus sounds more distant. From an early twentieth-century perspective, this kind of bricolage might be expected to result in a perceptually fragmented experience, a sense of discombobulation on hearing so many different acoustic spaces layered together. Yet contemporary listeners are not the least bit confused.[8]

Sound scholar Jonathan Sterne explains this development through reference to what he calls speaker culture, or how contemporary listeners are accustomed to hearing the embedded space of musical recordings come out of different kinds of speakers and blend with the acoustics of the immediate listening environment. He notes that if we define augmented reality (AR) as virtual spaces layered on top of existing ones, this speaker-based layering of audio spaces has produced augmented realities for a long time now. Sterne uses this observation to caution against claims

that AR marks a radical break with prior media forms because humans immersed in speaker culture appear to have adjusted to a world of layered virtual spaces just fine.[9]

Yet by focusing on the "overlay of physical and mediatic space" as his archetypal case for an encounter with recorded sound, Sterne's analysis stops just short of engaging with the more profound spatial reconfiguration that occurs when an audio interface bypasses the local space entirely, as with headphones that place speakers directly against the listener's ears. Even as the plastic reverb of modern audio production enabled sound that was "outside space" and thus "brackets its own historicity and situatedness," the overlayed sonic space of room-scale speaker setups was still shaped in the final instance by the acoustics of the immediate listening environment.[10] An air gap remained between listener and speaker so that the acoustics of the surrounding physical space conditioned any sound that passed through it.

While Sterne proposes contemporary listeners have simply become adept at listening to a mix of overlayed spaces, research on head-mounted spatial audio suggests that the acoustic mediation of the immediate physical location provides a crucial element of integration, grounding the various sonic layers through the more invariant acoustics of the built environment. No matter how complex and layered the virtual space on a recording may be, the sounds reach the ears sutured together into a "coherent sonic text" by the reassuringly familiar spatial signature of the local listening space.[11]

Headphone use, in contrast, bypasses the filter of the local environment. Like the later head-mounted interfaces of VR, headphones produce virtual acoustic spaces that perceptually seem to wrap around the perceiver's body but in fact only coalesce within the perceiver's head. By isolating left and right ears, headphones can reproduce a three-dimensional virtual space without the need to pass the sound through an existing physical location. Sterne locates what he calls the "detachable echo"—the variable relationship between any given sound and its spatial signature—as a phenomenon of the recording studio. Binaural audio over headphones, however, enable the detachment—the virtualization—of even the spatiality of the local listening environment. This chapter explores the emergence of this new space of listening, or what I will identify as the arrival of *detachable ambience*.

Sound and media scholars have long emphasized how headphone listening creates a more private and enclosed auditory space. Judith Williamson noted already in 1986 how the Walkman "turns the inside of the head into a mobile home."[12] In his mid-2000s study of iPod listeners, Michael Bull described how Apple headphones allowed listeners to become "enclosed" in "pleasurable and privatized sound bubbles," while the white cables signaled a desire to be left alone.[13] More recently, Mack Hagood has examined how Bose's noise-canceling headphones allow users "to construct an on/off interface with the aural environment and the space one shares with others."[14] While they differ in whether to understand this privatization as empowering or alienating, these studies each situate headphone listening as part of a broader trajectory toward privatized media consumption, one that promises individual control over a personalized sound environment.

Often inspired by Henri Lefebvre's approach in *Rhythmanalysis*, much of this work focuses on how the use of headphones promises listeners the ability to transform their emotional or energetic states via the rhythmic resources of portable, private music. Despite frequent references to urban space, however, these studies situate the social interface with sound recordings as primarily temporal: musically organized time intersects, intensifies, or flattens out the broader rhythms of contemporary capitalism. For example, cultural studies scholar Iain Chambers describes the Walkman as part of a transformation of the city from an "organizer of space" to a technological realm focused on the "organization of time."[15]

With a few notable exceptions, sound studies scholarship is nearly silent on the spatiality of headphone sound and only rarely attends to the acoustics of physical spaces where headphone listening occurs. Approaches to headphone culture have remained, until now, essentially monophonic, neglecting to consider the role of stereo sound spatialization in the history of headphone listening.[16] This spatially flattened approach has led sound and media scholars to overlook the historical importance of debates over stereo and binaural recording in the history of headphone use and in immersive media more broadly.

In this chapter, I attempt to rectify this by listening simultaneously to the history of virtual sonic space produced through headphones and the broader acoustic environments in which headphone listening takes place. At issue here is the precise way these two spaces become composited

within the listener's head. Finally, I turn to the transformation in social attitudes toward headphone listening following the market success of the Walkman to find clues about how the head-mounted media interface began to go mainstream.

Thanks to VR and AR, three-dimensional spatial audio has once again become a central focus for new headphone technologies.[17] At the same time, the current cultural reception of VR and AR headsets was preceded and shaped by long-running debates over the cultural politics of headphone use. At first, these debates largely played out in the pages of audio engineer and audiophile publications in countries like the United States, Germany, and Japan, only to spill over into more mainstream cultural contexts as headphone listening became popular globally in the post-Walkman era. While I draw on scholarship focused on the United States and Germany in what follows, I emphasize Japan's crucial but often neglected role in spatial audio history. The European and North American studies mentioned above often frame their work within a specifically Western trajectory, yet the Japanese discourse reveals a great deal of transnational continuity (even as specific developments occurred at slightly different times in each place).[18]

While hard to imagine today, headphone use was frequently stigmatized throughout much of the twentieth century. Like the early consumer VR headsets, headphones were associated with spatial disorientation, physical discomfort, and feelings of isolation, while their public image was shaped by broader discourses around gender and disability. I propose that it was only once the built environments of everyday life *also* became organized around a virtual acoustics that the headphone stigma began to fall away.

A HISTORY OF HEADPHONE STIGMA

From their invention in 1881, headphones were quickly understood to transport a person elsewhere, removing listeners from their immediate sensory environment. Headphones were used initially as specialist equipment in telecommunications contexts.[19] Early switchboard operators at Bell Telephone Company, for example, used a workplace model complete with shoulder supports to help prop up the over six-pound headset across long shifts.

Telephone service was the primary context for headphone use in Japan as well through the early twentieth century, for example, in scenes with Murai Ayako wearing headphones while at work as a switchboard operator in Mizoguchi Kenji's *Osaka Elegy* (*Naniwa ereji*, 1936).[20] Like phone booths more generally, the switchboard operators' headphones (and the larger enclosure of the operator's booth) served to isolate them from their immediate surroundings. As Sterne writes of this early headphone context, "not only was hearing to be separated from the proximal auditory environment, but the act of communication itself was to be separated from the surrounding physical environment."[21]

In one alternate history of cinematic immersion, audiences could have been listening to Mizoguchi's film *on* headphones as well. In the early days of Hollywood's conversion to sound film in the 1920s and 1930s, engineers at Bell Telephone Labs developed a sound system for cinema halls built around binaural audio provided through headphones, what media scholar Steve J. Wurtzler calls the "logical outcome of developing sound technology on the model of the human body."[22]

Bell Labs is where the idea to position microphones on artificial dummy heads to capture "auditory perspective" more accurately first emerged. Rather than strip away the acoustic detail of the original recording space, this binaural method aimed to capture it more accurately by including a model of the would-be listener's head for incoming sounds to reflect against. The dummy head technique attaches two monaural microphones to each side of a mannequin (usually just a head or head and upper torso) built to the dimensions of an "average" human body. Microphones at the time were too large to be situated within the dummy's ears, so Oscar—Bell Labs' name for their dummy—had microphones on his cheeks instead.[23]

When recordings made in this way are played back over headphones placed on the listener's own head (in approximately the same position as Oscar's original microphones), the listener's brain registers the subtle ambient distortions produced by the dummy head as if they were produced by their own body instead. This enabled an enhanced sense of where recorded sounds are situated spatially in relation to a listener's body. Researchers at Philips Research in Eindhoven, who developed a similar artificial head (what they called a *Kunstkopf*) recording technique by the end of the 1930s, noted that sounds recorded in such a manner were "so real that listeners had to turn their heads to reassure themselves that nobody was standing behind."[24]

Yet when Bell Labs presented binaural headphone listening to movie theaters as a means to achieve better sound localization in films, the idea was quickly rejected in favor of more standard loudspeaker systems. While partly due to the cost of equipping each cinema seat with its own pair of headphones, theater owners were also skeptical that audiences would be willing to isolate themselves perceptually in this way. As Wurtzler writes in his history of the era,

> Such a binaural acoustic system would have posed a drastic contrast to preexisting theatrical filmgoing experiences. Would audiences watch and listen to a live theatrical presentation and then at some cue from the theater reach beneath their seats and put on their telephone headsets? Would they sing along, following an on-screen bouncing ball, aurally isolated by their personal acoustic reproduction device, not even able to hear the sound of their own voice? And what of the construction of the cinema as a live, group-based social experience?[25]

Headphones would ultimately find a home in the cinema hall but only for one specific demographic: the hearing impaired. The subsequent long-term association between disability and headphones would underwrite, in part, a social stigma associated with headphone use that continued all the way until the 1970s. The isolation of headphone listening was figured as an option of last resort, reserved for the minority of audience members with hearing impairments. The privileged immediacy of not needing headphones in the theater became the default position, masking how the movie theater itself was already built with these normative hearing bodies in mind.

Headphones for use with home record players were also offered in the 1920s and 1930s, but they raised similar concerns about their isolating influence on the domestic scene. This silencing was particularly acute for those not in direct control of media technologies in the home. The editors of the *Living Stereo* anthology note how headphones in the United States at this time were often perceived "to silence conversation in the home and exclude others from the radio experience," even giving rise to gendered figures like the "wireless widow." One 1924 letter to the editor of *Radio Broadcast* describes the writer's struggle on being forced to "sit mum" while her husband was occupied by his headphones, "consoling herself with a book, or solitaire, having at least the chill comfort of his physical presence, though his soul go marching on."[26]

The overwhelmingly male-gendered space of both sound engineering and home audio intersected and in some ways muffled how the headphone stigma played out in the domestic context. In the private sphere, headphone listeners were also usually the head of the household and tried (not always successfully, judging by the audio magazine commentary) to bend domestic space to their will and to their hobby. One response to this domestic tension was to offset the isolation through equipment for simultaneous group headphone use. Home listening in the late nineteenth and early twentieth century offered accessories for multiple family members to listen "alone together" to the same recording simultaneously through separate headphones.[27] Yet much like group headphone use in the theater, it never really caught on.

When binaural reemerged in the postwar 1950s, it was a loudspeaker-driven phenomenon. Emory Cook, an audio engineer from New Jersey, kicked off the new binaural boom in 1952 with his invention of a two-channel stereo record system. Rather than print a two-channel signal in a single groove (technologically impossible at the time), Cook's system used a special two-pronged record arm to pick up sounds simultaneously from two grooves at once. Echoing the contemporaneous three-dimensional film boom, he promoted his new system widely as an innovation in "three-dimensional sound" and presented his own field recordings of passing trains and other mobile sound sources in ways that emphasized spatial depth.

A series of public events in Japan this same year introduced the Japanese public to binaural speaker broadcasts based on Cook's system. These included a three-dimensional sound broadcast via speakers on multiple buses set up in Hibiya Park in Tokyo, as well as indoor demonstrations at the International Radio Center. In late 1953, national broadcaster NHK launched a special binaural radio broadcast once a month where the left binaural channel was broadcast on one frequency and the right channel on another. This system had the advantage of remaining accessible to owners of only one radio (who could listen in mono) while also promoting the purchase (or at least the borrowing) of a second radio set to enable the full binaural experience.[28]

The broadcasts were a popular success. Cook's binaural records were also available as imports for purchase, but they were expensive for average Japanese consumers at the time (priced around 3,000 yen or $89 USD in 1955 prices). As *Shin denki* (New electronics) magazine complained at the time, it was still far cheaper to simply go to a live concert if you wanted to experience three-dimensional sound.[29]

Meanwhile, proponents of listening to binaural recordings on head-phones in the United States and Japan in the 1950s continued to face the stigma attached to headphone use. Audio engineers like Cook acknowl-edged the superior "fidelity" and "realism" of binaural headphone listening, but they argued that the available "earphones" were "both uncomfortable and anti-social." Promoting three-dimensional sound through loudspeak-ers instead, Cook believed, could turn binaural "from a tinkerer's hobby into a potentially popular medium."[30]

Through the mid-1970s, headphones remained limited to either bulky high-end headsets for audiophiles or simple monaural earbuds with poor sound quality. A July 1976 article in *Rajio gijutsu* (Radio technology) mag-azine notes that headphones capable of better-quality sound reproduction tended to be heavy, meaning they were difficult to use for long periods, and could even make a listener sweat in summer. Smaller earbud-type headphones could not achieve good enough audio quality for music lis-tening.[31] As with cinema headphones, the latter were, by this point, popu-larly associated primarily with hearing aids, adding another dimension to the ableist headphone stigma.[32]

DEBATES OVER HEADPHONE SOUND

Researchers and audiophiles in Japan and West Germany were reluctant to give up on headphone listening entirely, however. Japanese hi-fi enthu-siast magazines in the 1950s and 1960s featured numerous articles break-ing down the relative merits of mono, stereo, and binaural recordings, as well as speaker versus headphone playback. Writing in 1955, sound researcher Iguchi Seiji called binaural recording a "revolution in the audio world," but he noted many technical issues remained to be solved. While the engineers' aspiration was still toward better sound reproduction for music playback, binaural researchers were clear that three-dimensional binaural spatialization lent itself best to radio dramas and sound effects (like the steam trains and ping pong sounds on Cook's records).[33]

The *Sutereo haifai seisaku dokuhon* (Guidebook to building a stereo hi-fi), released amid the Japanese consumer hi-fi boom of 1962, sets out to illus-trate the different effects of monaural, stereo, and binaural audio for Japanese home listeners. As depicted in figure 1.1, the authors note how a single-channel

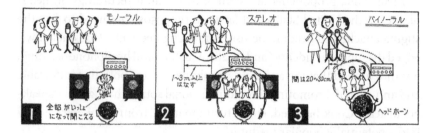

FIGURE 1.1 Illustration from *Guidebook to Building a Stereo Hi-Fi* showing the perceptual difference in sound localization between (1, left) monaural, (2, center) stereo, and (3, right) binaural recording and playback. *Sutereo haifai seisaku dokuhon* (1962), 14.

monaural recording creates a sound stage where the listener perceives all the sounds to be clumped together in one spot. Recording in stereo with two microphones at least 1 to 3 meters apart creates a two-dimensional sound field; thus, the different performers sound as if they were arranged in a line between the two speakers. In contrast, binaural recording uses two microphones placed only 20 to 30 centimeters apart (based on an inter-ear distance of twenty-three centimeters for the average human). A recording produced in this way and listened to on headphones creates a more intimate three-dimensional sound stage in close proximity to the listener's head.[34]

While the text doesn't mention it, the *Guidebook to Building a Stereo Hi-Fi* illustrator switches from the all-male quartets portrayed in the first two panels to a female vocal trio for the binaural illustration. For the implied male listener (seen in rear profile here), the greater intimacy of binaural sound appears to bring with it a different set of gender expectations. Historian Stefan Krebs notes how the primarily male recordists, trade journalists, and radio professionals in the 1970s recording world readily assumed that a male head would "represent an average listener."[35]

But notice the shift in representational strategies when binaural moves the soundstage up close. Rather than pull other men inside the male listener's head, the premise shifts to a promise of close physical proximity with (virtual) women. This gendering is further reflected in the preponderance of female voices and vocalists on binaural demonstration records from the 1950s through the 1970s. For example, Teichiku's *Invitation to Binaural Sounds* (figure 1.2), released in coordination with Matsushita in

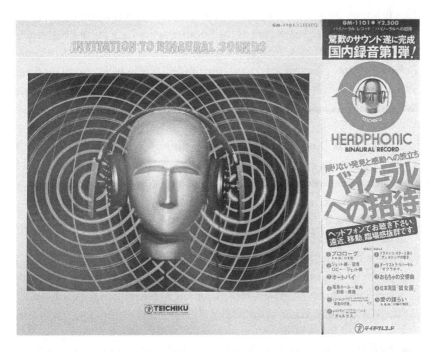

FIGURE 1.2 Cover and advertisement sleeve of Teichiku's vinyl record *Invitation to Binaural Sounds* (*Bainōraru e no shōtai*, 1976). The white text just above the track list in the lower right says, "Please listen on headphones. The sense of perspective, movement, and presence are outstanding."

1976 as part of the research developments detailed below, includes "narration" by voice actress Suzuki Hiroko and ends with her "Love Talk" (*ai no katarai*) whispered into the listener's ears.[36]

In Japan, as elsewhere, control over home-listening technology has long been primarily a male domain (as evidenced by the wireless widows of decades past), even as the gendering of binaural *performance* skews heavily female.[37] The switch to an ostensibly less threatening gender (for the implied male listener of the time) attempts to short-circuit what otherwise might be felt as an uncomfortable degree of homosocial intimacy and immediacy manifested in binaural listening—perhaps even a challenge to the spatial authority of the male home listener.

As prices dropped and incomes rose, stereo record players for home use became a key part of the Japanese leisure boom of the early 1960s.[38]

Headphones (*heddo-hon* or *heddo-fon*, also called earphones/*iyāfon*) for consumer use emerged as part of the boom, particularly for use with transistor radios, but they were again not without their detractors. Writing in *Rekōdo geijutsu* (Record art) magazine in 1961, audio technology reporter Wakabayashi Shunsuke differentiates the virtual acoustics of headphone listening for his readers like this:

> In the case of listening to stereo sounds through earphones, sounds go directly into the ears. There is no mediation. In contrast, when listening to stereo recordings on speakers, sounds pass through the medium of air before reaching the ears. Because sounds coming from speakers pass briefly through the room before arriving at the ears, the sound includes reverberation off the surrounding walls. Depending on the power, sounds from the left speaker may also be audible to the right ear. Compared with sound passing through space like this, with headphone use sounds instead reverberate directly from the outer ear into the eardrum. There is a big difference in sound.[39]

For Wakabayashi, speaker listening includes the interference of the reflective surfaces of the listening space (walls, floor, and windows, for example), giving stereo sound its "unique feeling of presence" (*sutereo dokutoku no rinjōkan*). He details this in an accompanying diagram (figure 1.3) that envisions sounds ricocheting off walls and floor on their way to the listener. As I noted above, headphone listening in contrast effectively bypasses the local acoustics of the listening space by collapsing the distance between ears and speakers, isolating the sound coming into each ear.

Wakabayashi cautions that if recordings designed for stereo speakers are listened to with headphones, some unfortunate effects occur. For example, if someone listens to a standard stereo recording of an orchestra over speakers, they are acoustically positioned as if they were in the concert hall audience. If a person listens to the same recording over headphones, however, the "sound image" suddenly comes much closer, placing the listener right in the middle of the orchestra pit.

For sound recordings produced with speaker playback in mind, headphones tend to give the impression that the sounds are simply moving around inside the listener's head.[40] For this reason, Wakabayashi notes, headphone listening is "not well suited to real music appreciation." Many

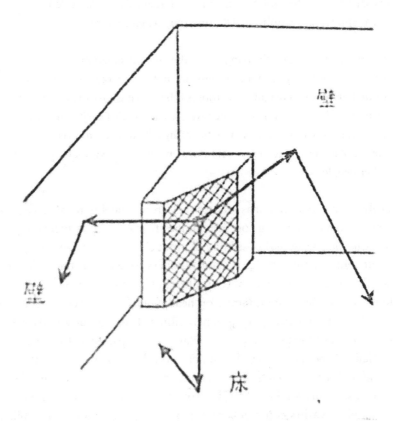

FIGURE 1.3 Illustration from Wakabayashi, "Iyāfon!?" (1961). The original Japanese caption reads: "Sounds coming out of the speaker reflect off walls, the floor, and other places before reaching the ears."

record producers at the time strongly advised against using headphones to listen to their recordings. Wakabayashi's article concludes that speaker listening generally provides a better experience, particularly in the case of music. Echoing Iguchi's earlier comments from the 1950s, Wakabayashi argues that headphone listening is the best choice only for the binaural reproduction of "real sounds" (*genjitsu-on*) like steam trains and jet engines or for the more accurate localization of discreet sound sources like opera soloists or actors in a radio drama.

Wakabayashi's article ends with a shift away from these concerns with pure audio fidelity, however, pivoting to a separate set of issues that would

prove decisive for headphone use in subsequent decades. Here he admits the real appeal of headphone listening may lie elsewhere:

> Despite all this, when thinking about the current situation in Japan, it's true most ordinary Japanese rooms are not very large, and moreover insulation between neighboring rooms is bad, so it is easy to hear sounds from next door. From this perspective, we can say that earphones offer a really easy way to listen to stereo recordings. It's difficult to overlook the appeal of being able to enjoy recordings on your own, without bothering other people.[41]

Wakabayashi explicitly warns readers that, from a fidelity perspective, listening to stereo recordings on headphones raises the "extremely dangerous" (*kiwamete kiken na*) possibility of producing a poor balance between the different instruments. He suggests listeners compare for themselves by using the same recording for both speaker and headphone playback. Yet he admits "late night stereo listening on headphones by yourself can also be fun."[42] The appeal of headphones here is ultimately less about sound quality and more about the provision of a solitary media space. Electronics historian Heike Weber notes a similar emphasis on "listening without bothering anyone" in West German headphone advertisements from the time. As in Japan, this was in part due to the poor sound insulation in German homes.[43]

As Wakabayashi's comments reveal, by the 1960s, headphones' ability to provide a more private listening enclosure began to register not as a liability but as a primary part of their appeal. The 1960s was also the decade when headphone use for film audiences finally found popular acceptance, albeit only in a very specific context: the in-flight movie. In the airplane cabin, the alienating potential of headphones was transformed into an asset for the solo traveler. The headphone enclosure offered a perceptual escape not just from plane noise but from the discomforts of the newest air travel innovation: the reduction in personal space known as economy class seating. In-flight headphones enabled what media scholar Stephen Groening calls the "separated spectator" in the skies.[44] Even as passengers were seated ever closer together, the virtual space provided by the headphones ensured they were perceptually apart.

As Wakabayashi's article hints, headphone use at home was in the midst of a similar, if more staggered transformation. Headphone listening

offered a chance to bypass home acoustics by piping the virtual space of a recording directly into a listener's ears. But the sound perspective issues persisted. If recordings were designed for speakers and thus recorded with microphones placed several meters apart, this larger sound stage would effectively be compressed into the smaller space between a listener's ears when played back on headphones. This resulted in what came to be known around this time as the sound-in-the-head problem. For example, a stereo recording of piano music heard over headphones would sound as if you had placed your head directly inside the performer's instrument (figure 1.4).

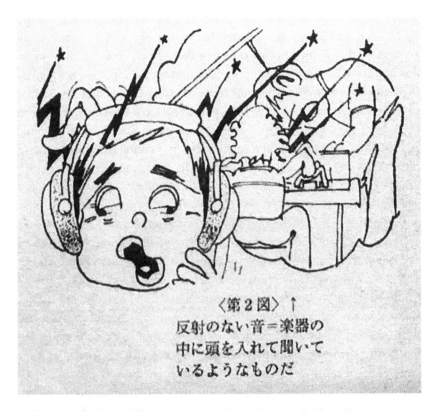

FIGURE 1.4 Illustration from *Rajio gijutsu* (Radio technology) magazine (July 1976) showing the problem with listening to stereo recordings on regular headphones. Caption: "Sounds without reflection = it's as if you are listening having put your head inside the instrument." Yamada and Kikuchi, "Tekunikusu anbiensu-hon no tokuchō," 251.

GETTING THE SOUND BACK OUTSIDE THE HEAD

To provide an appropriately sized virtual soundstage for headphone lis-
teners, the sound source somehow needed to be localized back into the
space around the body. Attempts to solve the sound-in-the-head prob-
lem would drive an increasing separation between binaural and stereo
recordings in the decades to follow. While Cook's binaural records were
intended for speakers and recorded with a pair of microphones placed
several meters apart, the new binaural recording practices instead took
a cue from Bell Labs' earlier dummy-head approach: spacing the micro-
phones roughly the width of a human head.

A breakthrough came in 1972, with an updated artificial head micro-
phone (*Kunstkopf*) designed by Berlin-based researchers Georg Plenge,
Ralf Kürer, and Henning Wilkens. Microphones could be made small
enough by this point to place them inside the ear canals of an artificial
head, making it possible to capture the auditory perspective provided by
the outer ears as well.[45] This new form of binaural was first introduced
to the West German public at Berlin's International Broadcasting Fair in
September 1973, followed by the broadcast of the first German binaural
radio drama. This kicked off a small boom in binaural headphone listen-
ing in West Germany that lasted through the end of the decade, at which
point most home audio equipment would include headphone jacks as a
standard feature.[46]

As Krebs notes, while many daily newspapers in West Germany were
enthusiastic about the new three-dimensional sound, and binaural was
popular with listeners, the audio engineer trade journals were less enthu-
siastic. As with the Japanese engineers, a range of technical and infrastruc-
tural compatibility concerns emerged, such as how binaural recordings
were effective in locating sounds on a left-right horizontal axis but had
much more difficulty positioning sounds in front of or behind the lis-
tener.[47] Krebs notes headphones at the time were still "associated with the
early years of radio broadcasting, and thus their use was perceived as a
step backwards in technical terms." The necessity of listening to binau-
ral broadcasts over headphones remained a sticking point. As one trade
author asks rhetorically in 1973, "who is willing to submit themselves to
these restrictions?"[48] Unable to secure larger institutional support, the
1970s West German binaural boom faded by the end of the decade.

In a striking parallel with the earlier Japanese sound magazine discourse, binaural headphone experiences even led some German audio experts to question the implicit assumption that greater three-dimensional access to "objective reality" would inherently lead to better or more satisfying listener experiences. For example, Peter Reinecke, director of the Berlin Institute of Musicology, declared at a 1969 conference the "need to question the ideological position of 'high fidelity'" because "music is not sound."[49] This is precisely where the long-standing binaural principle of fidelity to the original recording space bumped up against the parallel trajectory I described above, where audio engineers sought to detach recorded sound from any existing physical space. Krebs quotes Wilhelm Schlemm of Radio Free Berlin in 1974, who notes how more and more popular music was now recorded in acoustically "dry" studios, creating a "roomless" effect. At odds with this trend, "Kunstkopf stereophony has come at an untimely moment, leading to the following paradox: previously the history of electro-acoustical transmission was always driven by the desire for highest fidelity . . . now, just as the aim of perfect illusion can be achieved, it is no longer valued and desired."[50]

To complicate the situation further, as Krebs notes, the idea of perfect binaural fidelity to the original performance space also seemed to threaten the role of the audio engineers themselves, who, in the new era of postproduction spatial control, had come to see their work as an active and integral part of the larger creative process of crafting musical recordings. While the quest for increased fidelity and realism had long led audio engineering rhetoric, in practice the space of recorded sound had already moved far away from the original recording environment, to be placed under the control of both studio engineers and home listeners instead. Having grown accustomed to controlling the acoustics virtually, both parties were not about to sacrifice this flexibility in deference to the fixed "realism" of the original recording space.

Debates over headphone listening would similarly captivate Japanese audio hobbyists in the mid-1970s. Audio journalist Yamamoto Shūhei observes in a 1975 article for *Radio Technology* that headphone listening had finally emerged as a "quiet boom" (*shizuka na būmu*) among audio enthusiasts, yet the sound-in-the-head problem, the weight and discomfort of high-quality headphones, and the market dominance of stereo recordings intended for speaker playback all remained as obstacles.

Japanese audio engineers threw themselves at these problems in the years to follow, hoping to create an acoustic architecture that could retain the privacy and convenience of headphone use while "more naturally incorporating the atmosphere of the surrounding room."[51] Early experiments included a head-mounted speaker system designed to project a stereo recording to sound as if it were emerging from directly in front of the listener—a kind of audio-only head-mounted display (figure 1.5).

図15　前方定位のできるヘッドホン

FIGURE 1.5 Caption: "Headphones that can position sound in front of the head." Excerpted from Okahara Masaru, "Saikin no bainōraru," *Hōsō gijutsu* (January 1977): 112.

DETACHABLE AMBIENCE

Further developments along this line came from the Acoustic Research Laboratory at Matsushita, which came up with a different approach to what they called "outer head localization."[52] This research ultimately resulted in a consumer product released in 1977 on their Technics label: the Ambience Phone (*anbiensu-hon*). Explicitly marketed as a solution to the sound-in-the-head problem, the Ambience Phone used a four-channel audio processor to mix additional artificial echo and reverb into any stereo recording sent through the device. Instead of squeezing a stereo recording into the space between the ears, it would sound instead like it was coming from a pair of (virtual) speakers situated somewhere across the room.[53]

The Ambience Phone component box has just three controls: an on/off button, a button to turn the ambience function on and off, and a dial for the user to set the desired amount of ambience to add to the original signal (figure 1.6). By shifting the choice of sound placement from the producer to the consumer, the device sought to present a workaround to the distribution and infrastructure issues binaural recordings had repeatedly faced. The Ambience Phone approximated the acoustics of room-scale speaker playback within an individual, head-mounted space. Moving beyond the detachable echo of the recording studio, the Ambience Phone aimed to place an entire detachable ambience under the control of home listeners. Via the on-board "ambient controller," every listener was in effect put in charge of their own virtual dummy head. The push of a button would bring the virtual dummy head to life, and the turn of a dial would move the dummy's auditory perspective forward and back in virtual space.

The Ambience Phone was just one of a wide range of private acoustic enclosures to emerge globally around this time. One year later, Amar Bose would come up with the idea for noise-canceling headphones while commuting by plane.[54] That same year Brian Eno coined the term *ambient music* to describe a genre that aimed to provide self-selected emotional environments for private listeners, often by means of cavernous reverb-driven spaces within the recordings themselves.[55] And in 1979, Sony released the Walkman, a device that didn't solve the sound-in-the-head problem directly but effectively displaced it by introducing new possibilities for mobile headphone use.

FIGURE 1.6 Cover of the owner's manual for the Technics Ambience Phone (1977).

Headphone histories generally point to the Walkman's combination of lightweight, over-the-ear headphones with a portable cassette stereo as the moment when headphone use finally goes mainstream.[56] Yet this precise combination of features was far from a foregone conclusion. Independent research groups at Sony had been working separately on lightweight headphones and portable cassette players. The cassette player group had originally planned to release the device with a pair of much larger, heavier headphones on the assumption that sound quality would be the most important criterion for their customers. It was already late in the development process when Sony cofounder Ibuka Masaru recommended the two products be combined.[57] The lightweight, foam-covered headphones that were eventually used employed a patent Sony had licensed from Sennheiser but miniaturized the design even further.[58] Ibuka was prescient to realize that, for most consumers, better fidelity was no match for convenience and comfort.[59]

The second unexpected development for the Walkman occurred after the device was released to the public. Sony president Morita Akio had initially believed, based on his wife's input, that using the device alone in public would be considered rude. For this reason, a second headphone jack was included with the first release, much like the multi-headphone setups of home record players in the 1920s and 1930s. Early Walkman ads emphasized how the device could be shared, for example, by a "very tall American woman and an old Japanese gentleman," or two lovers on a tandem bike.[60] While later Walkman studies often present this as a historical curiosity, Morita's wife's concern was grounded in decades of stigma against the isolation of solitary headphone use.

After the Walkman was put on the market, however, it became clear listeners were using the device primarily to listen alone. As Morita later wrote, "buyers began to see their little portable stereo sets as very personal."[61] Musicologist Shūhei Hosokawa later dramatized this isolation in his widely read 1984 essay on the Walkman: "The listener seems to cut the auditory contact with the outer world where he really lives: seeking the perfection of his 'individual' zone of listening."[62]

To Sony's surprise, listeners began to treat the Walkman as a private extension of their own sound environment and to enjoy the freedom it provided to ignore—or at least remediate—the surrounding perceptual world. Walkman users too were subject to the headphone stigma early

on, often envisioned as rude young people purposefully refusing to attend to the larger social atmosphere.[63] Following the device's release, however, the social acceptance of public headphone use in Japan steadily increased. Weber notes a similar trend in the early Walkman reception in West Germany, as does personal stereo scholar Rebecca Tuhus-Dubrow in the United States.[64] The Walkman also allowed the isolation offered by headphone listening to be more accessible across gender lines, as African American studies and technology theorist Alexander Weheliye notes in his reading of the device as an "autonomous sonic space" for women who may otherwise have difficulty gaining control over space either at work or at home.[65]

As noted above, scholarship on the Walkman has often focused on how the listener's newfound mobility allowed private music to intersect with and reconfigure the embodied experience of movement through a city. What has yet to be recognized is how the Walkman normalized the practice of strapping stereo recordings directly to the head. By repositioning music listening back into the surrounding environment, both the Ambience Phone and the Walkman sought to offset the perceptual isolation of headphone use. The former used audio signal processing to fabricate a virtual space directly within the device, while the latter relied on live, on-location sound to surround the mobile listener and blend with the stereo recording, distracting them from the sound-in-the-head effect. The Ambience Phone and the Walkman offered a sonic prelude to virtual reality and augmented reality, respectively (minus the movement-tracking sensors that would only arrive a decade later).

THE EMERGENCE OF THE ONE-PERSON SPACE

Just as new sound technologies were making ambient control more accessible to the individual listener, the built environment itself was becoming more oriented toward privately mediated sound. Wakabayashi, remember, noted in the early 1960s that home headphone use was fun in part because it allowed for late-night listening where speaker playback would otherwise be bothersome (*meiwaku*) for neighbors and family members in adjoining rooms. Record numbers of Japanese relocated to urban environments at this time, often to live in wooden housing with notoriously

thin walls and in close proximity to neighboring homes. While these noise concerns were not exactly a novel phenomenon—the problem of noisy neighbors was even the central conceit of Japan's first sound film, *The Neighbor's Wife and Mine* (*Madamu to nyōbō*, Gosho Heinosuke, 1931)—these porous urban acoustics clearly impinged upon the promised freedoms of the 1960s leisure boom, among them the ability to make full use of your home hi-fi as you saw fit.

As Sterne traces in *The Audible Past*, from the early days of sound reproduction technologies, emergent middle classes have often sought to claim individual acoustic spaces as a form of private property.[66] For the rapidly expanding middle class of high-growth Japan, this first meant a shift to American-style, one-room-per-child family homes, an unheard-of level of personal space for most Japanese kids at the time.[67] Weber notes a similar trend in 1970s West Germany, where domestic media consumption would similarly become increasingly atomized, more about the pursuit of individual media spaces than collective family-oriented consumption. Headphone advertisements shifted in parallel to promote an ideal of isolated, concentrated listening, even associating it with relaxation and meditation practice.[68]

This trend was later taken to its logical extreme with the rise of concrete apartment blocks of one-room studios, or what in Japanese is called the *wan rūmu manshon* ("one-room mansion"). As urban studies scholar Nango Yoshikazu describes in *Hitori kūkan no toshiron* (Urban theory of the one-person space), when these single-occupant dwellings first emerged in the mid-1970s, they were initially intended as weekday places to sleep for urban workers who would return to their families in the suburbs on weekends. But they soon began to cater to the rising number of one-person households ready to give up a larger home to secure a space all their own in the city. The one-room mansion was advertised as a pathway to what in Japanese is known as *mai pēsu* ("my pace")—a life lived in your own way and at your own speed, even if it must take place within rather tight quarters.[69] A crucial element enabling this personal isolation was the one-room mansion's extremely effective sound insulation, which made it almost impossible to hear what was going on in the unit next door.[70]

As Nango notes, while these micro-apartments were derided as rabbit hutches by the American and European press, much like the Walkman, they ended up attracting an unexpectedly wide range of ages, income

levels, and occupations. Rather than bemoan the small space, Japanese media coverage at the time recognized the distinct appeal of the one-room lifestyle. Photobooks like Tsuzuki Kyōichi's *Tokyo Style* (1993) presented the one-room mansion as a kind of "cockpit" (*kokkupitto*) for the solo dweller: occupants could lie in bed and still have everything necessary to control their media environment within easy reach.[71] During the one-room mansion's heyday, from 1975 to 1985, this personalized cockpit might have been furnished with a television, a stereo, and perhaps later in the decade a video cassette deck or video game console.[72] As the one-room mansion demonstrates, the arrival of "electronic individualism" was as much architectural as it was mediated.[73]

Media scholar Thomas Lamarre notes how, around this time in Japan, the private television set began to serve as a pivot for "switching between media functions" so that "the personal bedroom begins to look like a broadcast-relay station."[74] While Lamarre's analysis captures the infrastructural side of this emergent personal media cockpit, the history I've presented here points to the three-dimensional virtualization of ambient perception that manifested in tandem with the establishment of these new media networks. The detachable ambience of the one-person space reimagined perception along the lines of a VR flight simulator, blocking out the perceptual determinants of the physical environment to allow for greater immersion into virtual realms. The arrival of the one-room mansion's acoustically sealed yet perceptually expansive media enclosure can be understood as a further step in the mainstreaming of the individual ambient space initially sought out through headphone use.

A HEAD-TRACKED ACOUSTICS

Even as urban architecture shifted to accommodate the one-person space, audio engineers continued to try and find ways to use virtual acoustics to transcend the immediate physical environment. Binaural reemerged in the post-Walkman 1980s in a few scattered experiments in North America like Norman Durkee's binaural opera *Oxymora* (complete with headphones provided to the audience), and a binaural recording of Steven King's short story *The Mist* produced by ZBS radio in upstate New York (both in 1984).

A brief hype also emerged around Argentinian inventor Hugo Zucca-
relli's "holophonic" binaural system. In a 1983 article in the *New Scientist*,
Zuccarelli claimed the human auditory system emitted a steady sound
that could be used as a reference tone for enhanced audio spatialization.
He sought to market the idea through a closely guarded proprietary bin-
aural technique he dubbed "holophonics," a riff on the global popularity
of three-dimensional holograms at the time. The system was deployed
in early 1980s albums by Psychic TV, Paul McCartney, and Pink Floyd,
and on demonstration recordings focused on close-to-the-head sound
effects, like scissors heard around the ears during a haircut. Media scholar
Takemura Mitsuhiro published two articles crafted to build anticipation
for holophonics in Japan around the time of the demonstration record's
Japanese release in the summer of 1987. But even these articles note the
system was shrouded in "mystification," with Zuccarelli suspiciously reluc-
tant to let outsiders verify his claims. In retrospect, it appears likely this
secrecy was to avoid further scrutiny of the questionable science behind
the system, as several responses to the *New Scientist* article had quickly
pointed out.[75] As Takemura notes, even in the post-Walkman years, the
fact that binaural systems like Zuccarelli's demanded headphone use to
achieve the promised three-dimensional auditory perspective remained
an obstacle to their popular adoption.[76]

In the meantime, however, three-dimensional spatial sound produced
via binaural methods quietly made further inroads into audio production
pipelines. Systems like the 1991 Roland Sound Space Processor promised
audio engineers the ability to position recorded sounds within a virtual
360-degree sound field. The system would then computationally calculate
the appropriate spatial acoustics to match the programmed features of the
virtual environment.[77]

On the consumer side, the outer head localization of the Ambience
Phone lived on as features in higher-end Japanese headphones, which today
come with an ever-larger set of ambient controls. For example, Sony's cur-
rent premier line of noise-canceling headphones, the WH-100XM series,
includes a smartphone app with "ambient sound control" options for lis-
teners to select (or have automatically chosen for them based on onboard
sensors). The app includes settings for listening while stationary, walking,
running, and in transit; the option to apply various concert hall and arena
acoustics; and, closest to the original Ambience Phone function, a set of

Front

FIGURE 1.7 Menu settings in the iOS app for Sony's WH-100XM2 headphones to virtually reposition the perceived sound origin in relation to the listener's head. The current selection situates the sound in front of where the listener is facing (captured October 20, 2018).

sound position control options that virtually displace the source of the sound to one of five locations further away from the head (figure 1.7).

While they increase the amount of ambient control available to sound engineers and headphone users, each of these systems positionally fix the virtual space to the headphones' own orientation. If a person turns to face a different direction, the entire soundstage rotates with them. In contrast, when such a system is combined with head-tracking technologies, the three-dimensional sound field can be updated in real time in precise alignment with the position of the listener's ears. This means that a virtual space will seem to stay fixed in place even as a listener moves within it.

This is achieved computationally by rotating or shifting the soundstage in real time in the exact inverse direction and degree of any movement or reorientation of the listener's head.[78] For example, if a listener turns their head left, the sound field produced by the headphones almost instantly pivots an equal and opposite degree to the right to give the impression the virtual ambient space hasn't shifted at all. In parallel with research on head-tracked visual displays (discussed in chapter 2), the first

head-tracked binaural audio was realized in 1988. Head-tracked three-dimensional audio and visuals combined serve as the basis for VR and AR headsets today.[79]

Extending the strategy used by the Ambience Phone, head-tracked audio effectively collapses the binaural dummy head with the listener's own. The listener's movements directly guide auditory perspective within virtual space. From a computational perspective, the listener's ears become just two more objects to position within a virtual sound field. Conversely, from a first-person listening perspective, the virtual sound environment seems to exist independently in three-dimensional space. Ambience now becomes detached not just from the local physical environment but also from the listener's own position within it.

Steven Jones notes how the spatial persistence of the virtual audio field independent of a listener's movements plays a crucial role in VR immersion, offering a way to "further distract the user's attention from the nonvirtual world, to solidify the technology's 'authority over the observer.' "[80] By providing a virtual space seemingly independent of the user, the headset becomes even more completely "a cockpit that the pilot wears," as VR researcher Thomas Furness once described it.[81] Detachable ambience allows a person to locate themselves perceptually "in" a virtual space, even as it remains strapped directly to their head.

EPILOGUE: ACROSS THE CHASM?

Echoing the trajectory of headphone listening, today social attitudes toward VR headsets continue to transform in tandem with the physical environments accompanying their use. Writing in the mid-1980s in one of the earliest cultural studies of the Walkman, Judith Williamson predicted that "personalized mobile viewing would be the logical next step," given moving image media consumption had already, like sound, moved from the public theater to the private home. "Imagine people walking round the streets with little TVs strapped in front of their eyes," she writes, essentially predicting that the head-mounted display would follow the Walkman out into the city. A few years later Sony's Morita Akio, of Walkman fame, similarly declared VR "the next big thing after camcorders."[82]

Compared with the Walkman, however, VR still had a range of obstacles to overcome before it could shake the stigma attached to head-mounted media. As I discuss in chapter 2, when VR headsets were first introduced to the general public, a head-mounted display (with a glove interface) cost somewhere between $90,000 to $200,000 USD and weighed five to ten pounds—replicating both the cost and discomfort of early headphones to an even more extreme degree.[83]

After the recent emergence of stand-alone consumer VR headsets, however, VR as a mobile one-person space has finally emerged as a possibility. People are already testing the cultural acceptability of VR in shared public spaces. In Tokyo, some early adopters of Facebook's Oculus Go headset have ventured out in public with the device. One such group is the Discord-based *Oculus Go o tanoshimu kai* (Oculus Go enjoyment society), which gathered in May 2018 eager to experiment with using the then-new headset on Tokyo trains (figure 1.8). This and

FIGURE 1.8 The Oculus Go Enjoyment Society (*Oculus Go o tanoshimu kai*) "Densha de Go" event, where participants gathered to try using the headset on Tokyo's Yamanote line trains. Photograph by Araki Ayaka, May 18, 2018. Used with permission.

similar events in restaurants and other spaces outside of the home tested how mobile VR might function in public space much like other portable media devices do already. Here too the social response to head-mounted media depends a great deal on the local context. Someone similarly tried to use a VR headset on Boston's Green Line in 2016 but was mocked on social media and criticized by the police for making themselves a "soft target" for thieves.[84]

As with the earlier headphone discourse, debates over what it would take to enable VR to achieve mainstream acceptance have been a prominent part of the recent VR revival. Facebook's purchase of Oculus in 2014 and the release of stand-alone headsets like the Go and Quest have each been anticipated as the moment when VR might finally achieve mainstream acceptance. Yet great uncertainty remains about just how large the market for VR may ultimately be. Signs of ambivalence or even outright antagonism toward VR are still easy to find.

Japanese VR evangelist GOROman (Kondō Yoshihito) presents one of the most evocative approaches to the question of how and when VR might overcome this stigma. He builds on marketer Jeffrey Moore's notion of a "chasm" between technologies that appeal only to early adopters and those that can garner an "early majority" user base, putting them on a path to mainstream acceptance. GOROman argues that the difference between these two positions is ultimately a question of the audience's gut reaction to a technology. He notes that (as he was writing in 2018) VR in popular culture still occupied the affective space of the *kimoi*, a slang abbreviation for *kimochi warui* ("gross," "unpleasant," "disagreeable"). What VR must cross over, then, is this *kimoi* chasm of instinctual revulsion (the *kimoi kyazumu*, or *kimozumu* for short).

GOROman argues that, like mobile phones in late 1990s Japan, VR may finally leap the chasm only once high school girls—a crucial Japanese marketing demographic—decide that wearing a VR headset is *kakkōii* ("cool") rather than *kimoi*.[85] Shin Kiyoshi similarly notes that for VR to become trendy in Japan, it first must overcome its association with the computer-obsessed male otaku culture that has adhered to it since the last VR boom of the 1990s (as chapter 5 of this book explores).[86] Beyond these questions of social positioning, the head-mounted audio trajectory documented in this chapter suggests that strapping a virtual space to the face will only make sense once the local environment transforms to make

that an acceptable and perhaps even obvious choice. A virtual interface doesn't emerge in a vacuum, but demands a particular social and physical context through which it can carve out a niche. Before VR could even hope to reach a broader audience in Japan, however, it first had to detach from its origins as an American military technology and be reframed as a device for accessing imaginary worlds. I will delve into the history of this initial reframing in chapter 2.

2

TRANSLATING THE VIRTUAL INTO JAPANESE

As virtual reality (VR) takes shape both as a concept and as a technology in the late twentieth century, it goes through a double translation. First comes the American rebranding of the largely military head-mounted display (HMD) research of the Cold War era, shifting it to the more creative, social, and even spiritual contexts that came to surround the idea of VR in the United States. Then comes a further redefinition as the term gets translated into Japanese amid the first VR boom of the early 1990s. What emerges from this double recontextualization is an approach to the VR headset that sees it not as an attempt to duplicate the real but as a portal to imaginary realities that make no claims to substitute for the existing world. As I work to unravel the various legacies and desires entangled in the term, my goal in this chapter is to clarify the stakes of how VR is understood and how this understanding is deeply shaped by local social and historical factors.

If the headset itself is a kind of perceptual enclosure, in a sense so are the broader cultural contexts of nation and language. While never absolute, these too often set the perceptual and ideological frames through which a person becomes situated in the world, including how a person understands their relation to a technology. American industry and marketing discourse often assumes that VR is culturally neutral. As noted in the introduction to this book, early VR theorists like Ken Hillis have argued that it carries distinctly American assumptions. Writing Japan

back into VR history complicates both notions, showing how, as the technology moves around the world, it becomes mediated by local cultural, social, and linguistic frameworks.

Japan's relationship with VR is best understood against the technology's earlier American history, so this chapter begins there. As with many new interfaces, the practical push for head-mounted three-dimensional visualization in the United States was initially driven by the military. Three-dimensional media scholar Jens Schröter notes how, after the stereoscope faded from popularity in the early twentieth century, three-dimensional imaging "leaves the area of entertainment apart from some occasional reappearances in movie theaters and in playrooms," only to become "operative in other fields having to do with the control of space (for example aerial reconnaissance) and via that route finally becomes popularized again in 'virtual reality.'"[1] This pivot from popular culture to U.S. military applications and back to popular culture critically shapes the emergence of VR as it exists in America today.

The U.S. Army Air Corps acquired inventor Edwin Link's pioneering Link Trainer flight simulator designs in 1934 and subsequently deployed these perceptual enclosures to train fighter pilots.[2] The U.S. Air Force also supported the development of Cinerama training films in the late 1930s and early 1940s, which similarly sought to fill more of a trainee's peripheral vision using a quarter-sphere screen design.

Inventor Morton Heilig cites this history of immersive military teaching aids in his 1961 patent application for his Sensorama arcade machine. The Sensorama is commonly described as the first attempt at a commercial VR device. Described throughout the patent as a "simulator," the Sensorama was a coin-operated stereoscopic viewer accompanied by stereo sound, physical vibrations, wind, and aromas. The machine offered a choice of experiences like a motorcycle ride through Manhattan and an amusement park date with a woman. Heilig argues that the machine's focus on perceptual immersion brought it closer to the "experience" itself, in contrast with merely reading about it or hearing about it in a lecture. "More can be learned about flying a supersonic jet by actually flying one," he writes, much like "a student would understand the structure of an atom better through visual aids than mere word descriptions."[3]

Just a few years later, computer scientist Ivan Sutherland similarly built on the military simulator approach to create the most influential early

computer-driven head-mounted display, supported by the U.S. Department of Defense's Advanced Research Project Agency (ARPA). Sutherland's 1968 report on the project emphasizes the importance of syncing a stereoscopic image with the viewer's head movement, or what he calls a kinetic depth effect:

> The fundamental idea behind the three-dimensional display is to present the user with a perspective image which changes as he moves. The retinal image of the real objects which we see is, after all, only two-dimensional. Thus if we can place suitable two-dimensional images on the observer's retinas, we can create the illusion that he is seeing a three-dimensional object. Although stereo presentation is important to the three-dimensional illusion, it is less important than the change that takes place in the image when the observer moves his head.[4]

The Sensorama, like the earlier peep-box, asks a viewer to position their head in relation to a stationary aperture, but Sutherland's head-mounted display enables an operator to turn their head all the way around, tilt their perspective up or down about forty degrees, and move up to three feet in any direction, with the three-dimensional wireframe, computer-generated image they see updating accordingly.

Sutherland had already produced a groundbreaking experiment in human-computer graphical interaction with his Sketchpad project, built as part of his Ph.D. thesis at the Massachusetts Institute of Technology (MIT) in 1962–1963. Like the Sensorama, Sutherland's influential 1965 conference presentation "The Ultimate Display" set out a program to expand immersive interface technologies to more than just vision, aspiring to serve "as many senses as possible." Like Heilig, Sutherland emphasizes the educational potential of immersive three-dimensional perspective. Through room-scale visualizations of mathematical principles, for example, "we can learn to know them as well as we know our own natural world."[5]

The reason Sutherland's presentation text has been influential, however, has to do with his speculation on the deeper implications of the immersive computer interface. These thoughts are framed through reference to Lewis Carroll's *Alice's Adventures in Wonderland* (1865) and its sequel, *Through the Looking-Glass* (1871), with Sutherland describing the computational display as a "looking glass into a mathematical wonderland." This

is the earliest example in what would become a long tradition of linking VR spaces to Carroll's other-worldly fantasies.[6] As part of this imaginative departure, the text's frequently cited final paragraph transposes Carroll's fantasy space into a suddenly more sinister register:

> The ultimate display would, of course, be a room within which the computer can control the existence of matter. A chair displayed in such a room would be good enough to sit in. Handcuffs displayed in such a room would be confining, and a bullet displayed in such a room would be fatal. With appropriate programming such a display could literally be the Wonderland into which Alice walked.[7]

While Sutherland's reference to a fatal bullet in computer-controlled space might first come across as no more than science fiction, this violent turn becomes more comprehensible once understood in the context of the long-term military interest in head-mounted displays and teleoperator control.[8] For at least some of this military research, the goal was that, with a more directly embodied interface, a bullet fired through Alice's Wonderland could indeed be fatal.[9]

U.S. government teleoperator studies emerged in parallel with the simulator trainers. As I detail in chapter 3, starting in the late 1940s, Raymond Goertz and others at the Argonne National Laboratory began to develop techniques of remote manipulation to handle radioactive materials as part of the U.S. government's Manhattan Project, laying the groundwork for the head- and hand-tracking in later VR systems. By the 1980s, first the U.S. Navy and then NASA set up labs to further develop teleoperator interface research for undersea and outer space uses, respectively. In this context, the goal was not simply an educational experience but a more direct manipulation of the world on the other side of the screen (or in Goertz's case, on the other side of a transparent protective glass).

This focus on military utility continued to shape head-mounted display research through the 1980s. Tom Furness's Super Cockpit flight simulator interface developed for the U.S. Air Force throughout the 1970s and 1980s further refined Sutherland's initial head-mounted displays.[10] In the second half of the 1980s, Scott Fisher and others at the NASA Ames Research Center also helped lay the foundation for the more consumer-focused VR of the early 1990s.[11]

While no longer dominant, the military orientation in American head-mounted display research persists today. Head-mounted interfaces continue to play a role in U.S. military strategy, such as Microsoft's 2018 contract with the U.S. Army to develop their HoloLens augmented reality headset into a battlefield "heads-up device." The military's stated goal for the interface is to "increase lethality by enhancing the ability to detect, decide and engage before the enemy."[12] And after his controversial exit from Facebook, Oculus founder Palmer Luckey shifted to focus on technologies for American border security with his new company Anduril while encouraging other American technology companies to get involved in U.S. military contracts.[13]

THE ORIGINS OF JAPANESE VR

In contrast, Japanese research in three-dimensional head-mounted interfaces grew out of a telecommunication rather than military context. Japanese research with military applications became more difficult in the wake of the war-renouncing framework set down in Article 9 of the postwar Japanese constitution, which was established by the American occupation forces in 1947. The Japanese economy became increasingly focused on home electronics across the high-growth years of the 1950s and 1960s, laying the groundwork for the subsequent rise of Japan's consumer electronics industry and its global market dominance in the years to follow.[14] This alternate trajectory would shape the course of three-dimensional interface research and development in the country.

Three-dimensional visual display research emerged in Japan alongside the spatial audio studies introduced in chapter 1. Ōkoshi Takanori's research on wide-view projection holography, published as *Three-Dimensional Imaging Techniques* in 1976, would inspire later research in holographic visualization like Steven Benton's work at MIT's Media Lab.[15] Researchers from the Auditory and Visual Processing Research Group at NHK also experimented with wide-field displays in the late 1970s in the interests of achieving a greater "sensation of reality" for future television broadcasts.[16]

Japanese teleoperator research began to build off the work of Goertz and others to experiment with new modes of teleoperation, as discussed

in the next chapter. An important figure here is Ishii Takemochi, a pioneering Japanese researcher in what would later come to be known as human-computer interaction (HCI). Ishii started his career in medicine, and only later shifted to computers in the mid-1950s under the influence of Norbert Weiner's *Cybernetics* (1948).[17] Ishii began work on teleoperator systems in the 1980s. Two of his students, Iwata Hiroo and Hirose Michitaka, would go on to become important VR researchers in the following decade.[18]

Hirose, for example, first encountered VR while at work on a project with the Tokyo Electric Power Company (TEPCO) in the mid-1980s.[19] His task was to use the new computer graphics techniques to create a three-dimensional visualization of TEPCO's power grid, because the grid was becoming too complicated for employees at TEPCO themselves to understand.[20] As part of the project, Hirose visited the newly opened Media Lab at MIT and met David Zeltzer, who at the time was at work on his AIP Cube, a framework to measure the affordances of the head-mounted interface along the three axes of autonomy, interaction, and presence (see figure 2.1 later in this chapter). As I explore in chapter 3, Tachi Susumu, the other leading Japanese VR researcher of the 1990s, had also spent time at MIT as a Senior Visiting Scientist during the 1979–1980 school year and had come to focus on three-dimensional head-mounted displays in the 1980s. He developed his own concept of telexistence in parallel to Marvin Minsky's notion of telepresence.

REDEFINING THE FIELD AS "VIRTUAL REALITY"

Japan thus had active research underway in the various VR-related fields by the late 1980s. But it wasn't until momentum began to build around the term *virtual reality* in the United States and soon after in Japan that these different projects began to coalesce under a single name. Researchers going back to Sutherland had used terms like *virtual image* and *virtual world* to describe computer-generated three-dimensional imagery, and Furness similarly makes frequent reference to "virtual space," "virtual displays," and "virtual worlds" throughout his publications on the Super Cockpit.[21] Software designer Ted Nelson took a similar approach, defining

virtuality in 1980 as a "structure of seeming" characteristic of interactive computer systems.[22] A competing term emerged in the early 1980s with video and media artist Myron Krueger's notion of *artificial reality*, which he used to describe his responsive video installations where "the laws of cause and effect are composed by the programmer" and new kinds of social relations can emerge.[23] Combining elements of these terms, former Atari employee Jaron Lanier began using the term *virtual reality* in the 1980s to describe the head-mounted displays and wearable computer interfaces under development at his company, VPL Research.

Throughout most of the 1980s, *artificial reality* had the edge as the more popular term. By the latter half of the decade, technology journalists were using Krueger's term in their article headlines, while sometimes introducing *virtual reality* within the article as a synonym. For example, Andrew Pollack's April 1989 article in the *New York Times*, "For Artificial Reality, Wear a Computer," explains only in the fifth paragraph how "the word virtual is used in the computer industry to refer to what appears to be present but is not."[24] Lanier, for his part, attempted to differentiate his term by emphasizing how not all virtual experiences are necessarily artificial: the voice on the other end of a telephone line, for example, is a real person's despite being only virtually present.[25]

Japanese technology journalist Hattori Katsura, who spent two years at MIT's Media Lab starting in 1987, recalls a great deal of confusion about the terminology at the time. He recalls how some in Massachusetts would refer to virtual reality simply as "what they call artificial reality on the West Coast," with many at the Media Lab complaining that both terms were simply oxymorons seeking to combine *reality* with the word's antonyms.[26]

In the influential 1988 memo he circulated to urge his company to pursue three-dimensional interface research, Autodesk cofounder John Walker similarly cast doubt on all the available terms. He includes another popular competitor, *cyberspace*—the term William Gibson introduced to describe the computer-mediated immersive world in his influential 1984 science fiction novel *Neuromancer*.[27] Walker writes,

> Several terms have been used to refer to a computer-simulated world, none particularly attractive. "Artificial reality" and "virtual reality" are oxymorons, Ted Nelson's term "virtuality" refers to a much more general class of computer worlds, "world simulator" is too grandiose for what

we're talking about, and "cyberspace" misuses the root "cyber" (from κυβερνήτης—"steersman") to denote computer rather than control.[28]

After begrudgingly landing on *cyberspace* as the least offensive choice, Walker ends the memo with a slogan that taunts the other terms even as it channels their transcendent promise: "Cyberspace: Reality isn't enough anymore."[29]

The terms *cyberspace, artificial reality*, and *virtual reality* each sought in different ways to shift the discourse away from the military and governmental origins of the technology, moving toward an imagination of the immersive computer interface as something both more artistic and more everyday. Lanier's term finally began to spread in the wake of a series of high-profile lectures and demonstrations he gave at the very end of the decade. This started with VPL's VR demo booth, a major attraction (alongside Autodesk's) at AT&T's Texpo '89 trade show in San Francisco in June 1989, and then again at SIGGRAPH 1989 in Boston later that summer. Curator Kathy Huffman recalls Lanier speaking about virtual reality to a rapt audience of 5,000 at the latter conference.[30] The hype continued to build at the twenty-four-hour "techno-rave-slash-VR-expo" Cyberthon, hosted by the Whole Earth Institute in October 1990.[31]

At these events, Lanier promised VR would enable more immediate, intuitive, and prelinguistic "virtual programming languages" (as referenced in the name of his company, VPL Research). Media theorist Lev Manovich describes Lanier's vision succinctly as a "fantasy of objectifying and augmenting consciousness" paired with a "desire to see in technology a return to the primitive happy age of pre-language, pre-misunderstanding."[32] Hillis notes how Lanier's VR promised a way "to have recourse to mediation in order to suggest that something more *pure* than this very mediation might now be on offer through a new media form."[33] Unlike the military applications, Lanier focused on depicting virtual reality as a " 'purer' thought realm, where the materiality of the body can be left behind."[34] Art and media historian Oliver Grau describes Lanier's project as "an attempt to combine diverse areas of research on the human-computer interface with different labels with utopian dreams in one, albeit paradoxical, catch phrase with a strong popular appeal."[35]

From here, momentum began to build for the term. By the summer of 1990, psychedelic drug advocate Timothy Leary could be seen doing a VR

demonstration on the American broadcast news program *20/20*. References to *virtual reality* in the major English-language newspapers began to climb the same year, overtaking the other terms and peaking in 1995 before falling off again (at least until the recent VR revival in 2016, when the term reemerged with no real competition).

Lanier's term—along with his public image as a dreadlocked "ascetic prophet" emerging "out of the desert" of New Mexico—catapulted off strains of techno-utopianism already circulating in the United States at the time, particularly in the Northern California techno-spiritual circles Lanier frequented in the late 1980s and early 1990s.[36] Cinema and media theorist Vivian Sobchack describes the worldview of the era's VR-enthusiast publications like *Mondo 2000* as an attempt to suture "New Edge high-technophilia with New Age and 'whole earth' naturalism, spiritualism, and hedonism."[37] Autodesk hired Leary to help promote their own head-mounted interface project, and VR quickly became associated with LSD in the popular American press. Grateful Dead lyricist-turned-'cyber-libertarian' John Perry Barlow began to appear frequently in *Wired* and *Mondo 2000* to hype VR as the next "electronic frontier."[38] The 1992 trade paperback edition of technology writer Howard Rheingold's bestselling *Virtual Reality* would feature blurbs from Leary, Stewart Brand, Jerry Garcia, Arthur C. Clarke, and Brian Eno.

Not everyone was on board. Brenda Laurel, another ex-Atari employee who founded Telepresence Research, Inc. with Scott Fisher in 1989, registers the flavor of these complaints during a 1991 talk she gave in Sydney, Australia: "We use the word telepresence because the term virtual reality is an oxymoron . . . Most of us in the business dislike it a lot. The word virtual is okay because in fact we're creating environments or realities that don't necessarily have concrete physical components to them. But the use of the word reality in the singular belies a certain cultural bias that most of us are not very comfortable with."[39] While they provided ample coverage for events like the Cyberthon, journalists were not always convinced by Lanier's techno-utopianism either. Ironically, the first major English-language newspaper article to include *virtual reality* in a headline is a highly skeptical September 1990 editorial by science writer Chet Raymo in the *Boston Globe*. Titled "Virtual Reality Is Not Enough," Raymo philosophically notes that while VR promises a user the unlimited ability to be anyone they want, meaning "every person is an astronaut, every person is

Donald Trump, every person is Top Gun," this misses the deeper mystery and meaning of environments full of what cannot be fully known or made fully perceptible. He ends by comparing VR's "goggle-eyed, boom-boxed Disneyworlds of the mind" unfavorably to a walk in his local New England woods.[40]

Taken together, Krueger's *artificial reality*, Gibson's *cyberspace*, and Lanier's *virtual reality* pushed the imagination of virtual space beyond the earlier military contexts. At the same time, they set the technology on a collision course with broader cultural anxieties rooted in the perennial notion that new media constitute a direct threat to humanity's grasp of the "real." As in Raymo's editorial, VR came to be popularly figured as the most powerful example yet of what sociologist and philosopher Jean Baudrillard in 1981 began to call *hyperreality*, a representation of the real detached from any broader referent, and that threatened to become more efficacious than the real itself. Here too Disney theme parks were the primary example.[41] In this context, the head-mounted interface became symptomatic of a larger mediated transformation where everyday life itself turned into a virtual reality, as Baudrillard himself would later come to argue.[42]

VR COMES TO JAPAN

When Lanier's VPL became the first company to release commercial head-mounted displays and glove interfaces in 1987, Hirose and others in Japan were quick to order them for their labs.[43] As in the United States, however, it took some time for *virtual reality* to become established as a term—with the added question of how best to translate it.

Back from his years at MIT's Media Lab, Hattori first introduced Lanier's term in the Japanese press as part of a January 1990 article in *Asahi pasokon* (Asahi personal computer) magazine. The article focuses on the emergent Japanese "multimedia boom," which, as fellow *Asahi* journalist Muro Kenji notes, was set to replace the "new media boom" of a few years prior.[44] This carried over into a string of articles Hattori penned to introduce VR in the magazine's parent newspaper, the *Asahi shimbun*. This series culminated in a more in-depth feature back in *Asahi pasokon*

in June 1990 titled "Welcome to the World of Virtual Reality" (*Bācharu riaritii no sekai e yōkoso*), paired with a long interview with Howard Rheingold.[45] At the urging of the Kōgyō chōsakai publishing house, Hattori's coverage of his visits to different VR labs inside and outside Japan was collected and published as a book in May 1991 (figure 2.1). This was the first book on VR for a general audience to appear in Japanese or English, and quite likely in any language. Rheingold's *Virtual Reality*, presented with a similar structure built around visits to domestic and overseas VR labs, appeared a few months later. Both books became best sellers.[46]

The continued confusion about what to call the technology at that point is clearly reflected in the title of Hattori's book. The main title is *Jinkō genjitsukan no sekai* ("the world of the feeling of artificial reality"), paired with the English-language subtitle *What's Virtual Reality?*[47] Hattori notes that *virtual* was not a commonly understood word in Japan when the book was published, so it can be inferred that the question in the subtitle was a real one for his potential readers.[48] Tachi Susumu's early 1990s publications similarly show evidence of how fluid the different terms were at the time. In a 1992 paper, for example, he defines artificial reality as equivalent to virtual reality, which in turn he argues is "virtually the same concept" as his own term, telexistence (at the time spelled tele-existence).[49]

Academics like Tachi who had been working on related technologies saw the popular attention suddenly accruing around Lanier's term and glimpsed an opportunity for increased funding and public recognition. A turning point came with the Human Machine Interfaces for Teleoperators and Virtual Environments conference at the Sheraton Hotel in Santa Barbara, California, from March 4 to 9, 1990. Organized by John Hollerbach of the Engineering Foundation, Nat Durlach and Thomas B. Sheridan at MIT, and Steve Ellis of NASA, the conference brought together researchers from what were at the time scattered research fields connected with telepresence, three-dimensional interface research, and computer simulation. Tachi was invited as part of the planning stage, and he presented his research along with Hirose, who was back in the United States at the time working at Lawrence Stark's lab at the University of California at Berkeley as a visiting scientist.[50]

Tachi refers to the event as the "big bang" that marked the start of academic VR research as a coherent field. "Prior to the Santa Barbara

FIGURE 2.1 Cover of Hattori Katsura, *Jinkō genjitsukan no sekai: What's Virtual Reality?* (1991), most likely the first book on VR published for a general audience. Building on Ivan Sutherland's invocation of *Alice's Adventures in Wonderland*, the cover situates John Tenniel's original illustration of Alice and Humpty Dumpty within David Zeltzer's AIP cube.

conference," he writes, "various terms such as *artificial reality, telepresence, telexistence, cyberspace,* and *virtual environments* were being used in different fields for VR. However, as the conference progressed, an implicit agreement was reached that all of these terms could be collectively called 'virtual reality.' "[51] Starting in 1992, Tachi began to describe VR as the convergence of many different fields of computer interface research, including teleoperation, computer-aided design, computer graphics, three-dimensional simulations, and telecommunication. The conference also led to what would become the first journal dedicated to telepresence and VR at MIT, initially titled *Presence: Teleoperators and Virtual Environments.*

BUILDING THE JAPANESE VR INDUSTRY

Within a few years, Japanese corporate, government, and research communities alike were aligned around the term. Not long after the Santa Barbara conference, Tachi worked with Ishikawa Shinji of the Japan Technology Transfer Association to establish the Japanese VR Research Committee, which in turn led to the Inaugural Symposium on Artificial Reality and Tele-Existence, held on October 19, 1990, at Tokyo Station and planned in collaboration with Hirose. Tachi would point to these developments as an indication that the number of Japanese researchers working in VR (or rather, who were now beginning to self-identify as VR researchers) already rivaled that of the United States.[52] With the support of Nikkei Inc. (publisher of the *Nihon keizai shimbun,* Japan's largest finance-focused newspaper), this group launched the first International Conference on Artificial Reality and Tele-Existence (ICAT). ICAT would be held annually in Japan from 1991 to 1996. Gifu prefecture, at the time led by the information-technology-focused governor Kajiwara Hiromu and subsequently home to the International Academy of Media Arts and Sciences (IAMAS), would later play a key supporting role in these VR efforts.[53]

Soon after the Santa Barbara conference, Tachi and others began a concerted effort to secure funds from the Japanese government to grow the field and incorporate it into the broader national science and technology agenda. They began to apply for Grants-in-Aid for Scientific Research from the Japanese government in 1991, and by 1995, the Japanese Ministry

of Education, Science, Sports, and Culture had designated VR a Priority Scientific Research Area and sponsored a Fundamental Study on Virtual Reality. Tachi led the latter project, with the participation of over 200 researchers at universities throughout the country.[54]

Building off this momentum, in 1996 affiliates from the same group launched the Virtual Reality Society of Japan (VRSJ) with 278 founding members. The VRSJ annual conference replaced ICAT the following year and has been held annually ever since. From 1991, the organization also began to hold VR product exhibitions, and two years later this grew into the annual Industrial Virtual Reality Show and Conference held in collaboration with the large-scale trade show organizer Reed Exhibitions. VRSJ also launched an ongoing student VR competition, the International-Collegiate Virtual Reality Contest, to help cultivate future generations of VR researchers.[55]

In parallel with this largely university-focused activity, Kyoto's Advanced Telecommunications Research Institute (ATR) eventually emerged as one of the best-funded independent VR and perceptual technology labs, with an annual research budget of $50 million USD contributed from a consortium of 140 communications and computer companies.[56] As computer scientist Benjamin Watson noted in 1994, while many of the public research institutes in Japan—including the oldest VR-related labs, like Tachi's—tended to focus on telepresence and force-feedback technologies, the private institutes concentrated more on telecommunications and display interfaces, with greater ambitions to generate public-facing products.[57]

The most famous among these was Matsushita's VR "decision support system," called the Viva, where customers could design their own made-to-order kitchen and experience it in VR before purchase. Matsushita (now known as Panasonic) promoted its VR demo kitchen as "the first commercial application of virtual reality in the world." The initial version debuted at Matsushita's newly opened Shinjuku showroom in 1991 to a great deal of press coverage both inside and outside Japan. Reservations to experience the kitchen demo were soon full up to a month in advance, with over three thousand people eventually taking part. While the company initially planned to present the demo for just one week, the strong public response prompted them to extend the run repeatedly, for a total of three years.[58]

The hardware wasn't cheap. The initial prototype used Silicon Graphics workstations and VPL's "Reality Built for Two" platform, at a total cost of somewhere between $500,000 to $900,000 USD (including $35,000 for each of VPL's EyePhone headsets).[59] Project director Nomura Junji notes that, while most people came because they wanted to try the VR system and not because they were interested in fancy kitchens, enough of the wealthier visitors placed an order that the project ended up paying for itself.[60]

In addition to the kitchen showroom, Matsushita also had two consumer VR products in development and originally planned for release by the spring of 1994. The first was a VR massage chair, the Relax-Refresh Lounger, that used a head-mounted audiovisual display and tactile massage feedback synchronized to a sitter's pulse. The VR audiovisuals were provided by videocassette tape and played back with a standard videocassette recorder (VCR). The second plan was for a stationary bicycle where riders could cycle around obstacles in a three-dimensional virtual environment.[61]

A wide range of other companies simultaneously attempted to market VR devices directly to Japanese consumers, necessitating a price point and a technical capacity far below any of VPL's more complex systems. The first of these was the Power Glove, a short-lived peripheral for use with the Nintendo Famicom (Nintendo Entertainment System in the United States) based on a drastically simplified version of VPL's DataGlove. Lanier and Thomas G. Zimmerman had aimed to collaborate directly with Nintendo, but the initial project failed. Abrams/Gentile Entertainment embarked on a redesign and finally brought the product to market. The peripheral was manufactured by the PAX Corporation in Japan—a short-lived bubble-era consumer electronics company—and Mattel in the United States. While four games designed specifically for the Power Glove were eventually released in the U.S., these games were never sold in Japan, and the PAX Power Glove was marketed instead as a general-purpose Famicom controller when it went on sale in the summer of 1990. Television advertisements from the time featured a Dr. Frankenstein–style mad scientist who points at the camera and declares *Omae no te o kaizō suru no da! Omae no te da!* ("You will convert your hand! Your hand!")

Sega began work on a VR headset for use with its Sega Genesis console in 1991. The headset was initially called Virtua VR and was intended as a follow-up to Sega's Mega-CD (Sega-CD) peripheral. Aimed at a target

price of around 20,000 yen ($200 USD), the headset promised 360-degree head tracking, three-dimensional audio and visuals, and a color screen. A low-cost head-tracking solution was to be provided by a company founded by engineer-inventor Mark Pesce in San Francisco called Ono-Sendai Corporation, named after the imaginary Japanese VR hardware producer in Gibson's *Neuromancer*. The product was announced at the 1993 Consumer Electronics Show and featured on the June 1993 cover of *Popular Science*, but the project was quietly shelved a few months later due to worries it would "make kids sick."[62]

Nintendo's attempt at a VR interface— the Virtual Boy—was first announced in November of the following year. While priced close to Sega's system, this was a stand-alone head-mounted display unit on legs (not unlike a peep-box), with a red-tinted three-dimensional display rather than a full color screen. It lacked any head tracking or 360-degree display capabilities. The red-tinged scanned linear array (SLA) screen technology was licensed from Reflection Technology, Inc., of Waltham, Massachusetts. Nintendo predicted sales of 3 million units within the first twelve months, but despite a large-scale advertising campaign, sales and reviews were lackluster, and Nintendo quietly abandoned the system within a year.[63]

Extending their already large catalogue of personal audiovisual devices like the Walkman, Watchman, and Diskman, Sony's first attempt at a consumer head-mounted display, the Visortron (1993), offered what amounted to a head-mounted television that could be hooked up to a VCR or game console.[64] The device set aside head-tracking to operate much like an Ambience Phone for the eyes, aiming to emulate "watching a 33-inch TV from four feet away." While the device did support stereoscopic visuals, it was designed primarily to be hooked up to a Sony Camcorder or other video playback devices producing a regular monoscopic signal. As with the in-flight headphones described in chapter 1, Sony first offered the device for use with in-flight entertainment on Japan Airlines flights.[65] The company's later Glasstron series (1996–1998) added an optional see-through mode and could also be used as a stereoscopic interface for Activision's first-person mech battle simulator *MechWarrior 2* (1995).

In 2002, Sony released another updated version—the PUD-J5A Head Mounted Display—for sale online only in Japan. It had two degrees of

head-tracking and six dedicated stereoscopic game titles for use with the PlayStation 2.[66] The system also featured an early 360-degree video format called FourthVIEW developed by Yoshimura Tsukasa at Sony from 1998 to 2004. Early FourthVIEW videos featured concert footage from popular singers like Hamasaki Ayumi and promised to bring viewers closer to their favorite artists.[67] This was followed by the HMZ-T series in 2011, sold as a "Personal HD and 3D Viewer."

Echoing Sony president Morita Akio's initial faith in VR as a successor to the Walkman and camcorder (described in chapter 1), Sony was the rare (and probably only) company to continue to release head-mounted displays all through the so-called VR winter. This in turn led the company to PlayStation VR (PSVR), released as a peripheral for the PlayStation 4 in October 2016. PSVR would go on to become the best-selling headset of the 2010s after the reawakening of VR interest, selling 5 million units by the end of the decade.[68]

TRADE WARS AND TECHNO-ORIENTALISM

By 1991, Japan was already home to more high-end VR headsets than any other country in the world (out of a global total of around four hundred).[69] One notable aspect of this early 1990s period is how deeply transnational many of these projects were, drawing on technologies and product designs from both Japan and the United States. The flurry of public- and private-sector investment in VR at this time must be understood transnationally as well. Throughout the 1980s and into the 1990s, fundraisers and bureaucrats in both the United States and Japan stoked local fears of technologically falling behind the other country in order to push for further VR investment at home. Computer industry scholar Joel West notes that U.S. technology initiatives put forward at the time were often taken far more seriously in Japan than in America itself, and observes how "the competitive threat of U.S. plans has regularly been used in Japan as a consensus-building tool, by providing the external pressure necessary to speed up the decision-making process and force things to a conclusion."[70]

Conversely, technology strategists in the United States were sensitive to the notion that Japan might take the lead in the emerging VR market and

often used it as a specter to scare up additional investment at home. Corporate governance specialist Scott Callon has argued that, to outsiders, Japan's national technology initiatives often appeared highly organized and nationally coordinated, but this masked what was in fact a wide range of individual and organizational agendas, and how frequent dissensus was often at play just under the surface.[71] The image of a unified Japanese threat could be a powerful force in its own right, however, particularly in the United States.

In May 1991, then Tennessee senator Al Gore held a special hearing on VR in front of the U.S. Senate Subcommittee on Science, Technology, and Space. He began by noting how "clearly the Japanese are serious about completely dominating this new field" and advocated for greater U.S. investment in response. Lanier was invited to speak as a witness at the hearing, and he emerges in this context as an unlikely defendant of Japanese interests. VPL Research had come to be highly dependent on Japanese companies to manufacture components for their VR systems. As Lanier recalls, after unsuccessfully trying to locate manufacturers in the United States, "we ended up buying most of our parts from Japan. I used to go there so much; it wasn't unusual to have to fly to Tokyo and back twice within the same week."[72] After admitting in response to Gore's questioning that "Japan alone is probably spending ten times the amount spent in the United States for VR research," Lanier provides a muted defense of the country enabling much of VPL's business: "it's inappropriate to criticize the Japanese for doing a good job, which is all they've done."[73]

Rheingold's *Virtual Reality* includes a section focused on Japan titled "Cool Gadgets and Industrial Policies." While the dismissal of Japan's VR projects as nothing but "gadgets" betrays a skepticism typical of the U.S. perspective at the time, the section ends with a quote from Lanier similarly seeking to downplay fears of VR's potential to spark another trade war:

> Because the USA has experienced some financial difficulties and some types of industrial decline, there is a tendency to overestimate the Japanese. There is unfortunate talk that the Japanese will "take over" VR. The Japanese believe in planning, and will tend to announce a long-range plan even when they are in fact groping beginners at VR, just like the rest of us. If we ascribe a supernatural quality to the Japanese, we aren't really seeing them, and that's destructive to collaboration.[74]

By the mid-1990s, Japan and the United States were competing over the development of internet infrastructure as well, with Japanese players pointing to the Clinton-Gore plan for "information superhighways" as evidence that Japan needed to catch up to the United States.[75] The broader multimedia boom during this period also served as a rationale for the need for greater network bandwidth. As West wrote at the time, only streaming video could justify Japan's need for a mass overhaul of the information infrastructure: "only multimedia content—home movies (video on demand), interactive videogames, interactive education, business videoconferencing, and so on—requires the bandwidth to justify a nationwide digital telecommunications network supplanting the existing telephone network."[76] The strategy would be reprised in 2019 and 2020, with NTT's Docomo for example pointing to the need to stream 8K VR content as a rationale for upgrading the nation's cellular networks to 5G.[77]

In parallel with this economic jockeying, the transpacific images of Japanese and American VR were also shaped by prevailing cultural projections. The image of Japanese VR in the United States was saddled with the techno-orientalist imagery of 1980s American cyberpunk—itself conceived in the midst of the trade wars. Most prominent was Gibson's *Neuromancer*. Gibson had imagined a VR future accessed via an "Ono-Sendai Cyberspace VII" machine that ran on a "Hosaka" computer, while the book's protagonist haunts the back alleys of Japan's "Chiba City." Gibson had never been to Japan at the time he wrote the book, but he was responding both to the country's dominance in the global consumer electronics market at the time and more specifically to Japanese technologies like the Sony Walkman, which he extrapolated into the more elaborate perceptual interface portrayed in the book.[78]

Yet even for frequent visitors like Lanier, the country remained tinted by these fictional associations:

There was a particular bond between Japan and the early culture of VR . . . In part, this was because Japanese culture felt exotic and symbolized the strangeness of the new world we were discovering in our labs. Walking in the blazing night of Shinjuku felt like what a virtual world might be someday. There was a lot of Japanese flavor in early cyberpunk, especially from William Gibson and in *Blade Runner*.

But also, the Japanese adored virtual reality. There were great early VR labs all over the country, and it was amazing to visit them. Henry Fuchs and I used to have a classification scheme for VR research—single person or multiperson, augmented or not, haptic or not, and so on—and we could find no way around having a separate category for "strange experiments from Japan."[79]

As is evident in Lanier's reminiscences here, American associations with Japanese VR slipped easily from a cyberpunk-influenced techno-orientalism to a sidelining of aspects of the Japanese research scene that didn't fit within American technology rubrics. The latter were situated instead as "cool gadgets" and "strange experiments" that didn't seem to warrant serious consideration. In the American popular imagination, Japan remained a place for future VR fantasies rather than real-time competition (a trend carried forward to the American reception of *Sword Art Online*, one of the VR fictions explored in chapter 4).[80] *Mondo 2000*'s Summer 1990 special issue on cyberspace characteristically slips in a small feature on plastic Gundam models (and where to buy them in the San Francisco Bay Area) alongside the feature articles on VR. "No collection of alien artifacts would be complete without some Japanese toys," the article begins.[81]

Meanwhile, from a Japanese perspective, the American VR imagination emerging through techno-utopian magazines like *Mondo 2000* appeared peculiar in its own right. From Hattori's perspective, VR was being situated in America as "the next fantasy world after drugs." He does note, however, that there was some of that flavor in Japan as well, with VR features appearing in occult and women's magazines, and Hirose witnessing "slightly edgy" trendsetters lining up to buy Hattori's book at Aoyama Book Center's fashionable Roppongi branch.[82] Lanier has similar memories: "VPL had a Tokyo showroom, and the visitors were the most interesting people from Japanese cultural and technical circles. We used to be on Japanese TV a lot."[83] The appetite for the virtually exotic flowed in both directions.

THE BOOM FIZZLES

In the end, the 1990s VR boom ended before the Japan-U.S. battle over VR dominance could come to pass. Public interest shifted to personal

computers (particularly after the release of Windows 95) and then the internet and mobile phones later in the decade. Concurrently, Japan's economy was sliding into a long-term recession. By the end of 1993, growth in Japanese VR research and development had largely gone flat, although there were still around twenty major VR research projects underway (mainly focused on a communications context).[84]

In some ways the 1990s Japanese VR boom could not have been more poorly timed, as it became caught in the turbulence of the collapsing asset price bubble. However, following Tachi, a small core of engineers stuck with VR as a framework for their research even after public attention shifted elsewhere. American commentators have often spoken favorably of Japanese engineers' commitment to long-term research and development. Although Tachi remembers facing plenty of detractors even during the initial VR boom, the long-term sustainability of Japanese VR research beyond the initial early 1990s enthusiasm amply demonstrates the power of this unwavering commitment.[85]

On the other hand, Hirose admits that, while the Japanese VR research community successfully cultivated a new generation of researchers (as evident in the continued activities of the VRSJ today), the considerable Japanese corporate and government investment in VR in the early 1990s produced no major impacts on industry.[86] Maeda Tarō notes that, if it weren't for Tachi and collaborators' efforts to turn VR into a broad engineering research field focused on human-computer interfaces, VR in Japan would likely have died out entirely once the initial popular boom faded.[87]

Of the consumer-facing VR devices that were ultimately released, few lasted very long. Hattori attributes this to the devices being ultimately "products that were neither here nor there" (chūtohanpa na seihin), neither delivering on the promises of the more advanced VR systems like VPL's nor delivering the entertainment value or utility of more straightforward two-dimensional interfaces.[88] Public response to the consumer VR of the 1990s reproduced many of the same complaints from earlier head-mounted media, from physiological concerns over headaches, eye strain, and nausea to similar social resistance to the perceptual isolation demanded. Participants at VR demos in Japan at the time also had hygiene concerns, showing "a great deal of reticence to use a piece of equipment that had been on someone else's face."[89] Sony notwithstanding, other major Japanese companies at the time avoided head-mounted

interfaces for many of the same reasons. NHK, for example, acted on a belief that "no-glasses" binocular displays were the technology of the future, a research agenda they have further pursued since.[90]

When consumer VR reemerged in the mid-2010s, the Japanese academic VR research community appears to have been largely caught off guard. Hirose describes a student in the mid-2010s coming up to him one day to share news of what was to them an interesting new device called an "HMD," unaware that the earlier VR boom had even taken place.[91] The old guard of VR researchers and journalists could only look on bemused as the Japanese press quickly declared 2016 the "first year" (*gannen*) of the VR era, with familiar promises of a new media revolution.[92] While the parallels were obvious to those who had lived through the first VR boom, commercial VR marketing was careful to avoid mention of this earlier period in order to distance the new VR ambitions from the previous "failure" to launch a VR market in the 1990s. Ironically, this raised the risk of repeating one of the main mistakes of the earlier wave of VR hype: raising consumer expectations to a level that current VR technologies could not possibly hope to meet.

Clear the air of the perennial emerging technology hype, however, and it becomes evident how the 2010s VR boom in many ways built on the legacy of 1990s VR. As games studies scholar Steven Boyer argues in relation to Nintendo's Virtual Boy, what seems at first like a simple story of market failure can obscure a wide range of significant and lasting transformations playing out just under the surface.[93] This is undoubtedly true in the case of the first VR boom, even as this history is largely (and often intentionally) neglected today. Media scholar James Cohen argues that, despite the dominant narrative of 1990s VR as a failure, a closer look reveals how projects like Autodesk's led to groundbreaking software like Sense8's WorldToolKit and internet-based immersive approaches like Mark Pesce and Tony Parisi's Virtual Reality Modeling Language (VRML).[94] Communications scholar Leighton Evans makes a similar point for the so-called VR winter that followed, describing this period as a "critical 'dark history' where significant advancements were made (away from the spotlight of popular culture)."[95]

Despite the paucity of clear market successes, the first VR boom played a critical role in shaping both the research and popular reception of later VR in Japan. Sony's extensive experience with head-mounted interfaces

helped inform their later success with PlayStation VR. Nintendo's peep-box style Virtual Boy similarly has echoes in the company's more recent VR Labo products.[96] Matsushita's Shinjuku kitchen demo served as the initial proof of concept that corporate VR demonstrations could be cost-effective in generating free advertising and mainstream media publicity, a trend that continues to shape the use of VR in advertising today.[97] And in 2018, Panasonic began offering its current lineup of core-training exercise chairs, developed from their original 1990s VR experiments. The newer products use current head-mounted displays to provide users with the experience of virtual canoeing and horseback riding, alongside guidance from a (virtual) personal trainer.[98]

While the contemporary VR headset market is now dominated by a few large companies like Facebook, Sony, and HTC, Japan continues to have a range of smaller VR hardware players. Tokyo-based FOVE was the first to market a headset with eye-tracking technologies. Fujii Naotaka's Haco-sco, a low-cost foldable cardboard VR shell, played a role in Japan akin to Google Cardboard in the United States, spreading the possibility of low-cost VR experiences early in the current VR revival.[99] Japan Display has focused in recent years on high-definition VR screens for enterprise use.[100]

In the meantime, a younger generation of VR enthusiasts has rekindled a VR hobbyist community in Japan, with GOROman and others successfully pushing to bring Oculus to Japan early in the new consumer headset revival.[101] While Facebook initially appeared hesitant to give much attention to the country, during the September 2020 Facebook Connect event, the company announced the opening of a separate Japan-specific Oculus Store, a Japanese keyboard for the Oculus VR interface, and a full translation of the developer guidelines into Japanese.[102]

Much like the headphone history examined in chapter 1, buried beneath these corporate and research histories are the ways VR headsets intersect with and transform the perceptual spaces of everyday Japanese life. While Facebook's first portable stand-alone headset, the Oculus Go, received only mixed reviews in the English-speaking world, the company appears to have been caught off guard by how well the Go sold in Japan after its 2018 release.[103] The promise of watching Netflix in the headset on a virtual large-screen television proved to be a particularly large draw in the context of the relatively small domestic spaces of urban Japanese homes, where a large TV or the large open space necessary to use a room-scale

VR system safely may be much harder to come by.[104] The absence of a strong personal computer (PC) gaming tradition also meant few in Japan had the hardware needed for higher-end tethered VR headsets.[105] These factors have favored portable or stand-alone VR systems that do not demand a separate computer.

THE VALENCE OF THE VIRTUAL

Beyond these consumer technology contexts, differences in American and Japanese VR approaches would also be shaped by different understandings of the phrase *virtual reality* itself. Even as Lanier's term began to spread overseas, the answer to the subtitle of Hattori's book—*what's virtual reality?*—continued to depend on the social and historical situatedness of the person responding. While Lanier's 2017 memoir playfully gives fifty-two different definitions for *virtual reality* in order to avoid a definitive answer, a more careful genealogy of the term can help disentangle the various cultural histories embedded in the concept.[106]

In its Euro-American history, the adjective *virtual* comes to fuse a technical term of optics with a religious vision of moral transcendence. As literature and technology scholar N. Katherine Hayles explores, a strong line in European thought going back to Plato rests on a firm dichotomy between matter and spirit. In the twentieth century, this dichotomy morphs into an opposition between matter and information, with digital data occupying the latter slot. "The great dream and promise of information," Hayles writes, "is that it can be free from the material constraints that govern the mortal world."[107] The real/virtual distinction can be understood as part of this same legacy, with the virtual joining information on the dematerialized spiritual side. Paired with an emphasis on immediacy, the virtual downplays or even seeks to transcend reality's material basis. The term is deeply rooted in a Platonic and later Christian understanding suspicious of material reality as a superficial and potentially deceptive realm, often turning to ritual means to access the deeper spiritual realities lying underneath.[108]

As sociologist Rob Shields examines in his book-length study of the word, the concept of the *virtual* first became prominent amid

sixteenth-century debates over whether bread and wine were literally or just virtually transformed into the body and blood of Jesus in the Christian ritual of the Eucharist.[109] Reformers like Martin Luther relied on the distinction as a way to explain how Christ's body and blood could achieve "virtual presence" during the ritual and thus have real spiritual effects, even if the objects involved didn't literally transform (as the Roman Catholic Church had previously insisted). Virtual presence promised ritual participants access to a higher, more ethical plane of reality via the formal transcendence of the mundane perceptual world. At the same time, it allowed Christians to continue to practice the Eucharist while distancing themselves from earlier beliefs in a more literal material transformation.

In this context, much like Plato's spirit, the word *virtual* referenced a transcendent idealism. In the Middle Ages, the Latin *virtualis* acquired the positive valence still carried by the English word *virtuous*: an embodiment of moral ideals that could transcend the mundane materiality of bread and wine. While the Latin word refers more generally to strength or potency,[110] in religious contexts, it comes to mean much more than that. As Shields notes, "as an adjective, a 'virtual person' was what we might today call a morally virtuous or good person: a person whose actual existence reflected or testified to a moral and ethical ideal."[111]

Luther's emphasis on the practical and temporary nature of virtual presence eliminated the need to prove anything was *actually* transformed during the ritual. It ultimately didn't matter if the bread and wine were materially still bread and wine if they produced their desired effect within the ritual context. This emphasis on practical efficacy carried forward into later secular definitions of the term, for example, in philosopher Charles Sanders Peirce's succinct formula from 1902: "A virtual X (where X is a common noun) is something, not an X, which has the efficiency (*virtus*) of an X."[112] A long philosophical tradition examining the efficacy of "the virtual" in relation to and in tension with "the actual" spun out from here and continues on today.[113]

During the Enlightenment, scientists began to apply the adjective *virtual* to more specific perceptual phenomena. What optics came to refer to as a *virtual image* was an image that appeared to a viewer to be situated on the other side of a lens, where light rays do not actually reach but still appear to converge. The virtual image was an intangible three-dimensional scene that nonetheless had a definite shape and position. The

British journal *Photographic Notes* of 1857 explicitly defines a virtual image as an image that appears as if it were actually present, in direct opposition to a real image, or "one through which rays of light actually pass."[114] Communication scholars Adriana de Souza e Silva and Daniel M. Sutko refer to this as the *technical virtual*, or "a nonphysical, simulated space constructed by the use of technology."[115]

By the middle of the twentieth century, a more expansive and imaginative approach to the technical virtual began to emerge, one that reintroduces some of the more emotional and affective dimensions absent from the strictly optical approach. The definition offered in philosopher Susanne Langer's *Feeling and Form* (1953) was especially influential:

> An image is, indeed, a purely virtual "object." Its importance lies in the fact that we do not use it to guide us to something tangible and practical, but treat it as a complete entity with only visual attributes and relations. It has no others; its visible character is its entire being.[116]

Virtual space for Langer is "like the space 'behind' the surface of a mirror," a "space that exists for vision alone."[117] While Langer derives her use of the word from "the physicists," she departs from the strict optics definition to envision a more plastic and imaginary space rather than the pure operation of light. Here the virtual coheres in the viewer's mind not just as the eye's response to lens and surface reflections but also by drawing on memory and past experience. The virtual image for Langer is a space imbued with feeling, crafted to elicit emotions in the audience. In other words, Langer pulls the optical lens-based definition of *virtual* back into a more subjective and introspective realm, where human feelings become invested in an imaginary space.

Lanier recalls Sutherland invoking Langer when he would speak of the possibilities of a "virtual world."[118] While the word *virtual* is absent from the 1965 "Ultimate Display" essay, Sutherland refers to the computer-generated shapes produced by his headset as a "virtual image" in the 1968 report.[119] But whereas Langer describes the virtual image as important precisely because it *doesn't* exist for anything outside perception alone, Sutherland follows the earlier U.S. military research in positioning virtual images as useful precisely for their ability to offer an efficacious substitute for the real scene. Luther's emphasis on the practical efficacy of "virtual

presence" comes back into the picture here, although in a military context rather than a religious one.

By the 1980s, the valence of virtuality again began to tip back in Langer's direction as more designers and artists got involved and a new rhetoric of computer-generated "reality" emerged. When Lanier turned to "virtual reality" in the 1980s, he drew directly on Sutherland's invocation of Langer, but he sought to move virtuality closer to Gibson's vision of cyberspace as a multiuser "consensual hallucination."[120] Lanier describes being "obsessed with the potential for multiple people to share such a place and to achieve a new type of consensus reality," noting that "it seemed to me that a 'social version' of the virtual world would have to be called virtual reality."[121]

This communicative aspect became central to the early VPL VR projects on which Lanier collaborated, like the landmark "Reality Built for Two" (1990).[122] As Lanier describes it, VPL's goal was to bring "a certain aspect of humanism and poetry to the field," downplaying the military focus of head-mounted display research in earlier decades.[123] Lanier's virtual reality in effect combined the military's computer-enabled "virtual worlds" and "kinesthetic depth effects" with the more social "consensus realities" already emerging through the computationally mediated social space of video games (including Lanier's own earlier work at Atari), as well as the highly social media art of artists like Krueger. These visions in turn have precomputational roots in 1970s tabletop role-playing games (RPGs) like Dungeons & Dragons (explored in chapter 4), as well as the immersive multimedia spaces of expanded cinema, multimedia concert performances, happenings, and related environmental art movements.[124]

At the same time, through Lanier and the techno-utopian dreams of the *Mondo 2000* crowd, the earlier morally transcendent promise of Luther's "virtual presence" began to seep back in.[125] While the "virtual image" of optics research had largely stripped away the "virtuous" valence of the virtual, Lanier's strategy of promoting VR as a technology for social good relied heavily on the Platonic notion of a spiritual realm of information capable of transcending mundane reality. Through the rhetoric of "virtual reality," the head-mounted interface reemerged by the early 1990s alongside claims it could radically transform society for the better. VR in early-1990s America became what technology and society scholar Morgan Ames describes as a "charismatic technology," where emotional investments surrounding an emerging technology gain strength by tapping into

"foundational narratives that are ritualistically circulated within groups to reinforce collective beliefs."[126] In the American context, VR gained momentum by tapping into a deep vein of desire for a virtuous virtual presence that could help leave the stubborn inertia of the existing material world behind.

This charisma worked best when VR remained primarily a speculative proposal, a technology most people hadn't actually tried. After promises of VR developing into a major consumer market failed to pan out, the techno-utopian ambitions shifted around the mid-1990s to the two-dimensional internet instead (though these dreams too would start to fade as the internet became altogether too familiar by the early 2000s).[127] Academic studies of virtual computer-based environments in English also tried to move away from "virtual reality" as a term, declaring it "philosophically confusing."[128]

Yet the techno-utopian promise of virtual reality remained potent enough for VR to stage a remarkable comeback in the early 2010s following Palmer Luckey's 2012 Kickstarter for what would become the Oculus Rift.[129] Chris Milk's influential portrayal of VR as the "ultimate empathy machine" and Oculus's later string of "VR for Good" projects built directly off a deeply held cultural desire to believe a more virtuous "virtual" reality could serve as a moral corrective to existing social bias and injustice.[130] While I have yet to encounter a contemporary American VR developer making reference to the term's historical origins, it is not hard to find evidence in the United States of a persistent desire to find something inherently virtuous about virtual space. Communication scholars Jeff Nagy and Fred Turner note how VR development in America even today is often rhetorically positioned as a "quasi-divine" vocation, a kind of Protestant "community of faith" where VR evangelists set out on a crusade to bring their promised future into being.[131]

TRANSLATING THE VIRTUAL

As Lanier's concept was introduced in Japan, however, it intersected with a different set of beliefs related to imaginary space. When the term *virtual*

began to appear in 1880s Japanese physics dictionaries in reference to virtual images, the term was translated as *kyozō* 虚像, with the first character implying a "false" or "fictional" image. Subsequent translations used *kari no* 假ノ or *kasō* 仮想 for *virtual*, implying something provisional or temporary. The latter term was taken up nearly a century later by Japanese IBM engineers in 1972 when they decided to translate the new computer term *virtual memory storage* into Japanese as *kasō kioku sōchi* 仮想記憶 装置.[132] The IBM engineers' translation set a precedent, leading to Lanier's term being widely translated into Japanese as *kasō genjitsu* 仮想現実 ("*kasō* reality") a decade later.[133]

Tachi has often argued that this translation of virtual reality into *kasō genjitsu* is fundamentally mistaken, because it misses the Peircean emphasis on real-world efficacy embedded in the English term. Emphasizing the cultural authenticity of the latter understanding, he cites the *American Heritage Dictionary*'s definition of *virtual* as "existing in essence or effect though not in actual fact or form."[134] In contrast, *kasō* refers to a mental supposition or a hypothetical idea that does not actually exist, a product of the imagination. The character *kyo* 虚 in *kyozō* similarly places the "virtual" on the side of fiction (*kyokō* 虚構) rather than drawing closer to reality.[135]

The translation of VR as *kasō genjitsu*, Tachi argues, has given Japanese speakers a mistaken understanding of what VR refers to. He notes that to think of a "virtual company" or a "virtual currency" as purely imaginary would be mistaken, because it misses these objects' real-world effects. Tachi considers the misunderstanding regrettable but in some sense inevitable, as what he calls the "extremely Euro-American" (*kiwamete ōbei-teki*) concept of the virtual had no precedent that translators could turn to in the Japanese language (or in Chinese, for that matter).[136] He argues that the best option is to stick with the original English term transliterated into the *katakana* script that Japanese uses for foreign loanwords: *bācharu riariti* バーチャルリアリティ.

Most academic VR researchers in Japan have followed Tachi's lead. Yet *kasō genjitsu* remains in regular use in the popular press and among many VR developers. In addition, Japanese dictionaries' entries for *bācharu* tend to refer directly back to *kasō*, with no reference to Tachi's preferred definition above. For example, this is how the second edition

of the authoritative, fourteen-volume *Nihon kokugo daijiten* defines the transliterated *virtual* and *virtual reality*:

> *Bācharu*. Adj. Not accompanied by the actual form [*jittai o tomonawanai sama*]. Imaginary [*kasō-teki*]. False [*giji-teki*].
>
> *Bācharu riariti*. Noun. A device appealing to the human sense organs by way of electronic technologies like a computer, in order to produce an imaginary [*kasō-teki*] world that does not actually exist, but makes a person feel as if they are there. Also, the experience of such a world. *Kasō genjitsu*.[137]

The "essence" aspect of the *American Heritage Dictionary* understanding is absent from both definitions, although the second does include a brief reference to feeling "as if" the imaginary world was real. This emphasis on the "feeling" of reality goes back to early 1990s Japanese translations of artificial reality and virtual reality mentioned above, as in Hattori's *Jinkō genjitsukan*. The extra character *kan* 感 ("feeling," "sensation") is added to the end of the translation to clarify that the term refers to the "feeling" of reality rather than reality itself.[138]

While Tachi is right to describe virtual reality as an "extremely Euro-American" concept, his pretense of sticking with the original American meaning flattens out the term's already complex history in English, as I have described above. Even before its arrival in Japan, Lanier's "virtual reality" was a historical palimpsest of philosophy, religion, art, and physics; subjective feeling and objective measure; a mix of moral aspiration, technical precision, and compelling marketing pitch. Rather than offering more precision, in practice the transliterated *bācharu riariti* works to leverage the more exotic and seemingly more authentic flavor of the original foreign term. Hattori notes that, in most cases, "virtual reality" in Japan simply came to refer to "a game or some other content using a head-mounted display and three-dimensional computer graphics," but using the original English term rather than a translated Japanese one at least retained some of the concept's "mysterious appeal."[139]

The *kasō* approach, in contrast, offers clues for understanding how VR intersects with conceptual tendencies already embedded in the Japanese language. Put simply, *kasō* divides reality along different lines than the Platonic spirit/matter distinction often running through virtuality

discourse in the Euro-American context. While the first definition of *bācharu* I quoted above invokes falsity (the *giji-teki*), Japanese etymological dictionaries are careful to point out the character *ka* 仮 in *kasō* is not to be understood as an antonym of *shin* 真 (truth). Rather, the distinction is primarily a temporal one. *Ka* is provisional and impermanent, like putting on a mask (*kamen* 仮面) or disguise (*kasō* 仮装). A *kasō* reality is fully present while it is manifest to a human observer, even as it remains but a temporary layer in the existing perceptual world.

Media scholar Tani Takuo, whose etymological research I draw on above, connects the notion of *kasō genjitsu* back to the rock garden tradition of *karesansui* 枯山水, noting that *kare* was once written with the character 仮 instead. Tani argues for a deep similarity between seeing a virtual image in a VR headset and the important concept of *mitate* in the Japanese garden tradition, where a viewer is at one level looking at a bunch of rocks but simultaneously glimpses the "mountains" and "oceans" latent in their form as they temporarily coalesce in the viewer's mind.[140]

The focus on virtuous essences is absent, and *kasō genjitsu* doesn't promise any kind of transcendence or access to a "deeper" layer of reality. It is simply a more fleeting, more imaginary slice of the world, produced in this case via the mediation of perception. Much like the virtual image in Langer's *Feeling and Form*, to the extent *kasō genjitsu* feels real it is not just due to perceptual fidelity but also a result of an emotional desire to peer into these fictional, mediated worlds. The feeling matters as much as the technology itself. Already by 1992, media critic Ōtsuka Eiji could call his essay collection on the semiotic codes of Japan's post-bubble consumerism *Kasō genjitsu hihyō* (*Kasō genjitsu* criticism), even though the book contains nothing focused on computers or three-dimensional graphics specifically.[141]

Discussing Tachi's argument about the Japanese terms for VR, Shin Kiyoshi notes that whatever term contemporary Japanese VR developers choose to use—and today they still tend to oscillate between *kasō genjitsu*, *bācharu riariti*, and the English abbreviation VR—their approach to the technology is often firmly rooted in an understanding closer to that of the *kasō*.[142] That is, they understand VR not as a way to transmit the "essence" of a reality beyond the technology itself but rather as a tool for fabricating fictional layers that add to rather than simulate the existing world.[143]

While I find the distinction between the English term's Platonic essentialism and the transient layers of *kasō genjitsu* useful for untangling VR's conceptual history, it would be too reductive to situate this as a simple opposition between national or regional cultures. Rather, *kasō genjitsu* helps highlight a contrasting approach to VR that stands out prominently in Japan but certainly isn't isometric with it. Researchers like Tachi focused on VR for teleoperating robots understandably want to emphasize the technology's real-world efficacy, and projects like Matsushita's kitchen demonstration likewise were invested in capturing the experiential essence of being in an actual kitchen.[144] Conversely, VR developers worldwide focused on gaming and entertainment often work from a premise closer to *kasō genjitsu*, whether or not their local languages contain an equivalent concept. And as the recurring *Alice in Wonderland* references suggest, even engineers attempting to build more practical VR tools were often influenced by these fantasy narratives.

The debate over *bācharu* and *kasō* within Japanese VR points to a broader split that runs through VR as a whole. Is VR a medium for stripping away the inessential to get at a deeper reality, or is the headset better understood as a perceptual portal into an imaginary space? I explore how the tension between these two approaches has played out since the 1990s in the rest of the book. The next chapter focuses on Tachi's extremely Platonic approach to what he calls VR telexistence, while the projects described in chapters 4 and 5 work from a decidedly more *kasō-teki*—that is, "fictional and imaginary"—understanding of virtual worlds.

3

VR TELEWORK AND THE PRIVATIZATION
OF PRESENCE

As virtual reality (VR) becomes a head-mounted space for remote work, it introduces new possibilities for controlling and monitoring a worker's perceptual environment. Building on the interface history put forth so far in the book, this chapter focuses on Japanese VR projects that attempt to offer a more embodied, self-contained perceptual platform for telepresent labor. I show how those individuals already most subject to mobility restrictions easily become the target for the perceptual privatization imposed by VR telework platforms. VR's emphasis on perceptual enclosure stands to make even a person's social "presence" dependent on the whims of VR platform providers.

If the contemporary drivers of the industry have their way, VR is poised to become a major platform for virtual labor and transit even as it continues to be advertised primarily as a personal media device. This is clear if you listen to Facebook CEO Mark Zuckerberg speak about why Facebook decided to purchase the Oculus VR start-up in 2014. Explaining Facebook's interest in VR to technology journalist Kara Swisher, he notes:

> I think one of the biggest issues economically today is that opportunity isn't evenly distributed . . . If you have a technology like VR where you can be present anywhere but live where you choose to, then I think that can be really profound . . . Historically cities have grown to be bigger by building better physical infrastructure. There'll be some amount of

that . . . but I have to believe that, we're here in 2018, it's much cheaper and easier to move bits around than it is atoms. It strikes me that something like VR or AR [augmented reality], or even video conferencing on the path to that, has to be a more likely part of the solution.[1]

VR proponents and commentators have long pointed to a reduction in the need for physical travel as a key social benefit potentially offered by the technology. As Japanese internet researcher Aizu Izumi speculated early in the first era of VR hype, "The twentieth century allowed people to physically move freely, but the twenty-first century might come to be an era where people can have their will move freely while they are physically in one place."[2] American VR proponents like Jaron Lanier and Brenda Laurel similarly promised VR would help minimize pollution by having people work from home rather than commute.[3] Autodesk's Eric Lyons told the *New York Times* in 1989, "It's the end of commuting . . . you put on your helmet at home, plug in to your light pipe and you're at work."[4] Lanier promised similar futures to the *Boston Globe* as early as 1988, noting how after "commerce, recreation, and daily life" largely shift to VR, "I guess I kind of see the physical plane becoming a national park—all of it."[5] As philosopher Daikoku Takehiko argues, VR's real "revolutionary" potential is less its much-touted ability for perceptual immersion and more what happens when it becomes part of the everyday computational infrastructure of the information society.[6]

Facebook's grander vision for VR clearly includes not just a way for the company to market its own hardware (easing its current dependency on other companies' devices) but also to own the next platform through which users become virtually present to one another socially.[7] VR offers Facebook the chance to become the virtual landlord of digital transit, work, and recreational infrastructures set to replace physical travel and real estate. In other words, Zuckerberg is interested in VR not just as a new communications platform but as a virtual substitute for basic spatial infrastructure as well.

While often downplayed in public-facing VR advertising, this ability to reshape the space of work stands to be one of the most socially significant aspects of virtual reality going forward. While the current push for networked employee tracking and surveillance has already transformed service and factory work today,[8] VR telework goes even further, separating

worker from workplace in order to monitor and regulate the perceptual interface between them. Whoever controls the dominant VR platforms will have control over how individuals move around and make themselves digitally present to the world—and the data they produce as they do so.

As Zuckerberg's comments hint, interest in VR as an immersive perceptual interface for remote work has historically been driven by economic incentives, even as its advocates operate under the banner of personal freedom and choice. VR transforms the "walled garden" corporate platforms of the twenty-first century internet into a wraparound three-dimensional space. As this chapter explores, VR telework also stands to enclose a worker's virtual presence in other ways, ensuring that their social participation remains within the platform and under the supervision of management. What this ultimately points to is what I call, as a subset of the broader VR enclosure, the *telepresence enclosure*: telework platforms that seek to capture and mediate each worker's audiovisual perception and embodied motor skills while at the same time keeping workers fixed in place and socially sequestered. Telepresence enclosure privatizes the perceptual space immediately around each worker's body, aiming for the privatization of presence itself.

FROM RADIOACTIVITY TO REHABILITATION

Telepresence refers to the use of technology to make a person appear present somewhere other than where they are physically, including the ability to interact with objects in this remote environment. Like the telegraph, telephone, and television before it, telepresence promises to extend human perception across inhuman distances. The field of telepresence overlaps with robotics, which provides the physical shells that telepresence operators remotely embody. Unlike VR focused on imaginary worlds, which locates the space of interaction entirely within a computer, VR-controlled telerobots seek to enable more immersive forms of mediated embodiment within existing physical environments.

While theorists in the United States sometimes position telepresence and VR in opposition to one another,[9] in Japan they are considered part of the same field. Telepresence research both predated and shaped the

emergence of VR in Japan in the 1990s, making the country an important site for thinking through how VR came to be situated as a new platform for immersive telework. Today, Japanese telepresence projects often focus on the use of telerobots to enable new forms of service and factory work in response to the demographic challenges posed by the country's shrinking and aging population. A spring 2019 joint survey of small and medium-sized companies by the Japan and Tokyo Chambers of Commerce and Industry found a full 66 percent of companies faced labor shortages, with over half expecting the situation to continue to worsen in the future. The most severe shortages were in hotels and restaurants, followed by caregiving and nursing positions.[10] In response to shortages like these, VR telepresence in Japan promises access to new populations of workers who may not otherwise be able to travel to work on-site.

While telepresence in Japan would come to focus on providing teleworkers to alleviate the labor shortage, this was far from the original context in which the technologies developed. What would become known as telepresence research first began with projects funded by the U.S. military at the Argonne National Laboratories in Illinois in the late 1940s. The immediate need was to find ways that human workers could safely but accurately manipulate radioactive materials, a new challenge born from the nuclear reactor research the same lab had performed as part of the Manhattan Project. What at the time was called *teleoperator* research sought ways to open up a safe distance between a human operator and the radioactive materials they worked with, while still allowing for the manipulative dexterity of direct physical contact. This resulted in a series of cable-based lever systems that telerobotics historian Blake Hannaford describes as "essentially tongs that grew longer and longer."[11]

The work of Raymond Goertz, an Argonne engineer employed by the Atomic Energy Commission, was particularly influential. Goertz developed the concept of degrees of freedom (DoF) to describe how many axes of movement a gestural tracking interface could utilize. This measurement is still commonly used to describe VR systems today. Goertz also made the fateful decision to cut the cables running from the teleoperator's control booth to the remote operator's arms, replacing this direct mechanical interface with a relay of electrical signals instead.[12] By opening up this gap, teleoperation expanded from the more direct physical

interfaces of mechanical engineering to become simultaneously a tele-communications medium.

Once the cables were cut, the distance between operator and operated-upon was limited only by the speed of electric signal transmission. Human gesture could effectively take place in two locations at once: initiated at one site but with its effects registered in another space entirely. Much like the telephone introduced the potential for nearly real-time bidirectional speech across long distances, teleoperator research aimed to extend other physical capacities: allowing hand and arm movements to be transposed immediately to a remote location while also allowing teleoperators to perceive and feel what happened on the other end of the line. Goertz's innovations were followed by a wide range of manipulators that achieved gradual increases in dexterity, lightness, and strength, including an early three-fingered hand from the Japanese Ministry of Communications' Electrotechnical Laboratory in the late 1970s.[13]

Not long after, the word *telepresence* emerged as a concept to describe what was transported here: physically embodied agency at a distance. The original Latin *praesentia*, appropriately, means "being at hand." Marvin Minsky, founder of the Artificial Intelligence Laboratory at the Massachusetts Institute of Technology (MIT), first introduced the term in a June 1980 article in the popular science magazine *OMNI*. The article outlines a scenario in the near future where lightweight jackets lined with sensors could be used to control a set of remote mechanical hands. "We could have a remote-controlled economy by the twenty-first century if we start planning now," Minsky speculates.[14]

Minsky's article extrapolates a vision of how telepresence could allow humans to work remotely in dangerous environments like nuclear reactors, under the ocean, and in outer space. He distinguishes telepresence from earlier teleoperator systems by emphasizing "the importance of high-quality sensory feedback," where the instruments "will feel and work so much like our own hands that we won't notice any significant difference."[15] Teleoperator researchers from the University of California at Los Angeles (UCLA) and the Naval Ocean Research Lab began to use the term in their published reports by that fall, and *telepresence* has since become the standard way to refer to teleoperator research in the United States.[16]

The period immediately following Minsky's article is also when Japanese teleoperator research begin to develop into a field of its own, beyond the Electrotechnical Laboratory's three-fingered hand. While Japanese researchers drew directly on developments in the United States, differences in the two countries' approaches reflected the larger research environment of each nation. As I explored in chapter 2, military projects played a decisive role in the development of both teleoperator and VR technologies in the United States, from nuclear research to flight simulators, along with projects connected to the NASA space program in the 1980s. Telepresence research in the United States continues to be shaped by these military missions, and teleoperator-controlled drone strikes by the U.S. military have emerged as a particular focus of critical academic attention in recent years.[17]

In contrast, Japanese research agendas have long had their horizons shaped by the war-renouncing framework set down in Article 9 of the postwar Japanese constitution, which limited Japan's direct participation in military conflict. Adherence to this restriction has weakened in recent years as the government gradually loosens guidelines on research with possible military applications. But in the 1980s and 1990s, this helped encourage telepresence engineers in Japan to focus on other rationales to guide and fund their research, such as applying telepresence toward goals of physical and social rehabilitation.

TELEPRESENCE AND TELEXISTENCE

Tachi Susumu's career in particular came to merge a rehabilitation focus with telepresence technologies. He first became interested in human augmentation via technology after he heard Norbert Weiner's *Cybernetics* read on Japanese radio and enrolled in the mathematical engineering program at the University of Tokyo in 1966.[18] His first project after receiving his PhD from the same institution was a robotic guide dog for the visually impaired, first proposed in 1975 and developed through the early 1980s. This led Tachi to a focus on human-machine systems for environmental navigation, including the need for "intelligent disobedience" on the part of the robot dog: the ability to disregard a human's

commands when it conflicted with what the dog's own environmental sensor technology was registering.[19]

With funding from the Japanese government, Tachi spent the 1979–1980 school year at MIT as a senior visiting scientist and developed his guide dog project under the guidance of Robert W. Mann. Mann's career trajectory was nearly a mirror image of Ishii Takemochi's (described in chapter 2). He started as a rocket scientist focused on new kinds of missiles but changed direction in the mid-1960s to focus on technology for augmenting human disabilities, which led him to develop the world's first biomedical prosthetics. Mann's lab was separate from the teleoperator research happening elsewhere in MIT's electrical engineering and computer science department at the time, including Minsky's telepresence work.

As Tachi recounts it, it was only after he returned to Tokyo that he was inspired to put the two research fields together under the rubric of what he would call *tele-existence* (*tereigujisutansu*), later contracted in English to the easier-to-pronounce *telexistence* around 1999. While Tachi appears to have been aware of Minsky's concept by the time of his first publications that introduce tele-existence in 1982, he claims the two terms were coined independently of one another and that he first conceived of tele-existence as he walked the halls of the University of Tokyo in the early autumn of 1980, a few months after his return from Massachusetts.[20] While *telepresence* went on to become the standard term for subsequent teleoperator research in the United States, under Tachi's influence, *telexistence* became a familiar concept within the Japanese robotics community.

According to Tachi, the two words refer to essentially the same idea. But while telepresence has tended to focus on teleoperated robots in real-world locations, often positioned in contrast to VR's focus on computer-generated worlds, telexistence can target either real or virtual spaces (or some mixture of the two), combining the two fields. While many products sold as telepresence robots today focus primarily on the robot's role at the worksite, without much concern for the operator's subjective sense of immersion in the device, telexistence research has tended to focus on providing an immersive perceptual interface for the teleworker. Rather confusingly, then, telepresence often prioritizes making it feel like the robot is really there for others on-site (what Tachi calls a "feeling of existence" or *sonzaikan*), while telexistence is more

interested in providing a highly embodied "feeling of presence" (*rin-jōkan*) for the robot operator as they perceive the space they are tele-working within.[21]

This early focus on creating a "feeling of presence" for the teleop-erator led Tachi to incorporate the stereoscopic (three-dimensional) head-mounted display early on as a key part of his more perceptually immersive robot interface. At the time, most telepresence research was focused on the hands, with only rudimentary attention to audiovisual perception. For example, Minsky's 1980 article describes a basic head-mounted display built by an engineer in Philadelphia consisting of a TV camera on top of a building that moved in tandem with a remote opera-tor's helmet, with the two-dimensional video feed visible to the operator through an attached screen. In Tachi's first papers introducing tele-exis-tence, he argues for how a stereoscopic head-mounted display would be superior to the then-common "wave front" visual reconstruction tech-niques for telerobot operation, citing Ivan Sutherland's work from the 1960s but substituting a real-world remote camera feed for Sutherland's virtual wireframe shapes.[22]

Tachi describes his early epiphany walking the halls of the University of Tokyo in the fall of 1980 as centered explicitly on the idea of using a stereoscopic display to enclose a human operator perceptually within a robot's perspective:

> I was suddenly reminded that all of human vision is just based on two images projected on our retinas, and we build the 3-D world by moving our heads and exploring the world. So if we replace that with a virtual image, what we experience is a kind of virtual world. Since we perceive the environment through sensors and reconstruct the world in our brains, if we gather that information from a robot and present it to the human, we can live through the experience of being embodied within the robot, existing in its specific environment.[23]

Prior systems allowed teleoperators to see their own hands and arms while at the controls. Tachi's tele-existence design instead positioned the worker within a larger control capsule, individually enclosing the work-er's head and directly interfacing with their hands and feet to mediate their audio, visual, and tactile perception of a remote environment more

コントロール・カプセル（統制装置）

FIGURE 3.1 Tachi Susumu's proposed tele-existence control capsule in 1982. Detail from an illustration in Tachi Susumu and Komoriya Kiyoshi, "Dai 3-sedai robotto," 56.

directly. A worker's perceptions would thus be more tightly synchronized with the robot's (figure 3.1). When the operator looked down, they saw the robot's arms in place of their own—what VR researcher Mel Slater would later call the "body ownership illusion."[24] Tachi's focus on producing a sense of presence through a head- and body-mounted enclosure was VR in all but name and, as noted in chapter 2, he adopted the term as another way to describe his research following Lanier's popularization of the phrase.

THE TELEXISTENCE SOCIETY

Tachi's tele-existence control capsule became the central premise for an eight-year national project, Advanced Robot Technology in Hazardous Environments, launched by the Japanese Ministry of International Trade and Industry (MITI) and running from 1983 to 1991. Tachi at this point was employed by the Japanese government as director of the Biorobotics Division at MITI's Mechanical Engineering Laboratory. His team presented their work as heralding the arrival of the third-generation robot, moving on from the preprogrammed sequences of first-generation industrial robots and the limited two-dimensional sensor technologies of the second generation. Operator immersion in head-mounted audio, visual, and tactile interfaces was a key part of the new proposal. While the MITI project's charge was to create robots for use in dangerous environments like nuclear reactors, outer space, and under the ocean (echoing the American telepresence focus), Tachi's team proposed the use of tele-existence in a range of other workplace and everyday settings as well: cleaning, civil engineering projects, agriculture, policing, expeditions, leisure pursuits, test piloting, and test driving.[25] MITI promised a future society "where everyone can freely telexist anywhere."[26]

Subsequent projects shifted even further away from the initial focus on environments inhospitable to humans. As researchers attempted to scale up their projects to a larger social level, research goals focused more and more on offering solutions to the challenges posed by Japan's aging and shrinking population. This pattern is clearly visible by the time of the fourth-generation national Japanese robotics initiative that began in the late 1990s, which aimed squarely at creating a "human-friendly and supportive robot."[27] Tachi's role in this project was to design an interface for teleworker robot control to be paired with and compliment more autonomous robot designs.[28]

Just how much the focus of telerobotics had shifted away from dangerous environments and toward more everyday settings is immediately clear from the start of the project outline:

Japan's population is aging rapidly, and people are having fewer children. This means that efficient and human-friendly machinery that can support daily life and the activities of humans, such as attending to the

elderly and the handicapped, is in great demand. Thus, this project aims to develop a safe and reliable human friendly robot system capable of carrying out complicated tasks and supporting humans within the sphere of human lives and activities. Through development of such a system, this project will contribute towards improvement in efficiency and safety in industry, making society and the living environment more convenient and comfortable, and towards the creation of new industries in the manufacturing and service sectors.[29]

The project sets out with a focus on supporting daily life for seniors and people with disabilities but quickly situates this humanitarian push within broader economic goals of increased efficiency and the creation of new manufacturing and service industries. This contextual drift toward broader economic concerns is key for understanding how telepresence research came to be shaped by the larger pressures of Japan's changing demographics.

It was not as if Japan had a lack of dangerous scenarios where telepresence robots might be of use. In fact, it was considered a major domestic failure when, faced with the need to check inside the damaged nuclear reactors at Tokyo Electric Power Company's Fukushima Daiichi plant in 2011, Japanese teleoperator and robotics researchers were not ready with a homegrown technological solution, and borrowed American robots were sent in instead.[30] By this time, however, Japanese telepresence research had drifted far from the field's initial focus on environments that humans could not otherwise access.

By the end of the 1990s, Japanese teleworker robots were positioned less as disaster-relief tools and more as a way to relieve the burden on care workers looking after the elderly or the sick. In effect, individuals in need of care due to age or illness came to constitute the "dangerous" environments in which telepresence robots would operate. A further shift occurred as Japan moved into the 2010s, buoyed in recent years by the reemergence of popular interest in VR. By this time, the broader implications of Japan's labor shortage were becoming more apparent far beyond the fields of nursing and elderly care. A more general labor shortage emerged across a wide range of industries, particularly in service positions and in fields reliant on physical labor. This led to a further transformation in how researchers imagined a future "telexistence society" would

function. Telexistence engineers in the late 1990s imagined sending robots out to work *on* the elderly and infirm; however, these same populations would now be called upon to become teleworkers themselves.

In some ways, this transposition returned telexistence research to Tachi's original focus on disability augmentation, in line with his robotic seeing eye dog for the blind. However, the focus now was no longer on enabling people with disabilities to walk the streets safely, but on rehabilitating the economic productivity of these same individuals, recasting them as an underutilized workforce. David T. Mitchell and Sharon L. Snyder's *Biopolitics of Disability* captures the neoliberal logic behind this kind of transformation, noting the rise of "inclusive techniques that have less to do with a more expansive tolerance toward formerly deviant citizens than the appropriation of disability as an opportunity for expansion at the consumption end of late capitalist marketplaces"—or in Japan's case, at the production end as well.[31]

The public-facing promise was still one of personal freedom, of increased agency and mobility for those who might otherwise find their social participation restricted. But the deeper economic rationale was to provide a technological solution to the increasingly desperate search for human workers. The implicit premise was that telexistence would open up a narrow path for the otherwise immobilized to provide their services remotely, while leaving the more socially unwelcome parts of the worker behind. In effect, everyday Japanese society was now positioned as the "dangerous" environment in which these new teleoperators would perform their work.

VISIONS OF A TELEPRESENT WORKFORCE

This premise is clear in two recent proposals to enable new populations of VR telerobot workers, which this section will describe in turn. Tachi is now attempting to transform his telexistence research into a commercial venture, building on his now several decades of work on what he calls the TELESAR (short for Telexistence Surrogate Anthropomorphic Robot). In 2017, the venture-backed start-up Telexistence Inc. was spun out of Tachi's lab with the collaboration of the University of Tokyo and Keio University.

The company's main objective is to turn Tachi's TELESAR into an off-the-shelf technology, the Model H, based on a concept where users purchase one of their suitcase-based VR "cockpit" systems (with an HTC Vive headset and haptic gloves) and use it to access a fleet of remote robot bodies on call in various remote locations.

A promotional video for the company imagines Model H put to use as a kind of bonding exercise for what appears to be an affluent White father and his son. They smile in wonder as they use VR headsets to teleoperate Model H units in varied sites on and off the planet. The video shows the Model H in outer space (gesturing toward the older telepresence focus on inhospitable environments), but otherwise focuses on more mundane tourist activities as the robots shop for surfboards in Hawaii and view cherry blossoms in Kyoto (figure 3.2). The "beyond presence" slogan that appears at the end of the video even makes a subtle dig at Minsky's original term. The advertisement presents the Model H system as an upscale leisure product; however, Tachi's website specifically highlights people with disabilities and the elderly as potential users.[32]

Telexistence Inc.'s most recent project is a pilot program with the major Japanese convenience store chain FamilyMart that uses their telerobot workers to restock shelves. The project currently aims to have robots at twenty stores in Tokyo, with a goal to expand the program to all branches throughout Japan if this initial rollout is successful.[33] This effort comes at a time when convenience stores frequently have difficulties finding staff and are increasingly reliant on immigrant workers.[34]

Japan's ever-growing senior population is also the focus of a 2016 trade paperback by Hirose Michitaka (as noted in chapter 2, the other main figure in Japanese academic VR research in the 1990s). The book carries the unwieldy title *Izure oite iku bokutachi o 100-nen katsuyaku saseru tame no sentan VR gaido* (Guide to the latest VR for making we who will get old anyway active for 100 years). The main premise is that VR telepresence technologies will rejuvenate the Japanese workforce by allowing the elderly to continue to work well past retirement age, into their nineties and beyond. VR, Hirose promises, will allow the bedridden to continue to work by swapping their own compromised physicality for a more powerful robot body.

Even if individual seniors may not have the physical capacity to hold down a full-time telework position, Hirose envisions a way to mix and

FIGURE 3.2 Using VR headsets (a) to view cherry blossoms in Kyoto through Model H telerobots (a). Screen captures from the Telexistence Inc. promotional video *Telexistence Model H Unveil*, available at https://youtu.be/KooT67zqjpI.

match scraps of the elderly's remaining capacity as laborers to stitch together what he calls "mosaic work" (*mozaiku shūrō*) solutions. He describes a system where different seniors could combine their skills, energy levels, and physical abilities in a flexible job-share telepresence platform he calls the "senior cloud" (*kōreisha kuraudo*). Hirose imagines

the platform could allow several teleworking seniors with complimentary skill sets to replace one able-bodied worker.[35] By consolidating whatever productive potential remains among the elderly, he promises the system could alleviate the labor crunch and relieve the burden on those remaining Japanese still within regular working age.

THE FACELESS WORKER

The individual freedoms promised by these telepresence platforms come with very specific limitations. Unlike most telepresence systems produced outside Japan, Telexistence Inc.'s robots do not include a screen showing the operator's face. Instead, the robots' appearance is determined by their own plastic heads, arms, and bodies. The designs are generally humanoid in shape, but they are deliberately nondescript and vaguely alien in appearance.

The invisibility of the operator here is in stark contrast to Tachi's earlier telexistence projects of the 1980s and 1990s, when he was adamant that the visibility of the operator's face (even if just as a crude projection onto the robot's head) was crucial for enabling an ethical relationship between the teleoperator and the people they encountered via the robot. Describing this as a principle of *anti-anonymity*, Tachi wrote, "it is unnecessary to discuss how dangerous it would be without a system which enables the visibility of the user."[36] Yet this is exactly the approach adopted by these later systems as they shift to focus on providing a socially acceptable feeling of the robot's "existence" (*sonzaikan*) for the customer on the other end.

In his essay "Machines with Faces," digital communications theorist Daniel Black argues that a robot face severed from its role as an intersubjective interface between two people should not be considered a face at all: "Two camera lenses positioned like eyes on the 'head' of a robot are not a face; a face is an endlessly mobile, dynamic entity animated by a reciprocity between living bodies."[37] Black grounds this argument in human developmental psychology, where experiments reveal four-month-old babies will enthusiastically engage with a live video of their mother's face, but this interest quickly fades if the video falls out of sync and the mother's face becomes unresponsive to its own. In other words, a face is only

fully a face when it enables the bidirectional sharing of emotion. "Facial-ity requires reciprocity: to see another's expressions while that other sees your own so that their affective charge can be shared . . . Looking into the face is so crucial that when [others'] faces are not visible, it seems that other people simply aren't there."[38]

Echoing Tachi's warning about teleworker anonymity, Black argues that, while humans are certainly capable of inflicting harm upon one another *despite* the reciprocity of the face, in historical moments of great human-to-human cruelty we often find "a need to actively neutralize the power of faces in order to facilitate the prosecution of violent acts."[39] Black speculates that the spread of autonomous robots with more humanlike, responsive faces would not condition humans to treat robots *more* like humans because they would always know they are on some level not sen-tient. He argues the more likely outcome is that people would continue mistreating robots *despite* their humanlike appearance, which might ulti-mately desensitize them to violence inflicted on actual humans as well. Black proposes one cause of the now well-documented history of robot abuse by humans is "perhaps the fact that we know the robot's human-like behavior to be a fraud; when it invokes the kind of consideration due to a real person, we aggressively act out its exclusion from the sphere of human personhood."[40]

What happens then when robots are teleoperated by someone known to be human, but who is effectively effaced by the interface itself? Black doesn't consider telepresence as part of his thought experiment, but it would seem to fall under what he describes as a state of "partial faciality," where some but not all of the reciprocity of a fully responsive human face is present. Black's example of partial faciality is a dog's face, capable of some degree of emotional reciprocity with humans but not nearly to the same degree. The underlying ableism of his argument quickly comes to the fore if we include individuals with facial paralysis caused by ALS or other conditions, which under this rubric can only be less than human. It is important here to resist the positioning of "partial faciality" as a *lesser* faciality, because that can only privilege the able-bodied and immediately present, downplaying the already central role of facial mediation in dis-tant visual communication media of all kinds.

I suggest the more important issue here is how VR telerobot plat-forms introduce a third party to the intimate reciprocity of face-to-face

communication: the telepresence platform provider. The intrusion of this third party into the face-to-face encounter is distilled most clearly in the 2017 Faceshare project from Hirose's lab at the University of Tokyo. The project aims to remediate facial expressions in real time on both ends of a live video link, so that a person who was not physically smiling would still appear to be doing so to the observer on the other end of the line. The project's creators promote the retail potential of a system that shifts demands for emotional labor away from employees and instead relies on an automated (and ideally seamless and invisible) expressive algorithm. Hirose even envisions Faceshare remediating a customer's perception of their own face. For example, a person might be more likely to purchase a piece of clothing if, after trying it on, they look at themselves in a Faceshare-enabled mirror and are greeted by a reflection of their own face smiling a little bit bigger than they actually are.[41]

This kind of opportunity for ambient perceptual manipulation is present across these telerobot platform proposals. While promoted as a way to empower otherwise immobile teleworkers with a means of greater social participation, arguably it is the platform owners, much more than the workers themselves, who gain control over the social interface. While Tachi has focused on more fully embodied mobility technologies in the past, the telepresence robots do little in themselves to make public spaces more physically accessible or socially accommodating for disabled bodies. By promising increased worker mobility even as it stands in the way of a more equitable society, VR telework exemplifies what sociologist Ruha Benjamin describes as technologies that offer "pragmatic inclusion in place of political and social transformation."[42] If anything, these proposals suggest public spaces should be designed around supporting *robot* presence rather than making spaces accessible to a wider range of humans.

IMPERATIVES FOR PRODUCTIVITY

The telerobot platforms' erasure of visible disability is paired with a strong message that *work* is the only path toward a meaningful social existence, what disability studies scholar Aimi Hamraie describes as an "imperative for productivity," which is often cited as a rationale for bringing "all"

citizens into the economic fold despite ongoing forms of spatial segregation targeting people with disabilities or from other marginalized groups.[43] In Tachi's imagined telexistence society, the elderly and people with disabilities would not only be expected to contribute to society through telework employment—no matter their condition—but also to use the robots to provide for their own physical care. This would fold the telepresence circuit back on itself to position the socially excluded as both the teleoperator *and* the dangerous environment to be operated upon. It would also, Tachi implies, relieve the rest of society from the need to attend to these individuals at all.[44]

Tachi's most recent vision of a future telexistence society echoes Hirose's call for enabling seniors and persons with disabilities to keep working, but he includes two other populations of would-be teleworkers as well (figure 3.3). The first consists of parents who work from home while raising children. In Tachi's illustrations, this stay-at-home parent is always pictured as female and somehow manages to look after young children while enclosed within the VR headset. Second, Tachi proposes his VR system could employ overseas workers at low cost through cross-border intercontinental telework. By doing so, he argues, Japanese factories and worksites could leverage time-zone differences to stay in operation twenty-four hours a day through interlocking work schedules. The illustration in figure 3.3 envisions three eight- to nine-hour shifts shared between

FIGURE 3.3 Teleworkers in Tachi Susumu's future telexistence society. Top left: stay-at-home parent; bottom left: seniors and persons with disabilities; bottom right: overseas workers in Nigeria and Mexico. From Tachi Susumu, "Aratana hatarakikata, ikikata, shakai no arikata no jitsugen ni mukete tereigujisutansu no shakai jissō o," *Sangakukan ronkoi jānaru* 14, no. 12 (December 2018): 30.

workers in Nigeria, Japan, and Mexico. The cheaper wages in the foreign teleworkers' home countries would keep costs down, even as the workers contributed directly to sustaining Japan's domestic productivity.

Overseas VR telework promises a way for Japanese employers to extract physical labor not only from the dwindling number of Japanese citizens, but also from foreign nationals otherwise excluded from the workforce by national borders and immigration law. This is a direct extension of the earlier cross-border telework and outsourcing strategies of the 1980s and 1990s based around phones and computers, extended now from that largely white-collar context to the blue-collar realms of manual labor and service industry jobs. The premise here is to teleport only the worker's laboring "presence" while leaving the rest of their social and physical identity—including things like their citizenship status, health care, and legal rights—for their home country to deal with.

In a revealing aside during a keynote I heard him deliver at the Digital Content Expo in Chiba, Japan, in November 2018, Tachi promoted cross-border VR telework as a way to allow Japan access to foreign labor while avoiding the "problems" (*mondai*) of direct immigration.[45] This vague reference to immigrants as "problems" echoes a recurring theme anthropologist Jennifer Robertson has identified in Japanese robotics more generally: a preference for robotic solutions to the labor shortage as a less culturally threatening (and more politically palatable) alternative to dramatically increasing the number of foreign workers in Japan.[46] While the ruling Liberal Democratic Party recently pushed a controversial immigration reform bill through the Japanese legislature—set to increase the number of lower- and medium-skilled work visas by 345,000 over the next five years—the changes still fall far short of fully addressing the labor shortage. In the meantime, existing programs to provide foreign labor on a more short-term basis, such as the Technical Intern Training Program, have been notoriously vulnerable to employee abuse and exploitation.[47]

Tachi's proposed system would instead selectively transmit VR telepresence across the network, keeping foreign workers' physically out of sight and behind closed borders. As Benjamin emphasizes in her work on technologies of anti-Blackness in the U.S. context, racism here functions not just as an output of biased systems but also as an input, "part of the social context of design processes" that drive technology development.[48] One characteristic way this plays out in the Japanese context is the use of

technology as a tool of perceptual erasure, enforcing a racial and physical "odorlessness" upon the foreign worker as the cost of social participation.

Sociologist Koichi Iwabuchi's frequently cited notion of "cultural odorlessness" usually describes the deliberate erasure of cultural signifiers present in Japanese audiovisual merchandise bound for export to other countries, like the physical form of the Walkman or the narrative content of anime series.[49] Yet these "odorless" strategies regularly attempt to erase signs of difference in the opposite direction as well. If, as Iwabuchi writes, "Japanese media industries seem to think that the suppression of Japanese cultural odor is imperative if they are to make inroads into international markets," it would be surprising if they did not apply the same logic to foreign *imports* as well.[50] Much like how some Japanese schools force students to dye or straighten their hair to match a "standard" physical appearance, or how anime and manga can work to redraw foreign bodies into a more familiar and caricatured form, the telework robot interface serves as a deodorizing technology that enables social participation only after the careful erasure of unwanted perceptual difference.[51]

HUMAN WORK WITHOUT HUMAN WORKERS

The power relationships inherent in these platforms ensure that remote workers remain highly dependent not only on those physically present at the worksite but also on whoever controls the telepresence platforms. As Oliver Grau writes, for telepresence, the decisive questions are "who controls the channels, who distributes rights of access, and who exercises economic and political authority over the networks."[52] The virtual mobility of the teleworker extends only as far as the labor market allows, and it can be unilaterally revoked at any time. While telework proposals promise new freedoms for those employed, in practice, it is employers who are the most liberated by the arrangement. Embodied telework risks extending the social erasure of the elderly and people with disabilities, and the further effacement of the foreign workers keeping the service and manufacturing industries of countries like Japan afloat.

For a preview of what this might look like on a larger scale, we can turn to existing digital microwork platforms like Amazon's Mechanical

Turk. The median hourly wage on Mechanical Turk is around $2 USD an hour. This comes with few opportunities for promotion or skills development, a risk of repetitive strain injuries and eye problems from long working hours, the ability for employers to hire and fire workers easily and at whim, and limited employee recourse when it comes to conflict resolution or the negotiation of better working conditions. Many workers on these platforms come from the world's poorest countries, and their labor helps sustain the economic productivity of the richest ones.[53] VR robot telework extends these precarious and often neocolonial labor relations far beyond the screen, incorporating and exposing workers' laboring bodies even as it encloses and limits their perceptual horizons.

Embodied telework also intersects in complex ways with ongoing debates around the world over immigrant labor and cross-border migration. Alex Rivera's prescient 2008 science fiction film *Sleep Dealer* provides one dystopian vision for how embodied telework might interweave with existing border politics. Rivera imagines a future where Tijuana factories use VR-enabled telework systems to allow workers in Mexico to perform construction work and other physical labor in the United States without being physically present. As one Mexican robot teleoperator in the film trenchantly puts it, "We give the United States what they always wanted: all the work, without the workers."

In the meantime, these telepresence proposals do little to address existing social triggers for the population decline in Japan, such as the high cost of child-rearing and increasing levels of poverty and inequality. The cognitive side of the disability spectrum is also conspicuously absent—a particularly glaring omission considering that the Japanese Ministry of Health predicts the population of seniors in Japan with dementia will reach 7 million by 2025, or one out of five people aged sixty-five or over.[54] The telepresence proposals for remote-controlled work also have remarkably little to say about the physical and psychological effects of spending long working hours perceptually displaced inside a telerobot enclosure.

Tachi promotes telerobotics as a more human alternative to full-scale automation, even as he plays up the technology's advantages over on-site human labor and increased immigration.[55] Despite this premise of telerobots as a more human-centered alternative to artificial intelligence, VR teleoperators will most likely work in tandem with automation efforts that target these same jobs. The most economically plausible scenario is

a blend of the two approaches, relying on automated systems for most tasks while falling back on remote human operators for roles where a live human still has the advantage. This already happens in existing online teleworker platforms like Mechanical Turk, where piecemeal human labor often provides a kind of stopgap intelligence to make up for full-scale automation when it still falls short.

Data generated by the human operators can also be used to train later autonomous replacements, an explicit aim of telepresence robots like Toyota's T-HR3. Generating autonomous teleworker "clones" has been a key objective of teleworker systems going back to Tachi's original third-generation robotics concept, which described how a human in a control capsule (figure 3.1) could switch between direct "telexistence mode" and a more supervisory role over a squadron of semiautonomous robots, all the while building up the system's "knowledge base" (*chishiki bēsu*) for future projects.[56] The long-term goal for the FamilyMart project is similarly to train the robots via the teleworker's movements so that they can eventually operate autonomously across stores and potentially save the company even more on labor costs.[57] Tachi speculates such behavioral recording could one day mean that "even after a person passed away, the person can exist for a long time in the form of his/her telexistence avatar robot," potentially enabling the person's (now fully privatized) laboring presence to continue working even beyond the grave.[58]

Lev Manovich has described VR as a process of "immobilization" that "probably represents the last act in the long history of the body's imprisonment" by media technologies.[59] Japan's VR telework engineers seem almost to relish the possibility. In his *Telexistence* book, Tachi envisions a future scenario where society has become so robotic that much of the outside world is dangerous for an unprotected human body, leading most people to stay indoors. Future humans may still want to participate in activities outside the home that have been taken over by robots, but "in practice," Tachi writes, "working in the same location as robots and machines is extremely dangerous." In this scenario, robotic telepresence "provides a method by which a person's desire to be involved in activities performed by robots and machines may be satisfied in a manner that does not infringe upon safety and social considerations."[60]

Telepresence's original goal of human operation in dangerous environments here comes full circle: as telepresence becomes the default, physical

movement beyond the home becomes inhospitable to more and more human bodies, accessible only by means of the telepresence platform. While Tachi seeks to assure his audience that "research into virtual reality and tele-existence is an attempt to release the user from spatial restrictions," his future speculations hint at the opposite outcome.[61] The entire population becomes technologically housebound, reliant on the telepresence enclosure to be "present" anywhere at all. While Tachi promises to center the experience of the human operator, this is quickly revealed as but one step toward a broader posthuman future, built off the data of those who may have had little choice but to surrender their embodied labor to the platform.

The infrastructure for an embodied teleoperator workforce is already emerging through the confluence of VR, robotics, and higher bandwidth 5G networks. At the individual level, these platforms may open up welcome new opportunities for those without other avenues for social participation and physical mobility. More ethnographic research with telerobot operators is certainly needed, along with a deeper engagement with perspectives from the fields of disability studies and aging studies than I have been able to provide here.[62]

From a broader population-level perspective, however, it seems clear one major effect of these platforms will be to shift the burden of sustaining society further onto those still not fully welcome within it, relieving socially dominant groups of the need to incorporate or accommodate these communities more fully. The telepresence enclosure forecloses ways these groups might otherwise contribute to the transformation and renewal of social space, what Mitchell and Snyder describe as "the creative ways in which lives experienced within differential bodies transform the environments of which they are a part."[63] This kind of creatively transformed space might well involve VR and other telepresence technologies—this is not an argument for rejecting all forms of mediated interaction. But a more livable and just platform for VR telework will need to be driven by principles other than labor extraction and enclosure.

The biggest social risk of the VR headset is how it opens up a perceptual gap right where bodies become present in the world, allowing outside parties to move in and establish control. Current visions for VR telework risk consolidating private ownership—whether from Facebook or others—over the media platforms governing not just online communication but

how people perceive the space around them, who is rendered as physically present, and in what form. VR telepresence is on track to develop into a more fully embodied and perceptually intrusive version of what internet scholar Safiya Umoja Noble calls "technological redlining," or the way algorithmic systems can intensify already existing spatial and social inequalities.[64] The more VR becomes a practical substitute for in-person social presence, the more existing infrastructure for human movement may be neglected, accruing even more power to whoever controls the digital pathways on which presence is now made to travel. Before VR telework becomes firmly established, it is incumbent upon all those involved to take a close look at whose interests are served in the shift to remotely embodied work and to theorize more carefully about what it means to be "present" within this space of perceptual enclosure.

4

IMMERSIVE ANXIETIES IN THE VR *ISEKAI*

To compliment the engineering focus of the first three chapters, the rest of this book focuses on what popular culture discourses both in and around virtual reality (VR) further reveal about the cultural politics of perceptual enclosure. This chapter maps out transformations in the Japanese imagination of VR technologies taking place from the late 1980s to the early 2010s. Attitudes and affects triggered in response to VR have changed dramatically across the last four decades. There is a shift from an early fear of VR's ability to offer threatening counterfeit realities to an embrace of the headset as a means of escape into alternative, dehistoricized worlds. Rooted in the *kasō genjitsu* approach I introduced in chapter 2, the popular imagination now understands the headset as a portal into what is known in Japanese as the *isekai* or "other world" fantasy. As Japan's fictional VR narratives make clear, the technology comes to merge a long linage of first-person fantasy immersion in other media with the more literal perceptual enclosure offered by the headset itself.

Tracing this shift in the popular VR imagination demands looking beyond a strict technology history to the narrative fictions that both respond to and deeply inform VR engineering and software development. Academics focused on the English-language context have examined the key role of William Gibson's *Neuromancer* and other English-language science fiction.[1] Engineers in Japan have similarly written at length of the influence of science fiction on their work.[2] Challenging this focus

on science fiction as the primary VR genre, I show how, in Japan, VR is deeply in dialogue with other genres like mystery writing and, above all, the quest narratives of fantasy literature and role-playing games (RPGs).

These narratives demonstrate how the mediated perceptual enclosures emerging in the late twentieth century were never determined by technological developments alone but were, at every stage, closely intertwined with broader transformations in the Japanese social and historical imagination. VR emerged as a marketable idea in part through the increasing centrality of the one-person space (as discussed in chapter 1), but this transformation in the built environment must in turn be understood in the context of a popular culture increasingly premised on the perceptual bracketing out of existing social spaces in favor of more fully immersive fictional worlds.

STUCK IN THE BOTTLE

Before this embrace of virtual fantasy, however, VR was understood as a manipulative threat. The earliest Japanese narratives about VR are not just suspicious of the technology as an alternative to reality but wary about interactive, immersive games as a challenge to the existing media industries. This dynamic is clear in the hit 1989 mystery novel *Kurain no tsubo* (Klein bottle), likely the first Japanese story to thematize VR technologies explicitly (figure 4.1). The novel is by Inoue Izumi and Tokuyama Junichi, who wrote as a pair under the name Okajima Futari.[3] *Klein Bottle* doesn't use the term *virtual reality*, which had barely begun to circulate even in the United States when the book was first published. But the novel is clearly inspired by the headset and glove-based immersive interfaces developed by Jaron Lanier and others throughout the 1980s.[4]

The narrative centers on a top-secret immersive gaming device under development by an American company for deployment in Japanese game arcades. The story begins when the narrator, a game scenario writer, answers a job advertisement to be a play tester for a new kind of arcade game. On showing up for the interview, he finds himself at a strangely isolated warehouse in Mizonokuchi, not far from Shibuya in southwestern Tokyo. He is loaded into a van with blacked-out windows and driven

FIGURE 4.1 Fujita Shinsaku's M. C. Escher–esque cover for Okajima Futari, *Kurain no tsubo* (Klein bottle, 1989).

to an unspecified location where the actual research is said to take place. After the game designers calibrate his touch and vision through a Data-Glove-style hand interface and a head-mounted display, he is invited into a special room to try the new system.

To enter the game, a player must take off all their clothes and climb onto a concave platform, at which point a symmetrical lid hinges down to enclose the player fully inside. The interior of the capsule then fills with a gel-like substance that surrounds the player's body and mediates their perceptual awareness. A mainframe computer in an adjacent room feeds a complete sensory rendition of a virtual world to the gel-filled capsule—so complete that the player is unable to distinguish it from a real environment. The whole system is code-named *Klein Bottle* 2, or KB2 for short.

The programmed world the play tester finds himself in is ostensibly a highly immersive *Indiana Jones*–style adventure game set in colonial Africa. The play tester becomes suspicious about the real motives behind the project, however, after he hears a strange voice from inside the game warning him about the dangers of the system. On his day off he sneaks back into the Mizonokuchi offices, only to discover the headquarters he thought he had been infiltrating is itself part of the virtual world. The play tester (and the book's readers) were made to assume he had been back in the "real world" of Tokyo, but this plot twist reveals he had still been inside the KB2 the entire time, with the game's designers observing his every move.

This precipitates what eventually becomes a psychotic break for the play tester. He becomes paranoid that he is still within the simulation, no matter how realistic he finds the Japan he perceives all around him. Readers are also given few clues to determine which is which. In a parallel plot twist nodding to anxieties about VR's military origins in the United States, the play tester also discovers that KB2 is in fact a secret weapon under development by the Pentagon and tested on unsuspecting Japanese subjects. The book ends on a bleak note, with the protagonist driven to suicide as a last-ditch attempt to uncover whether the reality he perceives all around him is real or virtual.

Inoue, who first came up with the plot, originally intended to call the novel *Kapusuru* ("capsule"), in reference to the pill shape of the book's imagined interface enclosure. This name brings out the druglike aspects of what the novel situates as the dangerous brainwashing potential of a

fully immersive interface.[5] The alternate name *Klein Bottle* was proposed by Okajima Futari's editor at Shinchōsha Publishing, Miyabe Hisashi, who noted that the novel's premise of a machine that eliminates the boundary between inside and outside sounded much like the topological figure of the Klein bottle (figure 4.2).[6]

Miyabe may have become acquainted with the Klein bottle through its prominent place in philosopher Asada Akira's surprise 1983 best seller *Kōzō to chikara* (Structure and power). There, Asada deploys the Klein bottle as a figure for how modern capitalism renders any point transferable with any other through the leveling force of commerce.[7] But while Okajima Futari followed their editor's advice in adopting *Klein Bottle* as the name for their fictional device, the novel's warning about the blurring of real and virtual feels closer to the work of Jean Baudrillard. In his later work on the mediation of the first Iraq war, Baudrillard similarly uses the figure of the Klein bottle to describe a process of enclosure within mediated realities: "This convolution of things that operate in a loop, that connect back round to themselves like a Klein bottle, that fold back into themselves. Perfect reality, in the sense that everything is verified by adherence to, by confusion with, its own image."[8]

Okajima Futari tie this topological figure directly to the power of computational simulation to collapse the distinction between everyday reality and computer-generated space, raising a Baudrillard-like warning of an America-built virtual simulacra substituting for the real. The novel presents VR as a technological instantiation of the Klein bottle itself: a machine to place both reality and virtual reality on a single contiguous surface that has no inside or outside. Along with the reference to the United States via the Pentagon, they link this immersive electronic threat specifically to video games, likely influenced by the then-recent blockbuster success of *Dragon Quest II* (Chunsoft, 1987) in the Japanese market. Unlike Asada's highly abstract image of 1980s Japan, the Tokyo presented in the novel consists of a far more banal landscape of tangled train lines and aging single-occupant apartments, punctuated only by the occasional visit to a stylish coffee shop in Shibuya. Amid this decay, it is interactive media—and video games in particular—that seem to threaten the authority of the real.

By making the protagonist a writer who has his narrative grasp on reality broken by computer programmers and their powerful new machines,

FIGURE 4.2 A Klein bottle. Illustration from Tttrung at Wikipedia.
https://en.wikipedia.org/wiki/Klein_bottle#/media/File:Klein_bottle.svg

Okajima Futari reveal an anxiety toward the apparent shift in Japan's media environment underway at the time: a move away from the authority of the written word and toward the powerful perceptual manipulations offered by the dawning era of "new media" machines.[9] This was an early hint of the shifts afoot in Japan's media industries as interactive, computational media became more central to the everyday perceptual landscape. The novel gives a palpable sense of the contemporary immersive anxieties over whether humans would lose control to computers, with VR positioned as the epitome of this perceptual threat.

ROLE-PLAYING IN THE MEDIA ENCLOSURE

Klein Bottle's worries over the collapse of the real into the virtual were likely also thrown into relief against the backdrop of the contemporaneous media panic around Miyazaki Tsutomu, a twenty-six-year-old man from western Tokyo who murdered four girls ages four to seven and mutilated their bodies, including having sex with one of the corpses and drinking its blood. Miyazaki taunted the media and his victims' families for almost a year before his arrest in June 1989. Afterward, widely circulated photographs of the apartment where he had kept the bodies showed a room stacked high with piles of VHS horror films, anime, and adult manga—a grotesque variation on the personal "media cockpit" described in chapter 1. While a photojournalist apparently staged the piles of adult manga and anime to appear more numerous than they actually were, this was enough to lead to a moral panic in the Japanese press, who dubbed Miyazaki the "otaku killer." Focus shifted to the possible influence of fictional fantasy media on his delusional crimes.[10] In the aftermath, animation director Miyazaki Hayao and novelist Murakami Ryū would discuss the need for media-obsessed otaku to "escape from their closed rooms" (*misshitsu kara no dasshutsu*), while media scholar Yoshimi Shunya argued that, for the killer, "the sense of reality, or the reality of killing, was already virtual."[11] Much like the protagonist in *Klein Bottle*, media commentators worried individuals were becoming unable to distinguish between fiction and reality—without the need for anything as sophisticated as the *KB2* interface.[12]

Whereas Baudrillard would later focus his theory of simulacra on built environments like Disneyland and American news media coverage of overseas wars, in Japan, these immersive anxieties circulated more specifically around the "closed rooms" of individuals surrounded by their personal media.[13] This extended earlier anxieties over headphone listening, the Walkman, and other personal media technologies from a decade prior (as discussed in chapter 1). It also strongly echoed early 1970s American paranoia over Dungeons & Dragons players hidden away in their basement acting out "occult" practices.[14] This intertwining of fantasy role play with the virtual media enclosure would become increasingly central to the VR imagination in subsequent decades.

If VR in the United States emerges through a West Coast countercultural rebranding of earlier military technologies, in Japan VR as *kasō genjitsu* is tied more directly to the rising popularity of fantasy narratives and RPGs. In the 1970s and 1980s, these fictional worlds become figured as a refuge from political concerns and economic struggles. Sociologist Mita Munesuke describes the period starting in the mid-1970s as an age where "reality" becomes opposed to "fiction," part of a turn away from both the materialism of the high-growth years and the political revolutions promised by the student movements of the time. These ambitions fell apart after the collapse of the leftist movements in the early 1970s and the slowdown of the economy following the 1973 oil shock, to be replaced, Mita argues, by the more durable fantasies offered by a burgeoning consumer media culture.[15]

Building on Mita's model, sociologist Miyadai Shinji notes a bifurcation in 1980s Japanese subcultures between, on one side, a "*nampa* ['flirtation']-type" approach that aimed to "fictionalize reality" by pursuing romance and acting out new lifestyle fantasies on the city streets, and, on the other, an "otaku-type" response that moved deeper into fantasy media in order to achieve the "real-ization of fiction" and search for a "transformation into another world."[16] This rhetorical fissure between those focused on "fictionalizing reality" and those who prefer the "real-ization of fiction" offers a clear precedent for the later conceptual divide between augmented reality (AR) and VR at the end of the century. The former attempts to reshape the given world by blending in some virtual elements; the latter pries open a media portal to enable a more complete perceptual immersion in virtual worlds.

In terms of style, the otaku-type approach entailed a move away from a "real world" aesthetics of naturalist realism (in literature) and photo-realism (in visual media), and toward an aesthetic orientation Ōtsuka Eiji would come to call "manga/anime realism." This refers to a sense of reality built not through the simulation of everyday perceptual environments but through adherence to the internal logic of fabricated manga and anime worlds.[17] Echoing Mita, Ōtsuka notes how this aesthetic shift served as an escape from "real history" (*genjitsu no rekishi*) to "virtual history" (*kasō no rekishi*). Along with manga and anime, Ōtsuka locates this shift in the rise of fantasy-based computer games, particularly RPGs, and the increasingly popular style of authors like Murakami Haruki (including his use of elements from genre fiction). Each "deliberately creat[e] imaginary chronologies and references" that *feel* real but have no factual connection to actual Japanese history.[18] As portrayed by Okajima Futari, VR threatened to weaponize this "real-ization of fiction," whether for the U.S. military or for the increasingly powerful video game industry.

ESCAPE HATCH FROM A MIXED REALITY

Japanese VR-themed narratives in the early 1990s continued to reference these immersive anxieties. The manga series *Yokohama Homerosu* (Yokohama Homer, Koike Kazuo/Kano Seisaku, 1991) similarly positions VR as a memory-replacing psychological weapon of American origin, this time created by the U.S. Central Intelligence Agency (CIA).[19] In Masaki Gorō's award-winning sci-fi novel *Viinasu shiti* (Venus city, 1992), meanwhile, economic anxieties in the wake of the U.S.-Japan trade wars come to the fore. *Venus City* is set in a world in the near future where Japan has become the dominant global economic power, but the novel's female Japanese protagonist is stuck working for a White male American boss. They end up reuniting inside the eponymous *Venus City* VR metaverse, where their virtual characters enter into a psychosexual power struggle for domination over the virtual network.[20] Baryon Tensor Posadas reads the novel as a nearly satirical literalization of American fears of a "virtual" Japan, responding to the trade war and techno-orientalism context described in chapter 2.[21] Along with popular American imports like the films *Total*

Recall (Paul Verhoeven, 1990) and *The Lawnmower Man* (Brett Leonard, 1992)—the latter coproduced by the anime industry's Takiyama Masao and released in Japan under the title *Bācharu wōzu* (Virtual wars)—these popular narratives cemented an anxious image of VR in the Japanese popular imagination.

Over the next decade, however, the Japanese media landscape again began to transform, shifting attitudes toward VR in the process. Computer networks continued to expand their reach into everyday life, especially with the arrival of internet-enabled cell phones in the early 2000s.[22] Experiments like the early Japan-based locative online game *Mogi: Item Hunt* (Newt Games, 2003) introduced ways to blend computational and noncomputational space more thoroughly.[23] Paul Milgram and Fumio Kishino had captured this broader spectrum in their well-known "reality-virtuality continuum," introduced as part of their work at the ART Computer Systems Research Lab in Kyoto in 1993.[24] Alongside AR, VR was now simply one of several ways into a broader blend of real and virtual perception that Milgram and Kishino simply called "mixed reality."

By 2001, media theorist Machiko Kusahara could point to Tokyo as a place where mixed reality was already an everyday condition:

> We are used to environments where there are screens and speakers everywhere, blending images and sounds from TV, video, games, CD, DVD, etc. with the real landscape and soundscape around us. We regard images on billboards, big screens on the facades of buildings, loud music from the car stereos on the street as a part of the real landscape/soundscape. A huge screen at the corner of Shibuya, Tokyo, is even larger than a house, showing all kinds of images from movie [sic], TV, music video, and commercials. Most of the images are computer manipulated or generated. We live in "real" environments that are flooded with "unreal" images . . . The image from the virtual world and the real here-and-now world are juxtaposed, to be seen as part of the real environment.[25]

As this mixed reality condition became more familiar, the VR imagination in Japan shifted away from the Baudrillardian threat imagined in stories like *Klein Bottle* and moved toward an exploration of how VR worlds might offer alternative spatial and social realities accessible from within these broader media networks. Daikoku Takehiko notes that, in

this sense, the earlier 1990s VR was the true "stand-alone" version, while VR today can only be understood as part of a larger internet-enabled, information-driven society.[26]

THE ARRIVAL OF THE *ISEKAI*

This shift is clearly reflected in a major narrative trend emerging at the time to become one of the most dominant in young adult fiction in the early twenty-first century: the *isekai* 異世界 or "other world." *Isekai* is a genre of fantasy narrative centered on characters from this world who find themselves in a different, unfamiliar world—closely related to what fantasy scholar Farah Mendlesohn calls the "portal-quest" in an English-language context.[27] In *isekai*/portal-quest stories, an everyday protagonist one day happens upon a portal from "this world" to some fantastic "other world," becomes stuck in the other world, and must figure out how this other world works in order to get back home. Along with similar themes found in the "epic, in the Bible, in the Arthurian romances, and in fairy tales,"[28] many critics trace the genre's modern roots back to Lewis Carroll's *Alice's Adventures in Wonderland* (1865) and its sequel, *Through the Looking-Glass* (1871)—key influences on a wide range of Japanese popular culture, and, as we have seen, a frequent reference point for VR journalists and developers as well.[29]

Japanese literary history too is home to many examples of fiction focusing on a "journey to an alternative world."[30] Starting around the time of Takachiho Haruka's novel *Isekai no yūshi* (Hero of the other world, 1979), however, *isekai* as a Japanese genre became closely associated with the particular brand of British-flavored medievalism pioneered by authors like J. R. R. Tolkien.[31] These medieval European settings entered Japan primarily via gaming contexts, first via tabletop RPGs like Dungeons & Dragons in the 1970s and then with the computer-based RPGs of the mid-1980s like *Wizardry* (Sir-Tech, 1981) and *Ultima* (Origin Systems, 1981). Both of the latter titles would in turn heavily influence the first Japanese RPG console video games, *Dragon Quest* (Chunsoft, 1986) and *Final Fantasy* (Square, 1987).[32]

Around this same time, novelizations adapted from transcripts of tabletop gaming sessions began to emerge as a new form of genre literature,

most notably with author and game designer Mizuno Ryō's *Record of Lodoss War* (*Rōdosu-tō senki*) series, serialized in *Comptiq* magazine from 1986 to 1988. The medieval fantasy characters in *Lodoss War* are not aware they are in a tabletop RPG, and there is no mention of the game structure within the text, although readers would have likely been aware of the stories' origin. This period also saw the first manga serializations of video game narratives or, in some cases, video game–*style* narratives like the RPG manga later published by *Comptiq*. Some of these, like Tajima Shōu's *Mōryō senki Madara* (1987), explicitly reference RPG mechanics like hit points and character design.[33]

Eventually *isekai* emerged where characters are aware not just that they have entered into a fantasy world but into a video game specifically. One early example is Takahata Kyōichirō's 1997 light novel *Kurisu kurosu: Konton no maō* (Criss-cross: Devil of chaos).[34] The text opens with the main character logging in for the first day of a new massively multiplayer online role-playing game (MMORPG) called *Dungeon Trial*, running on the latest Japanese supercomputer. He soon realizes there is no way to log out, meaning he must play through the game as if it were a real life-and-death dungeon adventure.

Criss-Cross was followed by a steady stream of trapped-in-a-game *isekai* narratives, where the protagonist is an ordinary Japanese gamer who finds themselves stuck inside a virtual MMORPG world. The protagonist must draw directly on their fluency with RPG fighting styles, social mechanics, and genre tropes in order to come out alive. Starting with *Criss-Cross*, many trapped-in-a-game *isekai* also bring in some kind of *desu gēmu* ("death game") twist, raising the stakes of the in-game outcome by connecting a "game over" state to the actual demise of the player's offline body. This premise essentially rewards players who can quickly figure out the algorithms that govern the other world and find ways to bend them to come out ahead.[35] Those who are already serious gamers are best prepared to learn and exploit the game settings and quickly level up.

The MMORPG-themed *isekai* easily grew to incorporate VR-based settings as authors searched for a more obvious portal to relocate players fully into the game world. And literary critics in Japan quickly recognized how the imaginative desires driving VR developments overlapped with this shift in popular narrative styles. Writing in 1993, literary critic Enomoto Masaki situates VR-themed novels as a part of a broader turn toward

"electronic literature" (*denshi bungaku*). Enomoto emphasizes how "here on the cusp of the twenty-first century, the emergence of VR cannot simply be considered an episode in the history of science. It's also an event in media history, cultural history, and I would even go so far as to say literary history as well." Enomoto emphasizes how VR as both a real technology and a media fantasy becomes key to the popular understanding of Japan's long-awaited "information society" (*jōhōshakai*).[36] In the new century, both *isekai* in general and the VR-themed *isekai* in particular would go on to become key genres at major Japanese online amateur writing platforms like *Shōsetsuka ni narō* (Let's become a novelist), in parallel with the general explosion in the market for fantasy narratives both inside and outside Japan during this time.[37] By 2017, *isekai* stories were so dominant that entries in the genre were banned by the major annual light novel competitions to make room for other types of narrative.[38]

RPGs position the player as both adventurer and anthropologist of other worlds, and the VR *isekai* positions the reader (via the hero) in a similar exploratory role.[39] The fictional VR headset here serves as a ready-made narrative portal underwriting the protagonist's fully embodied passage into the "other world." Presenting the portal as a piece of actually emerging technology meant the VR *isekai* could leverage existing excitement for VR and allow readers to more easily imagine having the experience one day for themselves.

TRAPPED IN THE GAME

The text that kicked off the VR *isekai* boom in twenty-first century Japan follows the trapped-in-a-death-game formula very closely: Kawahara Reki's light novel series *Sword Art Online* (*Sōdo āto onrain*; hereafter *SAO*). The first *SAO* volume originated in 2002 as a serialized web novel published by Kawahara under the pen name Kunori Fumio. After Kawahara won the Dengeki Novel Prize in 2008 for the first volume of what would become his other long-running series, *Accel World*, Kadokawa/ASCII Media Work's Dengeki Bunko imprint—the same press that had published *Criss-Cross*—published a revised version in light novel form with illustrations by abec (figure 4.3).[40] As I have examined elsewhere,

イラスト/abec

川原 礫

ソードアートオンライン

アインクラッド

001

SAO SWORD ART ONLINE

電撃文庫

FIGURE 4.3 Cover of Kawahara Reki, *Sword Art Online 1: Aincrad* (2009). Illustration by abec.

the series was a major influence on the new generation of VR engineers, including Palmer Luckey, the American developer of the Oculus headset that kicked off the 2010s VR boom.[41]

The series is set in Tokyo and surrounding prefectures starting in the summer of 2022 and follows a cast of teenage gamers who log into a new VR massively multiplayer online role-playing game (VRMMORPG). The game, the eponymous *Sword Art Online*, is the first of its kind to offer what its developers call a "full dive" interface. The headset, the "NerveGear," interfaces directly with the brain, allowing the game engine to fully replace a player's immediate sensory environment.[42] After the player lies down (usually at home in their bedroom), puts on the headset, and voices the command *rinku sutāto* ("link start"), brain signals are routed in and out of the *Sword Art Online* servers instead of the player's body. The latter is left inert and unaware, as if in a deep sleep.

Much like *Criss-Cross*, what sets the *SAO* drama in motion takes place on the first day of the public release of the game, when the first 10,000 players have logged in and are beginning to explore the new world: a floating castle of one hundred floors named Aincrad. Inside Aincrad, players attempt to use the usual downward hand swipe to bring up the menu to exit the game, only to discover the logout button has mysteriously disappeared. Soon after, all 10,000 players are summoned to the medieval town square where the game first began.

A massive caped figure descends from the sky; announces himself as the game's designer, Kayaba Akihiko; and reveals the logout button's disappearance is not a bug but a deliberate trap. Kayaba declares no player will be able to log out until someone beats the entire game. If a player's hit points run out in the meantime or if someone on the outside world attempts to remove the NerveGear from the player's body, the system will immediately microwave the player's brain, killing them instantly. Back in Japan, many of the player's bodies, now inextricably linked to their VR devices, are moved to hospitals and placed on life-support. The players' real-world muscles gradually weaken even as the players become stronger and progress within the "other world" of the game.

The rest of the Aincrad arc follows the main character, Kirito, as he levels up and works his way through the castle, eventually defeating Kayaba and emerging victorious after two years of continuous "full dive" immersion. During this period, 4,000 of the 10,000 players are killed by the

system, and many of those who manage to survive are left severely traumatized by the experience. The prominence of undiagnosed post-traumatic stress disorder (PTSD) is alluded to throughout the series, as is Kirito's own survivor's guilt in later volumes. Subsequent story arcs, set in other VR worlds built with Kayaba's original game engine, offer similar stories where the VR technology itself comes to serve as a violent threat to players' offline existence.

In contrast with *Criss-Cross* or other early trapped-in-an-MMORPG anime like *.hack//Sign* (Bee Train, 2002),[43] *SAO*'s narrative also dedicates a significant amount of time to the "actual" world outside the game, focusing in particular on how experiences inside and outside VR intersect with one another. In this way, the series marks a shift away from the real/virtual opposition of the late 1980s and early 1990s to focus on VR as part of a broader mixed-reality media landscape.

Unlike earlier VR narratives like *Klein Bottle*, which focused on the risk of a virtual simulation becoming indistinguishable from the real thing, *SAO* sets its characters out on a quest to understand and master the VRM-MORPG on its own terms, as a computational interface that can both help and harm the individual player through its insistence on perceptual enclosure. This is paired with a recognition that skill in navigating these virtual environments can translate into social power and prestige more generally. Kirito has few friends or practical life skills in the real world, but quickly becomes one of the most powerful and popular players in *SAO* thanks to long hours spent grinding away at the game as a volunteer beta tester. Even as *SAO* situates VR as a source of personal achievement, companionship, and social opportunity, however, scenes focused on the players' hospitalized and traumatized bodies also betray a strong anxiety about the physical costs of perceptual enclosure, and about how corporate and government power structures might manipulate these "other world" interfaces behind the scenes.

In Japan, the spread of computational media into everyday life occurred in tandem with the recessionary downturn of the late 1990s economy. In contrast with the transnational trade-war anxieties of the previous decade, the focus turned to just getting by. Cultural critic Uno Tsunehiro notes the paralyzing indecision frequently found in popular narratives of the late 1990s, followed by the emergence of what he calls an emphasis on the "feeling of survival" (*sabaibukan*) around 2001. He connects the new

survivalism to the felt precariousness of Japanese society following Prime Minister Koizumi Junichirō's neoliberal labor restructuring in 2001, as well as the global uncertainty felt in the wake of the terrorist attacks in the United States that September.[44]

Uno argues this newfound precarity is expressed most clearly in the "battle royale" (*batoru roiyaru*) trend that emerged in the wake of Takami Kōshun's hit 1999 novel of the same name. In battle royale narratives, a group (generally teenagers or young adults) is dropped in an enclosed space and faced with a kill-or-be-killed game. The players must quickly figure out the game's rules if they are to stay alive. While Uno doesn't emphasize technology history, he does point to how, around this time, RPG-like narratives were beginning to play a larger and larger role in Japanese popular culture, with an often game-like focus on ranked social hierarchy, forming temporary guilds, and "leveling up" to beat the system.

Echoing this reading of the battle royale as social allegory, Thomas Lamarre argues that the prevalence of "dramas about being trapped within games" like *SAO* is rooted in an underlying fear that games will "turn into just another site of discipline . . . just another enclosed site of work, to which you commute at certain times of day"—much like the VR telework enclosure I described in chapter 3. By forcefully eliminating the ability to exit the game, the trapped-in-a-game narrative becomes a space where

> the violence of disciplinary society is laid bare, fully exposed. If you fail to work on self and power up, if you are killed within the game, you die in reality. This sort of drama runs the risk, however, of endorsing a simplistic, primitive view of power as something that is held at the point of a sword or in an avatar, when in fact something else is at stake: the transformation of disciplinary procedures into a continuous retooling to acquire new skills and abilities, in keeping with the incessant modulations of markets and opportunities characteristic of neoliberal modes of control.[45]

Like Uno, Lamarre points to how trapped-in-a-game narratives reveal the implicit violence of the broader society by means of arresting movement into and out of the game world. Simultaneously, the in-game competition reflects a new understanding of the individual as in need of continuous

adaptation and upgrades to meet the ever-changing demands of neoliberal market conditions. Lamarre echoes Oliver Grau in warning that full sensory immersion "prevent[s] the game from developing any inner distances," meaning a focus on the broader society can emerge only when the immersive world glitches out and fails to function as intended.[46] While *SAO* initially relies on a similar premise of the game glitch in order to turn it from being just an RPG into a broader social "situation," it becomes clear over the course of the series how VR is itself the site of a deliberate attempt by players to establish an alternative social space at a remove from the disciplinary demands of the broader society.

Anime critic Furuya Toshihiro argues that one of the prime motivations driving Kirito's various struggles throughout *SAO* is the desire to ensure the VRMMORPGs spawned by Kayaba's game engine retain their status *as games*. The goal here is to keep VR from getting wrapped up in the corporate "disciplinary procedures" that would take it out of the safe space of fantasy and into the realm of life-or-death "adult" politics. Kirito's battles ultimately focus on protecting VR as an alternate space of fantasy entertainment and role play, a social enclosure innocent of broader political struggles—especially between the United States and Japan—and the consequential responsibilities of the "real" outside world.[47] As Furuya emphasizes, it is players' ultimate inability to preserve VR as a separate, safe space where *SAO* locates its real tragedy. Players could be free to explore and grow through VR, the series implies, if only the self-interested world of adult politics didn't continually intervene.

SAO portrays VR as repeatedly getting drawn back into the broader power struggles of Japan's "information society," including everything from battles for control over everyday perception to national and corporate interests in data capture and technocratic governance. These threats to the autonomy of VR's "other worlds" are the series' real villains. *SAO* imagines VR offering an alternative social structure where someone like Kirito can thrive—if it can avoid simply becoming a tool of existing corporate and government power.

The stakes of who controls VR become clearer if the series' many in-game battles are understood as a colonial power struggle, a king-of-the-hill game played out between corporate, government, and player interests for ownership of the virtual space. This is visualized quite literally

in the vertical architectures of Aincrad and the series' later VRMMORPG worlds like *ALfheim Online* and the Underworld, each of which feature a tall central structure through which players must work their way up to a final boss located on the top floor (figure 4.4). At any point in the game, players know exactly where they stand within this fully spatialized social hierarchy.[48] As they start to reach the higher floors, the players shift from fighting among themselves to confronting those in control of the VR platform itself.

The vertical structure clearly manifests the survivalist logic Uno highlights in Japanese narratives during this period, combining an intensely stratified kill-or-be-killed social hierarchy with the sense anyone could lose their status at any time based on the whims of those governing the system. In contrast to Uno and Lamarre's readings, however, the other worlds presented in *SAO* are never simply an allegorical mirroring of "real-world" social conditions, but instead locate the VR industry itself as a central venue in a broader, society-wide battle for computational and perceptual control.

FIGURE 4.4 The one-hundred-floor floating Aincrad castle within the *Sword Art Online* virtual reality massively multiplayer online role-playing game (VRMMORPG). Players begin on the bottom floor and must fight their way up to the final boss at the top, who is simultaneously the game master in control of the entire VR world. Screen capture from the *Sword Art Online* anime (A-1 Pictures, 2012), season 1, episode 8.

VIRTUAL COLONIALISM

Simultaneously, the specific VR worlds *SAO* players hope to inhabit are never simply "just a game," but actively work to virtually reposition Japan and Japanese VR within an alternative global history. The quasi-medieval setting of the series' virtual societies substitutes a very particular vision of the European Middle Ages in exchange for the social realities of contemporary Japan—while centering Japanese teenagers in European medieval cosplay as the world-saving protagonists. The ahistoricism is the point. Literature scholar Maria Sachiko Cecire finds a similar strategy running through British medievalist fantasy fiction, a kind of staged innocence and historical abstraction she calls "white magic":

> The "white magic" of fantasy literature collapses historical periods, especially enchanted versions of the Middle Ages and the ages of Anglo-American colonial expansion, and renders these texts "innocent" of even the most overt racial implications because of their associations with childhood and childish play—concepts that are themselves raced white and associated with clearly defined gender roles.[49]

As this medievalist fantasy/RPG lineage is taken up in Japan, this whitewashed historical imaginary is sustained, as is the tendency toward upholding traditional gender roles (an issue I will return to in chapter 5). The twist here is that the protagonist becomes Japanese, charismatically leading both White and Black players into battle. In *SAO*, this means Japanese girls playing blonde warrior-princesses like Yūki Asuna; virtual White European nonplayer characters (NPCs) like Alice Zuberg and Eugeo; and Andrew "Agil" Gilbert Mills, *SAO*'s sole Black character, born in Japan to African American parents. While the Japanese players come to dominate in the game, both Japan's own colonial past and precarious present are firmly displaced by the game's virtual set dressing of a timeless medieval Europe. With few exceptions, players from other parts of Asia are absent from *SAO*'s social imaginary.[50]

This virtual "other world" becomes a realm where the stubborn inertia of global geopolitics can be reimagined more freely, with Japanese players firmly at the center of the action. As I explored in chapter 2, the American techno-orientalist lineage often included Japan as part of the exotic virtual

fantasy. In contrast, in the Japanese *isekai*, the quest for the exotic often orients instead toward medieval European motifs, circling back to build off the deracialized and ahistorical medievalist fantasies Cecire identifies in the United Kingdom.

As in many *isekai* narratives, *SAO* imagines a selectively postracial future built on an imaginary (virtual) past, with a teenage Japanese boy as its primary savior. In beating the game, Kirito simultaneously masters both "European" culture (presented as a nonspecific, hazy past freely mixing different folklore traditions) and "American" technological prowess (positioned as sinister and shadowy military operatives or helpful supporting characters like Agil). The subordination of America and Europe and the erasure of Asia help soothe long-running anxieties about Japan's global position, both past and present. The ostensibly uncharted lands of the VRMMORPG offers the chance to reboot history and stake out a new claim. Europe's imagined medieval past becomes Japan's virtual future.

Once you start to look for them, colonial themes are everywhere in VR discourse.[51] When Lanier first introduced the term *virtual reality* at AT&T's summer 1989 conference in San Francisco, these colonial aspirations were hard to miss. "VR opens up a new continent of ideas and possibilities," the event pamphlet proudly states. "At Texpo '89 we set foot on the shore of this continent for the first time."[52] The pamphlet goes on to situate the day's events as the first annual celebration of "VR Day": "like Columbus Day, VR Day celebrates the opening of a new world. VR Day will be celebrated every year with a parade and a virtual beauty contest held *inside* Virtual Reality."[53]

John Perry Barlow took up the same theme the following summer in a *Mondo 2000* special issue section titled "Colonizing Cyberspace! The Race Is On." Echoing Lanier, he proposes, "Columbus was probably the last person to behold so much useable and unclaimed real estate (or unreal estate) as these cybernauts have discovered."[54] The rhetoric situates VR worlds as *tabula rasa* innocent of human history and ripe for capitalist exploitation, carefully erasing VR's military past and ignoring its broader social and material substrates. Transposed into twenty-first century Japan, the VR *isekai* builds from this attempt to position virtual space as a realm wholly set apart from this-world politics, leavened with the similar promises embedded in the alternate worlds of fantasy literature and RPGs.

In his classic early theorization from the late 1990s, Ken Hillis located in VR deep-woven desires to escape from the body, from history, from the planet, and above all a "flight from the reality of the 'other.' "[55] As noted earlier, he situates this as a particularly American mythology, "operating as it does to contemporize and extend the notion of a sense of individual renewal coupled to encountering a spatial frontier."[56] Yet the Japanese VR imagination shows how easily these colonial themes can be taken up by other former imperial powers. Japanese VR engineers echo and reframe the American discourse, invoking the history of Japanese imperialism alongside the Euro-American context. In a 1995 overview of VR's social implications, Hirose Michitaka explicitly situates the technology as driven by a colonial desire to jettison the past and stake a claim in the virtual future:

> For some people, the networked society represents a hugely attractive paradise. Because real society possesses thousands of years of history, it is tied down by various rules and conventions. Society accumulates a variety of strains, and past a certain limit we aim for a new piece of land and expand the frontier. Real historical examples exist of the discovery of a new land, like the colonizing of the new continents in America, or the settling of various colonies in Asia and Africa, or as far as our country, the establishment of Manchukuo.[57] It can be said that attempts to establish a utopia in a new land, where intractable problems do not exist, are a shared historical feature across humanity.
>
> For us in the present, however, we face the disappearance of frontiers we can easily act upon. At the very least the frontier no longer exists in the shape of land where a new society can be born. Put more strongly, the contemporary frontier is probably outer space. And yet, given current technological standards, we cannot set up a new society there. This truly is an age where the frontier has been lost. Compared with this blocked-off situation in the real world, inside the electronic world there is a lot more freedom. In some sense, the contemporary frontier exists within the electronic world.[58]

While Hirose seeks to universalize the colonial impulse as a "shared feature across humanity," his historical examples betray how this quest for the "electronic frontier" does not emerge from just anywhere. Instead, it

extends from the same countries and cultures responsible for so much of the settler colonialism of the past.

Whether in the pronouncements of engineers or in popular *isekai* fantasies like *SAO*, VR discourse borrows one of colonialism's key rhetorical strategies: position the new frontier as empty and unoccupied, promising newcomers the chance to jettison the social and material constraints of the past and reinvent themselves anew. It is no accident that *Klein Bottle*'s fictional VR adventure game positions the player amid colonial exploits on the African continent. And in *SAO*, Kirito and friends engage in a quite deliberate attempt to leave Japan behind in favor of a virtual world promising the "freedom" of this new electronic frontier.

ORIENTING TOWARD VIRTUALITY

As Edward Said famously explored in *Orientalism*, Europe's imagination of the "East" has historically been far more informed by its own projected desires than by the contemporaneous reality of the countries and regions invoked.[59] Game studies and Asian American studies scholar Tara Fickle has noted how concepts often invoked in game studies like Johan Huizinga's "magic circle" closely replicate the polarizing process of "spatializing the Other" characteristic of orientalist thought. When Fickle notes the "complete and unconscious lamination of the East/West binary onto the game/reality binary," she might just as well be describing the virtual/reality opposition too.[60] But there is no reason to assume Europe or America has a monopoly on "spatializing the Other," as the history of Japanese *isekai* medievalism makes clear.

By offering up an "other world," VR works to reframe the home "reality" of the one who puts on the headset, defining it through contrast as everything the imagined other space is not. The more VR operates as a fantasy frontier, the more the "reality" left behind comes to signify the inversion of these traits: everything that must be jettisoned for the fantasy to prosper. In establishing this orientalist polarity, the VR enclosure serves not just to create a virtual world within the headset, but simultaneously to redefine the "reality" it would seek to leave behind. Like Huizinga, the earlier theorizations of Mita, Miyadai, and Ōtsuka were

in fact already participating in this polarization process. In declaring a "turn to fiction," they rhetorically emphasized a separation between the two realms, while reducing the non-virtual "reality" to a specific subset of historical domains now singled out to be avoided.

Along with the polarity invoked by the term *virtual reality* itself, VR demands that its users adopt this oppositional framework through its brute-force insistence on an interface "portal" from one realm to the other. To wear a VR headset is necessarily to turn away from the "real" world and toward the "other" world. The interface makes it impossible to perceive "virtual" and "real" simultaneously or side-by-side.[61] To orient toward one is to give up the other.

Feminist, queer, and postcolonial theorist Sara Ahmed productively reads orientalism as a literal question of physical orientation, of where a person directs their gaze and what they expect to find there. Ahmed notes how the imagined "Orient"

> is not an empty place; it is full, and it is full of all that which is "not Europe" or not Occidental, and which in its "not-ness" seems to point to another way of being in the world—to a world of romance, sexuality, and sensuality. In a way, orientalism involves the transformation of "far-ness" as a spatial marker of distance into a property of people and places. "They" embody what is far away. Thus "farness" takes the direction of a wish, or even follows the line of a wish. The "far" often slides into the exotic, after all. The exotic is not only where we are not, but it is also future oriented, as a place we long for and might yet inhabit.[62]

Some of the most insightful definitions of the "virtual" echo this striving toward the far and distant, always pitched in the future tense. This comes through strongly in the work of scholars closely attending to what draws people to "virtual worlds" in the first place. In his anthropology of *Second Life*, Tom Boellstorff notes how the word *virtual* "connotes the actual *without arriving there*."[63] Victorian media scholar Alison Byerly's study of nineteenth-century panoramas and contemporaneous travel literature in the United Kingdom similarly leads her to describe VR as "an imaginative experience that is not fully realized, but aspirational."[64] The orientation of orientalism is in this way mirrored by the headset's turn

toward the virtual, as that which is not yet, or not quite, and that which is simultaneously imagined as having a sensory plenitude the existing reality can never hope to match. The VR headset thus combines orientalist desire—the promise of future access to an exotic world of romance and adventure—with the literal orientation of the body in space.[65] The other world perceived through the headset is always "over there" on the far side of the screen and speakers, and the VR user is always "almost there"—and so the virtual grass can always be imagined as greener on the other side.

This includes the promise to leave certain things behind: to offer a selectively diminished reality. Despite the earlier Baudrillardian anxieties about illusions substituting for reality, the appeal of VR as an alternative frontier depends as much on what *isn't* brought over from the existing world as what is. This is in fact a basic, if rarely stated, premise for any kind of simulation. Jens Schröter notes that, no matter how technologically advanced, a VR flight simulator will never try to simulate everything fully: "A real airplane should not be duplicated 1:1 . . . in the case of a simulated crash this would mean possible death, but it is exactly this that is to be prevented with the help of the simulators. A truly illusionist flight simulator would be quite meaningless."[66] The same would hold true for an alternate fantasy frontier that simply replicated the world it promised to transcend. What the VR *isekai* offers is as much about what is *not* mediated as what becomes perceptually "present" within the device.

Conversely, a properly functioning VR headset never truly threatens to cut off return access to the home environment either. The power to take off the headset at any time authorizes the colonial adventure and "identity tourism" enabled by the system, because a user never has to fully commit to the other realm.[67] Here lies the deeper horror of *SAO*'s death-game premise: the lack of a logout button threatens the voluntary status of the role play. The medievalist worlds of the *isekai* function best as fantasies when they remain discretionary, staying safely in the far-off realm of exotic possibility while reassuring VR users that they are ultimately still the ones in control. As filmmaker and media theorist Hito Steyerl puts it, in VR, "the viewer is at the center of the sphere yet at the same time . . .actually missing from it. They are fully immersed in something they are not a part of."[68]

THE PORTAL FANTASY AS A DENIAL OF HISTORY

Integral to the appeal of VR's colonial fantasies, in other words, is the option to log out at any time. In this light, we can understand the immersive anxiety that runs across Japan's more recent VR narratives not as an issue of real/virtual confusion (as in *Klein Bottle*), but as a fear this participation in virtual realms is gradually becoming involuntary and out of the player's own control. To be "trapped in the game" is to no longer inhabit the safe distance of the orientalist gaze, to lose the privilege of exiting at any time. To exist only on the "virtual" side of the virtual/reality divide is to be reduced to an NPC, called into existence only as much as the world's main player-protagonists decide to turn in your direction. To return to Lamarre's language, the space of VR would then truly become "just another site of discipline."

This quest to remain the subject rather than object of the colonial gaze is particularly fraught in Japan, as Hirose's cursory mapping of colonial history above suggests. Japan's twentieth century could in many ways be described as an attempt to inhabit the first-person protagonist role rather than become the site of some other country's quest for spatial domination. If this helped rationalize Japan's colonial and military aggression into other parts of Asia, and again informed the postwar path to becoming a global economic superpower, a more virtual resolution to these concerns was starting to emerge by the end of the twentieth century. Rather than seeking control over the unruly and unpredictable inhabitants of actual "other" places, it was far easier to seek to control the mechanisms through which other worlds come to appear.

While the cybernetic "closed worlds" of the Cold War brought these more technocratic strategies into view on a global stage, this shift also played out at the more local level of human perception through the closed rooms of the personal media cockpits described in chapter 1.[69] During the Cold War, Japanese society was already situating the rest of the world at more of a "far off" distance, with the country increasingly coming to appear to its citizens as a "safe haven in a precarious world."[70] With the recession that emerged alongside VR's arrival in the 1990s, however, it became more difficult to locate that safe haven within the existing spaces of Japanese domestic life.

This is when the first-person interfaces of VR and the virtual *isekai* fantasy emerged to offer worlds where the player would always be assured of maintaining control. As Ōtsuka emphasizes, the turn to fantasy in Japan deliberately served to put more distance between Japan's recent past and the "virtual histories" offered by these other immersive worlds.[71] What Furuya describes as a desire to keep fiction as fiction helps position the "other world" as a safely ahistorical space that is merely waiting for the player to arrive and take charge.

This flattening out of history is endemic to *isekai* as a genre. Historians of the portal-quest fantasy sometimes point to how the narrative structure grows in popularity in the wake of the colonial explorations of the fifteenth to the seventeenth centuries, out of a similar sense (much like Hirose describes above) that all real places have been explored and the only sites left for adventure in unknown lands are those made available through fictional fantasies. At the same time, these fictional environments offer a reassuring notion that a world "out there" is simply waiting to be discovered by a courageous adventurer, with none of the ambiguities or competing claims of the messy nonfictional reality back home. Mendlesohn notes how the portal-quest, more than any other genre of fantasy,

> embodies a denial of what history *is*. In the quest and portal fantasies, history is inarguable, it is "the past." In making the past "storable," the rhetorical demands of the portal-quest fantasy deny the notion of "history as argument" which is pervasive among modern historians. The structure becomes ideological as portal-quest fantasies reconstruct history in the mode of the Scholastics, and recruit cartography to provide a fixed narrative, in a palpable failure to understand the fictive and imaginative nature of the discipline of history.[72]

This tightly parallels Ōtsuka's argument that the turn to virtual history in Japan is simultaneously a return to an older notion of history, one assembled not from competing and contested perspectives but from a fixed body of lore passed down from on high.[73] As Mendlesohn notes, the enclosed formal structure of the portal-quest fantasy enhances this historical simplification: the isolation cuts the protagonist off from any

evidence that might lead them to question the authority of the world as it is given to them.[74]

The VR *isekai* similarly positions the past and the present of the virtual world as entirely self-evident, erasing ambiguity in favor of a tightly regulated space with fixed parameters and seemingly egalitarian rules. The godlike perspective of the programmer or game master in turn authorizes this perspective, acting as the ultimate locus of authority for the world building and eliminating any sense of historical contingency.[75] Carved out from a Japan felt to be too complex and precarious, the battle for command of these VR platforms may be cruelly stratified, but at least it seems to offer a clear set of demands and a solid path forward, governed by the supposedly more impartial algorithms of the game engine itself.[76]

THE STRUGGLE FOR PLATFORM CONTROL

Isekai narratives demonstrate how the VR enclosure is as much about the desire to eliminate context and rewrite history as it is about control over virtual space. While the colonial fantasy in American VR often moves toward expansive photorealist frontiers—outer space and vast unpopulated continents—Japan's fantasy environments came to be shaped instead by the *isekai* fantasies of manga, anime, and video games. This can be understood in part as due to the relative strengths of these industries in their respective countries: American cinema and video games have emphasized photorealism since the 1990s, but during the same period, Japan has doubled down on manga, anime, and manga/anime-style video games as its major exportable "contents."[77]

The medievalist *isekai* narratives also suggest this turn to a separate "manga/anime realism" represents a concerted attempt to segregate these fantasies from existing social and historical contingencies. And yet, while *SAO*'s "full dive" NerveGear interface attempts to take this perceptual split to its logical conclusion, even this series remains haunted by the social and political forces it seeks to leave behind. *SAO* makes clear how the main anxiety surrounding VR in Japan today concerns who will control the VR platforms themselves. Over the course of *SAO*'s several

dozen volumes, Kirito's goal in life shifts from being the strongest in-game player to building a real-world career in VR production and development. When he again picks up his virtual sword, it is now to defend his favorite VR platform from nefarious corporate and government interests.

As with the immersive anxieties of the late 1980s and early 1990s, America is again the chief antagonist here—but the battle is now not against the blurring of real and virtual but over who will control the new VR platforms. These anxieties over American control of the VR industry come to the fore in the "Alicization: War of Underworld" arc (books 15 to 18). Most of the arc takes place inside a corporate-sponsored medieval VR setting called the Underworld, built to cultivate more human-like artificial intelligence (AI) capabilities for Japan's Self-Defense Forces.[78] Echoing the "white magic" logic Cecire finds in British medievalist texts, the series' Japanese protagonists fight on the side of the "white" quasi-European AI villagers against the clans of the "dark territory," which include darker-skinned human NPCs as well as humanoid beasts like orcs and goblins. Soon enough, however, the real enemy emerges: a sadistic American mercenary who logs in after he is clandestinely hired by the American military to steal the new AI technology from Japan. As a result of the player account he steals to log in with, the mercenary is immediately recognized by the inhabitants of the dark territories as their emperor. He subsequently invites a large number of American VR players onto the server to fight on his behalf.

Along the way, the War of Underworld works to revise Japan's recent geopolitical history within this virtual setting. Echoing wartime propaganda depicting Japan as savior of the Asian nations, the narrative emphasizes how the Japanese players quickly recognize the humanity of the "dark territory" races, ultimately leading both them and the "white" NPCs against the invading American hordes. The American foot soldiers, in contrast, appear (especially in the anime) as uniform and faceless behind their full-body armor. The series portrays the Americans as a mass of bloodthirsty and disorganized thugs only there for the thrill of the graphic violence and "player killing" promised by the VR simulation. In contrast, the friendship, loyalty, and tightly coordinated teamwork of the Japanese players enables them not only to save their beloved VR world from destruction but simultaneously to protect Japanese VR innovations from the nefarious intentions of the Americans (along with

corrupt officials in the Japanese Self-Defense Forces paid off by American weapons manufacturers).

Near the end of the battle, a second sadistic American working under the VR emperor convinces tens of thousands of Chinese and South Korean VRMMORPG players to log in and fight for the American side. He does this by spreading false rumors on VRMMORPG message boards that the Japanese players are hackers who have stolen their high-level characters and are attempting to take over a foreign server. The mob anger that results is clearly intended to reference actual populist anti-Japan campaigns in both countries. These real-world movements are rooted in anger over the Japanese government's failure to atone adequately for wartime atrocities, and in territorial disputes between Japan and both China and South Korea over uninhabited islands. Glossing over these complex debates, *SAO* portrays this anti-Japanese sentiment as nothing but a product of external American manipulation, which keeps the Korean and Chinese players from understanding how the server territory is rightfully Japan's after all. Only one character from each country sees through the ruse—the only two given a face or a name—and both try unsuccessfully to get the anti-Japanese mobs to see the error of their ways.

These nationalistic themes resonate at a more personal level once the VR war is over and Kirito is back home with his family. Speaking formally to his parents across the dining table, Kirito announces that instead of going abroad after high school and studying at an American university, as he had planned earlier, it is now his firm intention to remain in Japan, study at a Japanese technology school, and go to work at the same Japanese firm that created the Underworld. The company is headed by Kayaba Akihiko's former lover, so this would further line up Kirito to be Kayaba's heir as game master of the most powerful VR platform around.

While *SAO* thus resolutely centers Japan within its revisionist virtual history, the series also explores how the technology might be open to more decentralized and cooperative forms of control once it is put under the benevolent stewardship of Japanese players. Once Kirito survives the initial trapped-in-a-game scenario, he helps orchestrate the free public release of Kayaba's VR game engine so others can use it to create new VRMMORPG titles, with security checks in place to prevent any further abuse. Other story arcs focus, for example, on how a group of terminally

ill patients uses the "full dive" interface to find solace and community through virtual embodiment in these alternate VR worlds.

Alongside its fantasy of Japanese teenagers' moral and technological superiority, the series thus points to more open and nonmonopolistic platforms as the best way forward for VR, including the need for VR users to maintain control over their own user data. Poised to usurp the title of game master himself, Kirito, in collaboration with other characters, chooses to use his power to allow a wide range of others to take up and share that role. In this way, even as it situates the VRMMORPG as an ahistorical colonial frontier, the series ultimately seeks to answer a broader political question, and a very real one facing VR developers today: how can VR be prevented from simply becoming an opportunity for a few (mostly American) companies like Facebook to consolidate control over their users' perceptual horizons? As *SAO* dramatizes, whether this can be achieved—when even the formal enclosure of the headset seems to work against it—is perhaps the deepest source of immersive anxiety at work in VR today.

5

VR AS A TECHNOLOGY OF MASCULINITY

Virtual reality (VR) developers in Japan have historically been overwhelmingly male. The contemporary VR scene hasn't changed much in this respect. In the late 2010s, I went to as many VR and VR-related talks, meetups, academic conferences, and industry events in Tokyo as I could find. By my own casual estimate, audiences at the events were consistently 90 to 95 percent cisgender men, mostly in their twenties through their forties. All-male panels and speaker lineups were the norm, to the extent it felt noteworthy when an event included a nonmale presenter. At the same time, the virtual characters that populated these men's projects were overwhelmingly female, with almost the exactly inverse gender ratio. The most prominent type of character by far was the teenage girl—most often presented as a *bishōjo* 美少女 (lit. 'beautiful girl') in anime style, but also occasionally as a photorealistic three-dimensional rendering. A recent survey of Japanese users of the popular social VR platform *VRChat* revealed a similar gender split. Eighty-seven percent of those surveyed were male, while 88 percent of those men used female character models within the platform, mostly in anime *bishōjo* style.[1]

This chapter seeks to understand this stark gender and age asymmetry: human men immersed in a world of virtual girls. Much like VR aims to bracket out other kinds of social and historical situatedness, here the head-mounted interface promises to shift gender presentation into

a closed-off virtual space. VR developers and users gain more comprehensive control over the perceptual environment while simultaneously ensuring their own physical bodies disappear. This reworking of gender relations within virtual space serves as an extension of the "turn to fiction" examined in chapter 4—an attempt to bracket out demands for real-world gender equity while covertly reinscribing gender norms within a more controllable virtual realm. Inside VR, these men are both everywhere in control and yet nowhere to be seen, and so it becomes difficult to recognize and confront this power imbalance head on.

The disappearance of masculinity within the VR enclosure offers some clues to understanding what anime producer and critic Okada Toshio has described as the *bācharu seifūzoku* ("virtual sex industry") produced by male "otaku" manga, anime, and computer game enthusiasts.[2] While much has been made of the anime, manga, and technology-obsessed otaku as an exemplar of Japan's "masculinity in crisis," VR suggests the turn to these fictional worlds can be understood more concretely as an ambient power play responding to the broader push for gender equity in Japanese society. VR in Japan defensively recenters male authority by shifting perception into an enclosed realm of virtual girls produced (and largely controlled) by men.[3]

Through this analysis, I aim to offer a counterpoint to the well-established lineage of critics who argue that the male otaku *bishōjo* fixation is not as sexist as it might first appear. For these writers, the virtual girl becomes the source of a more complex renegotiation of gender as men both obsess over and seek to emulate these fictional creatures. A recent example is anthropologist Patrick W. Galbraith's *Otaku and the Struggle for Imagination in Japan* (2019), which builds on psychiatrist and critic Saitō Tamaki's *Beautiful Fighting Girl* (2000) to situate otaku sexuality as a phenomenon of men "moving to the margins" of a patriarchal society, queering hegemonic masculinity by allowing men to leave their everyday subject positions behind and experiment with gender in a more fluid and ambiguous imaginative space.[4]

Scholars of two-dimensional virtual environments both in Japan and the United States have similarly sought to highlight more transgressive and liberatory uses for online identity experimentation going back to the early multiuser online communities of the late 1990s, including the potential of cross-gender play.[5] In multiuser VR environments as well there is

already ample evidence of people turning to virtual characters and virtual worlds in order to explore new identities and dimensions of the self, including in relation to gender and sexuality. I do not wish to downplay these potentials or to dismiss the diverse gender and sexual identities that have found a more welcoming home in virtual space.[6]

Yet to ignore the larger structural asymmetries while focusing solely on individual freedoms risks rehashing the 1990s promise of virtual space as an escape from historical context, overlooking how access to and control over VR itself remains far from evenly distributed. The wide range of individual identities VR makes available does not preclude the need to confront these broader patterns. The overrepresentation of virtual girls in so many Japanese VR projects remains symptomatic of VR as a male-dominated space. And as the superabundance of anime girl character models on the global *VRChat* platform clearly illustrates, these patterns extend far beyond Japan.

This gender asymmetry has been remarkably resilient and resistant to change over the first three decades of Japanese VR history.[7] And Japan overall continues to languish at 120th place (the lowest among the major advanced economies) among 156 countries in the annual World Economic Forum report on gender equality.[8] Both these trajectories suggest simply providing counterexamples or queer readings of these dominant tendencies is not a particularly helpful strategy if the goal is to understand the deeper population-level power dynamics at play.[9]

The three-dimensional, human-scale figures put forward in VR present a direct challenge to otaku theories that emphasize the unreality of two-dimensional illustrations. Recuperative readings of otaku sexuality have tended to emphasize an ontological split between two-dimensional imaginary *bishōjo* and real-life three-dimensional women, asserting the mutual isolation of real and virtual worlds. Understanding social VR as a purposefully self-isolating part of a broader social landscape, in contrast, necessarily upends the pretense that the two realms have nothing to do with one another. Grasping VR's persistence as a masculine space means moving beyond the focus on characters as fictional constructs and considering instead the broader forces—both inside and outside the headset—that drive men to build and inhabit virtual enclosures of their own design

THE GENDERED LANDSCAPE OF JAPANESE VR

Many prominent Japanese VR projects emerging since the 2010s VR revival have focused on spending time with simulated girls (figure 5.1).[10] Others promise life-sized encounters with already existing *bishōjo* characters.[11] Projects emerging from the Japanese VR hobbyist community, meanwhile, have often focused more simply on opportunities to "meet" life-sized *bishōjo* in virtual space, often drawing on freely available three-dimensional character models like Hatsune Miku (the popular vocaloid from Crypton Future Media) and Unity-chan (the official mascot/vocaloid of Unity Technologies Japan).

For example, one of the earliest independent VR projects of the current era, GOROman's *MikuMikuAkushu* (2013), used a custom-made hand interface alongside a head-mounted display to allow a user to exchange a "handshake" (*akushu*) with Miku in VR. GOROman describes choosing the Hatsune Miku model to work with in part as an easy way to draw attention to the project—making it attractive to existing Miku fans—but also because the character had become something like the equivalent of the computer-generated (CG) teapot historically deployed in many

FIGURE 5.1 Advertisement for the internet café–based VR platform *Virtual Gate* featuring virtual YouTuber Kizuna Ai. The tagline reads: "Transform 'want to meet' into 'can meet' in the VR world!"

computer graphics demonstrations: a standard visual referent familiar to all.[12] Unity-chan plays a similar role as a freely available and recognizable character model available for use in a wide range of amateur projects.[13]

The most prominent amateur VR development tutorial book in Japan similarly focuses on using Hatsune Miku three-dimensional character models from the program *MikuMikuDance* to teach VR development. The book has the title *Oculus Rift de ore no yome to aeru hon* (Book for meeting my wife in the Oculus Rift) that uses the male pronoun *ore*.[14] The cover art features Miku reaching out to take the implied male reader's hand (figure 5.2). Another project featured in the book, *Mikujalus* (Kyūkon, 2014), uses an Oculus Rift paired with a Nintendo Power Glove to allow a user to "pet" Miku on her head. *Spice and Wolf VR* (SpicyTails, 2019) features a similar petting mechanic with the fifteen-year-old wolf-girl Halo.

As this focus on touch suggests, the emphasis on virtual encounters often extends to other senses beyond the visual, echoing the historical emphasis on the "presence" of female voice actors in the three-dimensional binaural sound recordings described in chapter 1. Tokyo-based start-up Vaqso offers a smell interface attachment for the head-mounted display with the "pleasant scent of a woman" (*josei no ii kaori*) as one of the featured launch smells.[15] One booth at an amateur VR festival I attended in Tokyo sought to intensify the feeling of touch by employing a custom haptic vest that would contract as a VR user was approached and "hugged" by a *bishōjo* character within the VR space.

This emphasis on coming into contact with virtual women overlaps with more sexually explicit titles like *Let's Play with Nanai!* (*Nanai-chan to asobo!*, VRJCC, 2016) and *VR Kanojo* (VR girlfriend, Illusion, 2017). Both promise sex-on-demand with their eponymous virtual character, the former in anime style, the latter photorealistic. While *Let's Play with Nanai!* remains a relatively niche indie release, *VR Kanojo* (tagline: "I want to meet you soon!") has since its release been the best-selling Japanese VR title for the year on Steam, the globally dominant digital game store known for its relaxed content moderation rules. On Steam, *VR Kanojo* is available internationally in a censored version easily circumvented through external downloads from the developer's website. It is both the only Japanese title and the only sexually explicit title to appear regularly in the platform's annual list of best-selling VR titles worldwide.[16]

FIGURE 5.2 Cover of Ōkaichimon and Yūji, *Oculus Rift de ore no yome to aeru hon* (Book for meeting my wife in the Oculus Rift, 2014), with Hatsune Miku reaching out to take the reader's hand. Illustration by Mamama.

VR Kanojo began as a parody of another prominent girl-as-tech-demo VR project, Bandai Namco's *Summer Lesson* series (2016–2017). The first *Summer Lesson* release was a launch title in Japan for Sony's PlayStation VR system, although notably not for the overseas market. *Summer Lesson* is a "conversation simulator" where the VR user plays the role of a home tutor for a carefully rendered photorealistic high school girl. Subsequent titles introduced other tutees like a (blond, White) American girl studying the Japanese language at a beach house, and the sheltered daughter of a wealthy Japanese family. The marketing for *Summer Lesson* similarly promised enhanced feelings of "presence" while near to the virtual girl, with the tagline "She really is right there" (*Kanojo wa, hontō ni soko ni iru*).[17]

The game's carefully structured interactions push for virtual physical proximity whether it is wanted or not. American VR journalist Ben Lang describes how he was forced to move closer to the girl as *Summer Lesson* progressed: "This was every bit as awkward as walking up to a stranger on the street and putting my face inches away from theirs. It made me feel like a total creep—something no form of media outside of VR has ever done."[18] The creepiness is enhanced by how the narrative sets up an unequal power relationship from the beginning, casting the player as a trusted educational figure even as the game clearly has other things in mind. *VR Kanojo* essentially calls out *Summer Lesson* for maintaining a pretense of chasteness despite its leering sexualization of the students' bodies. *VR Kanojo* begins with a similar bedroom-set tutoring session (this time with comically easy questions), before pushing the scenario swiftly onward towards a sexual relationship.

While both *Summer Lesson* and *VR Kanojo* fixate on the virtual girl's body (including options to select and unlock new outfits for her to wear), in both titles players are given almost no body at all, appearing in the virtual space only as a semitransparent male torso—with a menu setting to become completely invisible if desired.[19] This asymmetry of visual exposure is also a key formal feature of live-action VR pornography (here meaning noninteractive 180- or 360-degree videos, usually using stereoscopic three-dimensional imagery). In these contexts as well, the camera primarily adopts a first-person male perspective, with only the bottom half of the male performer's body visible. The male performer keeps his upper body behind the camera and does not speak, while female performers are continuously centered in front of the lens.[20]

Although sequestered from general-audience VR software platforms, in terms of sheer volume of content, live-action pornography in this style is by far the largest genre of media created for VR headsets in Japan following the 2010s VR revival—and also one of the most profitable.[21] As of October 2021, DMM.com's Fanza, Japan's largest adult video-on-demand platform, offered over 8,700 VR videos, all featuring female performers (compared with just under 500 nonexplicit VR videos for sale on their general audience site). The films' directors are overwhelmingly male.

The broader media coverage and marketing of VR in Japan similarly present male VR producers and default male protagonists as those in control, while women are most often there to be put on display. This is clear on flipping through *VRFREEK*, a hobbyist magazine focusing on the Japanese VR scene first appearing in 2016. By my count, out of the seventy interviews with VR developers and technology executives appearing across the magazine's three issues, only three are with women. All fourteen of the interviews featured in *VRunner*, the freely distributed industry magazine produced by Japan's main private VR training school, Virtual Reality Professional Academy, are with men.

In these same pages, female bodies frequently serve as decoration for the VR headset itself. All three *VRFREEK* covers feature female models in VR headsets, and all twenty-one of the characters from Japanese VR titles featured in the magazine are women or girls (both human and animated). The first issue of *VRunner* similarly focuses on a "high school girl YouTuber" *bishōjo* character.[22]

In Tokyo-based VR hardware company FOVE's widely used promotional imagery, a woman shot from the shoulders up appears to have inexplicably removed her clothes before putting on the VR headset.[23] An article in the September 2018 issue of Uno Tsunehiro's *PLANETS* magazine takes a similar approach, using a Shutterstock photo of a naked woman hugging her knees while wearing a head-mounted display. The full-page image accompanies the text of a roundtable discussion with five men.[24] Rather than staging a more probable scene of VR use, these images hint not so subtly at the unrestrained scopophilia promised for the virtual space within. Female bodies are transposed outward to populate the space surrounding the device itself. The headset unmistakably obstructs the model's own view, as if to assure onlookers that the woman cannot return their gaze.

GENDERING AMERICAN VR

It may be tempting to read all this as evidence of a uniquely Japanese issue with gender inequality, so before going any further, I want to situate this gender asymmetry in relation to the American VR industry as well. In her work on adult manga, Sharon Kinsella makes the important point that English-language scholarship should resist the reductive framing of issues with gender and sexual representation in Japanese media as symptomatic of "Japanese culture" in general. This erases how such media has often been subject to debate and critique within Japan (by feminist critics, for example), and, conversely, discounts how these same media texts often find significant audiences overseas—sometimes garnering attention well beyond their initial domestic release.[25] *VR Kanojo*'s status as an international best seller on Steam bears this out.[26]

While it is easy for projects like *MikuMikuAkushu* or *VR Kanojo* to come across to an English-language audience as further evidence of Jaron Lanier's "strange experiments from Japan"—part of the techno-orientalism discussed in chapter 2—the fixation on "virtual sex" and "teledildonics" (i.e., virtual sex interfaces) was already prevalent in 1990s popular American VR discourse, and concerns quickly emerged then about whether VR would simply become one more avenue for the objectification of women's bodies.[27] To ward off the notion that this is somehow a uniquely Japanese phenomenon, in this section I want to briefly recap the strongly gendered history of VR in the United States as well.

During the first VR boom of the early 1990s, male VR advocates in the United States were eager to position virtual identities as nothing but the free expression of user agency, decoupled from any larger historical context. At the Cyberthon in 1990, Lanier promoted VR as a "great equalizer" that could turn gender, race, and age into nothing but an easily modified "invention."[28] Yet it was soon evident to many onlookers that the spaces emerging in VR were heavily shaped by the kinds of people creating them.

Feminist scholars of American culture and technology responding to the first VR boom quickly pointed to how VR's promise of perceptual freedom in practice worked to reproduce the worldview of the American VR developer community—at the time a community largely comprised of White middle-class men. These critiques remain highly applicable today, even if (or perhaps precisely because) they have been rarely cited in the

decades since. Here is how Brenda Laurel described the VR scene to the *Globe and Mail* in 1992: "It's a white-boy's toy . . . The sexism [embedded in VR discourse] is an artifact of where the technology came from, who was able to work on it and the uses to which it's been put . . . Its *raison d'etre* was military training and the new kids on the block, the Hollywood boys, are still white boys, albeit a mutant strain."[29]

Feminist philosopher Rosi Braidotti sounded a similar note in 1996, noting how the positionality of VR developers had direct implications for the virtual worlds they produced:

> I am sick and tired of Virtual Reality technology and cyberspace being toys for the boys . . . One of the great contradictions of virtual reality images is that they titillate our imagination, promising the marvels and wonders of a gender-free world while simultaneously reproducing not only some of the most banal, flat images of gender identity, but also of class and race relations that you can think of.[30]

Building from the work of feminist technoscience scholars, feminist VR critics quickly connected these promises of a "gender-free world" with VR developers' larger promises of physical transcendence. Writing in 1993, computer artist Sally Pryor again connects this directly to VR's military history:

> Could you feel pain if you had no body? Could you experience racism or sexism? A somewhat disembodied self, mediated via telepresence . . . might be appropriate in environments such as hazardous radioactive situations, modern warfare, or in space, where the body is truly obsolete. But it would not be much fun when holding your baby, to cite just one activity. My experience of the computing and high technology world is that it is populated by men . . . who are strongly identified and involved with their thoughts and ideas, and not so much with their bodies. Without being particularly aware of it, they reproduce the mind/body split in the technologies they produce.[31]

Artists working with VR soon began to try and push back against these disembodying tendencies. The Art and Virtual Environments project at the Banff Centre for the Arts in Canada served as one key early

site for these creative and critical explorations in the early 1990s, while immersive artist Char Davies' breath-driven *Osmose* (1995) became a frequent critical touchstone.[32] Artist and scientist Jacquelyn Ford Morie's mid-2000s catalogue of artist-created virtual environments found that 62 percent were created and/or designed by women, even as 90 percent of the names on the University of Washington's list of "Who's Who in Virtual Reality" technologies were men.[33] As N. Katherine Hayles described in 1996,

> Feminist responses to a construction of cyberspace as an escape from the body are enacted along a spectrum of resistance, from contestations of what physicality means to reinterpretations of what it implies to reconfigure the physical body with virtual stimuli. Each of these interpretations is struggling to establish itself in a field dominated by militaristic values and male high-tech culture; none is secure from reappropriation by masculinist projects.[34]

This gender asymmetry—tightly intersecting with race and class, as these authors note—has persisted into the VR revival of the 2010s. When Facebook acquired Oculus VR in 2014, the broader gaming community in the United States was in the throes of the misogynist #GamerGate movement, with online trolls harassing, doxing, and threatening feminist video game critics who had spoken out against sexism in games.[35] VR researcher Daniel Harley describes how this spilled over into the question-and-answer session during the first Oculus Connect VR developer conference in September 2014. Amid "questions from White men to a panel of White men," a woman in the audience asks the core Oculus team to discuss the company's "clear gender gap, and how you're gonna *not* port that into VR." Oculus founder Palmer Luckey answers by blaming the general lack of women in the tech industry and saying that he doesn't think there is anything in particular about VR that would discourage women from "becoming interested in virtual reality or coming to developer conferences or becoming game developers."[36]

Underneath a video of the Q&A session posted online, the comment section quickly devolved into "predominantly sexist" attacks targeting the questioner, the artist and researcher M Eifler, for daring to raise the issue at all.[37] As Eifler later recalled the experience,

there was 1 percent women at this conference and very few people of color and there were no female speakers and I was mad. So I went up and asked how they planned to prevent the clear race and gender biases of their conference and the industry as a whole from doing to VR what sexism and racism has done to video games. And they answered it really poorly. It was so lame. But since I am female and it was live streamed that question turned into doxing, and death threats on 4chan and Reddit.[38]

In the years since 2014, a wide range of individuals and initiatives in the global VR industry have worked hard to address these imbalances, and women are increasingly leading the field.[39] Despite these efforts, however, White cisgender men more often than not continue to serve as the most common "face" of the VR industry in North America, whether as corporate executives, journalists, online influencers, or simply as the implicit audience for most VR projects.[40] Not only did the new VR scene not engage with the toxic masculinity presented by the #GamerGate movement when it had the chance, but the lessons of the earlier 1990s period were also largely lost amid the broader jettisoning of VR's "failed" past.

VIRTUALITY PROBLEMS

The Japan context mirrors and intersects with this English-language history in many ways, even as the particulars of each national discourse remain distinct. If American VR culture comes out of a military and vaguely "Green-libertarian" ethos,[41] in Japan, consumer VR is tightly entwined with the broader community of technology and anime/manga/game enthusiasts often going under the name of otaku. In turn, the broader debates surrounding otaku sexuality and the turn toward virtual *bishōjo* going back to the 1980s offer a range of clues for understanding the subsequent gendering of VR space.

As noted in chapter 4, by the early 1980s, the apparent turn away from "reality" in favor of a retreat into virtual media worlds had emerged as a major issue in Japanese popular culture. Galbraith notes how criticism of the male manga/anime fans attending events like Comic Market in the 1980s often focused on their "reality problems," specifically their apparent

preference for illustrated young girls over real-life adult women.[42] Galbraith draws the phrase from a series of columns in the "totally *bishōjo*" *Manga burikko* magazine that first introduced the term *otaku* as a pejorative term for just such men. The final column in the series ends by directly addressing readers of the magazine itself: "As a real problem, take a good look at your reflection in the mirror. There you are with a smirk on your face as you look at this lolicon magazine."[43] Galbraith notes the phrase he translates as "real problem" here can be more literally rendered as a "reality problem" (*genjitsu mondai*): a tendency to escape to the virtual instead of confronting the real.

Kinsella notes how the male otaku's "complex fixation" on "young women, or perhaps the idea of young women (*shōjo*)" reflected "an awareness of the increasing power and centrality of young women in society, as well as a reactive desire to see these young women infantilized, undressed, and subordinate."[44] Historically, the characteristic otaku response to assertions like these has been to insist that virtual girls have nothing to do with real life women, and that to conflate the two represents a categorical error not worthy of consideration. Note the strong resonance with Furuya Toshihiro's reading of the *Sword Art Online* series, discussed in chapter 4, as a story about wanting to ensure the game stays "only a game." Like the later American #GamerGate campaign to "keep politics out of games," at issue here was not so much an inability to distinguish between real and virtual (as mainstream Japanese commentators at the time worried) but rather a desire to isolate the virtual worlds of manga, anime, and computer games as a safely male space immune to external social criticism.

Paralleling the American #GamerGate developments, by the late 2010s, it was common for feminist critics in Japan to point out sexism in manga, anime, and video games on social media platforms like Twitter, only to be greeted by a backlash from otaku-identifying respondents arguing that applying human social concerns to illustrated characters is fundamentally mistaken and an affront to the freedom of the human imagination. A recent example of this phenomenon is the fall 2018 online controversy over the portrayal of Kizuna Ai (the original and best-known virtual YouTuber—see figure 5.1) on a show produced by NHK about that year's Japanese Nobel Prize winners.[45] Lawyer and prominent Twitter commentator Ōta Keiko helped spark the debate with a tweet complaining that NHK's use of the character was inappropriate for a show focused on explaining

science.[46] What feminist critics found particularly unfortunate was the show's format of male human researchers explaining the science to Ai, who responded with her trademark daft and slow-witted responses. As pop culture journalist Patrick St. Michel notes in a *Japan Times* article summarizing the online debate, responses to these comments quickly escalated into a larger conflagration about whether it was appropriate to hold drawn characters to human standards, defenses of Kizuna Ai's character design against charges of oversexualization, counterassertions of the need to defend "free speech" and to ensure the more careful "zoning" of otaku media, and so on.[47]

Overall, the otaku dismissal of the feminist critiques fell back onto the same argument that the "real" and the "virtual" (in this case, the drawn, animated, or computer rendered) are two fundamentally distinct realms, meaning the social standards of the everyday human world can have no claims on the virtual worlds of fantasy and imagination.[48] For critics of Kizuna Ai's appearance on the show, however, the core issue was not about real versus virtual, nor any inherent problem with Kizuna Ai as a character, but how NHK positioned her in a way that reiterated gender stereotypes about women not belonging in scientific fields (with Ai portrayed like a child who needs men to explain the science to her).[49] Virtual or not, the way Ai interacted with the male scientists replicated a representational dynamic already common with human presenters on Japanese news and variety programs: a senior male does most of the explaining, while his younger female colleague's role is mostly to nod along and express surprise and delight at his explanations.

Kizuna Ai's online defenders argued that her clothing and character design were not especially sexualized compared to other virtual characters, but for the critics, it was the contrast between her appearance and the professional attire of the human male presenters that was the problem. While Kizuna Ai's design wouldn't stand out at all among other virtual YouTubers, the combination of male scientists and virtual girls on screen side-by-side revealed the stark asymmetry of gender representation across the two "realities."

A similar controversy emerged in early 2020 surrounding two artificial intelligence (AI) station agents installed on two-dimensional screens to assist travelers at the recently opened Takanawa Gateway train station in Tokyo. One station agent was a serious-looking photorealistic man,

while the other was an anime-style woman who, onlookers quickly noted, would coquettishly touch her hair as she answered customer queries. The female agent became a focus for Japanese debates over gender bias in AI when station visitors discovered her casually brushing off speech that would constitute sexual harassment if she were human, such as questions about her body measurements or comments about her appearance.[50] Here too, the side-by-side contrast of "real" and "virtual" gender presentations betrayed how both are part of a shared representational context, undermining the notion that these two modes have no relation to one another.[51]

Otaku in the 1980s often self-defined as people oriented toward the "two-dimensional" world of manga and anime and away from the "three-dimensional" world of humans.[52] Otaku media theory over the last three decades has similarly often emphasized the inhuman spatiality of two-dimensional characters and environments—from Azuma Hiroki's "database aesthetics" to Murakami Takashi's "superflat."[53] In this context, VR and its universe of life-sized, three-dimensional virtual characters offers a provocative complication, undermining claims that the imaginative worlds of anime and manga can be so readily sequestered from the perceptual environments of everyday life.[54] The ready incorporation of anime-style *bishōjo*, photorealistic CG models, and three-dimensional captures of human female performers into VR strongly suggests the turn to fictional worlds and characters was less about rejecting three-dimensionality than it was a project to shift gender into a more controllable male space—in however many dimensions were available.

While otaku defenses of the sexualization of young girls often hinge on the assertion that the characters are entirely and explicitly fictional, it is easy to find areas where these same approaches extend to the representational framing of real humans as well.[55] Galbraith's *Otaku* provides a clear example of this dynamic. While the book ostensibly offers a defense of male otaku sexuality by positioning two-dimensional *bishōjo* as purely imaginative, the book's ethnographic evidence nonetheless shows how these fantasies readily spill over into the three-dimensional space of Akihabara, where human women are employed to emulate two-dimensional characters for (predominantly male) otaku audiences.

Conversely, the emphasis on "meeting" *bishōjo* in VR draws directly from a broader pop culture focus on "meeting" young human female idols. Mid-1980s groups like the Akimoto Yasushi–produced Onyanko

Club established the idol genre as a major force in the Japanese pop music market. Akimoto's business model famously came to focus on the promise of "idols you can meet," centering around handshake events (*akushukai*) where fans—largely middle-aged men—could buy tickets to greet and shake hands with the teenage girls that populate his groups.[56] Projects like GOROman's *MikuMikuAkushu* in effect port this promise of on-demand contact with teenage girls over to the realm of VR.

This overlap between real and virtual dimensions is especially clear in the realm of pornographic VR software like *Let's Play with Nanai!* and *VR Kanojo*, where the divide between "manga/anime realism" and photorealism often appears as more a matter of market segmentation than opposing realities.[57] The physical scales also converge: *Let's Play with Nanai!* was presented at VR and adult entertainment trade shows using a smartphone gyroscope to synchronize the movements of the in-game character to an inflatable sex doll torso, emphasizing the ability to bring real human-scale movement to the world of anime characters.[58] The developers, for their part, claim to have "created the game as they reminisced about the times when they went through college without girlfriends," implying Nanai is both compensation for the lack of a human partner *and* an attempt to render a fictional anime substitute in full three-dimensional detail.[59]

In contrast, the few Japanese VR projects aimed specifically at women come close to inverting these spatial power dynamics. Two come from Voltage, a game developer specializing in *otome* games (dating simulators featuring male bachelors aimed at a female audience). Voltage's first VR project, *Isu-don VR* (Chair-don VR, 2016), is a seated experience riffing on the *kabe-don* trend from *shōjo* manga. *Kabe-don* refers to a fictional confession scenario where a man corners a female love interest as he leans in and lifts his arm over her shoulder, putting his hand on the wall (*kabe*) behind her with a decisive "bang" (*don*). *Isu-don* offers a variation on this experience from the first-person female perspective, substituting a chair (*isu*) for the wall such that the anime-style male suitor towers over the VR user before coming in for a kiss.

The studio's later *Wedding VR* (Kyoshiki VR, 2018) is a series of three short romantic heterosexual role-play scenarios each ending in an intimate marriage ceremony, with the VR user as the bride. Mirroring *Summer Lesson*, three choices of groom are available: a modern Japanese boy;

a blonde, White European prince; and a samurai general. The similar *VR Kareshi* (VR Boyfriend, Illusion, 2020), from the same studio as *VR Kanojo*, foregoes the sex and instead presents an idealized boyfriend in an apron who prepares a cup of coffee for you behind the bar of a cozy wood-paneled bistro. After kindly commenting that you must be tired from a long day at work, he then pats *you* on the head.[60]

While *VR Kanojo* and *Let's Play with Nanai!* promise the VR user algorithmic control over the body of the virtual girl, these titles are premised around a different set of fantasies focused on proactive interest and attentiveness from a virtual man. In both contexts, VR imports gendered and highly stereotyped power dynamics directly into the virtual realm. If, as game studies scholar Megan Condis notes, "the game girl is always already submissive to her man because she was programmed to be that way,"[61] the virtual boy can just as easily be programmed as always already in control of the space inside the headset.

MEN BECOMING *BISHŌJO*

This gendered asymmetry extends to practices of men using VR to embody *bishōjo* themselves. As anthropologist Anne Allison noted over fifteen years ago as part of a broader discussion of *bishōjo* characters, "men do not merely want to have schoolgirls . . . they also, in some sense, want to *be* them."[62] Some male VR users in Japan have spoken of how taking on the appearance of a *bishōjo* in VR and temporarily abandoning their middle-aged male body is in itself a "healing" experience.

Asahi shimbun journalist Tanji Yoshinobu has written enthusiastically and at length about his hobby of admiring himself in a virtual mirror and taking virtual selfies while embodying a three-dimensional Hatsune Miku model in the *PlayAniMaker* VR application. He describes the substitution of his fifty-six-year-old male appearance for a sixteen-year-old anime girl's as "a miraculous experience where the feelings of a young girl (*shōjo*) sprouted in my heart," allowing him to be "freed from the shackles of his male appearance."[63] His tweets on his VR experiences are organized around the hashtag *watashi kawaii* #私かわいい ("I'm cute," using the female-gendered pronoun). Rather than looking at himself in the mirror

as the *Manga burikko* columnist commanded, VR enables Tanji to see himself reflected back in the mirror *as* a teenage girl, while obscuring his existing body from view.[64]

In recent years, men becoming virtual *bishōjo* has become such a prevalent part of the Japanese VR and virtual YouTuber scene that a new term emerged as shorthand for the practice: *bācharu bishōjo juniku* バーチャル美少女受肉 (literally "putting on the flesh of a virtual beautiful girl"), frequently abbreviated to *babiniku* バ美肉. This sometimes includes the use of voice-changing software to make a male voice sound more stereotypically female. Tanji connects these *babiniku ojisan* (middle-aged men incarnated as virtual "beautiful girls") to the Japanese literary lineage of men writing from the perspective of a fictional woman, as in Ki no Tsurayuki's tenth-century *Tosa nikki*. The history of male Kabuki performers specializing in women's roles (*onnagata*) after women were banned from performing also comes to mind.[65]

As anthropologist Christine Yano writes in the context of Japanese *enka* music, such highly codified performance styles "create a code of gender, whose very patternedness makes gender separable from the biology of its players."[66] While VR, in principle, provides unprecedented latitude for experimentation with physical appearance, in practice the thorough programmability of virtual bodies tends to allow stereotypes and dominant social norms surrounding gender expression to register even more strongly. In VR, gender presentation is shaped almost completely by the desires and assumptions of those creating and controlling the virtual world.

Tanji's comments suggest the desire for *babiniku* is underwritten by negative feelings attached to the middle-aged male (*ojisan*) body, set off in stark contrast with the pop culture idealization of the *bishōjo*. When I asked him about this dynamic on Twitter, however, he was quick to emphasize a separation between the two:

> As far as I am aware, [embodying a VR *bishōjo* character] doesn't change my real-world body image at all. Miku's body belongs completely to "another world" [*mō hitotsu no sekai*]. Real is real, virtual is virtual [*riaru wa riaru, bācharu wa bācharu*]. However, in cases where social lives in the virtual world have become richer, I can't deny the possibility this might change. I think this is a question for the future.[67]

Like the otaku strategy described above, Tanji's first instinct here is to insist on a clear demarcation between virtual and real, emphasizing that Miku's physical form has no relation to bodies or identities in the "real" world. Yet the firewall between real and virtual already starts to give way by the second half of Tanji's tweet, where he recognizes the possibility that a virtual world may have real-world social impact. Whereas the "separate realities" argument is quick to dismiss negative responses to virtual representation like those directed at the NHK show, when it comes to producing richer social lives—especially for men—the real-world emotional impact of the virtual is acknowledged, even celebrated.

In social VR contexts like *VRChat*, explanations for the prevalence of *bishōjo* characters often include assertions that such characters are more approachable and easier to talk to thanks to a conventionally cute (*kawaii*) and nonthreatening appearance. In other words, *bishōjo* are ubiquitous in part because they dovetail with the online social imperative to make communication as frequent and frictionless as possible. The *bishōjo* body thus emerges as a kind of default embodiment within virtual space, an easy choice for VR developers, marketers, and online personalities aiming for popularity, accessibility, and reach.

In practice, this can entail adopting these practical advantages of a "beautiful girl" appearance, while dispensing with much of the possible friction of inhabiting a female body in a male-dominated society. As media theorist and transgender studies pioneer Allucquère Rosanne Stone pointed out in 1994 in a discussion of Fujitsu's *Habitat* (1990):

> On line, women attract more interest and get more attention . . . "Real world" men quickly figure this out, and appropriate it for their own advantage. Because they understand the role-playing aspects of gender presentation in the ludic space of the simulation . . . they are able to avail themselves of the advantages of gender switching without incurring the disadvantages. They enjoy the attractive and pleasurable qualities of being othered without having to experience the oppression and disempowerment that are part of its construction as well. Should any unpleasant or even incipiently boring events arise, they can simply log out.[68]

Again, while virtual environments in principle offer myriad possibilities for expanding or "queering" the norms of gender representation, this

apparent freedom masks strong social and market pressures to bow to the default virtual *bishōjo*—pressures that are more often than not coming from men.

While otaku discourse often situates the choice of "two-dimensional" over "real" women as a question of personal preference, this individualist consumer framing obscures how the substitution of virtual *bishōjo* for human talent also has a range of practical business advantages both inside and outside VR. Daniel Black notes how "turning the female body into a technological artifact . . . gathers it into the kinds of relationships based on ownership and control apparent in the otaku interest in computers."[69] The business strategy of the "virtual idol" first emerged during the original 1990s VR boom, with Hori Production's Date Kyōko becoming Japan's first three-dimensional, computer-generated idol in 1996. More recently, advertisement agency Hakuhōdō's "Saya the Virtual Human" project (2015–) has carried forward the girl-as-tech-demo approach, presenting Saya as a "CG high school girl" that can serve as both a photorealistic "pretty girl character" and a hub for various projects around advertising, AI, and emotional expression.[70] AI character producer Tifana similarly promotes its "Sakura-san" character, the model for the controversial anime-styled virtual agent used at Takanawa Gateway, in a wide range of customer-facing contexts and costumes.[71]

Sugiyama Tomoyuki, Date Kyōko's creator, describes how "a difficulty for the talent agencies is the management of their star talent. They age, and they might cause scandals or have accidents. Being able to control everything [about the virtual idol] is the appeal. It serves a need."[72] Virtual talent cannot leave for another company. Nor do they usually express political views or controversial opinions on social media, at a time when human celebrities in Japan are showing an increasing willingness to do so. And as with the telework context examined in chapter 3, anything that eases reliance on human workers is especially prized in the context of Japan's dwindling labor pool.

All this has led to the recent explosion of virtual YouTubers bringing virtual idol approaches to the online influencer context. While usually presented on a two-dimensional screen, virtual YouTubers use VR interfaces and motion-tracking technologies as an easy way to animate the bodies of three-dimensional character models in real time.[73] As with *VRChat*, the most prominent visual aesthetic for Japanese virtual YouTubers is once

FIGURE 5.3 Branding the *bishōjo*: Netflix Anime's virtual YouTuber, a California-born "sheep-human life-form" named N-ko Mei Kurono. Screen capture from Netflix Anime, *I'm N-Ko, Netflix Anime's Official VTuber!* (2021), https://www.youtube.com/watch?v =pTF_b_9q508.

again overwhelmingly *bishōjo*. Judging by the most extensive ranking of virtual YouTubers available online (listing the top 2,000 by popularity), the vast majority adhere to a *bishōjo* look along the lines of Kizuna Ai—over 90 to 95 percent according to my casual estimate.[74] While a virtual YouTuber's voice is often performed by a human female—with some exceptions, as in the case of characters voiced by *babiniku ojisan*—the most professionalized of these virtual *bishōjo* personas are often owned, managed, and otherwise programmed by men operating largely behind the scenes.[75] Companies from Suntory to Netflix have debuted their own virtual YouTubers to represent their brands and hopefully go viral online, with most a variation on the standard *bishōjo* style (figure 5.3).

GENDERING THE AMBIENT POWER PLAY

The male producer/virtual girl pairing can be understood as a gendered manifestation of what feminist scholars Neda Atanasoski and Kalindi

Vora call *technoliberalism,* or the "histories of disappearance, erasure, and elimination necessary to maintain the liberal subject as the agent of historical progress." Technoliberalism describes how once-default historical subjects—male, White (or in this case Japanese), able bodied, and so on—recenter their social privilege amid demands for a more equitable society by calling on technology to reinforce their agency by other, less obvious means.[76] Much like the robots Atanasoski and Vora describe, VR offers the chance to replace gendered and racialized human subordinates with more easily controllable virtual equivalents. Rather than assert direct control over space by foregrounding the male body, the technoliberal approach instead seeks to sustain control by shifting the terrain of action into more covertly controllable technological realms. The locus of masculine authority shifts to a focus on computational control over space as a whole, at work everywhere and nowhere to be seen.

I first became attuned to these dynamics through my study of ambient music history. In the late 1970s, Brian Eno, at the time inhabiting a highly visible pop star persona, suddenly decided to take the "figure out of the landscape," withdrawing from the on-stage spotlight and shifting to become a behind-the-scenes studio engineer instead.[77] He began speaking of getting out of the way to let nature take its course—even as in the studio he was acquiring more power than ever over the overall sound. Ambient music historian Victor Szabo notes a similar dynamic among ambient music listeners: "Ambient has been marketed toward, and continues to circulate within, a base of high-middlebrow listeners—largely, but not exclusively college-educated, white, middle-class men—who seek both social detachment and bodily disengagement through musical recordings."[78] Rather than risk becoming an embodied target of social critique, the privileged listener disappears into the background, working toward mediated control over the very space of perception itself.

The otaku claim of "moving to the margins" enacts a similar rhetorical strategy, performatively sacrificing social attention and physical authority in favor of voluntarily subordinating oneself to an impersonal environment and an ostensibly less powerful teenage girl persona. In practice, however, the turn to the virtual enclosure asserts even greater control over perceptual space by shifting the entire terrain of action onto a humanly mediated plane. VR's ambient power play offers a way to regain control through the programming of perceptual space while simultaneously

establishing a bulwark against accountability by allowing the men in control to vanish physically from the scene.

Condis notes how digital technologies like video games have historically served as a "means of reconstructing manliness to mean the mastery of technology as opposed to the body, and the ability to dominate in textual or intellectual games as opposed to athletics."[79] This formulation echoes Miyadai Shinji's distinction (discussed in chapter 4) between a body enhancement-focused "*nampa*-type" and a more disembodied and technology-oriented "otaku-type" masculinity in the 1980s, with the latter eventually winning out as Japanese popular culture shifted to focus on both digital technologies and the imaginary worlds of manga, anime, and video games. Japan studies scholar Susan Napier similarly describes the otaku persona as a kind of "technologized masculinity."[80]

The VR enclosure emerges directly out of this trajectory. The headset promises to confer power over space through its perceptual controls while naturalizing this power as simply the expression of the VR user's own first-person perspective. To borrow masculinity scholar Steve Garlick's language, VR promises a "technology of embodiment that limits the potentials of men's bodies to affect and be affected and that produces habitual ways of being oriented toward the dispelling of ontological insecurity through achieving and maintaining control or domination over nature and one's world."[81] Along with the "other world" fantasies discussed in chapter 4, the virtual *bishōjo* emerges as part of a larger project of establishing ontological security through ambient spatial control.

SELF-ERASURE INSIDE THE HEADSET

VR makes clear how techno-masculinity becomes not just a quest for control over specific bodies but also over the entire perceptual context in which these encounters take place. This becomes clear when looking beyond individual characters to the larger perceptual architectures of virtual space. As Tanji implies, the first step is to erase the visible presence of the male body.

Self-erasure emerges as a strong theme in otaku culture from the late 1970s on, often in tandem with the technologies of the one-person media

cockpit described in chapter 1. Galbraith quotes the influential manga art-ist Azuma Hideo, who expressed a desire to "erase himself" by turning away from the naturalist realism and political themes of the 1960s *gekiga* texts and toward a softer *shōjo* aesthetics.[82] In a more recent context, semi-otician Shunsuke Nozawa notes a running joke on the otaku-oriented internet streaming platform Niconico dōga that figures the appearance of an actual human face amid all the manga and anime-style characters as revolting (*kimoi*). The most ironically traumatic example is when the computer screen goes dark and a Niconico user is forced to see their own face reflected back. For virtually oriented otaku, "the actual human, in all its fullness, is gross."[83] Galbraith notes how maid cafés in Akihabara simi-larly block out windows and remove reflective surfaces to allow patrons to focus fully on the female café workers and avoid inadvertently mirroring back the predominantly male otaku clientele.[84]

In this context, the *Manga burikko* column's injunction to the emerging otaku crowd in 1983 to "take a good look at your reflection in the mirror" can be understood not just as a rhetorical turn of phrase but a very spe-cific optical injunction. What is the opposite of going "through the look-ing glass" into a virtual fantasy world? To see one's own body reflected back, fully situated in the existing social environment.[85] The emphasis on male self-erasure points to how gender is never just about the presenta-tion of bodies, but about how bodies intersect with the surrounding space and how they do or do not become the focus of attention.

The spatial reorganization of gender in VR also includes the bracketing out of other people's gazes, and not just through the enclosure of the head-set itself. The isolated settings of many Japanese VR projects are conspicu-ous. *Innocent Forest: The Bird of Light* (MyDearest, 2017) and *Project LUX* (SpicyTails, 2017) emphasize how the young girl the adult male first-per-son protagonist visits is living alone in a remote area, far from other peo-ple. *Summer Lesson*, *VR Kanojo*, and *Spice and Wolf VR* are similarly set in private interior spaces cut off from any broader social interaction, leaving the VR user alone with the *bishōjo*. While these choices all make sense from a game development perspective—allowing small teams to focus on rendering a single character and keeping the graphics from becoming too computationally intensive—the settings simultaneously emphasize how everything is taking place away from the view of others. These isolated VR scenarios help ensure that the virtual setting is sequestered from any

larger social and historical contexts that might call it into question, or perhaps force the VR user to reflect on their own identity, behavior, or social position. While the *Manga burikko* column urges otaku men to "take a good look in the mirror," the head-mounted interface and the isolated settings work together to ensure that this scene of spatial self-recognition is essentially impossible.

RESENTMENT TOWARD THE NONVIRTUAL WORLD

To bring the male body back into the picture, it helps to turn to texts depicting not just the *bishōjo* spaces inside VR, but how they fit into the broader practice of masculinity in the wider social world beyond the headset. Published a decade in advance of the recent VR revival, Hanazawa Kengo's VR-themed manga *Rusanchiman* (*Ressentiment*, 2004–2005) sharply satirizes the use of VR as a technology of masculinity.[86] The series follows Takurō, a thirty-year-old man in a near-future Japan who lives with his parents. He feels the printing factory job he has labored at for the last decade is beneath him, and simultaneously finds he is still unable to speak comfortably with women. He is full of rage at what he feels is his unfair social predicament.

One day Takurō is surprised when a friend in similar circumstances, Echigo, reveals he has a date lined up for that evening. Takurō soon discovers the date is with a collection of virtual girls Echigo has assembled inside a VR massively multiplayer online world. At Echigo's insistence, Takurō tries out the VR system, is bowled over by the sensory realism, and eventually decides to spend the last of his savings on a similar VR rig for himself. Echigo eggs him on, promising VR will solve Takurō's relationship problems, and he won't need to worry about "real women" any longer.

On browsing a Shibuya computer store's shelves of virtual girlfriend software, Takurō feels drawn to a box that has fallen to the floor featuring a character named Tsukiko. Logging in, he finds Tsukiko to be a young girl living alone on a remote, private island, while Takurō has meanwhile traded his out-of-shape thirty-year-old body for the appearance of a more conventionally attractive male teenager. Takurō immediately begins

making sexual demands of Tsukiko, but she refuses him. Enraged, Takurō sexually assaults her, and Tsukiko flees.

Takurō, who by this point believes he has fallen in love, pursues Tsukiko throughout the VR world and eventually establishes a (primarily sexual) relationship with her, although Tsukiko is more interested in going to school. In the meantime, outside VR, Takurō comes close to dating a female coworker his own age, only to have it fall apart when he decides he cannot stand the uncertainty of a real-world relationship. Back in the VR space, Tsukiko's AI starts to grow more intelligent and she realizes she is actually in love with her programmer, one of the oldest and most powerful VR users in the virtual world. As her powers grow further, Tsukiko moves to try to take control of the entire virtual universe, discarding both Takurō and her programmer in the process.[87]

Hanazawa describes the character of Takurō as based loosely on his own experiences working at a printing shop, living with his parents, and being a slovenly man unpopular with women (*himote no hetare otoko*). He recalls himself as a teenager inching toward becoming the kind of creep (*chotto yabai hito*) who would try to spy on the girl who lived next door.[88] In interviews, while he admits that the patriarchal structure of Japanese society is the bigger problem, he proposes there are three layers to the gender hierarchy: the successful men, then women below them, and then the truly undesirable (*himote*) and unsuccessful males for whom all women appear to be in a more powerful (*erasō*) position. Hanazawa says the lower ranking men's feelings of invisibility is the source of the irritation (*iraira*) that runs through his manga, with anger and jealousy misdirected toward women often emerging as an implicit theme.[89]

As theorized by philosophers like Søren Kierkegaard and Friedrich Nietzsche, *ressentiment* describes suppressed feelings of envy and hostility directed at what a person believes is the source of their frustration. When this rage is unable to be expressed directly, it becomes redirected inward through acts of self-debasement, which in turn makes the person even more resentful. As in the United States, in Japan this kind of resentment has sometimes spilled over into misanthropic and misogynist violence, such as the indiscriminate killing that took place in Akihabara in June 2008 when a twenty-seven-year-old man began to run down pedestrians with his truck before getting out to stab random passersby. After the man's arrest, media attention turned to his online message board posts where

he aired various grievances, including the lack of a girlfriend, a feeling of being ugly, and a fear he was about to lose his job as a temporary worker at a vehicle painting factory.[90]

In addressing what cultivates these feelings of resentment, Hanazawa blames a manga industry where most titles are content to traffic in "lies," presenting flattering and comforting fantasy worlds that reinforce a sense of male entitlement rather than confronting their readers' actual living conditions, economic hardships, and social struggles. Hanazawa describes himself as unable to draw a more conventional narrative where female characters fawn over a male protagonist, even if it would sell better, because he feels like he would just be lying to himself.[91] He notes that he purposefully made the real-world characters in *Ressentiment* look as unappealing as possible to contrast with the idealized character designs in the manga's fictional VR world.

Hanazawa expected his readers would go along with this, but after copies of the manga went up for sale all over Akihabara, he was disappointed to find they didn't sell well at all. When an interviewer proposes this was because readers couldn't empathize with the story, Hanazawa proposes that, to the contrary, maybe the Akihabara otaku audience found the story altogether too familiar for comfort.[92] As this exchange suggests, *Ressentiment* interrogates VR as a technology of masculinity by insisting on a depiction of the social and environmental contexts surrounding the headset, hoping to force manga readers to confront the relationship between virtual and nonvirtual space and undermining assertions they have nothing to do with one another.

Ressentiment situates VR as a consolation prize for men who have given up on the nonvirtual world (or at least are trying to convince themselves they have done so). The manga positions VR not as a complete substitute for reality but as a tool of perceptual and emotional compensation for a male underclass—a tool that ultimately can do little to address the abstract resentment Takurō feels toward Japanese society and toward women. In the manga, this takes on a tone that is both somber and satirical. Twisting the *Manga burikko* columnist's injunction to "take a good look at your reflection in the mirror," Echigo instead commands Takurō to "take a good look at reality. For people like us, virtual reality is all we have left" (*Genjitsu o chokushi shiro. Oretachi ni wa kasō genjitsu shika nain da*).[93] Within the manga's logic of VR self-degradation and *ressentiment*,

to confront reality fully is to realize there is no choice but to retreat to a virtual space.

Manga/anime critic Clarissa Graffeo points to the foregrounding of the "grotesque" otaku body in *Ressentiment*, comparing the sweat, tears, and stains accompanying Takurō's abject corporeality to the idealized male aesthetic of "thinness, elegance, grooming and beauty" ubiquitous in both mainstream manga/anime and live-action Japanese media.[94] At the same time, however, scenes of Takurō using VR emphasize how the virtual fantasy space is not just at odds with Takurō's real body but with the small tatami room he occupies on the second floor of his parent's working-class home (figure 5.4).

As Takurō throws himself at Tsukiko in virtual space, Hanazawa shows him painfully colliding with the unseen walls of his bedroom. He collapses on the floor after trying to sit in a virtual chair that cannot actually hold his weight. He even falls down the stairs at one point while in the headset, surprising his mother in the kitchen below.[95] Yet even as the manga emphasizes this misalignment between real and virtual, it demonstrates how movement in VR is first dependent on access to uninterrupted domestic space. Much like how the early headphone listeners in chapter 1 tended to be men who felt comfortable shutting out the rest of the family (perhaps over their partner's objections), the manga portrays Takurō retreating to his private room for VR sessions even as his parents are largely relegated to the common areas of the house. VR transforms Takurō's bedroom into his personal media cockpit (or "man cave," to use the explicitly gendered North American expression)—a room-scale interface where control over an expansive virtual realm first demands local control over one's own domestic enclosure.

Another revealing genre where this spatial dynamic occurs is online VR "Let's Play" videos, such as the 2018 *VR Kanojo* playthrough posted by the popular U.S.-based YouTube VR gaming channel Node.[96] The video features four men in their late twenties to early thirties joking around while each of them plays the game for the first time (figure 5.5). All four are clearly uncomfortable with the game's premise, and attempt to dispel the tension by joking with one another. By six minutes into the video, however, the first man in the headset has engaged first in (virtual) sexual harassment and then (virtual) sexual assault, egged on both by the local audience of other men and by the interaction mechanics of the game itself. The playthrough video provides a succinct demonstration of how

FIGURE 5.4 Emphasizing the contrast between real and virtual space. Dialogue from top to bottom: (1) You're no . . . no longer . . . alone. (2) I . . . I can touch!! (3) This girl exists!!" Page from Hanazawa, *Rusanchiman* (2004), vol. 1, 58. © Kengo Hanazawa, 2004.

FIGURE 5.5 Screen capture from Node, *VR Has Gone Too Far!* (2018), featuring a *VR Kanojo* playthrough with onlookers viewing a two-dimensional livestream of the view inside the headset. https://www.youtube.com/watch?v=Mvp2Xu5G7Zg.

the gender dynamics of VR are shaped not solely by the software content, nor just by the social environment surrounding the VR headset, but rather by how the two intersect.[97]

The review page for *VR Kanojo* on Steam similarly reveals a desire to socially register and share the embarrassment and discomfort of owning the game at all, even among the game's own players. *VR Kanojo*'s Steam page has over 1,000 reviews, mainly in English, Chinese, and Japanese. Many feature the same kind of self-deprecating humor that runs through Hanazawa's manga. Among the top-rated English-language comments:

> We're all degenerates
> I can't wait to tell my friends I have a girlfriend.
> THE FUTURE IS NOW BOYS
> Gameplay tip: don't forget to lock your room.
> 10/10 Would get divorced all over again for this.

The Japanese-language reviews have a similar self-deprecating tone, including one in the form of a reviewer's letter to his mother joyfully informing

her he finally has a girlfriend to bring home for the O-bon holidays—oh and by the way, does she have a computer there he could use?[98]

Even as the *ressentiment* is palpable in the reviews, the comments also serve as a performative rationalization for picking up the game in the first place: *yes, I acknowledge this is pathetic, but I'm going to do it anyway.* The predominantly male community of players both sanctions and contextualizes this decision.[99] VR's emergence as a masculine enclosure takes place with and through this complex mix of shared male resentment, shame, disavowal, playfulness, and self-deprecating humor. This larger homosocial arena is just as much a part of the experience as the perceptual enclosure of the headset itself.

An interesting recent exploration of these themes in the social VR context is the one-shot manga *VR ojisan no hatsukoi* (VR ojisan's first love, 2021), by a manga artist who publishes under the name Bōryoku Tomoko (Violence Tomoko). With a premise strongly reminiscent of *Black Mirror*'s "Striking Vipers" episode (Owen Harris, 2019), the story follows two men who fall in love while both embodying *bishōjo* characters in VR. One is a forty-year-old and single *babiniku ojisan* who describes himself as perfectly fitting the stereotypes of "otaku, gloomy, and grotesque" (*otaku, nekura, kimoi*).[100] The other *bishōjo* turns out to be an elderly man with terminal cancer who is estranged from his family. In the second half of the manga, the men spend time together in real life and develop an offline friendship in parallel with their ongoing love affair as *bishōjo* in the virtual world (figure 5.6).

VR Ojisan's First Love is unlike the earlier VR fictions mentioned here in that the VR scenes are closely based on existing consumer VR products, including *VRChat*, the Virtual Market (a Comic Market–like event for selling virtual goods held within *VRChat* starting in 2018), and popular VR games like *Beat Saber* (Beat Games, 2018). The manga's readership has also centered on those familiar with social VR, while extending to audiences for the fictional same-sex love stories in genres like BL and Yuri.[101] In contrast with Hanazawa's work, the manga affirmatively portrays social VR as opening possibilities for more accepting relationships to form among men as they encounter each other as *bishōjo* in virtual space. By all accounts, the story has been enthusiastically received by actual Japanese social VR users.[102]

At the same time, echoing *Ressentiment*, the series portrays the *babiniku ojisan* as a compensatory existence for men of the recessionary

FIGURE 5.6 The two protagonists as real-world friends (right) and VR lovers (left). The text (right to left) is from the perspective of the older man's grandson after he discovers their affair: "In reality they looked like regular acquaintances, but in VR they are dating as girls?" Bōryoku Tomoko, *VR ojisan no hatsukoi* (2021): 109. © Bōryoku Tomoko/ Ichijinsha, 2021.

"lost generation" who (under neoliberal demands for personal responsibility) can only blame themselves for their lack of social and economic advancement.[103] The manga portrays the men's choice of *bishōjo* characters—the forty-year-old is a young girl in a school uniform, while the older man chooses a voluptuous figure and appears in a series of overtly sexual outfits—as almost an unthinking adherence to the standard tropes of otaku culture. Yet here too, there are intersections with offline experience. A flashback connects the forty-year-old's choice of appearance with a scene from his school days where he gazes enviously at the seemingly carefree existence of a group of girls as he is bullied by other male students and laughed at by his teacher.[104] This initial curiosity never extends to any attempt to understand or empathize with the human women appearing at the fringes of the manga, however. The forty-year-old's nosy female

coworker and the elderly man's daughter, portrayed as overly career-focused, both come across primarily as annoyances to be avoided. Ultimately the manga situates the *bishōjo* bodies on offer in VR as little more than tools for aging men to use between themselves as they work to come to terms with their own mortality.

POSSIBILITIES FOR GENDERING OTHERWISE

This chapter has emphasized how the apparent freedom of embodiment offered by VR can end up intensifying the gendered power structures of the world beyond the headset, while shifting the locus of masculinity away from physical embodiment and toward the promise of technological control over virtual space. Much like the feminist critics of Kizuna Ai's appearance on NHK, I want to emphasize my critique here is not aimed at any particular VR character or title, nor do I question anyone's freedom to be who they want to be or to move across genders in virtual space. VR may indeed make available a more wide-open playing field for gender expression at the individual level. But at the population level, VR is just as subject to broader social forces as any other representational form and, in some ways, even more so given the computational control it provides over perceptual space.

In this context, VR works to underwrite male spatial authority even as it celebrates a world of virtual girls. AR/VR designer and artist Michelle Cortese eloquently describes the men embodied as anime girls she finds frequently harassing her in *VRChat*: "They built their own safe spaces, bolstered by toxicity, to experiment with gender identity." After interviewing them for a performance project, Cortese concludes that while "these men *did* push female-identifying persons out to replace them with effigies," *VRChat* nonetheless provided a space for the men to "confront themselves."[105] But I would ask: just what kind of self is left to confront when so much of what needs confronting has already been purposefully bracketed out?

While the gender asymmetry is aggravated by the spatial and perceptual isolation of the VR headset, the blame is not with the structure of the interface alone. Nor is it simply a "pipeline" issue of a lack of women

interested in the industry. Instead, I have pointed to a deeper issue with how gender in VR is put into practice: how the perceptual enclosure can serve to reassert and sustain a form of indirect masculinity rooted in control over both virtual embodiments and the broader environments in which they take place.

The slow progress on gender equity in Japanese VR since the 1990s is discouraging. What gives me some hope, however, is that the asymmetry I have described here is far less evident at more accessible VR venues in Japan that interface with the general public. This includes location-based VR arcades and VR events held in more public-facing venues (like shopping malls) where passersby might casually wander in. Audiences I encountered in these contexts were always far more gender-balanced and more diverse in age and background, with women attendees often among those most enthusiastically jumping into the VR experiences on offer. Witnessing numerous scenes like these leads me to believe a more inclusive and equitable VR is possible—if the will is there to create it.[106] Here too, the spatial and social environments surrounding VR use matter just as much as what is going on inside the headset.

I also find hope in the work of artists in Japan exploring other ways of using virtual space that take it far away from the girl-in-a-box contents described above. For example, Mizushiri Yoriko's *Otawamure* (Kodansha VR Lab, 2019) gives the VR user a pair of female-presenting hands to explore unusual modes of interaction with objects like pudding and soft-boiled eggs, in an extension of the play with touch and texture in her two-dimensional animation works. Painter Harada Iku and media artist Fujikura Asako build abstract virtual three-dimensional landscapes using motion graphics and game engine software, before depicting them in oil paintings and in projected CG animations, respectively. Notably, all three of these female artists focus on virtual spaces devoid of human figures, with no attempt to "meet" anyone at all. Conversely, artist Taniguchi Akihiko uses a three-dimensional scan of his own body to make himself expressly and almost excessively visible within the chaotic and cluttered space of his own bespoke three-dimensional environments, pushing back directly against the emphasis on male disembodiment and technological control described above.

Despite Palmer Luckey's attempt to shrug off the lack of women in the industry, the problem clearly is not insufficient interest in VR as a

medium, but the way the techno-masculine enclosure is perpetuated by those who benefit from it—ensuring the VR worlds that emerge continue to be skewed in the same predictable directions. Far better to support those working to ensure opportunities to build and inhabit VR spaces are just as accessible as the VR arcade, and to continue developing approaches to virtual identity rooted in something other than a resentful masculinity. Attention to who ultimately controls the perceptual space both inside and outside the headset is crucial.

CONCLUSION

nspired by Japan's more direct embrace of the virtual reality (VR) enclosure, this book has sought to map out how the headset stands to redistribute perceptual control. In the process, I have pushed for an approach to contemporary Japanese media that historicizes the real/virtual binary, pointing to how the "other worlds" of VR constitute a deliberate intervention into the cultural politics of everyday mediated space.

VR researchers Maria Sanches-Vives and Mel Slater note how "immersive virtual environments can break the deep, everyday connection between where our senses tell us we are and where we are actually located and whom we are with."[1] As with most VR discourse, the study this quote is drawn from quickly moves on from this opening observation to focus on how VR environments can substitute for everyday sensory emplacement, producing feelings of presence within virtual spaces instead. Yet as I have argued throughout this book, it is actually this initial turning away from the surrounding world where VR's deepest political significance lies. Wearing a VR headset not only provides access to virtual presence, but necessarily transforms a person's situatedness in their surrounding social and physical space as well.

Nothing captures this more succinctly than Hachiya Kazuhiko's *Inter Dis-Communication Machine*, an installation artwork appearing at Tokyo's InterCommunication Center (ICC) at the height of the first VR boom in 1993. The structure of Hachiya's work is simple: two participants each put

on a black- or white-colored head-mounted display, headphones, and a matching pair of wings. The wearer of the white headset perceives the live image and sound feed from a video camera and microphone attached to the black headset, and vice versa. Once this Klein bottle–like telepresence feedback loop is established, the two participants attempt to feel their way to each other across the (dis-)communicative divide.

This structure is strongly reminiscent of a moment Tachi Susumu and other telepresence researchers have long featured as part of their robot demonstrations. A volunteer using a VR headset to operate the robot is asked to look back using the robot's body to see their own body ensconced in the headset, creating an uncanny out-of-body experience. This is usually framed as a kind of philosophically potent sideshow feature next to the more practical ambitions of telepresent labor. Hachiya's machine instead centers on this physical displacement to drive home a critical point: as perceptual beings, we cannot really be in two places at once.

While the ICC served as a central site of techno-optimism about the future of digital communication in 1990s Japan—sponsored by the country's largest telecommunications company, NTT—Hachiya inserts a "dis-" into the seamless communication promised by the new telepresence technologies.[2] Along with its echoes of Tachi's telexistence demo, the installation both instantiates and parodies one of the promises frequently made for VR during the initial hype of the late 1980s and early 1990s. As Jaron Lanier mused to the *New York Times* in 1989, the emerging VR systems would let "you and your lover trade eyes so that you're responsible for each other's point of view . . . It's an amazingly profound thing."[3] Hachiya's machine, which he straightforwardly describes as a way "to make it possible to kiss or to make love with the partner while keeping the machines on," literalizes this fantasy while also, through the experience of dis-communication, pointing to its impossibility.[4] If Lanier promised a "reality built for two," Hachiya's system offers a reminder that any VR pairing will be deeply shaped by the perceptual deformations of the interface itself.[5] The artwork's sensory feedback loop in effect asks the VR user to "take a good look at themselves" as they strive for connection, while underlining how the interface itself becomes an obstacle to this intention.

FIGURE C.1 Installation view from Hachiya Kazuhiko, "Inter Dis-Communication Machine," 1993 (InterCommunication Center, Tokyo, 1993). Photo courtesy of NTT InterCommunication Center (ICC).

The *Inter Dis-Communication Machine* also deliberately extends beyond the closed loop of the two head-mounted displays. The ICC installation positions the two participants on top of a giant yin-yang symbol spread several meters across the floor, while attendants from the gallery dressed in matching outfits are on hand to guide and cheer the participants on (figure C.1). While the black-and-white symbolism and angelic costuming hint at a play of unity and duality, life and death, reality and virtuality, in practice Hachiya's fumbling participants rely on the environmental support of the aides and the visual cues on the floor to help them adjust to their new perceptual configuration. The space of the installation demonstrates how VR is never simply about the immediate merger of bodies and headsets, but relies on the broader environmental surroundings as a necessary supplement.[6]

PERCEPTUALLY MEDIATING THE SOCIAL

Taking a cue from these ICC attendants, I close this book by turning back to the broader industry players surrounding and cheering on VR use as I write this in 2021. Who are the off-screen players underwriting the VR enclosure today? The physical infrastructures are transnational no matter where in the world someone boots up a VR experience—for example, an Oculus Quest designed in Menlo Park and put together in Shenzhen, running software developed in Tokyo using a game engine built in Cary, North Carolina. The raw materials that make up the headset are extracted from geographies even more dispersed and even harder to trace.[7] Yet there is no mistaking the outsized role of companies like Facebook, Sony, and Valve keeping the current VR market afloat. Japanese VR developers are often left guessing about the next moves of the major (mostly American) platforms, such as what guidelines will determine which titles will be accepted onto Facebook's Oculus Store.[8]

The early Japanese corporate understanding of VR as either a gaming or telecommunications device has now become a global norm. In some ways, the potential for social interaction in VR space was central to the concept from the beginning, going back to VPL's "Reality Built for Two." As noted in chapter 2, however, at the time this social potential was limited not just by the high cost of the devices but also the lack of a high-speed network to enable virtual connections over a distance.

After the post-internet reawakening of consumer VR in the 2010s, this social potential has again taken center stage. Massively multiplayer social VR environments like *VRChat* have seem some of the highest user numbers overall, setting a record of 24,000 concurrent users in October 2020 (across both VR and two-dimensional interfaces).[9] Best-selling titles like *Beat Saber* have gravitated toward multiplayer options and, perhaps most significantly, Facebook has made clear its intent to use VR gaming as an interim step toward its broader objective of establishing VR as a new social platform for home and workplace use. This includes the increasingly tight merger of their Oculus VR wing with their main Facebook social networking service under the overarching banner of Facebook Reality Labs. One way to understand Facebook's long-term strategy here, as VR consultant Nima Zeighami starkly describes, is that "Mark Zuckerberg will be monetizing your field of view."[10]

This high-profile attempt to turn VR into an extension of Facebook necessarily complicates the earlier fantasy of VR as a portal into a tabula rasa limited only by a user's imagination. After all, Facebook's almost 3-billion-strong userbase is certainly large enough to constitute a new continent of its own. Yet awareness is also building that there is nothing neutral or apolitical about platforms themselves as providers of alternate worlds, and Facebook's reputation precedes it as it tries to stake a giant blue flag in virtual space. The head of Facebook Reality Labs, Andrew Bosworth, readily notes how far the company must go in order to regain user trust, even as he goes on to describe more and more ways a headset might soak up user data.[11]

The public response was largely hostile when Facebook announced that all users of their Oculus headsets would now need to log in using a verified Facebook account.[12] A more recent feature announcement introduced the ability to control Oculus Quest headsets verbally from inside any VR app by using the wake phrase "Hey, Facebook."[13] This idea too was met with predictable derision from those already skeptical of Facebook's privacy promises surrounding the biometric data collected by the headset. Yet prompting users to address the company directly by shouting "Hey, Facebook" at the machine does throw into stark relief one of the key problematics of VR as a social enclosure: no matter how much a VR space may appear as a reality built just for two—or three or four or 24,000— there is always going to be a third party there on the scene, largely invisible and at the same time omnipresent.

Like other forms of platform-mediated sociality, those who control the dominant VR platforms will have an incredible amount of control over the if, when, and how of social interaction taking place within their walled gardens. The more embodied and exhaustive perceptual demands of the VR interface raise the stakes even further, promising the ability to modulate how the sensory environment is rendered for each individual user in response not just to a person's accumulated data profile but their eye, head, and hand movements in real time. Jeremy Bailenson offers the example of a VR classroom where every student will see the teacher make frequent eye contact with them, no matter where they are seated or how many students there are. This would be an impossibility in a large in-person class, but it is a trivial matter in a virtual setting where each person's perspective on an ostensibly

shared social space is rendered individually by a third-party platform provider.[14] While research is emerging on moderation strategies and community-building efforts in social VR, there has yet been little reckoning with what it would mean to have a large portion of everyday social perception shift to a more fully privatized computational space. What John Perry Barlow once described as the "unclaimed real estate" of the virtual world increasingly has a very particular set of landlords, with renters or squatters in this space given little recourse should any disagreements arise.

This in turn has shifted the contours of the VR portal fantasy itself, as I traced across the latter part of the book by looking at how the concerns driving VR discourse have transformed since the original late 1980s/ early 1990s period. In the most interesting recent VR texts, the emphasis is less on virtual space as a tabula rasa and more on the evolving power struggle of learning to live inside a computational world run by a third party that may or may not be trying to exploit you. A close analysis of Japanese narratives *in* VR deserves a separate book and will have to wait for another time, but I am thinking here of VR visual novels from MyDearest (*Tokyo Chronos*, 2018; *ALTDEUS: Beyond Chronos*, 2020) and Cavy House (*Midnight Sanctuary*, 2018), as well as experiments with bringing manga storytelling into VR like *Tales of Wedding Rings VR* (Square Enix, 2018). MyDearest's narratives stage a battle for control over the virtual enclosure quite explicitly, while in the latter two texts, VR becomes the site for an encounter between modern and premodern forms of spatial authority.

In this twenty-first century context, the VR enclosure serves as an even deeper immersion into a media landscape already shaped by platform politics and surveillant sensor networks. The fantasy in this case is not one of escape from the existing reality, but to learn enough about how the system works to wrest control from the dominant platform powers and began operating as game master of the virtual world oneself.

This fantasy of ambient power generally approaches the VR enclosure as the site of a zero-sum battle for domination over perceptual space. But the more difficult question is how to envision a VR future governed by something other than a small set of corporate landlords and the same old geopolitical struggles. The development of more open platforms will likely be key to ensure that the social enclosure of virtual reality is not

organized entirely at the whims of a few select companies (or countries). But there is also a need to confront more directly the ambient power play of the VR headset itself: what it means for a media interface to assert control over someone's spatial awareness. I hope this book has offered some helpful ways to map out what happens when VR moves to reroute how we locate ourselves in the world.

ACKNOWLEDGMENTS

Thank you to everyone who provided the time, space, and travel opportunities essential for a book like this to happen. The project came together at the Massachusetts Institute of Technology (MIT) with the support of those in the (now defunct) Global Studies and Languages (GSL) section, and from my new home next door in Comparative Media Studies/Writing (CMS/W). Emma Teng, Ian Condry, Bruno Perreau, and the late Jing Wang each helped steer me through my initial years on campus and made sure that I could carve out enough of my own enclosure to get this project done.

Along with generous research leave support from MIT, the Mitsui Career Development Professorship in Contemporary Technology provided funds for a number of research trips to Japan, and allowed me to update my VR setup often enough to keep up with the latest developments. The project's most extended stay in the Tokyo area and excursions to VR events around the country were supported by a long-term research fellowship from the Japan Foundation. Yoshitaka Mouri and the Tokyo University of the Arts graciously hosted me during this research year. Thank you to the GSL, CMS/W, and Japan Foundation staff members for their help managing the day-to-day logistics.

For invitations to workshop these ideas with interdisciplinary audiences across several continents, I thank Jonathan Abel, Brooke Belisle, Andrew Campana, Kirsten Cather, Jennifer Coates, Yulia Frumer, Verina Gfader, Mack Hagood, David Humphrey, Diane Wei Lewis, Yoshitaka

Mouri, Samuel Perry, and Jeremy Yellen. Alexander Zahlten read several chapter drafts and served as a valuable sounding board. Marc Steinberg provided insightful feedback and sources in response to panel presentations at several stages along the way. My understanding also benefited from discussions, classes, and events related to VR and/or the book project at MIT with Takako Aikawa, Paloma Duong, Sandra Rodriguez, T. L. Taylor, William Uricchio, the Open Doc Lab, and the VR@MIT group.

Thank you to everyone in the Japanese VR scene who took the time to speak with me at the events, meetups, festivals, conferences, and startups I visited, and participants in the lively and ongoing VR discussion on Twitter. While I don't expect everyone will agree with all my conclusions here, the project was consistently spurred on by the warmth and enthusiasm of those I met during the fieldwork. My understanding of the VR industry as it reemerged across these past five years is also indebted to the daily reporting and critical perspectives of VR journalists both in Japan and the United States (many of them cited in the preceding chapters).

For their work shaping all this into a book, thank you to Philip Leventhal, the production team at Columbia University Press, and the anonymous reviewers whose feedback helped refine this text into its current form. Thank you as well to the editors and readers of the articles written on the way to these chapters, from *Real Life* and *LOGIC* magazines and the journals *Visual Culture, Sound Studies*, and *Media Theory*. An earlier version of chapter 1 appeared as "Acoustics of the One Person Space: Headphone Listening, Detachable Ambience, and the Binaural Prehistory of VR" in *Sound Studies* 7, no. 1 (2021): 42–63. Used with permission of the publisher (Informa UK Limited/Taylor & Francis Group). An earlier version of chapter 3 appeared as "Telepresence Enclosure: VR, Remote Work, and the Privatization of Presence in a Shrinking Japan" in *Media Theory* 4, no. 1 (2020): 33–62.

Finally, family remains a foundational space shaping everything I've been able to perceive here, especially when a pandemic pushes telepresence to its limits. A distant but hopefully resounding hello to the Roquet and Carvalho families back on the West Coast of the United States, and the Shimizu family up in Akita, Japan. Here in Massachusetts, the better part of my reality is thanks to Momoko Roquet Shimizu. To paraphrase the early VR article in the *Boston Globe*: all this technology pales in comparison to a wander together through the New England woods.

NOTES

INTRODUCTION

1. I occasionally experienced this night-sky view using the original Oculus Rift (2016). The phenomenon appears to have been eliminated in more recent headsets, which plunge you into a more complete darkness.

2. While *head-mounted display* (HMD) is the more common term, in this book I primarily use *headset* to refer to the screen and headphones together, reserving *head-mounted display* to refer to just the visual interface alone.

3. Karl Marx, *Capital: Volume 1: A Critique of Political Economy*, illustrated edition, trans. Ben Fowkes (New York: Penguin Classics, 1992), 881.

4. Mark Andrejevic, *iSpy: Surveillance and Power in the Interactive Era* (Lawrence: University Press of Kansas, 2007), 105–7. See also Ronald V. Bettig, "The Enclosure of Cyberspace," *Critical Studies in Mass Communication* 14, no. 2 (June 1997): 138–57; Nick Dyer-Witheford and Greig De Peuter, *Games of Empire: Global Capitalism and Video Games* (Minneapolis: University of Minnesota Press, 2009), 125–26.

5. Leighton Evans, *The Re-Emergence of Virtual Reality* (New York: Routledge, 2018), 38–48; Marcus Carter and Ben Egliston, "What Are the Risks of Virtual Reality Data?: Learning Analytics, Algorithmic Bias and a Fantasy of Perfect Data," *New Media & Society*, in press.

6. Mark Weiser, "The Computer for the 21st Century," *Scientific American* (September 1991): 94–95.

7. Cinema scholar Miriam Ross notes, for example, how in VR "the user is continuously situated at the center of the sensorial experience," with point-of-view shots serving as the "dominant spectatorial position." Miriam Ross, "Virtual Reality's New Synesthetic Possibilities," *Television & New Media* 21, no. 3 (March 2020): 302–3. For similar comments see also Brenda Laurel, *Computers as Theatre*, 2nd ed. (Upper Saddle River, NJ:

Addison-Wesley, 2013), 205; J. David Bolter and Richard A. Grusin, *Remediation: Understanding New Media* (Cambridge, MA: MIT Press, 1999), 22.

8. Lev Manovich, *The Language of New Media* (Cambridge, MA: MIT Press, 2001); Oliver Grau, *Virtual Art: From Illusion to Immersion* (Cambridge, MA: MIT Press, 2003); Daikoku Takehiko, *Vācharu shakai no 'tetsugaku': Bittokoin, VR, Posutoturūsu* (Tokyo: Seidosha, 2018), 258–60.

9. See Scott C. Richmond, *Cinema's Bodily Illusions: Flying, Floating, and Hallucinating* (Minneapolis: University of Minnesota Press, 2016).

10. Paul Roquet, *Ambient Media: Japanese Atmospheres of Self* (Minneapolis: University of Minnesota Press, 2016), 4.

11. Leo Spitzer, "Milieu and Ambiance: An Essay in Historical Semantics," *Philosophy and Phenomenological Research* 3, no. 1 (September 1942): 13.

12. Karen Pinkus, "Ambiguity, Ambience, Ambivalence, and the Environment," *Common Knowledge* 19, no. 1 (January 1, 2013): 93. Pinkus specifically mentions the dummy heads used to record binaural audio (discussed in chapter 1) as an example of the more precise ambient capture of bilateral human sensing.

13. Head-mounted AR displays sit somewhere between VR and more architectural approaches, taking up the individualized ambient mediation of the HMD but asserting less complete control over the visual field. On the intersection of the surrounding ambience with the computationally derived spaces inside VR, see Paul Roquet, "Ambiance In and Around the Virtual Reality Headset," in *Proceedings of the 4th International Congress on Ambiances, Alloaesthesia: Senses, Inventions, Worlds*, vol. 2 (France: Réseau International Ambiances, 2020), 14–19.

14. I suffered from all of these on numerous occasions while using VR during the research for this book, but it is important to emphasize that the discomfort of the headset is also unevenly distributed, generally increasing the further one's body diverges from the "default" VR user imagined by the hardware designers. When it comes to gender, for example, MacArthur et al. note how most VR cybersickness research "implicitly positions men as the control group with 'normal' experiences in VR, and the essentialized category of women as the deviant group to be ameliorated." Cayley MacArthur et al., "You're Making Me Sick: A Systematic Review of How Virtual Reality Research Considers Gender & Cybersickness," in *Proceedings of the 2021 CHI Conference on Human Factors in Computing Systems* (CHI '21: CHI Conference on Human Factors in Computing Systems, Yokohama Japan: ACM, 2021), 10.

15. As the science fiction writer Takashima Yūya puts it, " 'VR sickness' [*VR yoi*] is what helps make us aware we are at the midway point between reality and VR." Takashima Yūya, "Uso no shōshitsu: VR wa shōsetsu o ukeirerareru no ka," *SF magajin* (December 2016): 42.

16. Laurel, *Computers as Theatre*, 184. This need for a verbal supplement is nothing new when it comes to head-mounted interfaces. Art historian Maki Fukuoka describes a similar dynamic at late-eighteenth/early-nineteenth century Japanese *misemono* street fair attractions featuring a peep-box (*nozoki-megane*), a wooden box on legs housing an image within that can be seen by looking through a small lens installed on the side.

A peep-box lecturer would help verbally guide each participant on where to look and what they were seeing once a person was installed in front of the device. While the peep-box was promised to make viewers feel like they were present in the scene before them, much like VR today, in practice an explanatory verbal supplement was necessary to make up for the times when the blurry and fractured lenses on the devices fell short. What ultimately generated the "immersive" feeling of the peep-box view went far beyond the imaging technologies alone, relying on the lecturer's enthusiastic explanations and the festive *misemono* atmosphere. Maki Fukuoka, "Contextualizing the Peep-Box in Tokugawa Japan," *Early Popular Visual Culture* 3, no. 1 (May 2005): 22–24. For a parallel argument focusing on stereoscope spectacles in the early twentieth century United States, see Leon Gurevitch, "The Stereoscopic Attraction: Three-Dimensional Imaging and the Spectacular Paradigm 1850–2013," *Convergence* 19, no. 4 (November 2013): 401. Jon McKenzie similarly notes how these explanatory guides, whom he calls "prompters," became a decisive factor in shaping the "techno-performativity" of the VR demo experience during early 1990s VR events. Jon McKenzie, "Virtual Reality: Performance, Immersion, and the Thaw," *The Drama Review* 38, no. 4 (1994): 83–106. On VR as a sideshow attraction, see also Dan Golding, "Far from Paradise: The Body, the Apparatus and the Image of Contemporary Virtual Reality," *Convergence* 25, no. 2 (2017): 340–53.

17. Bolter and Grusin, *Remediation*, 21. See also Grau, *Virtual Art*, 349.

18. John Perry Barlow and Jaron Lanier, "Life in the DataCloud: Scratching Your Eyes Back In—John Perry Barlow Interviews Jaron Lanier," *Mondo 2000*, no. 2 (Summer 1990): 46.

19. Jeremy Bailenson, *Experience on Demand: What Virtual Reality Is, How It Works, and What It Can Do* (New York: Norton, 2018), 45.

20. Quoted in Michael LaRocco, "Developing the 'Best Practices' of Virtual Reality Design: Industry Standards at the Frontier of Emerging Media," *Journal of Visual Culture* 19, no. 1 (April 2020), 101.

21. Ken Hillis, *Digital Sensations: Space, Identity, and Embodiment in Virtual Reality* (Minneapolis: University of Minnesota Press, 1999), xxxvii, 58.

22. See the website, "Comolu," http://comolu.info/.

23. Tweet from @Atsuki_dash, April 11, 2018 (my translation).

24. While diminished reality is usually defined as an alternative approach to VR and AR, I would argue the VR headset is already a form of diminished reality the moment it blocks out a person's immediate surroundings. See Shohei Mori, Sei Ikeda, and Hideo Saito, "A Survey of Diminished Reality: Techniques for Visually Concealing, Eliminating, and Seeing Through Real Objects," *IPSJ Transactions on Computer Vision and Applications* 9, no. 1 (December 2017): 1–14.

25. David Jagneaux, "Oculus Go Review: Standalone VR For the Masses," *UploadVR*, May 2, 2018, https://uploadvr.com/oculus-go-review-standalone-vr/. Taiwan-based HTC has recently begun aligning their products more directly with this portable media tradition, with HTC Chairwoman and CEO Cher Wang promising the company's highly portable VIVE Flow headset (2021) would provide "the perfect opportunity to escape our four walls and immerse ourselves in our ideal ambience." VIVE, "HTC VIVE Breaks New

Ground with Launch of Portable VIVE Flow Immersive Glasses," October 14, 2021, https://www.vive.com/us/newsroom/2021-10-14. On the portable media tradition in Japan, see Mizuko Ito, Daisuke Okabe, and Misa Matsuda, eds., *Personal, Portable, Pedestrian: Mobile Phones in Japanese Life* (Cambridge, MA: MIT Press, 2005).

26. See Simon Partner, *Assembled in Japan: Electrical Goods and the Making of the Japanese Consumer* (Berkeley: University of California Press, 2000); Tomiko Yoda, "The Rise and Fall of Maternal Society: Gender, Labor, and Capital in Contemporary Japan," *South Atlantic Quarterly* 99, no. 4 (October 1, 2000): 872–73.

27. Yoda, "The Rise and Fall of Maternal Society," 877–78.

28. On the new media environments emerging around men in the early 1970s, see Yoshikuni Igarashi, *Japan, 1972: Visions of Masculinity in an Age of Mass Consumerism* (New York: Columbia University Press, 2021).

29. Marilyn Ivy, "Formations of Mass Culture," in *Postwar Japan as History*, ed. Andrew Gordon (Berkeley: University of California Press, 1993), 239–58.

30. Roquet, *Ambient Media*, 9–14.

31. Ōtsuka Eiji, "Mechademia in Seoul: Ōtsuka Eiji Keynote," trans. Alexander Zahlten, *Electronic Journal of Contemporary Japanese Studies* 17, no. 1 (April 23, 2017), https://www.japanesestudies.org.uk/ejcjs/vol17/iss1/otsuka.html.

32. Chris Chesher, "Colonizing Virtual Reality: Construction of the Discourse of Virtual Reality, 1984–1992," *Cultronix* 1 (1994): 15–28.

33. See Bailenson, *Experience on Demand*, 29.

34. Shin Kiyoshi, *VR bijinesu no shōgeki: 'Kasō sekai' ga kyodai manē o umu* (Tokyo: NHK shuppan, 2016), 87–89.

35. See Ryo Ikeda, "Big in Japan: Best Practices for Japanese Developers," https://www.facebook.com/watch/live/?v=313847663239317. This is not to say it has been an easy road to mass consumer adoption. For an even-handed take on the Japanese VR market circa 2018, see "Yume kara sameta VR: Bijinesu no genjō to mirai e no kadai," *Boss* (January 2019): 21–26.

36. Ikeda, "Big in Japan."

37. Shin, *VR bijinesu no shōgeki*, 23.

38. Kyōhei Mizutani, "VR Gaming in Japan: Bridging the Cultural Gap," *VRFocus*, October 9, 2020, https://www.vrfocus.com/2020/10/vr-gaming-in-japan-bridging-the-cultural-gap/.

39. See Marc Steinberg, *Anime's Media Mix: Franchising Toys and Characters in Japan* (Minneapolis: University of Minnesota Press, 2012), chap. 4.

40. The most influential here is Azuma Hiroki, *Otaku: Japan's Database Animals*, trans. Jonathan E. Abel and Shion Kono (Minneapolis: University of Minnesota Press, 2009).

41. See, for example, Alexander Zahlten, *The End of Japanese Cinema: Industrial Genres, National Times, and Media Ecologies* (Durham, NC: Duke University Press, 2017); Thomas Lamarre, *The Anime Ecology: A Genealogy of Television, Animation, and Game Media* (Minneapolis: University of Minnesota Press, 2018).

42. Steinberg, *Anime's Media Mix*, 44.

43. Shūhei Hosokawa, "The Walkman Effect," in *The Sound Studies Reader*, ed. Jonathan Sterne (New York: Routledge, 2012), 104–16.

44. As W. J. T. Mitchell and Mark B. N. Hansen point out, the role of media in the "historically changing sensory and perceptual 'ratios' of human experience" has been a key concern in media studies going back to Marshall McLuhan. W. J. T. Mitchell and Mark B. N. Hansen, eds., *Critical Terms for Media Studies* (Chicago: University of Chicago Press, 2010), xii. In addition to the work on media architecture and interior design history discussed in the first chapter, I also draw inspiration here from a range of recent studies of the spatial politics of the interface. This work has emerged largely within a game studies context, including James Ash, *The Interface Envelope: Gaming, Technology, Power* (New York: Bloomsbury Academic, 2016); Kiri Miller, *Playable Bodies: Dance Games and Intimate Media* (New York: Oxford University Press, 2017); and Brendan Keogh, *A Play of Bodies: How We Perceive Videogames* (Cambridge, MA: MIT Press, 2018).

45. As both Ōtsuka Eiji and Marc Steinberg's recent work emphasizes, the anime media mix can be understood as a predecessor to the "walled garden" internet platforms that first begin to emerge on Japanese cell phone networks around the turn of the twenty-first century. I offer VR here as another missing link between these two periods, one where the perceptual politics of the emerging computational media environments play out most vividly. Ōtsuka Eiji, *Kanjō-ka suru shakai* (Tokyo: Ōta shuppan, 2016); Marc Steinberg, *The Platform Economy: How Japan Transformed the Consumer Internet* (Minneapolis: University of Minnesota Press, 2019).

46. See, for example, Howard Rheingold, *Virtual Reality: The Revolutionary Technology of Computer-Generated Artificial Worlds—and How It Promises to Transform Society* (New York: Simon & Schuster, 1992); Barrie Sherman and Phillip Judkins, *Glimpses of Heaven, Visions of Hell: Virtual Reality and Its Implications* (London: Coronet, 1993); Benjamin Wooley, *Virtual Worlds: A Journey in Hype and Hyperreality* (London: Penguin, 1994); Ralph Schroeder, *Possible Worlds: The Social Dynamics of Virtual Reality Technology* (Boulder, CO: Westview Press, 1996); and, more recently, Jaron Lanier, *Dawn of the New Everything: Encounters with Reality and Virtual Reality* (New York: Henry Holt, 2017).

47. Janet Murray's classic *Hamlet on the Holodeck*, for example, situates the immersive interface (via *Star Trek*) as a "universal fantasy machine" independent of local context. Janet H. Murray, *Hamlet on the Holodeck: The Future of Narrative in Cyberspace*, updated edition (Cambridge, MA: MIT Press, 2017), 15.

48. Mark B. N. Hansen, *Bodies in Code: Interfaces with Digital Media* (New York: Routledge, 2006).

49. In East Asia alone, China, South Korea, and Taiwan are also home to vibrant and complex (if more recent) engagements with VR, intersecting in complex ways with everything described here.

1. ACOUSTICS OF THE ONE-PERSON SPACE

1. Steven Jones, "A Sense of Space: VR, Authenticity, and the Aural," *Critical Studies in Mass Communication* 10 (1993): 238–52; Frances Dyson, "When Is the Ear Pierced?: The

Clashes of Sound, Technology and Cyberculture," in *Immersed in Technology: Art and Virtual Environments*, ed. Mary Anne Moser (Cambridge, MA: MIT Press, 1996), 73–101.

2. Bruce Headlam, "Origins: Walkman Sounded Bell for Cyberspace," *New York Times*, July 29, 1999.

3. Jones, "A Sense of Space," 239.

4. John Carmack, *Oculus Connect 5 Keynote* (San Jose, California, 2018), https://youtu.be /VW6tgBcN_fA.

5. Jones, "A Sense of Space," 241.

6. Jocelyn Szczepaniak-Gillece, *The Optical Vacuum: Spectatorship and Modernized American Theater Architecture* (New York: Oxford University Press, 2018); Emily Ann Thompson, *The Soundscape of Modernity: Architectural Acoustics and the Culture of Listening in America, 1900–1933* (Cambridge, MA: MIT Press, 2002), 7.

7. Peter Doyle, *Echo and Reverb: Fabricating Space in Popular Music Recording, 1900–1960* (Middletown, CT: Wesleyan University Press, 2005).

8. Jonathan Sterne, "Space Within Space: Artificial Reverb and the Detachable Echo," *Grey Room* 60 (July 2015): 111, 114.

9. Sterne, "Space Within Space," 119–20.

10. Sterne, "Space Within Space," 114.

11. Sterne, "Space Within Space," 116.

12. Judith Williamson, *Consuming Passions: The Dynamics of Popular Culture* (London: Marion Boyars, 1986), 210.

13. Michael Bull, *Sound Moves: iPod Culture and Urban Experience* (New York: Routledge, 2008), 5, 33. For a more recent example, see Lindsay Mannering, "Now Playing in Your Headphones: Nothing," *New York Times*, January 19, 2018.

14. Mack Hagood, *Hush: Media and Sonic Self-Control* (Durham, NC: Duke University Press, 2019), 195.

15. Iain Chambers, "A Miniature History of the Walkman," *New Formations* 11 (1990): 3.

16. For exceptions, see Barry Blesser and Linda-Ruth Salter, *Spaces Speak, Are You Listening?: Experiencing Aural Architecture* (Cambridge, MA: MIT Press, 2009); Gascia Ouzounian, *Stereophonica: Sound and Space in Science, Technology, and the Arts* (Cambridge, MA: MIT Press, 2021).

17. Bose's wearable audio-only AR glasses are the most prominent product along these lines so far, but spatial audio has made inroads in many areas of audio production and consumption. The Audio Engineering Society, the main professional organization for audio engineers, focused on mobile spatial audio and AR audio (along with assistive listening) as key themes for their 2019 conference. On sonic AR, see Mack Hagood, "Here: Active Listening System: Sound Technologies and the Personalization of Listening," in *Appified: Culture in the Age of Apps*, ed. Jeremy Wade Morris and Sarah Murray (Ann Arbor: University of Michigan Press, 2018): 276–85.

18. For example, Michael Bull, "Thinking About Sound, Proximity, and Distance in Western Experience: The Case of Odysseus's Walkman," in *Hearing Cultures: Essays on Sound, Listening and Modernity*, ed. Viet Erlmann (Oxford: Berg, 2004), 173–91. This is despite important early Walkman essays focused on East Asian contexts, including Shūhei

Hosokawa, "The Walkman Effect," in *The Sound Studies Reader*, ed. Jonathan Sterne (New York: Routledge, 2012); Rey Chow, "Listening Otherwise, Music Miniaturized: A Different Type of Question About Revolution," *Discourse* 13, no. 1 (1990): 129–48.

19. Yamamoto Seishū, "Heddohon o rikai suru kōza," *Rajio gijutsu*, February 1975, 225.

20. On telephone switchboards in Japan, see Yoshimi Shunya, *'Koe' no shihonshugi: Denwa, rajio, chikuonki no shakaishi* (Tokyo: Kawade shobō shinsha, 2012); Kerim Yasar, *Electrified Voices: How the Telephone, Phonograph, and Radio Shaped Modern Japan, 1868–1945* (New York: Columbia University Press, 2018), 48–51.

21. Jonathan Sterne, *The Audible Past: Cultural Origins of Sound Reproduction* (Durham, NC: Duke University Press, 2003), 158.

22. Steve J. Wurtzler, *Electric Sounds: Technological Change and the Rise of Corporate Mass Media* (New York: Columbia University Press, 2008), 263.

23. Stefan Krebs, "The Failure of Binaural Stereo: German Sound Engineers and the Introduction of Artificial Head Microphones," *ICON* 23 (2017): 119–20. For more on "Oscar, the Auditory Perspective Dummy," see Ouzounian, *Stereophonica*, chap. 4.

24. Quoted in Krebs, "The Failure of Binaural Stereo," 120.

25. Wurtzler, *Electric Sounds*, 263.

26. Quoted in Paul Théberge, Kyle Devine, and Tom Everrett, eds., *Living Stereo: Histories and Cultures of Multichannel Sound* (New York: Bloomsbury Academic, 2015), 23–24.

27. Sterne, *The Audible Past*, 161–67.

28. Iguchi Seiji, "Denpa no sekai no miharashidai," *Denpa kagaku* (January 1955): 141. See also Steven C. Ridgely, *Japanese Counterculture: The Antiestablishment Art of Terayama Shuji* (Minneapolis: University of Minnesota Press, 2011), 51–53.

29. "Jōhōriron," *Shindenki*, February 1955, 113.

30. Quoted in Théberge, Devine, and Everrett, *Living Stereo*, 24.

31. Nishimaki Yasao, "Watashi no bainōraru rokuon saisei hōshiki no susume to jissai," *Rajio gijutsu* (July 1976): 248. On the West German context, see Heike Weber, "Head Cocoons: A Sensori-Social History of Earphone Use in West Germany, 1950–2010," *The Senses and Society* 5, no. 3 (November 2010): 339–63.

32. On the long-running quest to render hearing aids "invisible," see Mara Mills, "Hearing Aids and the History of Electronic Miniaturization," *IEEE Annals for the History of Computing* 33, no. 2 (2011): 24–44.

33. Iguchi, "Denpa no sekai no miharashidai," 140–41; See also *Sutereo haifai seisaku dokuhon* (Tokyo: Seibundō shinkōsha, 1962), 14.

34. *Sutereo haifai seisaku dokuhon*, 14.

35. Krebs, "The Failure of Binaural Stereo," 139. Krebs is describing the West German context, but the point holds just as well for Japan.

36. The latter segment is based on Pauline Réage's erotic novel *Story of O* (*Histoire d'O*, 1954), which had recently received a 1975 Franco-German film adaptation directed by Just Jaeckin. On the similar gendering of proximate binaural whispers in a more recent ASMR (autonomous sensory meridian response) context, see Joceline Andersen, "Now You've Got the Shiveries: Affect, Intimacy, and the ASMR Whisper Community," *Television & New Media* 16, no. 8 (December 2015): 683–700.

37. See, for example, Weber, "Head Cocoons," 347; Keir Keightley, " 'Turn It Down!' She Shrieked: Gender, Domestic Space, and High Fidelity, 1948–59," *Popular Music* 15, no. 2 (May 1996): 149–77.

38. Wakabayashi Shunsuke, "Iyāfōn!?: Sutereo saisei to bainōraru saisei no chigai, Sono 1," *Rekōdo geijutsu* (April 1961): 162.

39. Wakabayashi, "Iyāfon!?," 162 (my translation).

40. Wakabayashi, "Iyāfon!?," 162–63.

41. Wakabayashi, "Iyāfon!?," 163 (my translation).

42. Wakabayashi, "Iyāfon!?," 163.

43. Weber, "Head Cocoons," 343–46.

44. Stephen Groening, " 'No One Likes to Be a Captive Audience': Headphones and In-Flight Cinema," *Film History* 28, no. 3 (2016): 117.

45. See Blesser and Salter, *Spaces Speak, Are You Listening?*, for a detailed examination of the acoustics of in-head localization.

46. Krebs, "The Failure of Binaural Stereo," 117.

47. As Blesser and Salter note, this problem occurs because individual differences in the shape of the outer ear (the pinna) are crucial to how the brain locates sounds in front of or behind the body—a generic or average outer ear like the dummy head's is ineffective. Recent Sony-sponsored research at Princeton University's 3D Audio and Applied Acoustics Lab has focused on how to incorporate individual three-dimensional scans of a listener's pinna into the spatial audio processing to provide a more custom virtual localization. Blesser and Salter, *Spaces Speak, Are You Listening?*, 188. In the Japan context, see Nishimaki, "Watashi no bainōraru," 250; Ridgely, *Japanese Counterculture*, 66.

48. Quoted in Krebs, "The Failure of Binaural Stereo," 124.

49. Quoted in Krebs, "The Failure of Binaural Stereo," 133.

50. Krebs, "The Failure of Binaural Stereo," 134. On the complex history of audio fidelity promises, see Sterne, *The Audible Past*, 215–86.

51. Yamamoto, "Heddohon o rikai suru kōza," 225–26.

52. Gotō Toshiyuki et al., "Bainōraru juchō no onzō tōgai teii ni okeru zankyōon no yakuwari ni tsuite," *Chōkaku kenkyūkai shiryō* 31, no. 1 (January 1976): 14–17; Gotō Toshiyuki, Kimura Yōichi, and Watanabe Kōji, "Bainōraru rokuonhō," *National Technical Report* 22, no. 4 (August 1976): 469–77.

53. Yamada Akitoshi and Kikuchi Yoshinobu, "Tekunikusu Anbiensuhon no tokuchō," *Rajio gijutsu* (July 1976): 251.

54. Groening, " 'No One Likes to Be a Captive Audience,' " 133.

55. See Paul Roquet, *Ambient Media: Japanese Atmospheres of Self* (Minneapolis: University of Minnesota Press, 2016), for more on the broader turn to ambient aesthetics at the time.

56. Weber, "Head Cocoons," 340.

57. Shu Ueyama excerpted in Paul du Gay et al., *Doing Cultural Studies: The Story of the Sony Walkman*, 2nd ed. (Thousand Oaks, CA: SAGE, 2013), 131.

58. Weber, "Head Cocoons," 352.

59. Facebook would later make a similar bet by focusing on lower-powered but easier-to-use stand-alone VR headsets

60. Quoted in du Gay et al., *Doing Cultural Studies*, 59.

61. Quoted in du Gay et al., *Doing Cultural Studies*, 59.

62. Hosokawa, "The Walkman Effect," 106.

63. See Hosokawa, "The Walkman Effect."

64. Weber, "Head Cocoons," 353; Rebecca Tuhus-Dubrow, *Personal Stereo* (New York: Bloomsbury Academic, 2017), 44.

65. Alexander G. Weheliye, *Phonographies: Grooves in Sonic Afro-Modernity* (Durham, NC: Duke University Press, 2005), 133.

66. Sterne, *The Audible Past*, 160.

67. Ōtsuka Eiji goes so far as to locate the origins of Japan's *kawaii* ("cute") culture in this shift to individual rooms for children, noting how girls began to fill their rooms with consumer goods as a retreat from the outside world. Ōtsuka Eiji, *Shōjo minzoku-gaku: Seikimatsu no shinwa o tsumugu 'miko no matsuei'* (Tokyo: Kōbunsha, 1989).

68. Weber, "Head Cocoons," 347–51. A similar trend is already emerging with stand-alone VR headsets, such as the marketing of the HTC VIVE Flow (2021) as "VR glasses made for relaxation, wellness, and mindful productivity."

69. Nango Yoshikazu, *Hitori kūkan no toshiron* (Tokyo: Chikuma shinsho, 2018), 89.

70. Nango, *Hitori kūkan no toshiron*, 92.

71. Nango, *Hitori kūkan no toshiron*, 98; Tsuzuki Kyōichi, *Tokyo Style* (Tokyo: Chikuma shobō, 1993).

72. A related phenomenon emerged in the United States by the mid-1980s, popularized by marketing consultant Faith Popcorn as *cocooning*, a practice of staying inside the home surrounded by videocassette recorders and compact disc players rather than venturing out into the "scary" outside world. Popcorn describes cocooning in 1987 as "a rapidly accelerating trend toward insulating oneself from the harsh realities of the outside world and building the perfect environment to reflect one's personal needs and fantasies." Quoted in Beth Ann Krier, "The Essence of Cocooning," *Los Angeles Times*, August 7, 1987.

73. The phrase is from Kogawa Tetsuo, *Nyū media no gyakusetsu* (Tokyo: Shōbunsha, 1984), quoted in Anne Allison, *Millennial Monsters: Japanese Toys and the Global Imagination* (Berkeley: University of California Press, 2006), 89.

74. Thomas Lamarre, *The Anime Ecology: A Genealogy of Television, Animation, and Game Media* (Minneapolis: University of Minnesota Press, 2018), 200–201.

75. Takemura Mitsuhiro, "Onzō sōsa, shimyurakuru no rinkaiten: Seitai media to 'horofonikusu,'" *Yuriika* (June 1987): 165; Takemura Mitsuhiro, "'Genjitsu' o yurugaseru oto: Onzō shimyurēshon 'horofonikusu,'" *Kōkoku* (September 1987): 21. For a helpful breakdown of binaural and holophonic techniques and issues with the latter's claims, see Mark A. Jay, "Holophonic vs. Binaural," *Gearspace*, May 19, 2010, https://www.gearspace.com/board/all-things-technical/493726-holophonic-vs-binaural.html.

76. Takemura, "Onzō sōsa, shimyurakuru no rinkaiten," 163.

77. See Jones, "A Sense of Space," 244; Blesser and Salter, *Spaces Speak, Are You Listening?*, 194–98.

78. In industry parlance, a three-degrees-of-freedom system can track the device's rotation along three axes, but it cannot sense movement through space. A six-degrees-of-freedom

system also tracks the device's physical displacement in three dimensions, allowing a user to "move" through virtual space. See chapter 3 for more on the history of this metric.

79. Oliver Grau, *Virtual Art: From Illusion to Immersion* (Cambridge, MA: MIT Press, 2003), 168.

80. See Jones, "A Sense of Space," 240; The quote is from Jonathan Crary, *Techniques of the Observer: On Vision and Modernity in the Nineteenth Century* (Cambridge, MA: MIT Press, 1990), 102.

81. Thomas A. Furness, "Harnessing Virtual Space," *Proceedings of SID International Symposium Digest of Technical Papers*, 1988, 5.

82. Williamson, *Consuming Passions*, 210; Morita quoted in Barrie Sherman and Phillip Judkins, *Glimpses of Heaven, Visions of Hell: Virtual Reality and Its Implications* (London: Coronet Books, 1993), 15.

83. Andrew Pollack, "For Artificial Reality, Wear a Computer," *New York Times*, April 10, 1989.

84. Steve Annear, "Please Keep Your Virtual Reality Off the T," *Boston Globe*, April 1, 2016.

85. GOROman, *Mirai no tsukurikata 2020–2045: Boku ga VR ni kakeru wake* (Tokyo: Seikaisha shinsho, 2018), 132–40.

86. Shin Kiyoshi, *VR bijinesu no shōgeki: 'Kasō sekai' ga kyodai manē o umu* (Tokyo: NHK shuppan, 2016), 12–13. *Otaku* is a complex term and has been defined many ways, but for this book I use it to refer to anime/manga and computer enthusiasts in Japan who self-identify using the term. For an overview of debates surrounding the concept, see the essays in Patrick W. Galbraith, Thiam Huat Kam, and Björn-Ole Kamm, eds., *Debating Otaku in Contemporary Japan: Historical Perspectives and New Horizons* (New York: Bloomsbury Academic, 2015).

2. TRANSLATING THE VIRTUAL INTO JAPANESE

1. Jens Schröter, *3D: History, Theory and Aesthetics of the Transplane Image*. Rev. ed. Trans. Brigitte Pichon and Dorian Rudnytsky (New York: Bloomsbury Academic, 2014), 15.

2. On VR flight simulator history, see Patrick Crogan, *Gameplay Mode: War, Simulation, and Technoculture* (Minneapolis: University of Minnesota Press, 2011), 37–58.

3. Morton L. Heilig, Sensorama Simulator, 3050870, filed January 10, 1961, and issued August 28, 1962.

4. Ivan E. Sutherland, "A Head-Mounted Three Dimensional Display," in *Proceedings of the December 9–11, 1968, Fall Joint Computer Conference, Part I—AFIPS '68* (San Francisco: ACM Press, 1968), 757.

5. Ivan E. Sutherland, "The Ultimate Display," in *Proceedings of International Federation of Information Processing (IFIP)* (London: Macmillan, 1965), 506–8.

6. For example, one of VPL's launch demos for their "Reality Built for Two" system (see later in the chapter) included a version of the novel's "Mad Tea-Party," where the VR user became the teapot. John Walker's famous memo, also discussed later in the chapter, would be called "Through the Looking Glass" and reference Jefferson Airplane's 1967 hit

"Go Ask Alice." Ken Pimentel's 1993 book on VR is similarly subtitled *Through the New Looking Glass*. More recently, *Down the Rabbit Hole* (Cortopia Studios, 2019) and *Curious Alice* (Preloaded, 2020) provide more direct reinterpretations of Carroll's stories in VR. See also chapter 4, endnote 29 on Japanese references to *Alice*. Ken Pimentel, *Virtual Reality: Through the New Looking Glass* (New York: Intel/Windcrest, 1993).

7. Sutherland, "The Ultimate Display."

8. Crogan, *Gameplay Mode*, 43–44.

9. A fictionalized scenario exploring Sutherland's premise can be found in the "Phantom Bullet" arc (vols. 5–6) of Kawahara Reki's *Sword Art Online* light novel series (discussed in chapter 4), in which a player in the *Gun Gale Online* multiplayer VR battle royale shooting game appears to have figured out how to shoot someone in the game and have it be fatal to them in real life. The series presents *Gun Gale Online* as the creation of an American VR developer.

10. Thomas A. Furness, "Virtual Cockpit's Panoramic Displays Afford Advanced Mission Capabilities," *Aviation Week & Space Technology* (1985): 143–52. As Sherman and Judkins note, "VR was first used to deliver missiles more accurately, so that they would destroy and kill more efficiently." Barrie Sherman and Phillip Judkins, *Glimpses of Heaven, Visions of Hell: Virtual Reality and Its Implications* (London: Coronet Books, 1993), 29.

11. Fisher's 1981 MIT master's thesis on interactive stereoscopic displays opens with a reference to Kurosawa Akira's *Rashōmon* (1950), arguing that, like the film, contemporary imaging techniques challenge viewers to synthesize a coherent image from several different viewpoints. Scott Fisher, "Viewpoint Dependent Imaging: An Interactive Stereoscopic Display" (master's thesis, Massachusetts Institute of Technology, 1981), 4–5.

12. Quoted in Matt Binder, "Microsoft Signs $480 Million HoloLens Contract with U.S. Military to 'Increase Lethality,' " *Mashable*, November 29, 2018, https://mashable.com /article/microsoft-hololens-us-military-contract/.

13. See Paul Roquet, "Empathy for the Game Master: How Virtual Reality Creates Empathy for Those Seen to Be Creating VR," *Journal of Visual Culture* 19, no. 1 (April 2020): 74–76; Daniel Harley, "Palmer Luckey and the Rise of Contemporary Virtual Reality," *Convergence* 26, no. 5–6 (2020): 1144–58.

14. See Simon Partner, *Assembled in Japan: Electrical Goods and the Making of the Japanese Consumer* (Berkeley: University of California Press, 2000).

15. Ōkoshi Takanori, *Three-Dimensional Imaging Techniques* (New York: Academic Press, 1976).

16. Toyohiko Hatada, Haruo Sakata, and Hideo Kusaka, "Psychophysical Analysis of the 'Sensation of Reality' Induced by a Visual Wide-Field Display," *SMPTE Journal* 89 (1980): 568. The push for increased realism continues to be a focus of the NHK labs, most recently with their emphasis on "Super Hi-Vision" 8K broadcasts.

17. Ishii would later become known for the development of the autonomous distributed system (ADS), an approach to the flexible management of transportation infrastructure modeled on human biological systems. The ADS was first introduced in the Kobe subway system in 1982 and is now found throughout Japan. Ishii's concept of the holonic path similarly emphasized a vision of a decentralized autonomous society that would

192 2. TRANSLATING THE VIRTUAL INTO JAPANESE

continue to influence Japanese teleoperator and ubiquitous computing research in later years. Here Ishii (along with biologist Shimizu Hiroshi) builds on Arthur Koestler's notion of the holon from *The Ghost in the Machine* (1967). These cybernetic approaches sometimes shade into essentialist theories of Japaneseness [*nihonjinron*] popular at the time. Ishii Takamochi, *Horonikku pasu* (Tokyo: Kōdansha, 1985); See also Tessa Morris-Suzuki, "Fuzzy Logic: Science, Technology and Postmodernity in Japan," in *Japanese Encounters with Postmodernity*, ed. Jóhann Páll Árnason and Yoshio Sugimoto (New York: Routledge, 1995), 95–113. On the flexible operations of Japanese train systems, see Michael Fisch, *An Anthropology of the Machine: Tokyo's Commuter Train Network* (Chicago: University of Chicago Press, 2018).

18. Aramata Hiroshi, *VR bōkenki: Bācharu riariti wa yume ka akumu ka* (Tokushima: Just-Systems Corporation, 1996), 124. See, for example, Hiroo Iwata, Takemochi Ishii, and Michitaka Hirose, "ITV Camera Head for Teleoperation Activated by the Eye Motion of the Operator," *Transactions of the Japan Society of Mechanical Engineers* 53, no. 486 (January 1987): 518–21.

19. Hattori Katsura, *VR genron: Hito to tekunorojii no atarashii riaru* (Tokyo: Shōeisha, 2019), v–vi.

20. In this century, TEPCO would become well known internationally for mishandling the tsunami-triggered disaster at their Fukushima Dai-ichi plant in March 2011, an outcome they would controversially blame on inadequate risk assessment. On TEPCO's 1990s work with VR visualization, see David Kahaner, "Japanese Activities in Virtual Reality," *IEEE Computer Graphics and Applications* 14, no. 1 (January 1994): 76.

21. Thomas A. Furness, "The Super Cockpit and Its Human Factors Challenges," *Proceedings of the Human Factors Society Annual Meeting* 30, no. 1 (September 1986): 48–52.

22. Ted Nelson, "Interactive Systems and the Design of Virtuality," *Creative Computing*, (November 1980): 57.

23. Myron W. Krueger, "Videoplace: An Artificial Reality," in *Chi '85 Proceedings* (1985): 38.

24. Andrew Pollack, "For Artificial Reality, Wear a Computer," *New York Times*, April 10, 1989. Similarly, one of the first major articles to introduce head-mounted interfaces to a general readership, in the October 1987 issue of *Scientific American*, uses the term *artificial reality* throughout. See James D. Foley, "Interfaces for Advanced Computing," *Scientific American* 257, no. 4 (October 1987): 126–35.

25. Hattori Katsura, *Jinkō genjitsukan no sekai: What's Virtual Reality?* (Tokyo: Kōgyō chōsakai, 1991), 76–77.

26. Hattori, *Jinkō genjitsukan no sekai*, 75–76; Hattori, *VR genron*, 9. Other proposed names Hattori encountered in the United States at the time include *synthesized reality* and *5D* (three spatial dimensions plus time plus other senses).

27. In the novel, Gibson describes cyberspace as a "consensual hallucination" that humans can "jack into" using a computational interface that replaces perception of the local physical environment with direct perception of an expansive, networked, three-dimensional computational world. William Gibson, *Neuromancer* (New York: Ace, 1984), 51, 202.

28. John Walker, "Through the Looking Glass: Beyond 'User Interfaces,'" September 1, 1988, https://www.fourmilab.ch/autofile/e5/chapter2_69.html.

29. Walker, "Through the Looking Glass." James Cohen argues that, while this memo was ultimately overshadowed by Lanier's alluring term and evocative promises the following year, Walker's more thoughtful approach to the stereoscopic interface—carefully grounded in media history—was ultimately responsible for launching what would become the commercial VR market in the United States. James Nicholas Cohen, "Virtual Evolution: An Alternate History of Cyberspace, 1988–1997" (PhD diss., Stony Brook University, 2019).

30. Kathy Rae Huffman, "The Electronic Arts Community Goes Online," *TalkBack!*, no. 3 (1996). Lanier notes in his presentation that this was the first time there was a panel about VR at SIGGRAPH, the main research conference for computer graphics. See Coco Conn et al., "Virtual Environments and Interactivity: Windows to the Future," in *SIGGRAPH '89 Panel Proceeedings* (SIGGRAPH '89, Boston, MA, 1989), 7–18; Benjamin Wooley, *Virtual Worlds: A Journey in Hype and Hyperreality* (London: Penguin Books, 1994), chap. 1.

31. Cohen notes how the event was covered by major magazines like *Mother Jones*, *SPIN*, and *Sports Illustrated* and influenced a wide range of budding VR journalists like Ben Delaney. Cohen, "Virtual Evolution," 74, 121–29.

32. Lev Manovich, *The Language of New Media* (Cambridge, MA: MIT Press, 2001), 59.

33. Ken Hillis, *Digital Sensations: Space, Identity, and Embodiment in Virtual Reality* (Minneapolis: University of Minnesota Press, 1999), 127 (emphasis in original).

34. Phillip Hayward, "Situating Cyberspace: The Popularization of Virtual Reality," in *Future Visions: New Technologies of the Screen*, ed. Phillip Hayward and Tana Wollen (London: British Film Institute, 1993), 200.

35. Oliver Grau, *Virtual Art: From Illusion to Immersion* (Cambridge, MA: MIT Press, 2003), 22, endnote 49.

36. Hayward, "Situating Cyberspace," 198. Hattori, for his part, describes Lanier at the time as looking like a "hulking lion straight out of the *Wizard of Oz*." Hattori, *Jinkō genjitsukan no sekai*, 31.

37. Vivian Sobchack, "New Age Mutant Ninja Hackers: Reading *Mondo 2000*," *The South Atlantic Quarterly* 94, no. 4 (1993): 574.

38. Fred Turner, *From Counterculture to Cyberculture: Stewart Brand, the Whole Earth Network, and the Rise of Digital Utopianism* (Chicago: University of Chicago Press, 2008), 163–65.

39. Quoted in Rebecca Coyle, "The Genesis of Virtual Reality," in *Future Visions: New Technologies of the Screen*, ed. Phillip Hayward and Tana Wollen (London: British Film Institute, 1993), 162–3, footnote 1.

40. Chet Raymo, "Virtual Reality Is Not Enough," *Boston Globe*, September 10, 1990.

41. Jean Baudrillard, *Simulacra and Simulation*, trans. Sheila Faria Glaser (Ann Arbor: University of Michigan Press, 1994).

42. Jean Baudrillard, "The Virtual Illusion: Or the Automatic Writing of the World," *Theory, Culture & Society* 12 (1995): 97–107. See also Leighton Evans, *The Re-Emergence of Virtual Reality* (New York: Routledge, 2018), 26.

43. Hattori, *VR genron*, v–vi.

44. Miyawaki Yō et al., "Maruchimedia jidai ga yatte-kuru," *Asahi pasokon*, January 1, 1990, 118; See also Hattori, *VR genron*, 9.

45. Hattori Katsura, "Bācharu riaritii no sekai e yōkoso: Konpyūta ga tsumugidasu atarashii genjitsu," *Asahi pasokon*, June 1, 1990, 110–15.

46. Hattori, *VR genron*, 9. Hattori's book was also published in Korean translation in South Korea. Hattori first encountered VR in a lecture by Warren Robinett at the Media Lab and worked closely with Rheingold in securing interviews for the book in the United States. Hattori, *Jinkō genjitsukan no sekai*, 275–76.

47. Recently republished as Hattori, *VR genron*.

48. Nagakura Katsue, "VR būmu futatabi, rekishi wa kurikaesu ka?: 'VR kuro rekishi' kara tenbō suru kore kara no VR," *Huffpost Japan*, October 12, 2015, https://www.huffingtonpost .jp/katsue-nagakura/virtual-reality_b_8128690.html.

49. Susumu Tachi, "Artificial Reality and Tele-Existence: Present Status and Future Prospect," in *Proceedings of the 2nd International Conference on Artificial Reality and Tele-Existence*, 1992, 7.

50. Hirose Michitaka, "America first no hontō no imi: Sutāku kenkyūshitsu ni te," *Mine*, February 23, 2017, https://mine.place/page/d91f96f5-d14c-49b2-9752-25eff8d5274b.

51. Susumu Tachi, "Memory of the Early Days and a View Toward the Future," *Presence: Teleoperators and Virtual Environments* 25, no. 3 (December 1, 2016): 239–46 (emphasis in original). See also Tachi Susumu, *Bācharu riariti nyūmon* (Tokyo: Chikuma shinsho, 2002), 24–26.

52. Tachi, "Memory of the Early Days," 242.

53. Gifu-supported research included Japan's first CAVE-style VR system, called the CABIN, built at the University of Tokyo in 1997. Unlike earlier CAVE systems, the CABIN included both floor and ceiling projections. According to Hirose, it was the largest VR system in the world at the time. Kajiwara's plan was to cultivate Gifu as a focal point of Japan's information technology industry, centered around the Softopia Japan complex in Ogaku city (1996) and using VR projects to draw media attention. The name "Softopia" reflected an ambition to focus on the software industry at a time when Japan was known for its hardware but was seen as falling behind the United States in software development. Benjamin Watson connects this to how Japanese VR researchers in the early 1990s came largely out of engineering, whereas in the United States, most VR research was housed in computer science departments. See Hirose Michitaka, "HMD ga dame da to iwareta jidai: CABIN no tanjō," *Mine*, November 16, 2016, https://mine.place/page/9245bd60- 4be4-4ac0-95f2-32ea8c7ccof8; Nagakura, "VR būmu futatabi;" Benjamin Watson, "A Survey of Virtual Reality in Japan," *Presence* 3, no. 1 (1994): 3.

54. Tachi, "Memory of the Early Days," 243–44.

55. Tachi, "Memory of the Early Days," 242–43. Other university and government labs besides Tachi and Hirose's included Iwata's lab at the University of Tsukuba, Sato Makoto's lab at the Tokyo Institute of Technology, and Fukui Yukio's work on force feedback at the Ministry of International Trade and Industry's Product Science Research Institute. See David Kahaner, "Virtual Reality in Japan," *IEEE Micro* 13, no. 2 (April 1993): 66–73; Kahaner, "Japanese Activities in Virtual Reality."

56. For a detailed evaluation of ATR at the time, see David Kahaner, "Advanced Telecommunications Research Institute (ATR)," *Scientific Information Bulletin* 17, no. 2 (January 21, 1992): 19–23. Other private-sector research projects included NEC's work to integrate VPL DataGloves with CAD software, TEPCO's three-dimensional visualization software for their energy infrastructure, Fujita's collaboration with VPL on tele-operated construction robots, and Tōkyū Construction's related research on tele-operated deep-foundation work robots.

57. Watson, "A Survey of Virtual Reality in Japan," 14. Watson describes how China and South Korea were also beginning to turn to VR research, although Japan was clearly the central Asian hub for VR research at the time.

58. Nagakura, "VR būmu futatabi;" Sherman and Judkins, *Glimpses of Heaven, Visions of Hell*, 22; Junji Nomura and Kazuya Sawada, "Virtual Reality Technology and Its Industrial Applications," *IFAC Proceedings* 31, no. 26 (September 1998): 36.

59. In an effort to cut costs down to around $90,000 and set up similar demonstrations at other showrooms, the company later switched to Intel Pentium–based computers and Sausalito, California–based competitor Sense8's WorldToolKit, rewriting a majority of the software themselves. David Kellar, "Virtual Reality, Real Money," *Computerworld*, November 15, 1993, 70. The $500,000 figure is given in Nomura and Sawada, "Virtual Reality Technology," 34. Lanier gives slightly different prices; see Jaron Lanier, *Dawn of the New Everything: Encounters with Reality and Virtual Reality* (New York: Henry Holt, 2017), 190–91. See also the alternate numbers given in chapter 1, as well as Hattori, *Jinkō genjitsukan no sekai*, 238–41.

60. The most expensive kitchen order came to 20 million yen, or about $188,000 USD at the current exchange rate. Nagakura, "VR būmu futatabi."

61. Kellar, "Virtual Reality, Real Money," 70. These projects eventually morphed into a therapeutic horseback-riding simulator for back pain relief and core muscle development called the *jōba* [riding horse], which (to Matsushita's surprise) sold rather well. See Nomura and Sawada, "Virtual Reality Technology."

62. Mark Pesce, "Learning from History: How to Make VR Bigger Than the Web," *Medium*, June 27, 2016, https://medium.com/ghvr/tc-shanghai-2016-8ad6c097262d. As noted later in the chapter, Pesce would subsequently turn to focus on Virtual Reality Modeling Language (VRML), an attempt to enable virtual reality experiences through a web browser.

63. The Planet Virtual Boy website lists sales of 140,000 units in Japan, and 630,000 in the United States. Benjamin Stevens, "Virtual Boy Press Releases," Planet Virtual Boy, February 8, 2018, https://www.planetvb.com/modules/newbb/viewtopic.php?topic_id=7003&post_id=39594#forumpost39594. See also Steven Boyer, "A Virtual Failure: Evaluating the Success of Nintendo's Virtual Boy," *The Velvet Light Trap* 64, no. 1 (2009): 23–33.

64. Fujitsu's competing Virtual Vision Sport head-mounted display (HMD) took a similar approach, with a smaller screen covering only part of the right eye. This allowed the overall display to look closer to a pair of glasses, while viewers still perceived a large TV screen floating in space before them. Watson, "A Survey of Virtual Reality in Japan," 10.

65. Dennis Normile, "British TV Goggles . . . and Visortrons from Japan," *Popular Science*, March 1993. Yamamoto Masanobu, general manager of Sony's Display Technology

Research Department, pointed to dentist work as another context for potential use. Benjamin Watson notes a pronounced concern among Sony engineers, however, about possible discomfort due to prolonged HMD use, perhaps guiding them to simpler, more lightweight HMDs that forego head tracking. Watson, "A Survey of Virtual Reality in Japan," 12.

66. Echoing the military history described earlier in the chapter, four of the six titles were flight simulators or aerial fighting games. The other two were a roller coaster simulator and a train simulator. An additional title compatible with the system, *Virtual View: R.C.T. Eyes Play* (Pony Canyon, 2003), featured footage of five female "gravure" models in swimsuits, with the person in the headset playing the role of a photographer at a fashion shoot. I return to these gendered dimensions of Japanese VR software in chapter 5.

67. Somese Naoto, "90-nendai kōhan no densetsu no VR purojekuto Sony FourthVIEW Project kōhen," *Video Salon*, January 25, 2017, https://videosalon.jp/serialization/sony_fourth_view_project2/. The format's name refers to the ability to manipulate time, thus rendering a fourth dimension visually perceptible.

68. Ben Lang, "5 Million PlayStation VR Units Sold, Sony Announces," *Road to VR*, January 6, 2020, https://www.roadtovr.com/playstation-vr-sales-5-million-milestone-psvr-units-sold/.

69. Chris Chesher, "Colonizing Virtual Reality: Construction of the Discourse of Virtual Reality, 1984–1992," *Cultronix* 1 (1994).

70. Joel West, "Utopianism and National Competitiveness in Technology Rhetoric: The Case of Japan's Information Infrastructure," *The Information Society* 12, no. 3 (August 1996): 264.

71. Scott Callon, *Divided Sun: MITI and the Breakdown of Japanese High-Tech Industrial Policy, 1975–1993* (Stanford, CA: Stanford University Press, 1997).

72. Lanier, *Dawn of the New Everything*, 189.

73. Ben Delaney, *Virtual Reality 1.0—The 90's: The Birth of VR in the Pages of CyberEdge Journal* (CyberEdge Information Services, 2017), 64. See also Sherman and Judkins, *Glimpses of Heaven, Visions of Hell*, 15.

74. In the same section, Rheingold includes a skeptical quote from design researcher Don Norman that notes stylistic affinities between MIT and the Japanese VR labs, which would make sense given the frequent traffic between them and the handful of Japanese corporations sponsoring the MIT Media Lab from its opening in 1985: "The Japanese researchers have big plans . . . but they are no different from researchers everywhere: dreams and words outstrip reality. Many Japanese labs remind me of MIT's Media Lab: lots of flash, but I wonder how much substance there is to it." Howard Rheingold, *Virtual Reality: The Revolutionary Technology of Computer-Generated Artificial Worlds—and How It Promises to Transform Society* (New York: Simon & Schuster, 1992), 238–39.

75. West, "Utopianism and National Competitiveness in Technology Rhetoric," 263–64.

76. West, "Utopianism and National Competitiveness in Technology Rhetoric," 263–64; Joel West, Jason Dedrick, and Kenneth L Kraemer, "Back to the Future: Japan's NII Plans," in *National Information Infrastructure Initiatives: Vision and Policy Design*, ed. Brian Kahin and Ernest Wilson (Cambridge, MA: MIT Press, 1996), 61–111.

77. Jeremy Horowitz, "Docomo's 5G-Based 8K VR Event Streaming Service Will Launch in March," *VentureBeat*, January 23, 2020, https://venturebeat.com/2020/01/23/docomos -5g-based-8k-vr-event-streaming-service-will-launch-in-march/.

78. Gibson's narrative aim was to critique the direction that personal media like the Walkman was taking at the time, particularly in how they served (like the other drugs that populate the book) to sever people from their immediate surroundings and place them in a fantasy reality instead. Yet the novel's entrancing image of a computationally derived social world capable of transcending physical embodiment proved a highly potent stimulant for the VR imagination to come. Bruce Headlam, "Origins: Walkman Sounded Bell for Cyberspace," *New York Times*, July 29, 1999; Chesher, "Colonizing Virtual Reality." On *Neuromancer*'s "Japanified future," see Wendy Hui Kyong Chun, *Control and Freedom: Power and Paranoia in the Age of Fiber Optics* (Cambridge, MA: MIT Press, 2006), 171–95. On the impact of *Neuromancer* on the American VR research community, see Allucquère Rosanne Stone, "Will the Real Body Please Stand Up?: Boundary Stories About Virtual Cultures," in *Cyberspace: First Steps*, ed. Michael Benedikt (Cambridge, MA.: MIT Press, 1992), 95–99.

79. Lanier, *Dawn of the New Everything*, 216.

80. On the series' American reception, see Roquet, "Empathy for the Game Master," 73–76.

81. Ilsa VanHook, "Japanese Toys," *Mondo 2000*, Summer 1990, 22.

82. Hattori, *VR genron*, iv.

83. Lanier, *Dawn of the New Everything*, 216.

84. Kahaner, "Japanese Activities in Virtual Reality," 78.

85. Nagakura, "VR būmu futatabi."

86. Hattori, *VR genron*, xvii.

87. Nagakura, "VR būmu futatabi."

88. Hattori, *VR genron*, 312.

89. Brenda Laurel, *Computers as Theatre*, 2nd ed. (Upper Saddle River, NJ: Addison-Wesley, 2013), 185. This issue would be addressed in the 2010s VR boom through the use of so-called ninja masks, disposable oval-shaped eye masks worn between the face and the VR headset. These were invented in Japan for use at VR festivals and were eventually sold by Mogura VR. The hygiene issue was never entirely solved, however, and came roaring back with the COVID-19 pandemic and the subsequent collapse of the location-based VR industry in Japan and elsewhere.

90. Watson, "A Survey of Virtual Reality in Japan," 10. NHK was working on three-dimensional computer graphics for their Hi-Vision screens instead, such as a virtual museum walkthrough of Spain's Prado Museum (1994) using Silicon Graphics visualization systems.

91. Hattori, *VR genron*, iv.

92. Daikoku Takehiko, *Vācharu shakai no 'tetsugaku': Bittokoin, VR, Posutoturūsu* (Tokyo: Seidosha, 2018), 249.

93. Boyer, "A Virtual Failure," 23.

94. Cohen, "Virtual Evolution," 3.

95. Evans, *The Re-Emergence of Virtual Reality*, 13.

96. Setting off on a tangent from the mainstream VR emphasis on individual perceptual enclosure, Nintendo's cardboard VR Labo kits for their Switch console link VR back to the more casual and shareable interfaces that characterized popular home three-dimensional devices like Oliver Wendall Holmes' parlor stereoscope, a best seller in late nineteenth-century America that allowed people to pass it around easily in a more social setting. As Jon Irwin writes, "Nintendo's vision for VR is a pointed rebuke of what has been seen as the ideal experience: an all-encompassing escape to some secondary world other than our own." Jon Irwin, "Don't Write Off Nintendo's Latest Stab at VR," *Variety*, March 16, 2019, https://variety.com/2019/gaming/columns/nintendo-labo-vr-1203165009/.

97. Nagakura, "VR būmu futatabi."

98. Uno Mayuko, "VR de taikan torēningu: Panasonic, jōba-kei fittonesu kikai o BtoB tenkai," *Nikkei XTech*, July 30, 2018, https://xtech.nikkei.com/atcl/nxt/column/18/00001/00808/.

99. See Hacosco's website at https://hacosco.com/.

100. On other enterprise-focused uses of VR for simulation, training, and product design in Japan, see Itō Yūji, *VR inpakuto: Shiranai de wa sumasarenai bācharu riariti no sugoi sekai* (Tokyo: Daiyamondo bijinesu kikaku, 2017).

101. See GOROman, *Mirai no tsukurikata 2020–2045: Boku ga VR ni kakeru wake* (Tokyo: Seikaisha shinsho, 2018), chap. 2.

102. Ryo Ikeda, "Big in Japan: Best Practices for Japanese Developers," https://www.facebook.com/watch/live/?v=313847663239317.

103. John Carmack, *Oculus Connect 5 Keynote* (San Jose, California, 2018), https://youtu.be/VW6tgBcN_fA.

104. Kubota Shun, "Nekoronde Netflix o daigamen de miru hōhō," *Mogura VR*, May 4, 2018, https://www.moguravr.com/netflix-oculus-go/. See also Shin Kiyoshi, *VR bijinesu no shōgeki: 'Kasō sekai' ga kyodai mane o umu* (Tokyo: NHK shuppan, 2016), 123–24.

105. Shin, *VR bijinesu no shōgeki*, 208.

106. Lanier, *Dawn of the New Everything*.

107. N. Katherine Hayles, "The Condition of Virtuality," in *The Digital Dialectic: New Essays on New Media*, ed. Peter Lunenfeld (Cambridge, MA: MIT Press, 2000), 73, 75.

108. Margaret Wertheim, *The Pearly Gates of Cyberspace: A History of Space from Dante to the Internet* (New York: Norton, 2000).

109. Rob Shields, *The Virtual* (New York: Routledge, 2002), 5–6.

110. Brian Massumi, "Envisioning the Virtual," in *The Oxford Handbook of Virtuality*, ed. Mark Grimshaw (Oxford: Oxford University Press, 2014), 55.

111. Shields, *The Virtual*, 3 (emphases removed).

112. Charles Sanders Peirce, "Virtual," in *Dictionary of Philosophy and Psychology*, ed. James Mark Baldwin, vol. II (London: Macmillan, 1902), 763–64.

113. Building off an Aristotelian potentiality rather than a Platonic spirit/matter binary, philosophers like Gottfried Wilhelm Leibniz and Henri Bergson position the virtual as an emergent property that can then act back on and reshape reality. Gilles Deleuze later expanded on this approach to examine how difference emerges in the passage from real to virtual and back. This is also in alignment with Antonin Artaud's brief mention of *réalité virtuelle* as he describes the "purely fictitious and illusory world" of the theater in *The*

Theater and Its Double (1938), a world that can nonetheless go on to influence audience members as their imaginations become actualized. There are many more recent writings on virtual philosophy in this lineage, but, with a few notable exceptions like the work of Anne Friedberg and Anna Munster, most have surprisingly little to say about actual VR technologies. Conversely, this understanding of "the virtual" has had no discernible influence on popular discourse surrounding VR in either the United States or Japan. For this reason, and to avoid further complicating my terminology, I largely set aside the Leibniz-Bergson-Deleuze understanding of virtuality here, sticking with *virtual* as an adjective rather than a noun. See Anne Friedberg, *The Virtual Window: From Alberti to Microsoft* (Cambridge, MA: MIT Press, 2009), 10; Anna Munster, *Materializing New Media: Embodiment in Information Aesthetics* (Hanover, NH: Dartmouth College Press, 2006); Adriana de Souza e Silva and Daniel M. Sutko, "Theorizing Locative Technologies Through Philosophies of the Virtual," *Communication Theory* 21, no. 1 (February 2011): 23–42. *Réalité virtuelle* appears in Antonin Artaud, *The Theater and Its Double*, trans. Mary Caroline Richards (New York: Grove Press, 1958), 49. For a wide-ranging overview of how the term is used across different disciplines, see Mark Grimshaw, ed., *The Oxford Handbook of Virtuality* (Oxford: Oxford University Press, 2015).

114. Thomas Sutton, ed., *Photographic Notes* (London: Bland and Long, 1857), 215–16; See also Friedberg, *The Virtual Window*, 8–9.

115. De Souza e Silva and Sutko, "Theorizing Locative Technologies," 25.

116. Susanne K. Langer, *Feeling and Form: A Theory of Art* (New York: Charles Scribner's, 1953), 48.

117. Langer, *Feeling and Form*, 72.

118. Jaron Lanier, "Virtually There," *Scientific American*, April 2001; Lanier, *Dawn of the New Everything*, 42.

119. Sutherland, "A Head-Mounted Three Dimensional Display," 759.

120. Gibson, *Neuromancer*, 51.

121. Lanier, *Dawn of the New Everything*, 46. Daikoku Takehiko reads the turn to multiplayer "social VR" as unique to the 2010s revival, but social communication had already been a major theme from this earlier period. Daikoku, *Vācharu shakai no 'tetsugaku,'* 251.

122. Chuck Blanchard et al., "Reality Built for Two: A Virtual Reality Tool," in *Proceedings of the 1990 Symposium on Interactive 3D Graphics*, I3D '90 (New York: ACM, 1990), 35–36.

123. David L. Chandler, "Artificial Reality: It May Be Better Than the Real Thing," *Boston Globe*, February 26, 1990.

124. Hayward, "Situating Cyberspace," 189.

125. Wooley, *Virtual Worlds*, 60. On a similar connotative shift in the U.S. military context, see James Der Derian, *Virtuous War: Mapping the Military-Industrial-Media-Entertainment-Network*, 2nd ed. (New York: Routledge, 2009).

126. Morgan G. Ames, *The Charisma Machine: The Life, Death, and Legacy of One Laptop per Child* (Cambridge, MA: MIT Press, 2019), 18.

127. See Vincent Mosco, *The Digital Sublime: Myth, Power, and Cyberspace* (Cambridge, MA: MIT Press, 2004).

128. Sherman and Judkins, *Glimpses of Heaven, Visions of Hell*, 17.

129. See Janet H. Murray, "Virtual/Reality: How to Tell the Difference," *Journal of Visual Culture* 19, no. 1 (April 2020): 11–27.

130. See, for example, Kevin Gray, "Inside Silicon Valley's New Non-Religion: Consciousness Hacking," *Wired UK*, November 1, 2017, https://www.wired.co.uk/article/consciousness -hacking-silicon-valley-enlightenment-brain. "VR for Good" is a series of projects from Oculus VR Studios (https://www.oculus.com/vr-for-good). For a critique, see Lisa Nakamura, "Feeling Good About Feeling Bad: Virtuous Virtual Reality and the Automation of Racial Empathy," *Journal of Visual Culture* 19, no. 1 (April 2020): 47–64.

131. Jeff Nagy and Fred Turner, "The Selling of Virtual Reality: Novelty and Continuity in the Cultural Integration of Technology," *Communication, Culture and Critique* 12, no. 4 (December 1, 2019): 542.

132. Tani Takuo, "VR=bācharu riaritii ka, 'kasō' genjitsu ka," *Hōsō kenkyū to chōsa*, January 2020, 46–58.

133. The adjective *immersive* also dates to this time, translated into Japanese as *botsunyūkan* 没入感 (literally the "feeling of immersion"). While *immersion* had long been used in the context of baptisms and language pedagogy, the adjectival form of the word appears to have emerged first in the United States in the early 1990s in relation to VR before being picked up in Japan not long after. *Botsunyūkan* quickly spread to other media contexts as well, and it was applied retroactively to early role-playing video games like *Dragon Quest* (Chunsoft, 1986) and used in the marketing of large-screen television sets.

134. Tachi, *Bācharu riariti nyūmon*, 14.

135. This is still the character used in the Chinese word for virtual (虚拟), as noted in Christopher B. Patterson, *Open World Empire: Race, Erotics, and the Global Rise of Video Games* (New York: NYU Press, 2020), 251.

136. Tachi, *Bācharu riariti nyūmon*, 20.

137. *Nihon kokugo daijiten*, vol. 10 (Tokyo: Shōgakukan, 2001), 906.

138. Hattori, *Jinkō genjitsukan no sekai*, 3. For other examples, see "Dōsa nyūryoku, CG de 'michi' o taiken (Jinkō genjitsukan no sekai: Jō)," *Asahi shinbun*, February 17, 1990; "Iwata Hiroo-san, kasō genjitsu o aruku," *Asahi shinbun*, June 16, 1990. As noted in endnote 133, the Japanese word coined to translate "immersive," *botsunyūkan*, adopted a similar strategy.

139. Hattori, *VR genron*, 8. As information technology journalist Yajima Nobuyuki argues in relation to Japanese information technology contexts, when it comes to foreign loanwords, Japanese marketers often prefer transliterations over translations into existing and more readily understood Japanese terms. Because a transliterated foreign buzzword is less readily understood, it retains an aura of mystery and promise. This effect is enhanced when the word comes from a place (the United States or, even better, Silicon Valley) and a language (English) associated with social and technological capital. Yajima Nobuyuki, *Sofuto o tanin ni tsukuraseru Nihon, jibun de tsukuru Beikoku: Keiei to gijutsu kara mita kindaika no shomondai* (Tokyo: Nikkei BP-sha, 2013), 124–28.

140. Tani, "VR=bācharu riaritii ka, 'kasō' genjitsu ka," 55.

141. There is hardly any use of the term within the text itself, implying the title was perhaps a marketing decision to capitalize on the popular VR boom peaking at the time. Ōtsuka Eiji, *Kasō genjitsu hihyō: Shōhi shakai wa owaranai* (Tokyo: Shinyōsha, 1992).

142. Shin, *VR bijinesu no shōgeki*, 23.

143. This emphasis on layering is also reflected in the Japanese translation of "mixed reality" as *fukugō genjitsu* 複合現実, literally a "compound" or "composite" reality. For more on mixed reality, see chapter 4.

144. This also includes projects that could be labeled "VR for good" in Japan, such as VR projects to let people experience what it is like to have dementia or to teach them how to evacuate a building on fire safely. See Tomoko Otake, "Japanese Firm Uses VR Simulations to Offer a Glimpse into the World of Dementia," *Japan Times*, November 29, 2017; Sho Ooi, Taisuke Tanimoto, and Mutsuo Sano, "Virtual Reality Fire Disaster Training System for Improving Disaster Awareness," in *Proceedings of the 2019 8th International Conference on Educational and Information Technology*, ICEIT 2019 (New York: Association for Computing Machinery, 2019), 301–307.

3. VR TELEWORK AND THE PRIVATIZATION OF PRESENCE

1. Kara Swisher, "Facebook CEO Mark Zuckerberg: The Kara Swisher Interview," Recode Decode, accessed July 18, 2018, https://www.vox.com/2018/7/18/17575158/mark-zuckerberg -facebook-interview-full-transcript-kara-swisher.

2. Aizu Izumi, "Bācharu riariti," *Front*, September 1990, 43.

3. Lanier quoted in Chris Chesher, "Colonizing Virtual Reality: Construction of the Discourse of Virtual Reality, 1984–1992," *Cultronix* 1 (1994); Brenda Laurel, "Art and Activism in VR: Based on a Talk Given at the San Francisco Art Institute's Virtual Reality Symposium, August 1991," *Wide Angle* 15, no. 4 (December 1993): 13–21.

4. Andrew Pollack, "For Artificial Reality, Wear a Computer," *New York Times*, April 10, 1989.

5. Tom Ashbrook, "You Are About to Travel into Another Reality . . . ," *Boston Globe*, July 28, 1988. Promises of computer-based telework ending commutes and saving the environment go back far earlier than VR. See Joel West, "Utopianism and National Competitiveness in Technology Rhetoric: The Case of Japan's Information Infrastructure," *The Information Society* 12, no. 3 (August 1996): 260.

6. Daikoku Takehiko, *Vācharu shakai no 'tetsugaku': Bittokoin, VR, Posutotūrūsu* (Tokyo: Seidosha, 2018), 254. See also Leighton Evans, *The Re-Emergence of Virtual Reality* (New York: Routledge, 2018), 11–12.

7. On Facebook's approach to Oculus as a social media platform, see Ben Egliston and Marcus Carter, "Oculus Imaginaries: The Promises and Perils of Facebook's Virtual Reality," *New Media & Society*, forthcoming.

8. Ifeoma Ajunwa, Kate Crawford, and Jason Schultz, "Limitless Worker Surveillance," *California Law Review* 105, no. 3 (2017): 735–76.

9. See, for example, Ken Goldberg, ed., *The Robot in the Garden: Telerobotics and Telepistemology in the Age of the Internet* (Cambridge, MA: MIT Press, 2000), 5; Kris Paulsen, *Here/There: Telepresence, Touch, and Art at the Interface* (Cambridge, MA: MIT Press, 2017), 9.

10. Nihon shōkōkaigisho, "Hitode busoku nado e no taiō ni kan suru chōsa kekka ni tsuite," June 6, 2019, https://www.jcci.or.jp/news/2019/0606132502.html.

11. Blake Hannaford, "Feeling Is Believing: History of Telerobotics Technology," in *The Robot in the Garden: Telerobotics and Telepistemology in the Age of the Internet*, ed. Ken Goldberg (Cambridge, MA: MIT Press, 2001), 254.

12. Raymond C. Goertz et al., Electronic Master Slave Manipulator, US2846084A, filed June 21, 1955, and issued August 5, 1958. See David Parisi, *Archaeologies of Touch: Interfacing with Haptics from Electricity to Computing* (Minneapolis: University of Minnesota Press, 2018), Interface 4.

13. Tokuji Okada, "Object-Handling System for Manual Industry," *IEEE Transactions on Systems, Man, and Cybernetics* 9, no. 2 (1979): 79–89.

14. Marvin Minsky, "Telepresence," *Omni* (June 1980): 45.

15. Minsky, "Telepresence," 47.

16. Kevin Corker, Andrew Mishkin, and John Lyman, "Achievement of a Sense of Operator Presence in Remote Manipulation," Biotechnology Laboratory Technical Report (Naval Ocean Systems Center: University of California, Los Angeles, October 1980).

17. See, for example, Paulsen, *Here/There*, 147–82; Lisa Parks and Caren Kaplan, eds., *Life in the Age of Drone Warfare* (Durham, NC: Duke University Press, 2017).

18. Adrian Scoica, "Susumu Tachi: The Scientist Who Invented Teleexistence," *ACM Crossroads* 22, no. 1 (2015): 61. Tachi's paper for the Santa Barbara conference in 1990, discussed in chapter 2, was titled "Tele-existence and/or Cybernetic Interface Studies in Japan." Susumu Tachi, "Memory of the Early Days and a View Toward the Future," *Presence: Teleoperators and Virtual Environments* 25, no. 3 (December 1, 2016): 239.

19. Scoica, "Susumu Tachi," 62.

20. Tachi Susumu, "Tereigujisutansu no kenkyū (dai 2-hō): Tanshoku shikaku teiji ni yoru jitsuzaikan no hyōka" (1982): 211–12; Tachi Susumu, *Bācharu riariti nyūmon* (Tokyo: Chikuma shinsho, 2002); Susumu Tachi, *Telexistence*, 2nd ed. (Hackensack, NJ: World Scientific, 2014), 35.

21. Tachi Susumu, "Tereigujisutansu," *Nihon robotto gakkaishi* 33, no. 4 (2015): 217. As noted in chapter 2, here too the emphasis on *kan* or "feeling" comes through clearly.

22. Tachi, "Tereigujisutansu no kenkyū (dai 2-hō);" Susumu Tachi et al., "Tele-Existence (I): Design and Evaluation of a Visual Display with Sensation of Presence," in *Proceedings of RoManSy'84 The Fifth CISM-IFToMM Symposium* (RoManSy'84 The Fifth CISM-IFToMM Symposium, Udine, Italy, 1984), 245–54.

23. Quoted in Scoica, "Susumu Tachi," 62.

24. Mel Slater et al., "Towards a Digital Body: The Virtual Arm Illusion," *Frontiers in Human Neuroscience* 2 (2008): 6.

25. Tachi Susumu and Komoriya Kiyoshi, "Dai 3-sedai robotto," *Keisoku to seigyo* 21, no. 12 (December 1982): 57.

26. Tachi, *Telexistence*, 39.

27. For more on this context, see Yuji Sone, *Japanese Robot Culture: Performance, Imagination, and Modernity* (New York: Palgrave Macmillan, 2017); Jennifer Robertson, *Robo Sapiens Japanicus: Robots, Gender, Family, and the Japanese Nation* (Oakland: University

of California Press, 2017); Yulia Frumer, "Cognition and Emotions in Japanese Humanoid Robotics," *History and Technology* 34, no. 2 (April 3, 2018): 157–83.

28. Tachi, *Telexistence*, 46.

29. Quoted in Tachi, *Telexistence*, 44.

30. Shinji Kawatsuma, Mineo Fukushima, and Takashi Okada, "Emergency Response by Robots to Fukushima-Daiichi Accident: Summary and Lessons Learned," *Industrial Robot: An International Journal* 39, no. 5 (August 17, 2012): 428–35; Jennifer Robertson, "Rubble, Radiation and Robots," *The American Interest* 7, no. 1 (2011): 122-26.

31. David T. Mitchell with Sharon L. Snyder, *The Biopolitics of Disability: Neoliberalism, Ablenationalism, and Peripheral Embodiment* (Ann Arbor: University of Michigan Press, 2015), 11.

32. See https://tx-inc.com/; "TX Inc.," Tachi_Lab, accessed September 22, 2020, https://tachilab.org/en/about/company.html.

33. Luke Dormehl, "Japanese Convenience Stores Test Robot Shelf-Stackers," *Digital Trends*, July 8, 2020, https://www.digitaltrends.com/news/convenience-store-vr-robot-shelfstacker/.

34. See Serizawa Kensuke, *Konbini gaikokujin* (Tokyo: Shinchōsha, 2018).

35. Hirose Michitaka, *Izure oite iku bokutachi o 100-nen katsuyaku saseru tame no sentan VR gaido* (Tokyo: Kōdansha, 2016), 171.

36. Tachi, *Telexistence*, 18–23.

37. Daniel Black, "Machines with Faces: Robot Bodies and the Problem of Cruelty," *Body & Society* 25, no. 2 (June 2019): 7–8.

38. Black, "Machines with Faces," 9–10.

39. Black, "Machines with Faces," 14.

40. Black, "Machines with Faces," 20.

41. AP Television, *Tokyo University Develops a Mirror Which Can Put a Smile on Your Face*, 2014, https://www.youtube.com/watch?v=xYanXR7MDso.

42. Ruha Benjamin, *Race After Technology: Abolitionist Tools for the New Jim Code* (Medford, MA: Polity, 2019), 156.

43. Aimi Hamraie, *Building Access: Universal Design and the Politics of Disability* (Minneapolis: University of Minnesota Press, 2017), 71. Diane Wei Lewis identifies a similar discourse surrounding the exploitation of women's home-based labor in Japanese animation production. Diane Wei Lewis, "*Shiage* and Women's Flexible Labor in the Japanese Animation Industry," *Feminist Media Histories* 4, no. 1 (January 1, 2018): 115–41.

44. Tachi, *Telexistence*, 22.

45. Susumu Tachi, "Tereigujisutansu no ima: Jikūkan shunkan idō sangyō to tereigujisutansu shakai e no chōsen," keynote lecture, Digital Content Expo, Makuhari Messe, Chiba, November 15, 2018.

46. Robertson, *Robo Sapiens Japanicus*, 19.

47. See, for example, Eugene Lang, "Foreign Interns in Japan Flee Harsh Conditions by the Thousands," *Nikkei Asian Review* (August 6, 2018).

48. Benjamin, *Race After Technology*, 40.

49. Koichi Iwabuchi, *Recentering Globalization: Popular Culture and Japanese Transnationalism* (Durham, NC: Duke University Press, 2002), 27–28.

50. Iwabuchi describes this latter process instead as media producers adding a "Japanese odor" through various localization strategies. This formulation downplays both the active neutralization of the foreign and the way local norms at the same time often fall below the level of conscious awareness. Iwabuchi, *Recentering Globalization*, 94, 96.

51. References to the "odor" of unwanted neighbors as an indirect form of racism have a long history in Japan as they do elsewhere, a lineage Iwabuchi's term cannot help but uncomfortably invoke. See, for example, Takeda Satetsu's writing on how discrimination in Japan often routes through these more indirect expressions that "something is off" rather than straightforward hate speech. Clearly some racialized "odors" are more accepted in Japan than others—an uneven sensory terrain deeply entwined with the broader perceptual politics described in this book. Takeda Satetsu, *Nihon no kehai* (Tokyo: Shōbunsha, 2018). See also Joseph Doyle Hankins, "An Ecology of Sensibility: The Politics of Scents and Stigma in Japan," *Anthropological Theory* 13, no. 1–2 (March 2013): 49–66. On hair regulations in Japanese schools, see Tiffany May, "Japanese Student Forced to Dye Her Hair Black Wins, and Loses, in Court," *New York Times*, February 19, 2021. For a recent example of how the "odorless" imperative in anime character design can tip into overt racism, see Daniel Victor, "Ad Showing Naomi Osaka with Light Skin Prompts Backlash and an Apology," *New York Times*, January 22, 2019.

52. Oliver Grau, *Virtual Art: From Illusion to Immersion* (Cambridge, MA: MIT Press, 2003), 290.

53. See Mary L. Gray and Siddharth Suri, *Ghost Work: How to Stop Silicon Valley from Building a New Global Underclass* (Boston: Houghton Mifflin Harcourt, 2019).

54. "Japan Aims to Reduce Dementia Patients in 70s over 6 Year Period," *Kyodo News*, May 15, 2019.

55. See, for example, Tachi, *Telexistence*, 242.

56. Tachi and Komoriya, "Dai 3-sedai robotto," 54.

57. Tim Kelly, "Japanese Robot to Clock in at a Convenience Store in Test of Retail Automation," *Japan Times*, July 19, 2020.

58. Tachi, *Telexistence*, 31.

59. Lev Manovich, *The Language of New Media* (Cambridge, MA: MIT Press, 2001), 113.

60. Tachi, *Telexistence*, 241.

61. Susumu Tachi, "Artificial Reality and Tele-Existence: Present Status and Future Prospect," in *Proceedings of the 2nd International Conference on Artificial Reality and Tele-Existence*, 1992 10.

62. For example, disability studies scholar Mark Bookman offers an enthusiastic account of the (non-VR) Ory Laboratory telework robot café on his *Accessible Japan* blog. Mark Bookman, "Engineering Employment: Robots and Remote Work for Persons with Disabilities at a Japanese Cafe," *Accessible Japan* (blog), 2019, https://www.accessible-japan .com/engineering-employment-robots-and-remote-work-for-persons-with-disabilities -at-a-japanese-cafe/. For more on the Ory Laboratory robots, see Paul Roquet, "Telepresence Enclosure: VR, Remote Work, and the Privatization of Presence in a Shrinking Japan," *Media Theory* 4, no. 1 (2020): 47–52.

63. Mitchell with Snyder, *The Biopolitics of Disability*, 6.

64. Safiya Umoja Noble, *Algorithms of Oppression: How Search Engines Reinforce Racism* (New York: NYU Press, 2018), 1.

4. IMMERSIVE ANXIETIES IN THE VR *ISEKAI*

1. N. Katherine Hayles, *How We Became Posthuman: Virtual Bodies in Cybernetics, Literature, and Informatics* (Chicago: University of Chicago Press, 1999); Wendy Hui Kyong Chun, *Control and Freedom: Power and Paranoia in the Age of Fiber Optics* (Cambridge, MA: MIT Press, 2006), 171–95; Melanie Chan, *Virtual Reality: Representations in Contemporary Media* (New York: Bloomsbury Academic, 2015); Heather Duerre Humann, *Reality Simulation in Science Fiction Literature, Film and Television* (Jefferson, NC: McFarland, 2019); Marisa Brandt and Lisa Messeri, "Imagining Feminist Futures on the Small Screen: Inclusion and Care in VR Fictions," *NatureCulture* 5, 2019, 1–25.

2. See, for example, Sakamura Ken, *Dennō toshi*, new edition (Tokyo: Iwanami shoten, 1987); Inami Masahiko, *Sūpāhyūman tanjō! Ningen wa SF o koeru* (Tokyo: NHK shuppan shinsho, 2016). On the reception of VR in the Japanese science fiction community, see *SF magajin*, VR/AR special issue, December 2016.

3. Okajima is a common Japanese surname, while *futari* simply means "two people." The unit was active throughout the 1980s and won multiple mystery fiction awards along the way for their puzzle and game-themed novels like *Chokorēto gēmu* (Chocolate game, 1985) and *99% no yūkai* (The 99% kidnapping, 1988). After thirteen years together, they decided to end their partnership with the publication of *Klein Bottle*. Inoue went on to write more science fiction–themed works in the 1990s under the name Inoue Yumehito.

4. The book was later turned into a television miniseries on NHK's educational channel in 1996, with several alterations to the characters and plot.

5. There are also echoes here of the Capsule biker gang in Ōtomo Katsuhiro's manga and anime feature *AKIRA* (manga, 1982–1990; film, 1988), one of the most prominent Japanese science fiction narratives of the decade.

6. Inoue Yumehito, *Okashi na futari: Okajima Futari seisuiki* (Tokyo: Kōdansha, 1993), 294. First described in 1882 by German mathematician Felix Klein, the Klein bottle is a mathematical structure where a single, one-sided surface wraps around and folds in on itself. It is similar to the more commonly known Möbius strip, but whereas the Möbius shape has clear boundaries on both sides of the strip, the three-dimensional Klein bottle eliminates these and wraps the two edges of the strip around themselves to create a tubular, bottle-like structure. A traveler who moved vertically on the exterior of a Klein bottle would eventually find themselves on the interior, only to remerge on the outer surface once again if they kept moving in the same direction.

7. *Structure and Power* merges Jacques Lacan's passing mention of the Klein bottle as a figure for the human psyche with the historical progression presented in Gilles Deleuze and Félix Guattari's *Anti-Oedipus* (1972). The book's cover features an Andy Warhol-esque grid of twenty-four Klein bottles in different colors and orientations. As Tanaka Komimasa writes in a highly critical account of Asada's work, Asada seemed to be nearly

obsessed with the Klein bottle at the time, repeatedly bringing it up in the discussions included at the end of his 1984 follow-up *Tōsōron* (On escape). Asada Akira, *Kōzō to chikara: Kigōron o koete* (Tokyo: Keisōshobō, 1983); Tanaka Komimasa, "Kurain no tsubo," *Kaien*, February 1989, 131.

8. Jean Baudrillard, *The Intelligence of Evil: Or the Lucidity Pact*, trans. Chris Turner (New York: BERG, 2005), 60. Engineers themselves were also drawing connections to these mathematical parallels. Ishii Takemochi, for example, notes how the real/virtual dichotomy resembles the distinction between real and imaginary numbers, or between Euclidian and non-Euclidian space. Hattori Katsura, *Jinkō genjitsukan no sekai: What's Virtual Reality?* (Tokyo: Kōgyō chōsakai, 1991), 274.

9. As Murray notes, this anxiety about interactive and immersive media was also common among English-language writers at the time, and, of course, it has a long prehistory as well. Janet H. Murray, *Hamlet on the Holodeck: The Future of Narrative in Cyberspace*, updated edition (Cambridge, MA: MIT Press, 2017), 19–25.

10. As explored in chapter 5, Patrick W. Galbraith marks this as a doubling of the "reality problem" in otaku history, where the image of the fictional girl-obsessed otaku becomes popularly associated not just with the socially awkward and perverse (as it was earlier in the decade), but with pedophilia and sexual predation as well. Patrick W. Galbraith, *Otaku and the Struggle for Imagination in Japan* (Durham, NC: Duke University Press, 2019), 69.

11. The first quote is from Miyazaki Hayao and Murakami Ryū, "Kinkyū taidan: Misshitsu kara no dasshutsu," *Animage* (November 1989): 17-18. This and Yoshimi are quoted in Galbraith, *Otaku*, 67–69.

12. See Miho Aida, "The Construction of Discourses on Otaku: The History of Subcultures from 1983 to 2005," in *Debating Otaku in Contemporary Japan: Historical Perspectives and New Horizons*, ed. Patrick W. Galbraith, Thiam Huat Kam, and Björn-Ole Kamm (New York: Bloomsbury Academic, 2015), 107–18.

13. Jean Baudrillard, *Simulacra and Simulation*, trans. Sheila Faria Glaser (Ann Arbor: University of Michigan Press, 1994); Jean Baudrillard, *The Gulf War Did Not Take Place*, trans. Paul Patton (Sydney: Power Publications, 2012).

14. See David M. Ewalt, *Of Dice and Men: The Story of Dungeons & Dragons and the People Who Play It* (New York: Scribner, 2014), chap. 10.

15. Munesuke Mita, *Social Psychology of Modern Japan*, trans. Stephen Suloway (London: Kegan Paul, 1992).

16. In terms of Tokyo neighborhoods, Miyadai associates the former with Shibuya, at the time serving as Tokyo's key youth fashion district, and the latter with Akihabara, on the opposite side of the Yamanote loop line and the central neighborhood for both electronics and computer hobbyists and the emerging otaku culture centered around manga, anime, and video games. Shinji Miyadai, "Transformation of Semantics in the History of Japanese Subcultures Since 1992," trans. Shion Kono, *Mechademia* 6 (2011): 236. On Shibuya in the 1980s, see also Shunya Yoshimi, "The Market of Ruins, or the Destruction of the Cultural City," *Japan Forum* 23, no. 2 (June 2011): 287–300. On Akihabara, see Galbraith, *Otaku*, chap. 4.

17. Ōtsuka Eiji, *Kyarakutā shōsetsu no tsukurikata* (Tokyo: Kōdansha, 2003), 24.

18. Ōtsuka Eiji, "Mechademia in Seoul: Ōtsuka Eiji Keynote," trans. Alexander Zahlten, *Electronic Journal of Contemporary Japanese Studies* 17, no. 1 (April 23, 2017), https://www.japanesestudies.org.uk/ejcjs/vol17/iss1/otsuka.html.

19. Koike Kazuo and Kano Seisaku, *Yokohama Homerosu*, 4 vols. (Tokyo: Koike shoin, 1992).

20. Masaki Gorō, *Viinasu shiti* (Tokyo: Hayakawa shoten, 1995).

21. Baryon Tensor Posadas, "Beyond Techno-Orientalism: Virtual Worlds and Identity Tourism in Japanese Cyberpunk," in *Dis-Orienting Planets: Racial Representations of Asia in Science Fiction*, ed. Isiah Lavender III (Jackson: University Press of Mississippi, 2017). These creators struggled in their own right to get out from under the influence of American VR portrayals. Masaki's work was frequently compared to Gibson's, to his chagrin. *Yokohama Homer* cribs directly from the virtual memory implantation interface seen in *Total Recall*.

22. See Marc Steinberg, *The Platform Economy: How Japan Transformed the Consumer Internet* (Minneapolis: University of Minnesota Press, 2019).

23. See Christian Licoppe and Yoriko Inada, "Geolocalized Technologies, Location-Aware Communities, and Personal Territories: The Mogi Case," *Journal of Urban Technology* 15, no. 3 (December 2008): 5–24.

24. Paul Milgram et al., "Augmented Reality: A Class of Displays on the Reality-Virtuality Continuum" (Photonics for Industrial Applications, Boston, MA, 1995), 282–92.

25. Machiko Kusahara, "Mini-Screens and Big Screens: Aspects of Mixed Reality in Everyday Life," in *Casto1: Living in Mixed Realities*, vol. 31 (Bonn: netzspannugn.org, 2001), 33.

26. Daikoku Takehiko, *Vācharu shakai no 'tetsugaku': Bittokoin, VR, Posutoturūsu* (Tokyo: Seidosha, 2018), 267.

27. Farah Mendlesohn, *Rhetorics of Fantasy* (Middletown, CT: Wesleyan University Press, 2008), chap. 1.

28. Mendlesohn, *Rhetorics of Fantasy*, 57.

29. Hattori includes an illustration of the white rabbit from Carroll's work in his early *Asahi pasokon* article ("Bācharu riaritii no sekai e yōkoso"), while his *Jinkō genjitsukan no sekai* weaves in a number of John Tenniel's original illustrations (see figure 2.1 of this book). *Sword Art Online*'s "Alicization" arc (books 9 through 18, 2012–2016), discussed later in this chapter, further riffs on the Alice theme. As far as actual Japanese VR titles, *Alice Mystery Garden* (AMG Games, 2017) asks players to guide and embody Alice alternatively as she solves puzzles in a Wonderland setting. She literally passes through a looking glass on the completion of each level. On the broader influence of Carroll's work on Japanese popular culture, see Amanda Kennell, "Alice in Evasion: Adapting Lewis Carroll in Japan" (PhD diss., University of Southern California, 2017).

30. Susan Napier, *The Fantastic in Modern Japanese Literature: The Subversion of Modernity* (New York: Routledge, 1995), 141.

31. On Tolkien's fantasies of medieval Britain, see Maria Sachiko Cecire, *Re-Enchanted: The Rise of Children's Fantasy Literature in the Twentieth Century* (Minneapolis: University of Minnesota Press, 2019).

32. The Japanese port of *Wizardry* by ASCII Entertainment was hugely popular, outstripping the game's success in the English-language market and shaping the future of Japanese

console-based RPGs. For details, see Yasuda Hitoshi, *Shinwa seisaku kikairon* (Tokyo: BNN, 1987). Thanks to Marc Steinberg for this reference.

33. Marc Steinberg, "8-Bit Manga: Kadokawa's Madara, or, The Gameic Media Mix," *Kinephanos* 5 (December 2015): 47. A similar genre of RPG-based novels would later emerge in countries like Russia under the name "LitRPG."

34. Takahata Kyōichirō, *Kurisu kurosu: Konton no maō* (Tokyo: Dengeki bunko, 1997). Light novels are roughly the equivalent of Japanese young adult genre literature, with the added feature of manga-style illustrations interspersed throughout. They are also often set in worlds that feel very manga, anime, video game, or VR-inflected, and are emblematic of Ōtsuka's "manga/anime realism." Today many have their initial start on amateur online writing platforms like *Shōsetsuka ni narō* (discussed later in this chapter). See Satomi Saito, "Narrative in the Digital Age: From Light Novels to Web Serials," in *Routledge Handbook of Modern Japanese Literature*, ed. Rachael Hutchinson and Leith Douglas Morton (New York: Routledge, 2016), 315–27.

35. Some aspects of the stuck-in-a-game plot can also be traced back to the film *TRON* (Steven Lisberger, 1982), another frequent reference point in early 1990s VR discourse, although there the aesthetic is more arcade game than medieval fantasy. *TRON*'s into-the-arcade-game aesthetic would later be taken up in a Japanese gaming context in Mizuguchi Tetsuya's *Rez* (United Game Artists, 2001), with the expanded version *Rez Infinite* ultimately ported to VR in 2016. For an example of early 1990s references to *TRON*, see Hattori, *Jinkō genjitsukan no sekai*, 18.

36. Enomoto Masaki, *Denshi bungakuron* (Tokyo: Sairyūsha, 1993), 117. Thanks to Andrew Campana for this reference. On the "information society" discourse in Japan at the time, see Tessa Morris-Suzuki, *Beyond Computopia: Information, Automation and Democracy in Japan* (New York: Routledge, 1988).

37. As of October 2021, *Shōsetsuka ni narō* hosts over 6,000 web novels in the genre of "VR game" stories, and over 150,000 works tagged as *isekai*. For an insightful analysis of the free labor and career ambitions cultivated by these web novel sites, see Gabriella Lukács, *Invisibility by Design: Women and Labor in Japan's Digital Economy* (Durham, NC: Duke University Press, 2020), chap. 5.

38. Kyarikone nyūsu henshūbu, "Ranobe kontesuto de 'isekai tensei NG' no shibarihirogaru: Nettomin 'kore wa rōhō' to kangei," *Kyarikone nyūsu*, May 18, 2017, https://news.career connection.jp/career/general/35597/.

39. For a recent novella focused on the intersection of VR and anthropology, see Shibata Katsuie, *Unnanshō Sū-zoku ni okeru VR gijutsu no shiyōrei* (Tokyo: Hayakawa shobō, 2018).

40. The series currently numbers thirty-four published volumes, which have collectively sold over 26 million copies worldwide as of April 2020. Official translations are available in Chinese, Korean, English, Thai, Vietnamese, French, Spanish, Polish, and Russian. Volumes 1 through 18 were adapted into three seasons of an extremely popular anime series of the same name (2012–2020). The first feature-length film, the AR-oriented *Sword Art Online the Movie: Ordinal Scale* was released theatrically in 2016 and 2017 on over 7,500 screens in twenty-seven countries. The series also has a large catalogue of spin-off

manga, video games, and merchandise; plans for a live-action version from Netflix; and a number of *SAO*-themed VR and AR experiences. Kawahara Reki, *Sōdo āto onrain*, 34 vols. (Tokyo: Dengeki bunko, 2009–2021). On *SAO* as a media mix, see Andrew Hillan, "Sword Art Everywhere: Narrative, Characters, and Setting in the Transmedia Extension of the *Sword Art Online* Franchise," in *Transmedia Storytelling in East Asia: The Age of Digital Media*, ed. Dal Yong Jin (New York: Routledge, 2020), 75–89.

41. Paul Roquet, "Empathy for the Game Master: How Virtual Reality Creates Empathy for Those Seen to Be Creating VR," *Journal of Visual Culture* 19, no. 1 (April 2020). Some of the following paragraphs draw from this article as well.

42. Direct brain-computer interfaces like the NerveGear are still largely speculative, but they are the subject of active research, such as Hirose Michitaka's experiments at the University of Tokyo using brain signals as a kind of "virtual joystick." Anatole Lécuyer et al., "Brain-Computer Interfaces, Virtual Reality, and Videogames," *Computer* 41, no. 10 (October 2008): 66–72.

43. On the *.hack* franchise, see Thomas Lamarre, *The Anime Ecology: A Genealogy of Television, Animation, and Game Media* (Minneapolis: University of Minnesota Press, 2018), chap. 12.

44. Uno Tsunehiro, *Zero-nendai no sōzōryoku* (Tokyo: Hayakawa shobō, 2008), chap. 5.

45. Lamarre, *The Anime Ecology*, 306.

46. Lamarre, *The Anime Ecology*, 308. See also Oliver Grau, *Virtual Art: From Illusion to Immersion* (Cambridge, MA: MIT Press, 2003), 286.

47. Furuya Toshihiro, *Kyokō sekai wa naze hitsuyō ka?: SF anime 'chō' kōsatsu* (Tokyo: Keisōshobō, 2018), 60.

48. Here VR extends the use of the vertical axis as social allegory, which Kristen Whissel locates as a common trope in contemporary films that make heavy use of computer graphics: "digitally enhanced verticality facilitates a rather literal naturalization of culture in which the operation and effects of (social, economic, military) power are mapped onto the laws of space and time." Kristen Whissel, *Spectacular Digital Effects: CGI and Contemporary Cinema* (Durham, NC: Duke University Press, 2014), 22.

49. Cecire, *Re-Enchanted*, 176.

50. One exception is the Korean Japanese character An Si-eun, introduced in the "Mother's Rosario" arc, along with the brief introduction of South Korean and Chinese players in the episode discussed later in the chapter. On the portrayal of characters from other parts of Asia in Japanese video games, see Rachael Hutchinson, *Japanese Culture Through Videogames* (New York: Routledge, 2019).

51. Chris Chesher, "Colonizing Virtual Reality: Construction of the Discourse of Virtual Reality, 1984–1992," *Cultronix* 1 (1994).

52. Quoted in Howard Rheingold, *Virtual Reality: The Revolutionary Technology of Computer-Generated Artificial Worlds—and How It Promises to Transform Society* (New York: Simon & Schuster, 1992), 154.

53. Pamphlet reproduced in Hirose Michitaka, *Bācharu riariti* (Tokyo: Ōmusha, 1995), 3 (emphasis in original).

54. John Perry Barlow, "Being in Nothingness: Virtual Reality and the Pioneers of Cyberspace," *Mondo 2000*, Summer 1990, 37. Quoted in Chesher, "Colonizing Virtual Reality."

55. Ken Hillis, *Digital Sensations: Space, Identity, and Embodiment in Virtual Reality* (Minneapolis: University of Minnesota Press, 1999), xvi–xvii.

56. Hillis, *Digital Sensations*, xxxvii.

57. Japan's colony in Manchuria, 1932–1945.

58. Hirose, *Bācharu riariti*, 132–33 (my translation).

59. Edward W. Said, *Orientalism* (New York: Vintage, 1979).

60. Tara Fickle, *The Race Card: From Gaming Technologies to Model Minorities* (New York: NYU Press, 2019), 125.

61. Here I echo art historian Timon Screech's description of the peep-box, an earlier placed-against-the-face interface where "eyes were sent leaping through glassware before being allowed to land in the space of a picture which, though precisely drawn and plausible, was in no way checkable against a world outside." Timon Screech, *The Lens Within the Heart: The Western Scientific Gaze and Popular Imagery in Later Edo Japan* (Honolulu: University of Hawai'i Press, 2002), 98. See also endnote 16 of the introduction.

62. Sara Ahmed, *Queer Phenomenology: Orientations, Objects, Others* (Durham, NC: Duke University Press, 2006), 114.

63. Tom Boellstorff, *Coming of Age in Second Life: An Anthropologist Explores the Virtually Human*, new edition (Princeton, NJ: Princeton University Press, 2015), 19 (emphasis in original).

64. Alison Byerly, *Are We There Yet?: Virtual Travel and Victorian Realism* (Ann Arbor: University of Michigan Press, 2012), 7.

65. VPL Research (discussed in chapter 2) even had an in-house orientalist joke: one of their VR demos was called the "Oriental carpet," called by that name because the unreliable positional tracking meant the VR carpet on view just "keeps on reorienting." Coco Conn et al., "Virtual Environments and Interactivity: Windows to the Future," in SIGGRAPH '89 Panel Proceedings (SIGGRAPH '89, Boston, MA, 1989), 9.

66. On "identity tourism" in two-dimensional digital worlds, see Lisa Nakamura, *Cybertypes: Race, Ethnicity, and Identity on the Internet* (New York: Routledge, 2002), chap. 2.

67. Jens Schröter, *3D: History, Theory and Aesthetics of the Transplane Image*. Rev. ed. Trans. Brigitte Pichon and Dorian Rudnytsky (New York: Bloomsbury Academic, 2014), 381. On the relation between real and virtual in military simulator systems, see also Lucy Suchman, "Configuring the Other: Sensing War Through Immersive Simulation," *Catalyst* 2, no. 1 (April 22, 2016): 1–36.

68. Hito Steyerl, lecture, "Bubble Vision: Guest, Ghost, Host: Machine!," City Hall, London, October 7, 2017, https://www.youtube.com/watch?v=boMbdtu2rLE.

69. Paul N. Edwards, *The Closed World: Computers and the Politics of Discourse in Cold War America* (Cambridge, MA: MIT Press, 1997).

70. Ann Sherif, *Japan's Cold War: Media, Literature, and the Law* (New York: Columbia University Press, 2016), 1.

71. Ōtsuka, "Mechademia in Seoul."

72. Mendlesohn, *Rhetorics of Fantasy*, 85 (emphasis in original).

73. Ōtsuka, "Mechademia in Seoul."

74. Mendlesohn, *Rhetorics of Fantasy*, 69.

75. See Roquet, "Empathy for the Game Master." On *isekai* and Japanese colonialism, see also Zachary Samuel Gottesman, "The Japanese Settler Unconscious: Goblin Slayer on the 'Isekai' Frontier," *Settler Colonial Studies* 10, no. 4 (2020): 529–57.

76. This is akin to what philosopher C. Thi Nguyen describes as the "value capture" proposition of gamification more generally, where the complex moral landscape of everyday life is traded in for a world where the value system is reassuringly clear, and achievements are readily recognized and quantifiable. C. Thi Nguyen, *Games: Agency As Art* (Oxford: Oxford University Press, 2020), chap. 9.

77. On the shift away from photorealism in Japanese visual media in the 1990s, see the discussion with Inoue Akito et al., "Media mikkusu kara pachinko e: Nihon gēmu seisuishi 1991–2018," *Genron* 8 (2018): 16–74. On the "contents" industry, see Steinberg, *The Platform Economy*, chap. 1.

78. The "Underworld" name is likely another *Alice* reference, this time to the self-published version of the story Carroll gave to the real-life Alice Liddell, entitled *Alice's Adventures Under Ground*.

5. VR AS A TECHNOLOGY OF MASCULINITY

1. Among 341 *VRChat* users surveyed over June and July 2019, 87 percent identified as male, 9 percent as female, and 4 percent replied "neutral" (or not applicable); asked about the gender of the character they mainly played on the platform, 4 percent answered male, 87 percent female, and 9 percent "neutral." Eighty-eight percent of male participants reported using a female character model, while just 10 percent of female participants used a male one. Overall, 75 percent of character models used were anime-style humans. Kazuya Nagamachi et al., "Pseudo Physical Contact and Communication in VRChat: A Study with Survey Method in Japanese Users," in *ICAT-EGVE 2020—International Conference on Artificial Reality and Telexistence and Eurographics Symposium on Virtual Environments—Posters and Demos* (The Eurographics Association, 2020), 2 pages.

2. Okada quoted in Patrick W. Galbraith, *Otaku and the Struggle for Imagination in Japan* (Durham, NC: Duke University Press, 2019), 129.

3. On Japanese "masculinity in crisis" discourse, see the introduction to Sabine Frühstück and Anne Walthall, eds., *Recreating Japanese Men* (Berkeley: University of California Press, 2011). On the antifeminist backlash, see Tomomi Yamaguchi, "The Mainstreaming of Feminism and the Politics of Backlash in Twenty-First-Century Japan," in *Rethinking Japanese Feminisms*, ed. Julia C. Bullock, Ayako Kano, and James Welker (Honolulu: University of Hawai'i Press, 2018), 68–86.

4. Galbraith, *Otaku*, 23–24; Tamaki Saitō, *Beautiful Fighting Girl*, trans. J. Keith Vincent and Dawn Lawson (Minneapolis: University of Minnesota Press, 2011).

5. On the wide range of motivations for cross-gender play in video games, see Esther MacCallum-Stewart, "Real Boys Carry Girly Epics: Normalising Gender Bending in Online Games," *Eludamos* 2, no. 1 (February 29, 2008): 27–40. On gender play in Japanese massively multiplayer online role-playing games (MMORPGs), see Nemura Naomi,

Posutohyūman eshikkusu josetsu: Saibā karuchā no shintai o tou (Tokyo: Seikyūsha, 2017), chaps. 1–2.

6. See, for example, Noa Robinson, *ENDGAME VR Live Stream—The VRchat Transgender Community* (ENDGAME, 2018), https://www.youtube.com/watch?v=MdIU5lvvKE4.

7. The gender ratios given at the start of this chapter have been surprisingly consistent across the last three decades of Japanese VR history, judging by the presenter lists at VR events in Japan going back to the initial International Conferences on Artificial Reality and Tele-Existence held in the 1990s (discussed in chapter 2). The largest nonacademic Japanese VR/AR conference in recent years, XR Kaigi, has so far averaged a similar ratio of one woman for every nineteen men among presenters at their first two annual events in 2019 and 2020, with a slight increase in female speakers in 2021.

8. See "Japan Ranks 120th in 2021 Gender Gap Report, Worst among G-7," *Kyodo News*, March 31, 2021.

9. On the need for "population-level thinking" around subjectivity and gender norms, see Steve Garlick, *The Nature of Masculinity: Critical Theory, New Materialisms, and Technologies of Embodiment* (Vancouver: University of British Columbia Press, 2018), 56.

10. Early examples include the two *Innocent Forest* titles (MyDearest, 2017); *Project LUX* (SpicyTails, 2017); and puzzle and rhythm games played alongside a young female assistant like *Airtone* (AMG, 2017), *Alice Mystery Garden* (AMG, 2017), *Tale of the Fragmented Star* (Jitensha sōgyō, 2018), and *Last Labyrinth* (Amata, 2019).

11. See *Hop Step Sing* (Kōdansha, 2017), *Gal*Gun VR* (Inti Creates, 2017), *Hatsune Miku VR* (Degica/Crypton Future Media, 2018), *Spice and Wolf VR* (SpicyTails, 2019), *Little Witch Academia VR* (Univrs, 2020). and *Kizuna Ai: Touch the Beat!* (Activ8, 2020).

12. GOROman, *Mirai no tsukurikata 2020–2045: Boku ga VR ni kakeru wake* (Tokyo: Seikaisha shinsho, 2018), 79–82.

13. This use of the female body as tech demo (also found in projects like Saya, discussed later in this chapter, or Unreal Engine's Siren) extends the long history of "China Girl" models used on leaders in color film development. On the China Girl, see Genevieve Yue, "The China Girl on the Margins of Film," *October* 153 (July 1, 2015): 96–116.

14. *Ore no yome* (lit. "my wife") is otaku slang a male character enthusiast might use to describe his favorite female character. Ōkaichimon and Yūji, *Oculus Rift de ore no yome to aeru hon: Unity to MMD moderu de tsukuru hajimete no bācharu riariti* (Tokyo: Shōeisha, 2014).

15. Other featured smells include "zombie," "ramen," "fish," and "grassland." See https://vaqso.com/.

16. Since 2018, *VR Kanojo* has consistently appeared in the Platinum category on Steam's annual Best of VR list, which includes the top twelve VR-only titles for the year, measured by gross revenue on the platform. The game initially received a takedown warning for explicit content, only to be allowed after Steam controversially announced in the summer of 2018 that it would "allow everything onto the Steam Store, except for things that we decide are illegal, or straight up trolling." "Who Gets to Be on the Steam Store?," Steam Blog, June 6, 2018, https://store.steampowered.com/news/group/27766192/view/.

17. See https://summer-lesson.bn-ent.net/. *Summer Lesson* was created by developers from Bandai Namco's *Tekken* franchise and built on the three-dimensional character modeling technology developed for that series.

18. Shin similarly notes how the game engages the intimate personal space just centimeters from the player's head. Ben Lang, " 'Summer Lesson' for PlayStation VR Made Me Feel Like a Creep, and That's a Good Thing," *Road to VR*, September 16, 2015, https://www.roadtovr.com/summer-lesson-for-playstation-vr-made-me-feel-like-a-creep-and-thats-a-good-thing/. Shin, *VR bijinesu no shōgeki*, 147–48.

19. *Summer Lesson* does give the option of selecting a "female" tutor torso, but the default is male.

20. As described by "Genius Hiza," a producer for the major Japanese adult VR production studio KM Produce. Quoted in "Yume kara sameta VR: Bijinesu no genjō to mirai e no kadai," *Boss* (January 2019): 23. For an interesting interview with adult VR producers on the difficulties of shooting in this style—particularly for the male performer—see Ōtsugu, "SOD ga katatta, adaruto VR no ima," *Mogura VR*, January 14, 2019, https://www.moguravr.com/sod-vr-4/. On the aesthetics of VR and stereoscopic pornography, see Miriam Ross, "From the Material to the Virtual: The Pornographic Body in Stereoscopic Photography, 3D Cinema and Virtual Reality," *Screen* 60, no. 4 (December 1, 2019): 548–66.

21. In 2018, DMM.com reported over 4 billion yen in sales from their VR video library, including 150 videos making between 5 and 10 million each. Kubota Shun, "Kōchō tsuzuku DMM VR, 2-nen me no uriage wa zennenhi no 2-bai no 40 oku en toppa," *Mogura VR*, November 10, 2018, https://www.moguravr.com/dmm-vr-interview-2/.

22. Smartpr!se, "Joshikōsei YouTuber 'Fuji Aoi,' " *VRRunner*, August 20, 2018, 12. See later in this chapter for more on virtual YouTubers.

23. See fove-inc.com.

24. Kurihara Kazutaka et al., "Shōkyokusei dezain de heiwa o jitsugen suru," *PLANETS*, 2018, 82. One possible Japanese origin for the "naked in VR" trope can be found in *Klein Bottle*, the early VR narrative discussed in chapter 4. As noted there, *Klein Bottle* imagines a virtual reality system where a user must first disrobe completely to let the gel interface transmit sensory information to the skin. The female play tester for the game—and later love interest of the male protagonist—is initially reluctant to undress, but the game developers pressure her to go through with it. Okajima Futari, *Kurain no tsubo* (Tokyo: Shinchōsha, 1993), 102–3.

25. Sharon Kinsella, *Adult Manga: Culture and Power in Contemporary Japanese Society* (New York: Routledge, 2000), 14.

26. The studio that produced *VR Kanojo*, Illusion, is no stranger to this phenomenon. Illusion is best known in a Japan studies context as the studio responsible for *RapeLay* (2006), an adult computer game that sparked an international controversy surrounding its depiction of stalking, rape, and sexual assault. As Jennifer deWinter notes, while *RapeLay* was not especially provocative or unusual within the small Japanese market for adult computer games (where most titles sell only around 1,000 or 2,000 copies), it sparked a backlash outside Japan after a 2009 article in the *Belfast Telegraph* highlighted

how anyone in Ireland could purchase the game from Amazon. See Jennifer deWinter, "Regulating Rape: The Case of *RapeLay*, Domestic Markets, International Outrage, and Cultural Imperialism," in *Video Game Policy: Production, Circulation, Consumption*, ed. Steven Conway and Jennifer deWinter (New York: Routledge, 2016), 244–58.

27. See, for example, Sally Pryor and Jill Scott, "Virtual Reality: Beyond Cartesian Space," in *Future Visions: New Technologies of the Screen*, ed. Philip Hayward and Tana Wollen (London: British Film Institute, 1993), 175. As Pryor's description of the *MacPlaymate* (Mike Saenz, 1985) software hints, much about the basic mechanics and popular discourse surrounding interactive pornography has changed relatively little with the arrival of VR, even as it becomes more fully embodied, photorealistic, three-dimensional, and human scaled.

28. Quoted in James Nicholas Cohen, "Virtual Evolution: An Alternate History of Cyberspace, 1988–1997" (PhD diss., Stony Brook University, 2019), 210.

29. Laurel quoted in Chris Dafoe, "The Next Best Thing to Being There," *Globe and Mail*, September 5, 1992.

30. Rosi Braidotti, "Cyberfeminism with a Difference," *New Formations* 29 (1996): 15, 21–22.

31. Pryor and Scott, "Virtual Reality," 172.

32. See Mary Anne Moser and Douglas MacLeod, eds., *Immersed in Technology: Art and Virtual Environments* (Cambridge, MA: MIT Press, 1996).

33. Jacquelyn Ford Morie, "Female Artists and the VR Crucible: Expanding the Aesthetic Vocabulary," *Proceedings of SPIE*, ed. Ian E. McDowall and Margaret Dolinsky (IS&T/ SPIE Electronic Imaging, Burlingame, California, USA, 2012), 5–6.

34. N. Katherine Hayles, "Embodied Virtuality: Or How to Put Bodies Back into the Picture," in *Immersed in Technology: Art and Virtual Environments*, ed. M. Anne Moser (Cambridge, MA: MIT Press, 1996), 15.

35. Daniel Harley, "Palmer Luckey and the Rise of Contemporary Virtual Reality," *Convergence* 26, no. 5–6 (2020): 6. On #GamerGate, see Megan Condis, *Gaming Masculinity: Trolls, Fake Geeks, and the Gendered Battle for Online Culture* (Iowa City: University of Iowa Press, 2018), chap. 4.

36. Quoted in Harley, "Palmer Luckey," 7 (emphasis in original).

37. Harley, "Palmer Luckey," 7.

38. Interview in 2016 with the Techies Project, quoted in Harley, "Palmer Luckey," 8.

39. There are women playing important roles in the Japanese VR scene as well, but to give just one example of outreach efforts without tokenizing anyone: the "Women in VR/AR Japan" group held a series of women-only workshops and meetups from 2015 to 2017 in Tokyo and Osaka, starting as a spin-off of the Warsaw-based Geek Girls Carrots community.

40. Dan Golding, "Far from Paradise: The Body, the Apparatus and the Image of Contemporary Virtual Reality," *Convergence* 25, no. 2 (2017): 347; Paul Roquet, "Empathy for the Game Master: How Virtual Reality Creates Empathy for Those Seen to Be Creating VR," *Journal of Visual Culture* 19, no. 1 (April 2020).

41. Phillip Hayward, "Situating Cyberspace: The Popularization of Virtual Reality," in *Future Visions: New Technologies of the Screen*, ed. Phillip Hayward and Tana Wollen (London: British Film Institute, 1993), 181.

42. Galbraith, *Otaku*, 62.

43. Quoted in Galbraith, *Otaku*, 62. "Lolicon" here is short for "Lolita complex"—initially from the 1955 Vladimir Nabokov novel, but in this context referring more generally to adult men drawn to illustrations of young, fictional girls [*shōjo*] in the style of children's manga and anime.

44. Kinsella, *Adult Manga*, 122.

45. See later in this chapter for details on virtual YouTubers.

46. Senda Yūki, "Nōberu-shō no NHK kaisetsu ni 'Kizuna Ai' wa tekiyaku nanoka?," *Yahoo! News Japan*, October 3, 2018, https://news.yahoo.co.jp/byline/sendayuki/20181003 -00099158/.

47. Patrick St. Michel, "Kizuna AI's NHK Appearance Sparks Debate on Social Media," *Japan Times*, October 13, 2018.

48. While especially prominent in the online otaku context today, this line of argument has plenty of precedents. For example, the prominent Japanese prewar mystery writer Edogawa Rampo made similar defenses of his often gleefully perverse detective fiction in the 1930s, insisting on an "absolute distinction" between "real life" and the "pure fantasy" of his fictional worlds. Seth Jacobowitz, "The Claustrophilic Enclosure: Toward a Speculative Philosophy of Perversion in Edogawa Rampo," *Japan Forum*, forthcoming.

49. Senda Yūki, "Hyōgen no jiyū' wa dono yō ni mamorareru beki nanoka? Futatabi Kizuna Ai sōdō ni yosete" *Yahoo! News Japan*, October 4, 2018, https://news.yahoo.co.jp/byline /sendayuki/20181004-00099263/.

50. Kokumai Ananda and Kuribayashi Fumiko, "Takanawa shineki no AI 'Sakura-san,' sekuhara ukenagashi butsugi," *Asahi shinbun*, March 19, 2020. The AI agents' developer, Tifana, later altered some of these responses manually in response to the criticism.

51. Galbraith describes a similar episode where *Manga burikko* readers in the early 1980s reacted negatively to a side-by-side magazine spread of photographed female models and illustrated girls. Due to reader demand, pictures of human women were quickly dropped from the magazine's pages to create an entirely illustrated and safely "fictional" space. While Galbraith reads this as an example of readers simply realizing their preference for illustrations over "real" women, I would point to how the juxtaposition itself works to disturb the premise that there can ever be a strict separation of real and virtual representational logics. Galbraith, *Otaku*, 54–55.

52. Aleardo Zanghellini quoted in Galbraith, *Otaku*, 65.

53. Azuma Hiroki, *Otaku: Japan's Database Animals*, trans. Jonathan E. Abel and Shion Kono (Minneapolis: University of Minnesota Press, 2009); Takashi Murakami, *Superflat* (San Francisco: Last Gasp, 2003).

54. This includes attempts to establish the category of the "2.5 dimensional" as a means to incorporate three-dimensional otaku contexts like live performance while still sequestering them from the broader human world. These arguments tend to downplay the extensive role of three-dimensional computer graphics in both video games and animation starting in the late 1990s, as well as the inherently three-dimensional spatiality of character figures, cosplay, and other related activities.

55. On legal debates surrounding the sexualization of real and fictional children in Japanese media, see Mark J McLelland, "Thought Policing or the Protection of Youth? Debate in Japan over the 'Non-Existent Youth Bill,'" *International Journal of Comic Art* 13, no. 1 (2011): 348–67.

56. Yuya Kiuchi, "Idols You Can Meet: AKB48 and a New Trend in Japan's Music Industry," *Journal of Popular Culture* 50, no. 1 (2017): 30–49.

57. Steve Garlick notes how the "Browse by Category" menu at the XTube pornography streaming site, arranged alphabetically, starts with "Amateur, Anal, Anime, Asian." Here too the difference between "real" and "virtual" is presented less as an ontological distinction than one of consumer preference. The slippage between racialization and virtualization I discussed in chapter 4 is also fully evident. Garlick, *The Nature of Masculinity*, 141.

58. This and a wide range of similar projects appeared at Japan's first Adult VR Festival, held on June 12, 2016, in Akihabara, Tokyo. The event was shut down early due to an unexpectedly large crowd of over 600 people on the street outside waiting to get in. Oyama Ondemando, "Adaruto VR fesuta," *Den fami niko gēmā*, June 12, 2016, https://news .denfaminicogamer.jp/kikakuthetower/adult-vr01.

59. Dean Takahashi, "Will Japanese VR Sex Simulation with Dolls Fly in the U.S.?," *VentureBeat*, January 11, 2017, https://venturebeat.com/2017/01/11/will-japanese-vr-sex-simulation-with -dolls-fly-in-the-u-s/.

60. *VR Kareshi* has yet to be released, but demonstration versions have been put on display at various game and anime expos. See Kyle Melnick, "This 'VR Boyfriend' Served Me a Romantic Meal at Anime Expo 2019," *VRScout*, July 8, 2019, https://vrscout.com/news /vr-kareshi-love-simulation-game/.

61. Condis, *Gaming Masculinity*, 52.

62. Anne Allison, *Millennial Monsters: Japanese Toys and the Global Imagination* (Berkeley: University of California Press, 2006), 140 (emphasis in original). See also Kinsella, *Adult Manga*, 122.

63. Tanji Yoshinobu, "Ojisan no kokoro ni meboeta 'bishōjo': VR ga motarasu, mō hitotsu no mirai," *WithNews*, March 29, 2018. https://withnews.jp/article/f0180329000qq000000000000000 W00g10701qq000017016A.

64. Mirrored reflections of the virtual body have played a key role in VR researchers' attempts to induce what Slater calls the "virtual body illusion." See Mel Slater et al., "Inducing Illusory Ownership of a Virtual Body," *Frontiers in Neuroscience* 3 (2009): 214–20.

65. Liudmila Bredikhina explores the historical resonances between Kabuki and *babiniku* in "Virtual Theatrics and the Ideal V Tuber *Bishōjo*," *Replaying Japan* 3 (March 2021): 21–32.

66. Christine Yano, "The Burning of Men: Masculinities and the Nation in Popular Song," in *Men and Masculinities in Contemporary Japan: Dislocating the Salaryman Doxa*, ed. James E. Roberson and Nobue Suzuki (New York: Routledge, 2002), 79.

67. @tanji_y on Twitter, April 4, 2018 (my translation).

68. Allucquère Rosanne Stone, "Sex and Death Among the Disembodied: VR, Cyberspace, and the Nature of Academic Discourse," *Sociological Review* 42, no. 1 (May 1994): 254. See also Lisa Nakamura, *Cybertypes: Race, Ethnicity, and Identity on the Internet* (New York: Routledge, 2002), 40–41.

69. Daniel Black, "The Virtual Idol: Producing and Consuming Digital Femininity," in *Idols and Celebrity in Japanese Media Culture*, ed. Patrick W. Galbraith and Jason G. Karlin (London: Palgrave Macmillan UK, 2012), 217 (emphasis removed).

70. Genta Nakahara, "Saya the Virtual Human Project Opens New Creative Frontiers," HAKUHODO, July 9, 2018, https://www.hakuhodo-global.com/news/saya-the-virtual -human-project-opens-new-creative-frontiers.html. Imma, a later virtual model from Shibuya-based ModelingCafe, follows a similar photorealistic approach.

71. Tifana, "Jinkō chinō (AI) tōsai kyarakutā 'Sakura' ni yoru sekkyaku shisutemu: Riyō shiin," accessed October 28, 2020, https://tifana.ai/case/.

72. Quoted in Nagakura Katsue, "VR būmu futatabi, rekishi wa kurikaesu ka?: 'VR kuro rekishi' kara tenbō suru kore kara no VR," *Huffpost Japan*, October 12, 2015, https://www .huffingtonpost.jp/katsue-nagakura/virtual-reality_b_8128690.html. On Date Kyōko, see also Black, "The Virtual Idol." This emphasis on "controllability" was also a frequent claim among virtual YouTuber promoters at industry conferences and trade fairs I attended, such as Contents Tokyo 2019.

73. For further details see *Yuriika*, Bācharu YouTuber Special Issue, July 2018; Liudmila Bredikhina, "Virtual Theatrics and the Ideal VTuber *Bishōjo*."

74. See User Local, "Ninki bācharu yūchūbā rankingu," https://virtual-youtuber.userlocal. jp/document/ranking/.

75. This is my impression after attending numerous business presentations and reading interviews from executives and employees of the major virtual YouTuber studios, although the exact personnel behind specific virtual YouTubers are usually kept purposefully hidden. The pairing of male producers and female "talent" is common in Japanese popular music more generally. As Yano writes of *enka*, because Japanese pop "derives from a male-centered frame with predominantly male producers, directors, composers and lyricists, its female characters, songs and singers become products and projections of male desire." Yano, "The Burning of Men," 81.

76. Neda Atanasoski and Kalindi Vora, *Surrogate Humanity: Race, Robots, and the Politics of Technological Futures* (Durham, NC: Duke University Press, 2019), 6.

77. Paul Roquet, *Ambient Media: Japanese Atmospheres of Self* (Minneapolis: University of Minnesota Press, 2016), 56.

78. Victor Szabo, "Ambient Music as Popular Genre: Historiography, Interpretation, Critique" (PhD diss., University of Virginia, 2015), 26.

79. Condis, *Gaming Masculinity*, 20.

80. Susan Napier, "Where Have All the Salarymen Gone?: Masculinity, Masochism, and Technomobility in *Densha Otoko*," in *Recreating Japanese Men*, ed. Sabine Frühstück and Anne Walthall (Berkeley: University of California Press, 2011), 155. Related notions emerging in other Japanese performance and media contexts can be found in Jennifer Robertson, *Takarazuka: Sexual Politics and Popular Culture in Modern Japan* (Berkeley: University of California Press, 1998); Yano, "The Burning of Men."

81. Garlick, *The Nature of Masculinity*, 96.

82. Quoted in Galbraith, *Otaku*, 32.

83. Shunsuke Nozawa, "The Gross Face and Virtual Fame: Semiotic Mediation in Japanese Virtual Communication," *First Monday* 17, no. 3 (March 2, 2012).

84. Galbraith, *Otaku*, 202. Architecture theorist Morikawa Kaichirō similarly points to how Akihabara's "windowless buildings" are designed so as to better focus attention on the *isekai* (other worlds) of the manga and anime on offer. Quoted in Shinji Miyadai, "Transformation of Semantics in the History of Japanese Subcultures Since 1992," trans. Shion Kono, *Mechademia* 6 (2011): 236.

85. While Galbraith positions this move toward male self-erasure as unique to the otaku subculture at the time, similar patterns can be found in popular Japanese video games and literature from the 1980s. Protagonists become hollowed-out and nondescript, as with Murakami Haruki's famously empty *boku* narrators.

86. Hanazawa Kengo, *Rusanchiman*, 4 vols. (Tokyo: Big Comics, 2004). The work won a Sense of Gender award in 2005 from the Japanese Association for Gender Fantasy & Science Fiction; the award is given to works that "invite us to reconsider gender profoundly and excitingly." Japanese Association for Gender Fantasy & Science Fiction, "The Herstory of Sense of Gender Award," 2014, http://gender-sf.org/assets/files/HerstorySOG.pdf.

87. This narrative trajectory was later echoed in the film *Her* (Spike Jonze, 2013), which, as manga artist Kira Takashi notes, in many ways is simply a more "fashionable" (*oshare*) version of Hanazawa's manga. See *Sōtokushū Hanazawa Kengo: Hīrō-naki sekai o ikiru*, KAWADE yume mukku (Tokyo: Kawade shobō shinsha, 2016), 46–47.

88. *Sōtokushū Hanazawa Kengo*, 17–19. Coincidentally, Miyazaki Tsutomu had also worked at a print shop before committing his crimes in the late 1980s.

89. Hanazawa Kengo, " 'Himote' de sura nai motenai otoko no ikisama," *Tsukuru*, 2010, 58. On the broader *himote* discourse, see Elizabeth Miles, "Manhood and the Burdens of Intimacy," in *Intimate Japan: Ethnographies of Closeness and Conflict*, ed. Allison Alexy and Emma E. Cook (Honolulu: University of Hawai'i Press, 2019), 148–63. *Ressentiment* parodies the superficially anticapitalist stance of *himote* activists like Honda Tōru via Takurō's decision to spend all his savings on expensive VR equipment. Anthropologist Ian Condry succinctly glosses this otaku investment in virtual commodities as offering a model of "manhood through consumption." Ian Condry, *The Soul of Anime: Collaborative Creativity and Japan's Media Success Story* (Durham, NC: Duke University Press, 2013), 195.

90. Jenny Uechi, "Society's Role in Kato's Crime," *Japan Times*, July 1, 2008. In the U.S. context, scholars have pointed to #GamerGate as an early instance of the kind of misogynist harassment and violence that would later erupt into a more mainstream context surrounding incel (a portmanteau of "involuntary celibate") male supremacist groups online, particularly following the shooting near the University of California at Santa Barbara in 2014. In a broader online context, gender *ressentiment* among Japanese *netto-uyoku* ["net right-wing"] communities intersects in complex ways with the so-called American alt-right, including a shared visual vocabulary of anime in general and *bishōjo* characters in particular. For an overview, see Brett Fujioka, "Japan's Cynical Romantics, Precursors to the Alt-Right," *Tablet*, August 8, 2019, https://www.tabletmag.com /sections/news/articles/japans-cynical-romantics.

91. Hanazawa, "'Himote' de sura nai motenai otoko no ikisama." The gender dynamics of *Sword Art Online* (see chapter 4) offer a typical example of this so-called harem structure where all the female characters inevitably fall in love with the otherwise geeky male lead.

92. *Sōtokushū Hanazawa Kengo*, 22.

93. Hanazawa, *Rusanchiman*, vol. 1, 96.

94. Clarissa Graffeo, "The Great Mirror of Fandom: Reflections of (and on) *Otaku* and *Fujoshi* in Anime and Manga" (master's thesis, University of Central Florida, 2006), 55.

95. Hanazawa, *Rusanchiman*, vol. 1, 46, 65, 104.

96. As of October 2021, the Node channel has 3.27 million subscribers, and the *VR Kanojo* playthrough has 2.8 million views. For more on the domestic spaces surrounding video game streaming, see T. L. Taylor, *Watch Me Play: Twitch and the Rise of Game Live Streaming* (Princeton, NJ: Princeton University Press, 2018), 99–102.

97. On sexual harassment in VR, see Jordan Belamire, "My First Virtual Reality Groping," *Medium*, October 22, 2016, https://medium.com/athena-talks/my-first-virtual-reality-sexual-assault-2330410b62ee. In an article for *Kotaku*, games journalist Kate Gray attempts to defend *VR Kanojo* from assumptions that it can only lead to this kind of behavior, pointing out how the main character still seems to retain some amount of (programmed) agency even in the midst of this inherently unequal power structure. Her main example is how the girl asks the VR user to turn away while she undresses, which they must physically do for the scene to continue. While this interaction is likely there so the developers can avoid the difficult task of animating clothing removal, Gray's reading does point to the possibility of a more complex power dynamic emerging through the game's staged relationship. Kate Gray, "This VR Girlfriend Simulator Is About More Than Cybersex," *Kotaku*, February 27, 2018, https://kotaku.com/vr-kanojos-anime-girlfriend-is-more-than-just-a-sex-dol-1823329702.

98. Steam, "Steam Community: VR Kanojo," accessed October 28, 2020, https://steamcommunity.com/app/751440/reviews/.

99. Condry emphasizes how the emotional connection with *bishōjo* characters in some ways appears to be taken up only in order to be discussed and debated on social media and in the broader society, generating new social connections in the process. Condry, *The Soul of Anime*, 200–201.

100. Bōryoku Tomoko, *VR ojisan no hatsukoi* (Tokyo: Zero-Sum Comics, 2021), 45.

101. Tamagomago, "'VR ojisan no hatsukoi' ga rosujene sedai ni tsukisasaru 'otaku, nekura, kimoi, datte ore sono tōri nandamon': Bōryoku Tomoko ni kiku," *QJWeb*, April 16, 2021, https://qjweb.jp/feature/49078/.

102. The manga first went viral in serialized form on social media; as of October 2021, the published version currently has a 4.9/5.0 average on Amazon.co.jp across 663 reviews.

103. Tamagomago, "'VR ojisan no hatsukoi' ga rosujene sedai ni tsukisasaru."

104. Bōryoku, *VR ojisan no hatsukoi*, 46–47.

105. Michelle Cortese, "Virtual_ Healing," *Medium*, December 3, 2019, https://medium.com/@ellecortese/virtual-healing-bf2b5f0cbf51 (emphasis in original).

106. On possibilities for imagining a more feminist future for VR, see Marisa Brandt and Lisa Messeri, "Imagining Feminist Futures on the Small Screen: Inclusion and Care in VR Fictions," *NatureCulture* 5, 2019.

CONCLUSION

1. Maria V. Sanches-Vives and Mel Slater, "From Presence to Consciousness Through Virtual Reality," *Nature Reviews Neuroscience* 6 (2005): 332.

2. On the broader InterCommunication project (including a bit about Hachiya's work), see Marilyn Ivy, "The *InterCommunication* Project: Theorizing Media in Japan's Lost Decades," in *Media Theory in Japan*, ed. Marc Steinberg and Alexander Zahlten (Durham, NC: Duke University Press, 2017), 101–27.

3. Andrew Pollack, "For Artificial Reality, Wear a Computer," *New York Times*, April 10, 1989.

4. Hachiya Kazuhiko, "Shichōkaku kōkan mashin," accessed July 13, 2020, http://www.petworks.co.jp/~hachiya/works/shi_ting_jue_jiao_huanmashin.html.

5. Digital cinema scholar Nick Jones convincingly argues that the "monstrous" distortions three dimensional imagery introduces into digital imaging should be considered a core element of the three-dimensional aesthetic overall. "More so than any other representational media," he writes, "3D seems to create and accentuate the absence that lies at the heart of any visual depiction of the world." Nick Jones, *Spaces Mapped and Monstrous: Digital 3D Cinema and Visual Culture* (New York: Columbia University Press, 2020), 213.

6. Michael Saker and Jordan Frith note how the environments around the headset play a key framing role for the experiences within VR, a relationship they describe as "coextensive space." Michael Saker and Jordan Frith, "Coextensive Space: Virtual Reality and the Developing Relationship Between the Body, the Digital and Physical Space," *Media, Culture & Society* 42, no. 7–8 (June 19, 2020): 1427–42. See also Paul Roquet, "Ambiance In and Around the Virtual Reality Headset," in *Proceedings of the 4th International Congress on Ambiances, Alloaesthesia: Senses, Inventions, Worlds*, vol. 2 (France: Réseau International Ambiances, 2020).

7. The ecological footprint of VR headset manufacture is a critical and largely unaddressed aspect of the industry, especially in this era of rapid iteration and short headset life cycles. The Oculus Go headset, for example, barely lasted two years before Facebook began sunsetting the hardware and its associated platform.

8. See MyDearest CEO Kishigami Kento's 2019 post about this in relation to Facebook's often oblique and America-centric Oculus Store requirements. Kishigami Kento, "Facebook kara Nihon VR kai e no yomei senkoku na no ka!?: Oculus Quest kontentsu shinsa kitei to wa," *note*, March 10, 2019, https://note.com/tokimekishiken/n/n3e944d9e25ad. As noted in the introduction, Facebook's recent announcement of a separate Japanese Oculus store goes some way toward addressing this issue, albeit via content segregation rather than any deeper consideration of the international market. More generally, Shin's 2018 book already warned Japan was falling at least one to two years behind the American VR competition. Shin Kiyoshi, *VR bijinesu no shōgeki: 'Kasō sekai' ga kyodai manē o umu* (Tokyo: NHK shuppan, 2016), 208–11.

9. According to *VRChat* CEO Graham Gaylor, 52 percent (or 12,500) were using a VR headset to access the platform. Ben Lang, "Spurred by Quest 2 Launch, 'VRChat' Hits

Record 24,000 Concurrent Users, More Than Half in VR," *Road to VR*, November 4, 2020, https://www.roadtovr.com/vrchat-record-concurrent-users-traffic-quest-2/.

10. Quoted in David H. Freedman, "Facebook's Plan to Dominate Virtual Reality—and Turn Us into 'Data Cattle,'" *Newsweek*, December 23, 2020, https://www.newsweek.com /facebooks-plan-dominate-virtual-reality-turn-us-data-cattle-1556805.

11. Danielle Abril, "Meet the Executive Leading Facebook's Big Augmented and Virtual Reality Push," *Fortune*, October 17, 2019, https://fortune.com/2019/10/17/qa-facebook -andrew-bosworth-augmented-virtual-reality/.

12. Adi Robertson, "Facebook Is Making Oculus' Worst Feature Unavoidable," *Verge*, August 19, 2020, https://www.theverge.com/2020/8/19/21375118/oculus-facebook-account -login-data-privacy-controversy-developers-competition.

13. Ian Hamilton, " 'Hey Facebook' Wake Words Roll Out to Oculus Quest 2," *UploadVR*, February 25, 2021, https://uploadvr.com/hey-facebook-are-you-listening/.

14. Jeremy Bailenson, *Experience on Demand: What Virtual Reality Is, How It Works, and What It Can Do* (New York: Norton, 2018), 244.

BIBLIOGRAPHY

Abril, Danielle. "Meet the Executive Leading Facebook's Big Augmented and Virtual Reality Push." *Fortune*, October 17, 2019. https://fortune.com/2019/10/17/qa-facebook-andrew-bosworth-augmented-virtual-reality/.

Ahmed, Sara. *Queer Phenomenology: Orientations, Objects, Others*. Durham, NC: Duke University Press, 2006.

Aida, Miho. "The Construction of Discourses on Otaku: The History of Subcultures from 1983 to 2005." In *Debating Otaku in Contemporary Japan: Historical Perspectives and New Horizons*, ed. Patrick W. Galbraith, Thiam Huat Kam, and Björn-Ole Kamm, 105–28. New York: Bloomsbury Academic, 2015.

Aizu Izumi. "Bācharu riariti." *Front*, September 1990, 42–43.

Ajunwa, Ifeoma, Kate Crawford, and Jason Schultz. "Limitless Worker Surveillance." *California Law Review* 105, no. 3 (2017): 735–76.

Allison, Anne. *Millennial Monsters: Japanese Toys and the Global Imagination*. Berkeley: University of California Press, 2006.

Ames, Morgan G. *The Charisma Machine: The Life, Death, and Legacy of One Laptop per Child*. Cambridge, MA: MIT Press, 2019.

Andersen, Joceline. "Now You've Got the Shiveries: Affect, Intimacy, and the ASMR Whisper Community." *Television & New Media* 16, no. 8 (December 2015): 683–700.

Andrejevic, Mark. *iSpy: Surveillance and Power in the Interactive Era*. Lawrence: University Press of Kansas, 2007.

Annear, Steve. "Please Keep Your Virtual Reality Off the T." *Boston Globe*, April 1, 2016.

AP Television. *Tokyo University Develops a Mirror Which Can Put a Smile on Your Face*, 2014. https://www.youtube.com/watch?v=xYanXR7MDso.

Aramata Hiroshi. *VR bōkenki: Bācharu riariti wa yume ka akumu ka*. Tokushima: JustSystems Corporation, 1996.

Artaud, Antonin. *The Theater and Its Double*. Trans. Mary Caroline Richards. New York: Grove, 1958.

Asada Akira. *Kōzō to chikara: Kigōron o koete*. Tokyo: Keisōshobō, 1983.

Ash, James. *The Interface Envelope: Gaming, Technology, Power*. New York: Bloomsbury Academic, 2016.

Ashbrook, Tom. "You Are About to Travel into Another Reality . . ." *Boston Globe*, July 28, 1988.

Atanasoski, Neda, and Kalindi Vora. *Surrogate Humanity: Race, Robots, and the Politics of Technological Futures*. Durham, NC: Duke University Press, 2019.

Azuma, Hiroki. *Otaku: Japan's Database Animals*. Trans. Jonathan E. Abel and Shion Kono. Minneapolis: University of Minnesota Press, 2009.

Bailenson, Jeremy. *Experience on Demand: What Virtual Reality Is, How It Works, and What It Can Do*. New York: Norton, 2018.

Barlow, John Perry. "Being in Nothingness: Virtual Reality and the Pioneers of Cyberspace." *Mondo 2000* (Summer 1990): 34–43.

Barlow, John Perry, and Jaron Lanier. "Life in the DataCloud: Scratching Your Eyes Back In—John Perry Barlow Interviews Jaron Lanier." *Mondo 2000* (Summer 1990): 44–51.

Baudrillard, Jean. *The Gulf War Did Not Take Place*. Trans. Paul Patton. Sydney: Power Publications, 2012.

——. *The Intelligence of Evil: Or the Lucidity Pact*. Trans. Chris Turner. New York: BERG, 2005.

——. *Simulacra and Simulation*. Trans. Sheila Faria Glaser. Ann Arbor: University of Michigan Press, 1994.

——. "The Virtual Illusion: Or the Automatic Writing of the World." *Theory, Culture & Society* 12 (1995): 97–107.

Belamire, Jordan. "My First Virtual Reality Groping." *Medium*, October 22, 2016. https://medium.com/athena-talks/my-first-virtual-reality-sexual-assault-2330410b62ee.

Benjamin, Ruha. *Race After Technology: Abolitionist Tools for the New Jim Code*. Medford, MA: Polity, 2019.

Bettig, Ronald V. "The Enclosure of Cyberspace." *Critical Studies in Mass Communication* 14, no. 2 (June 1997): 138–57.

Binder, Matt. "Microsoft Signs $480 Million HoloLens Contract with U.S. Military to 'Increase Lethality.'" *Mashable*, November 29, 2018. https://mashable.com/article/microsoft-hololens-us-military-contract/.

Black, Daniel. "Machines with Faces: Robot Bodies and the Problem of Cruelty." *Body & Society* 25, no. 2 (June 2019): 3–27.

——. "The Virtual Idol: Producing and Consuming Digital Femininity." In *Idols and Celebrity in Japanese Media Culture*, ed. Patrick W. Galbraith and Jason G. Karlin, 209–28. London: Palgrave Macmillan UK, 2012.

Blanchard, Chuck, Scott Burgess, Young Harvill, Jaron Lanier, Ann Lasko, Mark Oberman, and Mike Teitel. "Reality Built for Two: A Virtual Reality Tool." In *Proceedings of the 1990 Symposium on Interactive 3D Graphics*, 35–36. I3D '90. New York: ACM, 1990.

Blesser, Barry, and Linda-Ruth Salter. *Spaces Speak, Are You Listening?: Experiencing Aural Architecture*. Cambridge, MA: MIT Press, 2009.

Boellstorff, Tom. *Coming of Age in Second Life: An Anthropologist Explores the Virtually Human.* New ed. Princeton, NJ: Princeton University Press, 2015.

Bolter, J. David, and Richard A. Grusin. *Remediation: Understanding New Media.* Cambridge, MA: MIT Press, 1999.

Bookman, Mark. "Engineering Employment: Robots and Remote Work for Persons with Disabilities at a Japanese Cafe." *Accessible Japan* (blog), 2019. https://www.accessible-japan.com /engineering-employment-robots-and-remote-work-for-persons-with-disabilities-at-a-japanese -cafe/.

Bōryoku Tomoko. *VR ojisan no hatsukoi.* Tokyo: Zero-Sum Comics, 2021.

Boyer, Steven. "A Virtual Failure: Evaluating the Success of Nintendo's Virtual Boy." *The Velvet Light Trap* 64, no. 1 (2009): 23–33.

Braidotti, Rosi. "Cyberfeminism with a Difference." *New Formations* 29 (1996): 9–25.

Brandt, Marisa, and Lisa Messeri. "Imagining Feminist Futures on the Small Screen: Inclusion and Care in VR Fictions." *NatureCulture* 5 (2019): 1–25.

Bredikhina, Liudmila. "Virtual Theatrics and the Ideal VTuber *Bishōjo.*" *Replaying Japan* 3 (March 2021): 21-32.

Bull, Michael. *Sound Moves: IPod Culture and Urban Experience.* New York: Routledge, 2008.

——. "Thinking About Sound, Proximity, and Distance in Western Experience: The Case of Odysseus's Walkman." In *Hearing Cultures: Essays on Sound, Listening and Modernity,* ed. Viet Erlmann, 173–91. Oxford: Berg, 2004.

Byerly, Alison. *Are We There Yet?: Virtual Travel and Victorian Realism.* Ann Arbor: University of Michigan Press, 2012.

Callon, Scott. *Divided Sun: MITI and the Breakdown of Japanese High-Tech Industrial Policy, 1975–1993.* Stanford, CA: Stanford University Press, 1997.

Carmack, John. *Oculus Connect 5 Keynote.* Presented at Oculus Connect 5, San Jose, California, 2018. https://youtu.be/VW6tgBcN_fA.

Carter, Marcus, and Ben Egliston. "What Are the Risks of Virtual Reality Data? Learning Analytics, Algorithmic Bias and a Fantasy of Perfect Data." *New Media & Society,* forthcoming.

Cecire, Maria Sachiko. *Re-Enchanted: The Rise of Children's Fantasy Literature in the Twentieth Century.* Minneapolis: University of Minnesota Press, 2019.

Chambers, Iain. "A Miniature History of the Walkman." *New Formations* 11 (1990): 1–4.

Chan, Melanie. *Virtual Reality: Representations in Contemporary Media.* New York: Bloomsbury Academic, 2015.

Chandler, David L. "Artificial Reality: It May Be Better Than the Real Thing." *Boston Globe,* February 26, 1990.

Chesher, Chris. "Colonizing Virtual Reality: Construction of the Discourse of Virtual Reality, 1984–1992." *Cultronix* 1 (1994): 15–28.

Chow, Rey. "Listening Otherwise, Music Miniaturized: A Different Type of Question About Revolution." *Discourse* 13, no. 1 (1990): 129–48.

Chun, Wendy Hui Kyong. *Control and Freedom: Power and Paranoia in the Age of Fiber Optics.* Cambridge, MA: MIT Press, 2006.

Cohen, James Nicholas. "Virtual Evolution: An Alternate History of Cyberspace, 1988–1997." PhD diss., Stony Brook University, 2019.

Condis, Megan. *Gaming Masculinity: Trolls, Fake Geeks, and the Gendered Battle for Online Culture.* Iowa City: University of Iowa Press, 2018.

Condry, Ian. *The Soul of Anime: Collaborative Creativity and Japan's Media Success Story.* Durham, NC: Duke University Press, 2013.

Conn, Coco, Jaron Lanier, Margaret Minsky, Scott Fisher, and Allison Druin. "Virtual Environments and Interactivity: Windows to the Future." In *SIGGRAPH '89 Panel Proceeedings*, 7–18. Boston, MA, 1989.

Corker, Kevin, Andrew Mishkin, and John Lyman. "Achievement of a Sense of Operator Presence in Remote Manipulation." Biotechnology Laboratory Technical Report. Naval Ocean Systems Center: University of California, Los Angeles, October 1980.

Cortese, Michelle. "Virtual_ Healing." *Medium*, December 3, 2019. https://medium.com/@ellecortese/virtual-healing-bf2b5f0cbf51.

Coyle, Rebecca. "The Genesis of Virtual Reality." In *Future Visions: New Technologies of the Screen*, ed. Phillip Hayward and Tana Wollen, 148–65. London: British Film Institute, 1993.

Crary, Jonathan. *Techniques of the Observer: On Vision and Modernity in the Nineteenth Century.* Cambridge, MA: MIT Press, 1990.

Crogan, Patrick. *Gameplay Mode: War, Simulation, and Technoculture.* Minneapolis: University of Minnesota Press, 2011.

Dafoe, Chris. "The Next Best Thing to Being There." *Globe and Mail*, September 5, 1992.

Daikoku Takehiko. *Vācharu shakai no 'tetsugaku': Bittokoin, VR, Posutoturūsu.* Tokyo: Seidosha, 2018.

de Souza e Silva, Adriana, and Daniel M. Sutko. "Theorizing Locative Technologies Through Philosophies of the Virtual." *Communication Theory* 21, no. 1 (February 2011): 23–42.

Delaney, Ben. *Virtual Reality 1.0—The 90's: The Birth of VR in the Pages of CyberEdge Journal.* CyberEdge Information Services, 2017.

Der Derian, James. *Virtuous War: Mapping the Military-Industrial-Media-Entertainment Network.* 2nd ed. New York: Routledge, 2009.

deWinter, Jennifer. "Regulating Rape: The Case of *RapeLay*, Domestic Markets, International Outrage, and Cultural Imperialism." In *Video Game Policy: Production, Circulation, Consumption*, ed. Steven Conway and Jennifer deWinter, 244–58. New York: Routledge, 2016.

Dormehl, Luke. "Japanese Convenience Stores Test Robot Shelf-Stackers." *Digital Trends*, July 8, 2020. https://www.digitaltrends.com/news/convenience-store-vr-robot-shelfstacker/.

"Dōsa nyūryoku, CG de 'michi' o taiken (Jinkō genjitsukan no sekai: jō)." *Asahi shinbun*, February 17, 1990.

Doyle, Peter. *Echo and Reverb: Fabricating Space in Popular Music Recording, 1900–1960.* Middletown, CT: Wesleyan University Press, 2005.

du Gay, Paul, Stuart Hall, Linda Janes, Anders Koed Madsen, Hugh Mackay, and Keith Negus. *Doing Cultural Studies: The Story of the Sony Walkman.* 2nd ed. Thousand Oaks, CA: SAGE, 2013.

Dyer-Witheford, Nick, and Greig De Peuter. *Games of Empire: Global Capitalism and Video Games.* Minneapolis: University of Minnesota Press, 2009.

Dyson, Frances. "When Is the Ear Pierced?: The Clashes of Sound, Technology and Cyberculture." In *Immersed in Technology: Art and Virtual Environments*, ed. Mary Anne Moser, 73–101. Cambridge, MA: MIT Press, 1996.

Edwards, Paul N. *The Closed World: Computers and the Politics of Discourse in Cold War America*. Cambridge, MA: MIT Press, 1997.

Egliston, Ben, and Marcus Carter. "Oculus Imaginaries: The Promises and Perils of Facebook's Virtual Reality." *New Media & Society*, forthcoming.

Enomoto Masaki. *Denshi bungakuron*. Tokyo: Sairyūsha, 1993.

Evans, Leighton. *The Re-Emergence of Virtual Reality*. New York: Routledge, 2018.

Ewalt, David M. *Of Dice and Men: The Story of Dungeons & Dragons and the People Who Play It*. New York: Scribner, 2014.

Fickle, Tara. *The Race Card: From Gaming Technologies to Model Minorities*. New York: NYU Press, 2019.

Fisch, Michael. *An Anthropology of the Machine: Tokyo's Commuter Train Network*. Chicago: University of Chicago Press, 2018.

Fisher, Scott. "Viewpoint Dependent Imaging: An Interactive Stereoscopic Display." MA thesis, Massachusetts Institute of Technology, 1981.

Foley, James D. "Interfaces for Advanced Computing." *Scientific American*, October 1987, 126–35.

Freedman, David H. "Facebook's Plan to Dominate Virtual Reality—and Turn Us into 'Data Cattle.'" *Newsweek*, December 23, 2020. https://www.newsweek.com/facebooks-plan-dominate-virtual-reality-turn-us-data-cattle-1556805.

Friedberg, Anne. *The Virtual Window: From Alberti to Microsoft*. Cambridge, MA: MIT Press, 2009.

Frühstück, Sabine, and Anne Walthall, eds. *Recreating Japanese Men*. Berkeley: University of California Press, 2011.

Frumer, Yulia. "Cognition and Emotions in Japanese Humanoid Robotics." *History and Technology* 34, no. 2 (2018): 157–83.

Fujioka, Brett. "Japan's Cynical Romantics, Precursors to the Alt-Right." *Tablet*, August 8, 2019. https://www.tabletmag.com/sections/news/articles/japans-cynical-romantics.

Fukuoka, Maki. "Contextualizing the Peep-Box in Tokugawa Japan." *Early Popular Visual Culture* 3, no. 1 (May 2005): 17–42.

Furness, Thomas A. "Harnessing Virtual Space." *Proceedings of SID International Symposium Digest of Technical Papers*, 1988, 4–7.

——. "The Super Cockpit and Its Human Factors Challenges." In *Proceedings of the Human Factors Society Annual Meeting*, 30, 48–52, 1986.

——. "Virtual Cockpit's Panoramic Displays Afford Advanced Mission Capabilities." *Aviation Week & Space Technology*, 1985, 143–52.

Furuya Toshihiro. *Kyokō sekai wa naze hitsuyō ka?: SF anime 'chō' kōsatsu*. Tokyo: Keisōshobō, 2018.

Galbraith, Patrick W. *Otaku and the Struggle for Imagination in Japan*. Durham, NC: Duke University Press, 2019.

Galbraith, Patrick W., Thiam Huat Kam, and Björn-Ole Kamm, eds. *Debating Otaku in Contemporary Japan: Historical Perspectives and New Horizons*. New York: Bloomsbury Academic, 2015.

Garlick, Steve. *The Nature of Masculinity: Critical Theory, New Materialisms, and Technologies of Embodiment*. Vancouver: University of British Columbia Press, 2018.

Gibson, William. *Neuromancer*. New York: Ace, 1984.

Goertz, Raymond C., Downers Grove, William M. Thompson, and Robert A. Olsen. Electronic Master Slave Manipulator. US2846084A, filed June 21, 1955, and issued August 5, 1958.

Goldberg, Ken, ed. *The Robot in the Garden: Telerobotics and Telepistemology in the Age of the Internet*. Cambridge, MA: MIT Press, 2000.

Golding, Dan. "Far from Paradise: The Body, the Apparatus and the Image of Contemporary Virtual Reality." *Convergence* 25, no. 2 (2017): 340–53.

GOROman. *Mirai no tsukurikata 2020–2045: Boku ga VR ni kakeru wake*. Tokyo: Seikaisha shinsho, 2018.

Gotō Toshiyuki, Kimura Yōichi, Murai Katsumi, and Yamada Akitoshi. "Bainōraru juchō no onzō tōgai teii ni okeru zankyōon no yakuwari ni tsuite." *Chōkaku kenkyūkai shiryō* 31, no. 1 (January 1976): 14–17.

Gotō Toshiyuki, Kimura Yōichi, and Watanabe Kōji. "Bainōraru rokuonhō." *National Technical Report* 22, no. 4 (August 1976): 469–77.

Gottesman, Zachary Samuel. "The Japanese Settler Unconscious: Goblin Slayer on the 'Isekai' Frontier." *Settler Colonial Studies* 10, no. 4 (2020): 529–57.

Graffeo, Clarissa. "The Great Mirror of Fandom: Reflections of (and on) *Otaku* and *Fujoshi* in Anime and Manga." MA thesis, University of Central Florida, 2006.

Grau, Oliver. *Virtual Art: From Illusion to Immersion*. Cambridge, MA: MIT Press, 2003.

Gray, Kate. "This VR Girlfriend Simulator Is About More Than Cybersex." *Kotaku*, February 27, 2018. https://kotaku.com/vr-kanojos-anime-girlfriend-is-more-than-just-a-sex-dol-1823329702.

Gray, Kevin. "Inside Silicon Valley's New Non-Religion: Consciousness Hacking." *Wired UK*, November 1, 2017. https://www.wired.co.uk/article/consciousness-hacking-silicon-valley-enlightenment-brain.

Gray, Mary L., and Siddharth Suri. *Ghost Work: How to Stop Silicon Valley from Building a New Global Underclass*. Boston: Houghton Mifflin Harcourt, 2019.

Grimshaw, Mark, ed. *The Oxford Handbook of Virtuality*. Oxford: Oxford University Press, 2015.

Groening, Stephen. "'No One Likes to Be a Captive Audience': Headphones and In-Flight Cinema." *Film History* 28, no. 3 (2016): 114–38.

Gurevitch, Leon. "The Stereoscopic Attraction: Three-Dimensional Imaging and the Spectacular Paradigm 1850–2013." *Convergence* 19, no. 4 (2013): 396–405.

Hachiya Kazuhiko. "Shichōkaku kōkan mashin." Accessed July 13, 2020. http://www.petworks.co.jp/~hachiya/works/shi_ting_jue_jiao_huanmashin.html.

Hagood, Mack. "Here: Active Listening System: Sound Technologies and the Personalization of Listening." In *Appified: Culture in the Age of Apps*, ed. Jeremy Wade Morris and Sarah Murray, 276–85. Ann Arbor: University of Michigan Press, 2018.

——. *Hush: Media and Sonic Self-Control*. Durham, NC: Duke University Press, 2019.

Hamilton, Ian. "'Hey Facebook' Wake Words Roll Out to Oculus Quest 2." *UploadVR*, February 25, 2021. https://uploadvr.com/hey-facebook-are-you-listening/.

Hamraie, Aimi. *Building Access: Universal Design and the Politics of Disability*. Minneapolis: University of Minnesota Press, 2017.

Hanazawa Kengo. "'Himote' de sura nai motenai otoko no ikisama." *Tsukuru*, 2010, 56–59.

——. *Rusanchiman*, 4 vols. Tokyo: Big Comics, 2004.

Hankins, Joseph Doyle. "An Ecology of Sensibility: The Politics of Scents and Stigma in Japan." *Anthropological Theory* 13, no. 1–2 (March 2013): 49–66.

Hannaford, Blake. "Feeling Is Believing: History of Telerobotics Technology." In *The Robot in the Garden: Telerobotics and Telepistemology in the Age of the Internet*, ed. Ken Goldberg, 246–75. Cambridge, MA: MIT Press, 2001.

Hansen, Mark B. N. *Bodies in Code: Interfaces with Digital Media*. New York: Routledge, 2006.

Harley, Daniel. "Palmer Luckey and the Rise of Contemporary Virtual Reality." *Convergence* 26, no. 5–6 (2020): 1144–58.

Hatada, Toyohiko, Haruo Sakata, and Hideo Kusaka. "Psychophysical Analysis of the 'Sensation of Reality' Induced by a Visual Wide-Field Display." *SMPTE Journal* 89 (1980): 560–69.

Hattori Katsura. "Bācharu riariti no sekai e yōkoso: Konpyūta ga tsumugidasu atarashii genjitsu." *Asahi pasokon*, June 1, 1990, 110–15.

——. *Jinkō genjitsukan no sekai: What's Virtual Reality?* Tokyo: Kōgyō chōsakai, 1991.

——. *VR genron: Hito to tekunorojii no atarashii riaru*. Tokyo: Shōeisha, 2019.

Hayles, N. Katherine. "The Condition of Virtuality." In *The Digital Dialectic: New Essays on New Media*, ed. Peter Lunenfeld, 68–95. Cambridge, MA: MIT Press, 2000.

——. "Embodied Virtuality: Or How to Put Bodies Back into the Picture." In *Immersed in Technology: Art and Virtual Environments*, ed. M. Anne Moser, 1–28. Cambridge, MA: MIT Press, 1996.

——. *How We Became Posthuman: Virtual Bodies in Cybernetics, Literature, and Informatics*. Chicago: University of Chicago Press, 1999.

Hayward, Phillip. "Situating Cyberspace: The Popularization of Virtual Reality." In *Future Visions: New Technologies of the Screen*, ed. Phillip Hayward and Tana Wollen, 180–204. London: British Film Institute, 1993.

Headlam, Bruce. "Origins: Walkman Sounded Bell for Cyberspace." *New York Times*, July 29, 1999.

Heilig, Morton L. Sensorama Simulator. 3050870, filed January 10, 1961, and issued August 28, 1962.

Hillan, Andrew. "Sword Art Everywhere: Narrative, Characters, and Setting in the Transmedia Extension of the *Sword Art Online* Franchise." In *Transmedia Storytelling in East Asia: The Age of Digital Media*, ed. Dal Yong Jin, 75–89. New York: Routledge, 2020.

Hillis, Ken. *Digital Sensations: Space, Identity, and Embodiment in Virtual Reality*. Minneapolis: University of Minnesota Press, 1999.

Hirose Michitaka. "America first no hontō no imi: Sutāku kenkyūshitsu ni te." *Mine*, February 23, 2017. https://mine.place/page/d91f96f5-d14c-49b2-9752-25eff8d5274b.

——. *Bācharu riariti*. Tokyo: Ōmusha, 1995.

——. "HMD ga dame da to iwareta jidai: CABIN no tanjō." *Mine*, November 16, 2016. https://mine.place/page/9245bd60-4be4-4ac0-95f2-32ea8c7ccof8.

——. *Izure oite iku bokutachi o 100-nen katsuyaku saseru tame no sentan VR gaido*. Tokyo: Kōdansha, 2016.

Horowitz, Jeremy. "Docomo's 5G-Based 8K VR Event Streaming Service Will Launch in March." *VentureBeat*, January 23, 2020. https://venturebeat.com/2020/01/23/docomos-5g-based-8k-vr-event-streaming-service-will-launch-in-march/.

Hosokawa, Shūhei. "The Walkman Effect." In *The Sound Studies Reader*, ed. Jonathan Sterne, 104–16. New York: Routledge, 2012.

Huffman, Kathy Rae. "The Electronic Arts Community Goes Online." *TalkBack!*, no. 3 (1996). https://www.lehman.edu/vpadvance/artgallery/gallery/talkback/issue3/centerpieces/huffman .html.

Humann, Heather Duerre. *Reality Simulation in Science Fiction Literature, Film and Television.* Jefferson, NC: McFarland, 2019.

Hutchinson, Rachael. *Japanese Culture Through Videogames.* New York: Routledge, 2019.

Igarashi, Yoshikuni. *Japan, 1972: Visions of Masculinity in an Age of Mass Consumerism.* New York: Columbia University Press, 2021.

Iguchi Seiji. "Denpa no sekai no miharashidai." *Denpa kagaku*, January 1955, 140–1.

Ikeda, Ryo. "Big in Japan: Best Practices for Japanese Developers." Presented at Facebook Connect, September 16, 2020. https://www.facebook.com/watch/live/?v=313847663239317.

Inami Masahiko. *Sūpāhyūman tanjō! Ningen wa SF o koeru.* Tokyo: NHK shuppan shinsho, 2016.

Inoue Akito, Kurose Yōhei, Sayawaka, and Azuma Hiroki. "Media mikkusu kara pachinko e: Nihon gēmu seisuishi 1991–2018." *Genron* 8 (2018): 16–74.

Inoue Yumehito. *Okashi na futari: Okajima Futari seisuiki.* Tokyo: Kōdansha, 1993.

Irwin, Jon. "Don't Write Off Nintendo's Latest Stab at VR." *Variety*, March 16, 2019. https://variety .com/2019/gaming/columns/nintendo-labo-vr-1203165009/.

Ishii Takamochi. *Horonikku pasu.* Tokyo: Kōdansha, 1985.

Ito, Mizuko, Daisuke Okabe, and Misa Matsuda, eds. *Personal, Portable, Pedestrian: Mobile Phones in Japanese Life.* Cambridge, MA: MIT Press, 2005.

Itō Yūji. *VR inpakuto: Shiranai de wa sumasarenai bācharu riariti no sugoi sekai.* Tokyo: Daiyamondo bijinesu kikaku, 2017.

Ivy, Marilyn. "Formations of Mass Culture." In *Postwar Japan as History*, ed. Andrew Gordon, 239–58. Berkeley: University of California Press, 1993.

——. "The *InterCommunication* Project: Theorizing Media in Japan's Lost Decades." In *Media Theory in Japan*, ed. Marc Steinberg and Alexander Zahlten, 101–27. Durham, NC: Duke University Press, 2017.

Iwabuchi, Koichi. *Recentering Globalization: Popular Culture and Japanese Transnationalism.* Durham, NC: Duke University Press, 2002.

Iwata, Hiroo, Takemochi Ishii, and Michitaka Hirose. "ITV Camera Head for Teleoperation Activated by the Eye Motion of the Operator." *Transactions of the Japan Society of Mechanical Engineers* 53, no. 486 (January 1987): 518–21.

"Iwata Hiroo-san, kasō genjitsu o aruku." *Asahi shinbun*, June 16, 1990.

Jacobowitz, Seth. "The Claustrophilic Enclosure: Toward a Speculative Philosophy of Perversion in Edogawa Rampo." *Japan Forum*, forthcoming.

Jagneaux, David. "Oculus Go Review: Standalone VR For the Masses." *UploadVR*, May 2, 2018. https://uploadvr.com/oculus-go-review-standalone-vr/.

"Japan Aims to Reduce Dementia Patients in 70s over 6 Year Period." *Kyodo News*, May 15, 2019.

Japanese Association for Gender Fantasy & Science Fiction. "The Herstory of Sense of Gender Award," 2014. http://gender-sf.org/assets/files/HerstorySOG.pdf.

"Japan Ranks 120th in 2021 Gender Gap Report, Worst Among G-7." *Kyodo News*, March 31, 2021.

Jay, Mark A. "Holophonic vs. Binaural." *Gearspace*. May 19, 2010. https://www.gearspace.com /board/all-things-technical/493726-holophonic-vs-binaural.html.

"Jōhōriron." *Shindenki*, February 1955, 113.

Jones, Nick. *Spaces Mapped and Monstrous: Digital 3D Cinema and Visual Culture*. New York: Columbia University Press, 2020.

Jones, Steven. "A Sense of Space: VR, Authenticity, and the Aural." *Critical Studies in Mass Communication* 10 (1993): 238–52.

Kahaner, David. "Advanced Telecommunications Research Institute (ATR)." *Scientific Information Bulletin* 17, no. 2 (January 21, 1992): 19–23.

——. "Japanese Activities in Virtual Reality." *IEEE Computer Graphics and Applications* 14, no. 1 (January 1994): 75–78.

——. "Virtual Reality in Japan." *IEEE Micro* 13, no. 2 (April 1993): 66–73.

Kawahara Reki. *Sōdo āto onrain*. 34 vols. Tokyo: Dengeki bunko, 2009–2021.

Kawatsuma, Shinji, Mineo Fukushima, and Takashi Okada. "Emergency Response by Robots to Fukushima-Daiichi Accident: Summary and Lessons Learned." *Industrial Robot: An International Journal* 39, no. 5 (August 17, 2012): 428–35.

Keightley, Keir. "'Turn It Down!' She Shrieked: Gender, Domestic Space, and High Fidelity, 1948–59." *Popular Music* 15, no. 2 (May 1996): 149–77.

Kellar, David. "Virtual Reality, Real Money." *Computerworld*, November 15, 1993, 70.

Kelly, Tim. "Japanese Robot to Clock in at a Convenience Store in Test of Retail Automation." *Japan Times*, July 19, 2020.

Kennell, Amanda. "Alice in Evasion: Adapting Lewis Carroll in Japan." PhD diss., University of Southern California, 2017.

Keogh, Brendan. *A Play of Bodies: How We Perceive Videogames*. Cambridge, MA: MIT Press, 2018.

Kinsella, Sharon. *Adult Manga: Culture and Power in Contemporary Japanese Society*. New York: Routledge, 2000.

Kishigami Kento. "Facebook kara Nihon VR kai e no yomei senkoku na no ka!?: Oculus Quest kontentsu shinsa kitei to wa." *note*, March 10, 2019. https://note.com/tokimekishiken/n /n3e944d9e25ad.

Kiuchi, Yuya. "Idols You Can Meet: AKB48 and a New Trend in Japan's Music Industry." *Journal of Popular Culture* 50, no. 1 (2017): 30–49.

Kogawa Tetsuo. *Nyū media no gyakusetsu*. Tokyo: Shōbunsha, 1984.

Koike Kazuo and Kano Seisaku. *Yokohama homerosu*. 4 vols. Tokyo: Koike shoin, 1992.

Kokumai Ananda and Kuribayashi Fumiko. "Takanawa shineki no AI 'Sakura-san', sekuhara ukenagashi butsugi." *Asahi shinbun*, March 19, 2020.

Krebs, Stefan. "The Failure of Binaural Stereo: German Sound Engineers and the Introduction of Artificial Head Microphones." *ICON* 23 (2017): 113–43.

Krier, Beth Ann. "The Essence of Cocooning." *Los Angeles Times*, August 7, 1987.

Krueger, Myron W. "Videoplace: An Artificial Reality." In *Chi '85 Proceedings*, 35–40, 1985.

Kubota Shun. "Kōchō tsuzuku DMM VR, 2-nen me no uriage wa zennenhi no 2-bai no 40 oku en toppa." *Mogura VR*, November 10, 2018. https://www.moguravr.com/dmm-vr-interview-2/.

——. "Nekoronde Netflix o daigamen de miru hōhō." *Mogura VR*, May 4, 2018. https://www
.moguravr.com/netflix-oculus-go/.

Kurihara Kazutaka, Nishida Takeshi, Hamasaki Masahiro, and Yanase Yōhei. "Shōkyokusei
dezain de heiwa o jitsugen suru." *PLANETS*, 2018, 82–97.

Kusahara, Machiko. "Mini-Screens and Big Screens: Aspects of Mixed Reality in Everyday Life."
In *Cast01: Living in Mixed Realities*, 31, 31–33. Bonn: netzspannugn.org, 2001.

Kyarikone nyūsu henshūbu. "Ranobe kontesuto de 'isekai tensei NG' no shibarihirogaru: Net-
tomin 'kore wa rōhō' to kangei." *Kyarikone nyūsu*, May 18, 2017. https://news.careerconnection
.jp/career/general/35597/.

Lamarre, Thomas. *The Anime Ecology: A Genealogy of Television, Animation, and Game Media.*
Minneapolis: University of Minnesota Press, 2018.

Lang, Ben. "5 Million PlayStation VR Units Sold, Sony Announces." *Road to VR*, January 6, 2020.
https://www.roadtovr.com/playstation-vr-sales-5-million-milestone-psvr-units-sold/.

——. "Spurred by Quest 2 Launch, 'VRChat' Hits Record 24,000 Concurrent Users, More Than
Half in VR." *Road to VR*, November 4, 2020. https://www.roadtovr.com/vrchat-record
-concurrent-users-traffic-quest-2/.

——. "'Summer Lesson' for PlayStation VR Made Me Feel Like a Creep, and That's a Good
Thing." *Road to VR*, September 16, 2015. https://www.roadtovr.com/summer-lesson-for
-playstation-vr-made-me-feel-like-a-creep-and-thats-a-good-thing/.

Lang, Eugene. "Foreign Interns in Japan Flee Harsh Conditions by the Thousands." *Nikkei Asian
Review*, August 6, 2018.

Langer, Susanne K. *Feeling and Form: A Theory of Art.* New York: Charles Scribner, 1953.

Lanier, Jaron. *Dawn of the New Everything: Encounters with Reality and Virtual Reality.* New
York: Henry Holt, 2017.

——. "Virtually There." *Scientific American*, April 2001, 66–75.

LaRocco, Michael. "Developing the 'Best Practices' of Virtual Reality Design: Industry Stan-
dards at the Frontier of Emerging Media." *Journal of Visual Culture* 19, no. 1 (April 2020):
96–111.

Laurel, Brenda. "Art and Activism in VR: Based on a Talk Given at the San Francisco Art Insti-
tute's Virtual Reality Symposium, August 1991." *Wide Angle* 15, no. 4 (December 1993): 13–21.

——. *Computers as Theatre.* 2nd ed. Upper Saddle River, NJ: Addison-Wesley, 2013.

Lécuyer, Anatole, Fabien Lotte, Richard B. Reilly, Robert Leeb, Michitaka Hirose, and Mel Slater.
"Brain-Computer Interfaces, Virtual Reality, and Videogames." *Computer* 41, no. 10 (Octo-
ber 2008): 66–72.

Lewis, Diane Wei. "*Shiage* and Women's Flexible Labor in the Japanese Animation Industry."
Feminist Media Histories 4, no. 1 (January 1, 2018): 115–41.

Licoppe, Christian, and Yoriko Inada. "Geolocalized Technologies, Location-Aware Communi-
ties, and Personal Territories: The Mogi Case." *Journal of Urban Technology* 15, no. 3 (Decem-
ber 2008): 5–24.

Lukács, Gabriella. *Invisibility by Design: Women and Labor in Japan's Digital Economy.* Durham,
NC: Duke University Press, 2020.

MacArthur, Cayley, Arielle Grinberg, Daniel Harley, and Mark Hancock. "You're Mak-
ing Me Sick: A Systematic Review of How Virtual Reality Research Considers Gender &

Cybersickness." In *Proceedings of the 2021 CHI Conference on Human Factors in Computing Systems*, 1–15. Yokohama Japan: ACM, 2021.

MacCallum-Stewart, Esther. "Real Boys Carry Girly Epics: Normalising Gender Bending in Online Games." *Eludamos* 2, no. 1 (February 29, 2008): 27–40.

Mannering, Lindsay. "Now Playing in Your Headphones: Nothing." *New York Times*, January 19, 2018.

Manovich, Lev. *The Language of New Media*. Cambridge, MA: MIT Press, 2001.

Marx, Karl. *Capital: Volume 1: A Critique of Political Economy*. Trans. Ben Fowkes. Illustrated ed. New York: Penguin Classics, 1992.

Masaki Gorō. *Viinasu shiti*. Tokyo: Hayakawa shoten, 1995.

Massumi, Brian. "Envisioning the Virtual." In *The Oxford Handbook of Virtuality*, ed. Mark Grimshaw, 55–70. Oxford: Oxford University Press, 2014.

May, Tiffany. "Japanese Student Forced to Dye Her Hair Black Wins, and Loses, in Court." *New York Times*, February 19, 2021.

McKenzie, Jon. "Virtual Reality: Performance, Immersion, and the Thaw." *The Drama Review* 38, no. 4 (1994): 83–106.

McLelland, Mark J. "Thought Policing or the Protection of Youth? Debate in Japan over the 'Non-Existent Youth Bill.'" *International Journal of Comic Art* 13, no. 1 (2011): 348–67.

Melnick, Kyle. "This 'VR Boyfriend' Served Me a Romantic Meal at Anime Expo 2019." *VRScout*, July 8, 2019. https://vrscout.com/news/vr-kareshi-love-simulation-game/.

Mendlesohn, Farah. *Rhetorics of Fantasy*. Middletown, CT: Wesleyan University Press, 2008.

Miles, Elizabeth. "Manhood and the Burdens of Intimacy." In *Intimate Japan: Ethnographies of Closeness and Conflict*, ed. Allison Alexy and Emma E. Cook, 148–63. Honolulu: University of Hawai'i Press, 2019.

Milgram, Paul, Haruo Takemura, Akira Utsumi, and Fumio Kishino. "Augmented Reality: A Class of Displays on the Reality-Virtuality Continuum," 282–92. Boston, MA, 1995.

Miller, Kiri. *Playable Bodies: Dance Games and Intimate Media*. New York: Oxford University Press, 2017.

Mills, Mara. "Hearing Aids and the History of Electronic Miniaturization." *IEEE Annals for the History of Computing* 33, no. 2 (2011): 24–44.

Minsky, Marvin. "Telepresence." *Omni*, June 1980, 45–52.

Mita, Munesuke. *Social Psychology of Modern Japan*. Trans. Stephen Suloway. London: Kegan Paul International, 1992.

Mitchell, David T., with Sharon L. Snyder. *The Biopolitics of Disability: Neoliberalism, Ablenationalism, and Peripheral Embodiment*. Ann Arbor: University of Michigan Press, 2015.

Mitchell, W. J. T., and Mark B. N. Hansen, eds. *Critical Terms for Media Studies*. Chicago: University of Chicago Press, 2010.

Miyadai, Shinji. "Transformation of Semantics in the History of Japanese Subcultures Since 1992." Trans. Shion Kono. *Mechademia* 6 (2011): 231–58.

Miyawaki Yō, Muro Kenji, Hattori Katsura, and Shimizu Kazuhiro. "Maruchimedia jidai ga yatte kuru." *Asahi pasokon*, January 1, 1990, 110–22.

Miyazaki Hayao and Murakami Ryū. "Kinkyū taidan: Misshitsu kara no dasshutsu." *Animage*, November 1989, 17–18.

Mizutani, Kyōhei. "VR Gaming in Japan: Bridging the Cultural Gap." *VRFocus*, October 9, 2020. https://www.vrfocus.com/2020/10/vr-gaming-in-japan-bridging-the-cultural-gap/.

Mori, Shohei, Sei Ikeda, and Hideo Saito. "A Survey of Diminished Reality: Techniques for Visually Concealing, Eliminating, and Seeing Through Real Objects." *IPSJ Transactions on Computer Vision and Applications* 9, no. 1 (December 2017): 1–14.

Morie, Jacquelyn Ford. "Female Artists and the VR Crucible: Expanding the Aesthetic Vocabulary." In *Proceedings of SPIE*, ed. Ian E. McDowall and Margaret Dolinsky. Burlingame, California, 2012.

Morris-Suzuki, Tessa. *Beyond Computopia: Information, Automation and Democracy in Japan.* New York: Routledge, 1988.

——. "Fuzzy Logic: Science, Technology and Postmodernity in Japan." In *Japanese Encounters with Postmodernity*, ed. Jóhann Páll Árnason and Yoshio Sugimoto, 95–113. New York: Routledge, 1995.

Mosco, Vincent. *The Digital Sublime: Myth, Power, and Cyberspace.* Cambridge, MA: MIT Press, 2004.

Moser, Mary Anne, and Douglas MacLeod, eds. *Immersed in Technology: Art and Virtual Environments.* Cambridge, MA: MIT Press, 1996.

Munster, Anna. *Materializing New Media: Embodiment in Information Aesthetics.* Hanover, NH: Dartmouth College Press, 2006.

Murakami, Takashi. *Superflat.* San Francisco: Last Gasp, 2003.

Murray, Janet H. *Hamlet on the Holodeck: The Future of Narrative in Cyberspace.* Updated ed. Cambridge, MA: MIT Press, 2017.

——. "Virtual/Reality: How to Tell the Difference." *Journal of Visual Culture* 19, no. 1 (April 2020): 11–27.

Nagakura Katsue. "VR būmu futatabi, rekishi wa kurikaesu ka?: 'VR kuro rekishi' kara tenbō suru kore kara no VR." *Huffpost Japan*, October 12, 2015. https://www.huffingtonpost.jp/katsue-nagakura/virtual-reality_b_8128690.html.

Nagamachi, Kazuya, Yuki Kato, Maki Sugimoto, Masahiko Inami, and Michiteru Kitazaki. "Pseudo Physical Contact and Communication in VRChat: A Study with Survey Method in Japanese Users." In *ICAT-EGVE 2020—International Conference on Artificial Reality and Telexistence and Eurographics Symposium on Virtual Environments—Posters and Demos.* The Eurographics Association, 2020.

Nagy, Jeff, and Fred Turner. "The Selling of Virtual Reality: Novelty and Continuity in the Cultural Integration of Technology." *Communication, Culture and Critique* 12, no. 4 (December 1, 2019): 535–52.

Nakahara, Genta. "Saya the Virtual Human Project Opens New Creative Frontiers." HAKUHODO, July 9, 2018. https://www.hakuhodo-global.com/news/saya-the-virtual-human-project-opens-new-creative-frontiers.html.

Nakamura, Lisa. *Cybertypes: Race, Ethnicity, and Identity on the Internet.* New York: Routledge, 2002.

——. "Feeling Good About Feeling Bad: Virtuous Virtual Reality and the Automation of Racial Empathy." *Journal of Visual Culture* 19, no. 1 (April 2020): 47–64.

Nango Yoshikazu. *Hitori kūkan no toshiron.* Tokyo: Chikuma shinsho, 2018.

Napier, Susan. *The Fantastic in Modern Japanese Literature: The Subversion of Modernity*. New York: Routledge, 1995.

——. "Where Have All the Salarymen Gone?: Masculinity, Masochism, and Technomobility in *Densha Otoko*." In *Recreating Japanese Men*, ed. Sabine Frühstück and Anne Walthall, 154–76. Berkeley: University of California Press, 2011.

Nelson, Ted. "Interactive Systems and the Design of Virtuality." *Creative Computing*, November 1980, 56–62.

Nemura Naomi. *Posutohyūman eshikkusu josetsu: Saibā karuchā no shintai o tou*. Tokyo: Seikyū-sha, 2017.

Netflix Anime. *I'm N-Ko, Netflix Anime's Official VTuber!*, 2021. https://www.youtube.com /watch?v=pTF_b_9q5o8.

Nguyen, C. Thi. *Games: Agency As Art*. Oxford: Oxford University Press, 2020.

Nihon kokugo daijiten. Vol. 10. Tokyo: Shōgakukan, 2001.

Nihon shōkōkaigisho. "Hitode busoku nado e no taiō ni kan suru chōsa kekka ni tsuite," June 6, 2019. https://www.jcci.or.jp/news/2019/0606132502.html.

Nishimaki Yasao. "Watashi no bainōraru rokuon saisei hōshiki no susume to jissai." *Rajio gijutsu*, July 1976, 245–50.

Noble, Safiya Umoja. *Algorithms of Oppression: How Search Engines Reinforce Racism*. New York: NYU Press, 2018.

Node. *VR Has Gone Too Far!*, 2018. https://www.youtube.com/watch?v=Mvp2Xu5G7Zg.

Nomura, Junji, and Kazuya Sawada. "Virtual Reality Technology and Its Industrial Applications." *IFAC Proceedings* 31, no. 26 (September 1998): 29–39.

Normile, Dennis. "British TV Goggles . . . and Visortrons from Japan." *Popular Science*, March 1993, 26.

Nozawa, Shunsuke. "The Gross Face and Virtual Fame: Semiotic Mediation in Japanese Virtual Communication." *First Monday* 17, no. 3 (March 2, 2012).

Okada, Tokuji. "Object-Handling System for Manual Industry." *IEEE Transactions on Systems, Man, and Cybernetics* 9, no. 2 (1979): 79–89.

Okahara Masaru. "Saikin no bainōraru." *Hōsō gijutsu*, January 1977, 107–13.

Ōkaichimon and Yūji. *Oculus Rift de ore no yome to aeru hon: Unity to MMD moderu de tsukuru hajimete no bācharu riariti*. Tokyo: Shōeisha, 2014.

Okajima Futari. *Kurain no tsubo*. Tokyo: Shinchōsha, 1989.

Ōkoshi, Takanori. *Three-Dimensional Imaging Techniques*. New York: Academic Press, 1976.

Ooi, Sho, Taisuke Tanimoto, and Mutsuo Sano. "Virtual Reality Fire Disaster Training System for Improving Disaster Awareness." In *Proceedings of the 2019 8th International Conference on Educational and Information Technology*, 301–7. New York: Association for Computing Machinery, 2019.

Otake, Tomoko. "Japanese Firm Uses VR Simulations to Offer a Glimpse into the World of Dementia." *Japan Times*, November 29, 2017.

Ōtsugu. "SOD ga katatta, adaruto VR no ima." *Mogura VR*, January 14, 2019. https://www.moguravr .com/sod-vr-4/.

Ōtsuka Eiji. *Kanjō-ka suru shakai*. Tokyo: Ōta shuppan, 2016.

——. *Kasō genjitsu hihyō: Shōhi shakai wa owaranai*. Tokyo: Shinyōsha, 1992.

——. *Kyarakutā shōsetsu no tsukurikata.* Tokyo: Kōdansha, 2003.

——. "Mechademia in Seoul: Ōtsuka Eiji Keynote." Trans. Alexander Zahlten. *Electronic Journal of Contemporary Japanese Studies* 17, no. 1 (April 23, 2017). https://www.japanesestudies.org .uk/ejcjs/vol17/iss1/otsuka.html.

——. *Shōjo minzoku-gaku: Seikimatsu no shinwa o tsumugu 'miko no matsuei.'* Tokyo: Kōbunsha, 1989.

Ouzounian, Gascia. *Stereophonica: Sound and Space in Science, Technology, and the Arts.* Cambridge, MA: MIT Press, 2021.

Oyama Ondemando. "Adaruto VR fesuta." Den fami niko gēmā, June 12, 2016. https://news .denfaminicogamer.jp/kikakuthetower/adult-vr01.

Parisi, David. *Archaeologies of Touch: Interfacing with Haptics from Electricity to Computing.* Minneapolis: University of Minnesota Press, 2018.

Parks, Lisa, and Caren Kaplan, eds. *Life in the Age of Drone Warfare.* Durham, NC: Duke University Press, 2017.

Partner, Simon. *Assembled in Japan: Electrical Goods and the Making of the Japanese Consumer.* Berkeley: University of California Press, 2000.

Patterson, Christopher B. *Open World Empire: Race, Erotics, and the Global Rise of Video Games.* New York: NYU Press, 2020.

Paulsen, Kris. *Here/There: Telepresence, Touch, and Art at the Interface.* Cambridge, MA: MIT Press, 2017.

Peirce, Charles Sanders. "Virtual." In *Dictionary of Philosophy and Psychology*, ed. James Mark Baldwin, Vol. II: 763–64. London: Macmillan, 1902.

Pesce, Mark. "Learning from History: How to Make VR Bigger Than the Web." *Medium*, June 27, 2016. https://medium.com/ghvr/tc-shanghai-2016-8ad6c097262d.

Pimentel, Ken. *Virtual Reality: Through the New Looking Glass.* New York: Intel/Windcrest, 1993.

Pinkus, Karen. "Ambiguity, Ambience, Ambivalence, and the Environment." *Common Knowledge* 19, no. 1 (January 1, 2013): 88–95.

Pollack, Andrew. "For Artificial Reality, Wear a Computer." *New York Times*, April 10, 1989.

Posadas, Baryon Tensor. "Beyond Techno-Orientalism: Virtual Worlds and Identity Tourism in Japanese Cyberpunk." In *Dis-Orienting Planets: Racial Representations of Asia in Science Fiction*, ed. Isiah Lavender III, 144–59. Jackson: University Press of Mississippi, 2017.

Pryor, Sally, and Jill Scott. "Virtual Reality: Beyond Cartesian Space." In *Future Visions: New Technologies of the Screen*, ed. Philip Hayward and Tana Wollen, 166–79. London: British Film Institute, 1993.

Raymo, Chet. "Virtual Reality Is Not Enough." *Boston Globe*, September 10, 1990.

Rheingold, Howard. *Virtual Reality: The Revolutionary Technology of Computer-Generated Artificial Worlds—and How It Promises to Transform Society.* New York: Simon & Schuster, 1992.

Richmond, Scott C. *Cinema's Bodily Illusions: Flying, Floating, and Hallucinating.* Minneapolis: University of Minnesota Press, 2016.

Ridgely, Steven C. *Japanese Counterculture: The Antiestablishment Art of Terayama Shuji.* Minneapolis: University of Minnesota Press, 2011.

Robertson, Adi. "Facebook Is Making Oculus' Worst Feature Unavoidable." *Verge*, August 19, 2020. https://www.theverge.com/2020/8/19/21375118/oculus-facebook-account-login-data -privacy-controversy-developers-competition.

Robertson, Jennifer. *Robo Sapiens Japanicus: Robots, Gender, Family, and the Japanese Nation.* Oakland: University of California Press, 2017.

——. "Rubble, Radiation and Robots." *The American Interest* 7, no. 1 (2011): 122–26.

——. *Takarazuka: Sexual Politics and Popular Culture in Modern Japan.* Berkeley: University of California Press, 1998.

Robinson, Noa. *ENDGAME VR Live Stream—The VRchat Transgender Community.* ENDGAME, 2018. https://www.youtube.com/watch?v=MdIU5lvvKE4.

Roquet, Paul. "Ambiance In and Around the Virtual Reality Headset." In *Proceedings of the 4th International Congress on Ambiances, Alloaesthesia: Senses, Inventions, Worlds,* 2, 14–19. France: Réseau International Ambiances, 2020.

——. *Ambient Media: Japanese Atmospheres of Self.* Minneapolis: University of Minnesota Press, 2016.

——. "Empathy for the Game Master: How Virtual Reality Creates Empathy for Those Seen to Be Creating VR." *Journal of Visual Culture* 19, no. 1 (April 2020): 65–80.

——. "Telepresence Enclosure: VR, Remote Work, and the Privatization of Presence in a Shrinking Japan." *Media Theory* 4, no. 1 (2020): 33–62.

Ross, Miriam. "From the Material to the Virtual: The Pornographic Body in Stereoscopic Photography, 3D Cinema and Virtual Reality." *Screen* 60, no. 4 (December 1, 2019): 548–66.

——. "Virtual Reality's New Synesthetic Possibilities." *Television & New Media* 21, no. 3 (March 2020): 297–314.

Said, Edward W. *Orientalism.* New York: Vintage, 1979.

Saito, Satomi. "Narrative in the Digital Age: From Light Novels to Web Serials." In *Routledge Handbook of Modern Japanese Literature,* ed. Rachael Hutchinson and Leith Douglas Morton, 315–27. New York: Routledge, 2016.

Saitō, Tamaki. *Beautiful Fighting Girl.* Trans. J. Keith Vincent and Dawn Lawson. Minneapolis: University of Minnesota Press, 2011.

Sakamura Ken. *Dennō toshi.* New ed. Tokyo: Iwanami shoten, 1987.

Saker, Michael, and Jordan Frith. "Coextensive Space: Virtual Reality and the Developing Relationship Between the Body, the Digital and Physical Space." *Media, Culture & Society* 42, no. 7–8 (June 19, 2020): 1427–42.

Sanches-Vives, Maria V., and Mel Slater. "From Presence to Consciousness Through Virtual Reality." *Nature Reviews Neuroscience* 6 (2005): 332–39.

Schroeder, Ralph. *Possible Worlds: The Social Dynamics of Virtual Reality Technology.* Boulder, CO: Westview Press, 1996.

Schröter, Jens. *3D: History, Theory and Aesthetics of the Transplane Image.* Rev. ed. Trans. Brigitte Pichon and Dorian Rudnytsky. New York: Bloomsbury Academic, 2014.

Scoica, Adrian. "Susumu Tachi: The Scientist Who Invented Teleexistence." *ACM Crossroads* 22, no. 1 (2015): 61–62.

Screech, Timon. *The Lens Within the Heart: The Western Scientific Gaze and Popular Imagery in Later Edo Japan.* Honolulu: University of Hawai'i Press, 2002.

Senda Yūki. "Hyōgen no jiyū' wa dono yō ni mamorareru beki nanoka? Futatabi Kizuna Ai sōdō ni yosete." *Yahoo! News Japan,* October 4, 2018. https://news.yahoo.co.jp/byline/sendayuki/20181004-00099263/.

——. "Nōberu-shō no NHK kaisetsu ni 'Kizuna Ai' wa tekiyaku nanoka?: Netto de enjōchū." *Yahoo! News Japan*, October 3, 2018. https://news.yahoo.co.jp/byline/sendayuki/20181003 -00099158/.

Serizawa, Kensuke. *Konbini gaikokujin.* Tokyo: Shinchōsha, 2018.

SF magajin, VR/AR special issue, December 2016.

Sherif, Ann. *Japan's Cold War: Media, Literature, and the Law.* New York: Columbia University Press, 2016.

Sherman, Barrie, and Phillip Judkins. *Glimpses of Heaven, Visions of Hell: Virtual Reality and Its Implications.* London: Coronet, 1993.

Shibata Katsuie. *Unnanshō Sū-zoku ni okeru VR gijutsu no shiyōrei.* Tokyo: Hayakawa shobō, 2018.

Shields, Rob. *The Virtual.* New York: Routledge, 2002.

Shin Kiyoshi. *VR bijinesu no shōgeki: 'Kasō sekai' ga kyodai manē o umu.* Tokyo: NHK shuppan, 2016.

Slater, Mel, Daniel Pérez Marcos, Henrik Ehrsson, and Maria V. Sanchez-Vives. "Inducing Illusory Ownership of a Virtual Body." *Frontiers in Neuroscience* 3 (2009): 214–20.

Slater, Mel, Daniel Pérez Marcos, Henrik Ehrsson, and Maria V. Sanches-Vives. "Towards a Digital Body: The Virtual Arm Illusion." *Frontiers in Human Neuroscience* 2 (2008): 6.

Smartpr!se. "Joshikōsei YouTuber 'Fuji Aoi.' " *VRunner*, August 20, 2018, 12.

Sobchack, Vivian. "New Age Mutant Ninja Hackers: Reading *Mondo 2000*." *The South Atlantic Quarterly* 94, no. 4 (1993): 569–84.

Somese Naoto. "90-nendai kōhan no densetsu no VR purojekuto Sony FourthVIEW Project kōhen." *Video Salon*, January 25, 2017. https://videosalon.jp/serialization/sony_fourth _view_project2/.

Sone, Yuji. *Japanese Robot Culture: Performance, Imagination, and Modernity.* New York: Palgrave Macmillan, 2017.

Sōtokushū Hanazawa Kengo: Hīrō-naki sekai o ikiru. KAWADE yume mukku. Tokyo: Kawade shobō shinsha, 2016.

Spitzer, Leo. "Milieu and Ambiance: An Essay in Historical Semantics." *Philosophy and Phenomenological Research* 3, no. 1 (September 1942): 1–42.

St. Michel, Patrick. "Kizuna AI's NHK Appearance Sparks Debate on Social Media." *Japan Times*, October 13, 2018.

Steam. "Steam Community: VR Kanojo." Accessed October 28, 2020. https://steamcommunity.com /app/751440/reviews/.

Steam Blog. "Who Gets to Be on the Steam Store?," June 6, 2018. https://store.steampowered .com/news/group/27766192/view/.

Steinberg, Marc. *Anime's Media Mix: Franchising Toys and Characters in Japan.* Minneapolis: University of Minnesota Press, 2012.

——. "8-Bit Manga: Kadokawa's Madara, or, The Gameic Media Mix." *Kinephanos* 5 (December 2015): 40–52.

——. *The Platform Economy: How Japan Transformed the Consumer Internet.* Minneapolis: University of Minnesota Press, 2019.

Sterne, Jonathan. *The Audible Past: Cultural Origins of Sound Reproduction.* Durham, NC: Duke University Press, 2003.

——. "Space Within Space: Artificial Reverb and the Detachable Echo." *Grey Room* 60 (July 2015): 110–31.

Stevens, Benjamin. "Virtual Boy Press Releases." Planet Virtual Boy, February 8, 2018. https://www.planetvb.com/modules/newbb/viewtopic.php?topic_id=7003&post_id =39594#forumpost39594.

Steyerl, Hito. "Bubble Vision." Lecture presented at the Guest, Ghost, Host: Machine! Marathon, City Hall, London, October 7, 2017. https://www.youtube.com/watch?v=boMbdtu2rLE.

Stone, Allucquère Rosanne. "Sex and Death Among the Disembodied: VR, Cyberspace, and the Nature of Academic Discourse." *Sociological Review* 42, no. 1 (May 1994): 243–55.

——. "Will the Real Body Please Stand Up?: Boundary Stories About Virtual Cultures." In *Cyberspace: First Steps*, ed. Michael Benedikt, 81–118. Cambridge, MA: MIT Press, 1992.

Suchman, Lucy. "Configuring the Other: Sensing War Through Immersive Simulation." *Catalyst* 2, no. 1 (April 22, 2016): 1–36.

Sutereo haifai seisaku dokuhon. Tokyo: Seibundō shinkōsha, 1962.

Sutherland, Ivan E. "A Head-Mounted Three Dimensional Display." In *Proceedings of the December 9–11, 1968, Fall Joint Computer Conference, Part I—AFIPS '68*, 757–64. San Francisco: ACM Press, 1968.

——. "The Ultimate Display." In *Proceedings of International Federation of Information Processing (IFIP)*, 506–8. London: Macmillan, 1965.

Sutton, Thomas, ed. *Photographic Notes.* London: Bland and Long, 1857.

Swisher, Kara. "Facebook CEO Mark Zuckerberg: The Kara Swisher Interview." Recode Decode. July 18, 2018. https://www.vox.com/2018/7/18/17575158/mark-zuckerberg-facebook-interview -full-transcript-kara-swisher.

Szabo, Victor. "Ambient Music as Popular Genre: Historiography, Interpretation, Critique." PhD diss., University of Virginia, 2015.

Szczepaniak-Gillece, Jocelyn. *The Optical Vacuum: Spectatorship and Modernized American Theater Architecture.* New York: Oxford University Press, 2018.

Tachi_Lab. "TX Inc." Accessed September 22, 2020. https://tachilab.org/en/about/company .html.

Tachi Susumu. "Aratana hatarakikata, ikikata, shakai no arikata no jitsugen ni mukete tereigujisutansu no shakai jissō o." *Sangakukan renkei jānaru* 14, no. 12 (December 2018): 28–30.

——. "Artificial Reality and Tele-Existence: Present Status and Future Prospect." In *Proceedings of the 2nd International Conference on Artificial Reality and Tele-Existence*, 7–16, 1992.

——. *Bācharu riariti nyūmon.* Tokyo: Chikuma shinsho, 2002.

——. "Memory of the Early Days and a View Toward the Future." *Presence: Teleoperators and Virtual Environments* 25, no. 3 (December 1, 2016): 239–46.

——. *Telexistence.* 2nd ed. New Jersey: World Scientific, 2014.

——. "Tereigujisutansu." *Nihon robotto gakkaishi* 33, no. 4 (2015): 215–21.

——. "Tereigujisutansu no ima: Jikūkan shunkan idō sangyō to tereigujisutansu shakai e no chōsen." Keynote lecture presented at the Digital Content Expo, Makuhari Messe, Chiba, November 15, 2018.

——. "Tereigujisutansu no kenkyū (dai 2-hō): Tanshoku shikaku teiji ni yoru jitsuzaikan no hyōka," 211–12, 1982.

Tachi Susumu and Komoriya Kiyoshi. "Dai 3-sedai robotto." *Keisoku to seigyo* 21, no. 12 (December 1982): 52–58.

Tachi, Susumu, K. Tanie, K. Komoriya, and M. Kaneko. "Tele-Existence (I): Design and Evaluation of a Visual Display with Sensation of Presence." In *Proceedings of RoManSy'84 The Fifth CISM-IFToMM Symposium*, 245–54. Udine, Italy, 1984.

Takahashi, Dean. "Will Japanese VR Sex Simulation with Dolls Fly in the U.S.?" *Venture-Beat*, January 11, 2017. https://venturebeat.com/2017/01/11/will-japanese-vr-sex-simulation-with-dolls-fly-in-the-u-s/.

Takahata Kyōichirō. *Kurisu kurosu: Konton no maō*. Tokyo: Dengeki bunko, 1997.

Takashima Yūya. "Uso no shōshitsu: VR wa shōsetsu o ukeirerareru no ka." *SF magajin*, December 2016, 40–45.

Takeda Satetsu. *Nihon no kehai*. Tokyo: Shōbunsha, 2018.

Takemura Mitsuhiro. "'Genjitsu' o yurugaseru oto: Onzō shimyurēshon 'horofonikusu.'" *Kōkoku*, September 1987, 19–22.

——. "Onzō sōsa, shimyurakuru no rinkaiten: Seitai media to 'horofonikusu.'" *Yuriika*, June 1987, 159–67.

Tamagomago. "'VR ojisan no hatsukoi' ga rosujene sedai ni tsukisasaru 'otaku, nekura, kimoi, datte ore sono tōri nandamon': Bōryoku Tomoko ni kiku." *QJWeb*, April 16, 2021. https://qjweb.jp/feature/49078/.

Tanaka Komimasa. "Kurain no tsubo." *Kaien* (February 1989): 126–45.

Tani Takuo. "VR=bācharu riaritii ka, 'kasō' genjitsu ka." *Hōsō kenkyū to chōsa* (January 2020): 46–58.

Tanji Yoshinobu. "Ojisan no kokoro ni meboeta 'bishōjo': VR ga motarasu, mō hitotsu no mirai." *WithNews*, March 29, 2018. https://withnews.jp/article/fo180329000qqooooooooooooooo Woog10701qq000017016A.

Taylor, T. L. *Watch Me Play: Twitch and the Rise of Game Live Streaming*. Princeton, NJ: Princeton University Press, 2018.

Théberge, Paul, Kyle Devine, and Tom Everrett, eds. *Living Stereo: Histories and Cultures of Multichannel Sound*. New York: Bloomsbury Academic, 2015.

Thompson, Emily Ann. *The Soundscape of Modernity: Architectural Acoustics and the Culture of Listening in America, 1900–1933*. Cambridge, MA: MIT Press, 2002.

Tifana. "Jinkō chinō (AI) tōsai kyarakutā 'Sakura' ni yoru sekkyaku shisutemu: Riyō shiin." Accessed October 28, 2020. https://tifana.ai/case/.

Tsuzuki Kyōichi. *Tokyo Style*. Tokyo: Chikuma shobō, 1993.

Tuhus-Dubrow, Rebecca. *Personal Stereo*. New York: Bloomsbury Academic, 2017.

Turner, Fred. *From Counterculture to Cyberculture: Stewart Brand, the Whole Earth Network, and the Rise of Digital Utopianism*. Chicago: University of Chicago Press, 2008.

Uechi, Jenny. "Society's Role in Kato's Crime." *Japan Times*, July 1, 2008.

Uno Mayuko. "VR de taikan torēningu: Panasonic, jōba-kei fittonesu kikai o BtoB tenkai." *Nikkei XTech*, July 30, 2018. https://xtech.nikkei.com/atcl/nxt/column/18/00001/00808/.

Uno Tsunehiro. *Zero-nendai no sōzōryoku*. Tokyo: Hayakawa shobō, 2008.

User Local. "Ninki bācharu yūchūbā rankingu." Accessed June 25, 2021. https://virtual-youtuber.userlocal.jp/document/ranking/.

VanHook, Ilsa. "Japanese Toys." *Mondo 2000* (Summer 1990): 22–23.

Victor, Daniel. "Ad Showing Naomi Osaka with Light Skin Prompts Backlash and an Apology." *New York Times*, January 22, 2019.

VIVE. "HTC VIVE Breaks New Ground with Launch of Portable VIVE Flow Immersive Glasses." October 25, 2021. https://www.vive.com/us/newsroom/2021-10-14/www.vive.com /us/newsroom/2021-10-14/.

Wakabayashi Shunsuke. "Iyāfōn!?: Sutereo saisei to bainōraru saisei no chigai, sono 1." *Rekōdo geijutsu*, April 1961, 162–63.

Walker, John. "Through the Looking Glass: Beyond 'User Interfaces.'" September 1, 1988. https:// www.fourmilab.ch/autofile/e5/chapter2_69.html.

Watson, Benjamin. "A Survey of Virtual Reality in Japan." *Presence* 3, no. 1 (1994): 1–18.

Weber, Heike. "Head Cocoons: A Sensori-Social History of Earphone Use in West Germany, 1950–2010." *The Senses and Society* 5, no. 3 (November 2010): 339–63.

Weheliye, Alexander G. *Phonographies: Grooves in Sonic Afro-Modernity.* Durham, NC: Duke University Press, 2005.

Weiser, Mark. "The Computer for the 21st Century." *Scientific American* (September 1991): 94–104.

Wertheim, Margaret. *The Pearly Gates of Cyberspace: A History of Space from Dante to the Internet.* New York: Norton, 2000.

West, Joel. "Utopianism and National Competitiveness in Technology Rhetoric: The Case of Japan's Information Infrastructure." *The Information Society* 12, no. 3 (August 1996): 251–72.

West, Joel, Jason Dedrick, and Kenneth L Kraemer. "Back to the Future: Japan's NII Plans." In *National Information Infrastructure Initiatives: Vision and Policy Design*, ed. Brian Kahin and Ernest Wilson, 61–111. Cambridge, MA: MIT Press, 1996.

Whissel, Kristen. *Spectacular Digital Effects: CGI and Contemporary Cinema.* Durham, NC: Duke University Press, 2014.

Williamson, Judith. *Consuming Passions: The Dynamics of Popular Culture.* London: Marion Boyars, 1986.

Wooley, Benjamin. *Virtual Worlds: A Journey in Hype and Hyperreality.* London: Penguin, 1994.

Wurtzler, Steve J. *Electric Sounds: Technological Change and the Rise of Corporate Mass Media.* New York: Columbia University Press, 2008.

Yajima Nobuyuki. *Sofuto o tanin ni tsukuraseru Nihon, jibun de tsukuru Beikoku: Keiei to gijutsu kara mita kindaika no shomondai.* Tokyo: Nikkei BP-sha, 2013.

Yamada Akitoshi and Kikuchi Yoshinobu. "Tekunikusu anbiensuhon no tokuchō." *Rajio gijutsu* (July 1976): 251–55.

Yamaguchi, Tomomi. "The Mainstreaming of Feminism and the Politics of Backlash in Twenty-First Century Japan." In *Rethinking Japanese Feminisms*, ed. Julia C. Bullock, Ayako Kano, and James Welker, 68–86. Honolulu: University of Hawai'i Press, 2018.

Yamamoto Seishū. "Heddohon o rikai suru kōza." *Rajio gijutsu* (February 1975): 225–28.

Yano, Christine. "The Burning of Men: Masculinities and the Nation in Popular Song." In *Men and Masculinities in Contemporary Japan: Dislocating the Salaryman Doxa*, ed. James E. Roberson and Nobue Suzuki, 77–90. New York: Routledge, 2002.

Yasar, Kerim. *Electrified Voices: How the Telephone, Phonograph, and Radio Shaped Modern Japan, 1868–1945*. New York: Columbia University Press, 2018.

Yasuda Hitoshi. *Shinwa seisaku kikairon*. Tokyo: BNN, 1987.

Yoda, Tomiko. "The Rise and Fall of Maternal Society: Gender, Labor, and Capital in Contemporary Japan." *South Atlantic Quarterly* 99, no. 4 (October 1, 2000): 865–902.

Yoshimi Shunya. *'Koe' no shihonshugi: denwa, rajio, chikuonki no shakaishi*. Tokyo: Kawade shobō shinsha, 2012.

——. "The Market of Ruins, or the Destruction of the Cultural City." *Japan Forum* 23, no. 2 (June 2011): 287–300.

Yue, Genevieve. "The China Girl on the Margins of Film." *October* 153 (July 1, 2015): 96–116.

"Yume kara sameta VR: Bijinesu no genjō to mirai e no kadai." *Boss*, January 2019, 21–26.

Yuriika. Bācharu YouTuber special issue, 2018.

Zahlten, Alexander. *The End of Japanese Cinema: Industrial Genres, National Times, and Media Ecologies*. Durham, NC: Duke University Press, 2017.

INDEX

ableism, 96

Accel World, 117

acoustics, 20–22, 30, 33, 35–37, 41–42; virtual, 23, 30, 35, 42–44

Adult VR Festival, 216n58

Advanced Research Project Agency (ARPA), 51

Advanced Robot Technology in Hazardous Environments project, 90–91

Advanced Telecommunications Research Institute (ATR), 62

aging: population in Japan, 84, 90, 168; studies, 103. *See also* elderly

Ahmed, Sara, 128

AIP Cube, 54, 60

Aizu Izumi, 82

Akihabara (Tokyo), 150, 159, 161–62, 206n16, 216n58, 218n84

AKIRA, 205n5

Alice Mystery Garden, 207n29, 212n10

Alice's Adventures in Wonderland, 51–52, 60, 80, 115, 190n6, 207n29, 211n78

Allison, Anne, 152

Amazon, 100–101, 214n26

ambience, 5, 37, 183n25. *See also* detachable ambience

Ambience Phone, 37–38, 40, 43, 45, 64

ambient, 5, 14, 18, 24, 44, 192n13; interface, 5; music, 37, 157; perceptual control, 37, 40, 43–44, 97, 158; power play, 6, 9, 15, 137, 157–58, 176–77; space, 42, 44

Ames, Morgan G., 75

Andrejevic, Mark, 3

anime, 10, 100, 111, 113, 208n34, 215n43; characters in, 151; fans of, 137, 147, 190n86, 206n16; industry, 114, 132, 163; media mix, 12–13, 185n45; and right-wing, 218n90; worlds, 12, 148, 150–51, 158, 208n34, 218n84. *See also* manga/anime realism

anti-anonymity, 95–96

Argonne National Laboratory, 52, 84

Artaud, Antonin, 198n113

artificial intelligence (AI), 101–2, 133, 149–50, 155, 161

artificial reality, 55–56, 58–59, 61, 78, 192n24

Asada Akira, 109, 205n7

ASMR, 187n36

Atanasoski, Neda, 156–57

Audible Past, The, 41

auditory perspective, 24, 29, 33–34, 37, 43–45